Crossing Boundaries &
Confounding Identity

SUNY series in Asian Studies Development

Roger T. Ames and Peter D. Hershock, editors

Crossing Boundaries & Confounding Identity

Chinese Women in Literature, Art, and Film

Edited by

Cheryl C. D. Hughes

SUNY
PRESS

Cover image credit: Wang Tiantian, She, 2002. Litograph. © Wang Tiantian.

Published by State University of New York Press, Albany

For information, contact State University of New York Press, Albany, NY
www.sunypress.edu

Library of Congress Cataloging-in-Publication Data

Name: Hughes, Cheryl D., 1945– editor.
Title: Crossing boundaries and confounding identity : Chinese women in
 literature, art, and film / Cheryl C. D. Hughes.
Description: Albany : State University of New York Press, 2023. | Series:
 SUNY series in Asian studies development | Includes bibliographical
 references and index.
Identifiers: LCCN 2022025201 | ISBN 9781438492155 (hardcover : alk. paper) |
 ISBN 9781438492162 (ebook) | ISBN 9781438492148 (pbk. : alk. paper)
Subjects: LCSH: Women—China. | Women in literature. | Women in art. |
 Women in motion pictures.
Classification: LCC HQ1767 .C78 2023 | DDC 305.40951—dc23/eng/20220727
LC record available at https://lccn.loc.gov/2022025201

10 9 8 7 6 5 4 3 2 1

This volume is dedicated to Drs. Roger Ames, Peter Hershock, and Elizabeth Buck, all directors and founders of the East-West Center's Asian Studies Development Program (ASDP). Most of the authors of *Crossing Boundaries and Confounding Identity: Chinese Women in Literature, Art, and Film* are alumnae of one or more programs sponsored by the ASDP and thus have fallen under the tutelage of these outstanding scholars. The depth of their knowledge and their great enthusiasm for their subject matter is captivating to those lucky enough to attend their workshops, seminars, field trips, and conferences. For many young scholars, an ASDP event is life changing. The intent is not to make Asian studies experts of the attendees, but to have them carry over the knowledge and excitement gained in the programs into their general teaching of undergraduates in a number of fields. ASDP was and is a place to begin to become acquainted with the rich culture of Asia. Most of those writing in this book enjoyed weeks-long studies in Chinese culture—its peoples, history, philosophy, literature, and art—at the ASDP offices at the University of Hawaii, Manoa, and/or traveling in China. Thus, with great gratitude, I dedicate *Crossing Boundaries and Confounding Identity* to the ASDP mentors, Roger Ames, Peter Hershock, and Elizabeth Buck.

Contents

Illustrations

Acknowledgments

It took far longer than I had imagined it would to bring this volume to completion. A monograph is a work entirely one's own. Delays, false starts, and abrupt stops belong to no one else but the author. Its strengths and weaknesses are her own. In an edited volume, there are several authors with their own time constraints, professional obligations, families, friends, and outside influences that intrude on their commitment to the project. Add to the personal and professional distractions the malign attack of the COVID-19 pandemic and it is a wonder that this volume has come to completion so beautifully. Our success is due to the astounding dedication and enthusiasm of the contributors. They were patient, diligent, creative, and responsive to editorial requests and suggestions. To my writers—Emma Teng, Dona Cady, Marla Lunderberg, Catherine Ryu, Laura Xie, Jinhua Li, Yanhong Zhu, Shelley Hawks, and Jessica Sheetz-Nguyen—I owe my deepest gratitude and appreciation. Thank you, one and all, especially Shelley Hawks for helping organize the illustrations and their documentation.

My much-published friend Margaret Lee, a constant support, was always ready with good ideas and helpful hints. Peter Hershock, of the Asian Studies Development Program of the East-West Center, was the first to suggest that I edit a volume on Chinese women in the arts. I had asked him for advice on my article on Chinese women warriors. Creating an edited volume was not something I had ever considered, although my article was intended to be included in such a collection. One thing led to another, and here we are.

Of course, none of this work could have happened without the love and support of my family. My amazing husband, Bill Hughes, kept me focused and well fed. He is a gourmet cook with a delight in new

wines and a good sense of humor. He is, quite simply, my best friend. My daughter, Christine, and sons, Robert and Alexander, were always there for me to talk over a thorny formatting problem or give me a pep talk. My family is my main source of strength and inspiration. They know they have my eternal thanks and devotion.

Preface with List of Contributors

This volume grew quite organically out of the enthusiasm of scholars who had experienced various workshops, seminars, and field studies conducted by the Asian Studies Development Program (ASDP) of the East West Center in Hawaii. Most, but not all, of the authors of this book are alumnae of one or more ASDP program. The other authors were recruited personally by ASDP alumnae who know them and their work. It was a word-of-mouth endeavor to bring together scholars who could engage readers in a wide array of topics on the theme of Chinese women in literature, art, and/or film. The authors submitted proposals for chapters according to their own expertise and interest. This volume, therefore, is a result of scholars writing about what is of most interest to them and what they believe will further a wider understanding of Chinese women as subjects or creators of literature, art, and/or film within the scholarly community of faculty and students, as well as for the educated reader. That there are only female scholars is a result of only female scholars responding to the request for proposals, it was not the intent of this editor to limit the authors by gender. As a matter of authorial decisions, the chapters of this volume vary in time and place from the early dynasties to the very present, with much of the emphasis on the modern period. Here are the authors who wrote Crossing Boundaries and Confounding Identity: Chinese Women in Literature, Art, and Film:

Professor Emma Jinhua Teng, who holds her degrees from Harvard University, has moved down Massachusetts Avenue to teach at the Massachusetts Institute of Technology. A senior scholar, she lends her expertise to this volume with her Introduction.

xiv | Preface with List of Contributors

Professor **Dona M. Cady** of Middlesex Community College who writes her essay on Emily Georgiana Kemp, has advanced degrees from Notre Dame and Oxford, and has taught a variety of courses centering on Chinese religion and philosophy. She is particularly interested in exploring the Heart-Mind of China.

Professor **Marla Hoffman Lunderberg** of Hope College presents her analysis of one of Ling Menchu's seventeenth century vernacular short stories. She earned her Ph.D. from the University of Chicago in English Literature. She has hiked part El Comino to Santiago de Compostela.

Professor **Catherine Ryu** of Michigan State University takes crossing boundaries to heart going from China to Japan in her studies of *Genji*. Professor Ryu holds a Ph.D. from the University of Michigan.

Professor **Cheryl C. D. Hughes** traces historical and mythological Chinese women warriors through time and across media. Professor Hughes holds her Ph.D. from Durham University in England and, until her recent retirement, taught Humanities, Film, Religious Studies, and Chinese Culture at Tulsa Community College.

Professor **Laura Xie** of the Virginia Military Institute offers a critical look at women who specialize in taking on the roles of men in Chinese classical theater. Professor Xie holds her Ph.D. in East Asian Languages and Cultures from Stanford University.

Professor **Jinhua Li**, of the University of North Carolina Ashville's Chinese Studies and Language Department, dissects the most recent film of Pearl Buck's novel *Pavilion of Women*. Professor Li earned her Ph.D. from Purdue University in Comparative Literature.

Professor **Yanhong Zhu**, discusses two of China's most celebrated female film directors. Professor Zhu earned her Ph.D. from the University of Southern California and teaches East Asian languages and culture at Washington and Lee University.

Historian **Shelley Drake Hawks** analyzes the visual depictions of or by Chinese women over the last one hundred years by examining works by ten very different artists. Professor Hawks holds a Ph.D. in History

from Brown University. She is an independent scholar and an adjunct professor at Middlesex Community College where she teaches World Civilizations and Art History.

Professor Emerita **Jessica Sheetz-Nguyen** of the University of Central Oklahoma provides wide-ranging textual and visual resources on the history of Chinese Women, from the oracle bones to the near present. She holds a Ph.D. from Marquette University and is the past president of the Asian Studies Development Program alumni organization.

Everyone told me that editing a volume was like herding cats. That has not been the case with this volume. Never has there been a more committed group of authors, all eager to bring a volume to completions. Perhaps it lies in the fact that each author proposed her own topic and then followed through to completion. That is not say that life did not intervene in the forms of sick children, parents, or spouses. Professional commitments also got in the way. The Covid 19 virus reared its ugly head and shut everything down, leaving faculty scrambling to put courses online for their students. As Chinua Achebe and William Butler Yeats before him noted, "Things fall apart." Despite everything, only a single author had to withdraw altogether from the project, and that due to a serious personal illness. It has been a privilege to work with so many exceptional women delving into such a wide array of topics in order to bring to readers a greater appreciation of Chinese women as subjects or creators of literature, the visual arts, and the performing arts.

Cheryl "Cherie" C.D. Hughes
Tulsa, Oklahoma
February 2021

Introduction

EMMA JINHUA TENG

Chinese women have been a vital subject of study in Europe and North America since the second half of the nineteenth century, with successive generations of scholars and writers dedicated to dispelling what Sarah Pike Conger called the "pronounced misrepresentation of China's womanhood" (Conger viii). From Conger's *Letters from China: With Particular Reference to the Empress Dowager and the Women of China* (1909), to Julia Kristeva's *Des Chinoises [About Chinese Women]*, originally published in 1971, and the recent *Women in Song and Yuan China* (2020) by Bret Hinsch, the study of Chinese women has undergone significant shifts over time, reflecting changing social values, scholarly approaches, and feminist or gender theories, but it has remained constant in its ability to generate interest among various groups of readers. To the long list of noteworthy authors on the topic, a new generation of scholars adds its voice to the conversation with this volume, *Crossing Borders and Confounding Identity: Chinese Women in Literature, Art, and Film*.

The scholarship represented here remains as imperative as when Conger first attempted to shine the "light of understanding" on Euro-American ignorance of women in China. Misrepresentations of Chinese women still abound in contemporary media, whether in the stereotypical figures of the Lotus Blossom or Dragon Lady, or in the more recent incarnation of the Tiger Mom, overshadowing the more significant achievements of women such as Tu Youyou (b. 1930), the first Chinese winner of the Nobel Prize in Physiology or Medicine, or Tsai Ing-wen (b. 1956), Taiwan's first

female president. Even Disney's live-action film *Mulan* (2020), featuring a martial female protagonist, reinforces the stereotype of the submissive and subordinate Chinese woman as a normative ideal. Such stereotypes find no place in this collection, which takes the thematic focus of women crossing borders and boundaries of various types, whether of geography, culture, or media. With its particular emphasis on literature and the arts, *Crossing Borders and Confounding Identity* advances our understanding of the diversity of women's experiences and achievements in China and adds complexity and nuance to this picture at a time when tensions between China and the United States run high.

Chapter 1, Dona M. Cady's "Emily Georgiana Kemp: An Early Twentieth-Century Traveler's Perspective on the Heart-Mind of China," brings to light the travel accounts of Kemp (1860–1939), an intrepid explorer, prolific writer, gifted artist, and interfaith advocate, who traveled through China in the late Qing and early Republican periods. The daughter of a wealthy British cotton mill owner, and one of the earliest graduates of Somerville College, Oxford, Kemp was a founding member of the World Congress of Faiths and an adventurous traveler. Although less well known today than Isabella Bird, Kemp achieved recognition in her own time for her travel accounts, and she was the first woman awarded the French Geographical Society's Grande Médaille de Vermeil. Cady argues that Kemp wrote from deeply religious and feminist perspectives and that her accounts of China are "remarkably free from imperialist cultural stereotypes" and the missionary gaze, despite her family connections with missionary work. Perceptively, Kemp wrote in 1921 that her "rooted conviction is that the future of the world depends largely on what happens in China during the next decade" (Kemp 11). Little could Kemp have imagined that these words would ring equally true a century later. Although not focused on Chinese women per se, Cady's chapter demonstrates how a British woman traveler's identity is reconfigured by crossing borders and by her encounters with the Other in China, including Chinese women of diverse class backgrounds. Roughly a generation older than American writer Pearl S. Buck (1892–1973), who appears in two later chapters of this volume, Kemp was among the pioneering foreign women writers who became deeply embedded in China and key interpreters of Chinese women's experiences for Western audiences.

Chapter 2 shifts backward in time and to a male perspective as Marla Hoffman Lunderberg's "Women's Agency at the Close of the Ming Dynasty: Vulnerability, Violation, and Vengeance in Ling Mengchu's Ver-

nacular Short Stories" explores the representation of sexual violence and its aftermath in a seventeenth-century short story. One of the masters of the Ming vernacular short story, Ling Mengchu (1580–1644), first published "Wine Within Wine: Old Nun Chao Plucks a Frail Flower; Craft Within Craft: The Scholar Chia Gains Sweet Revenge" in 1628 in his much-celebrated *Chuke pai'an jingqi* (*Slapping the Table in Amazement, First Collection*). As with most stories in this collection, this short story is in fact two stories in one, each a tale of an assault survivor, but with vastly different outcomes. Following in the path of Kimberly Besio's examination of Ming adaptations of the Wang Zhaojun legend and Wai-yee Li's work on representations of female virtue in relation to larger historical processes, Lundberg analyzes cultural constructions of virtuous women and Ling's moralizing in this complex, nuanced vernacular short story. Lundberg argues that this double narrative has an allegorical dimension, because the physical assaults endured by the female protagonists "parallel the violations of traditional value systems faced by the people living in a culture in chaos" at the end of the Ming. The protagonists represent not only the vulnerabilities experienced by women at the close of the dynasty but also the multiple ways they could respond, from resignation and accommodation to revenge. Lundberg concludes that despite Ling's reputation for sometimes "cloying" moralizing in his vernacular fiction, in this story he raises both politically sensitive and psychologically fraught questions. This chapter elucidates Ling's brilliance in dealing with issues that remain germane in our own time and highlights the subject of female agency, a key thread running through this volume.

Continuing our literary explorations, female virtue is again a theme in chapter 3, which takes us to Japan with Catherine Ryu's work on "A Flight of Cultural Imagination in Heian Japan: The Image of Yang Guifei in *Genji monogatari* and 'Chang hen ge.'" Bringing together two canonical works in East Asian literature—Murasaki Shikibu's (fl. ca. 1012) *Genji monogatari* (*The Tale of Genji*) (ca. eleventh c.) and Bai Juyi's (772–846) "Changhen ge" ("Song of Everlasting Sorrow") (806)—and employing the expansive conceptual framework of Silk Road studies, this chapter examines famous Chinese beauty Yang Guifei (719–756) as a literary motif in Heian Japan. Ryu demonstrates how *Genji monogatari*'s female author employs the figure of a *maboroshi*—the Japanese counterpart of the Daoist wizard who links the desires of the living and the dead in "Changhen ge"—to transform the image of Lady Yang. Robustly engaging with the border-crossing themes of this volume, Ryu's essay demonstrates

how "not only objects and people but also intangible literary motifs and their attendant ideas moved through Silk Roads, transforming a local society's worldview and cultural production in the process." Through her analysis of Murasaki Shikibu's use of the Lady Yang motif in her narrative of ill-fated lovers, Ryu demonstrates how this tragic romantic figure's circulation along the Silk Roads enabled her dramatic transformation as a fictional heroine.

Shifting from the virtuous women of chapter 2 and the tragic beauties chapter 3, in chapter 4, "Women Generals and Martial Maidens: China's Warrior Women in History, Literature, and Film," Cheryl C. D. Hughes examines women warriors as characters who defy the Western stereotype of Chinese women as meek and subservient. Warrior women in Chinese narratives, she shows, prove themselves equal (or at times superior) to their male counterparts in martial skill, bravery, and accomplishments. This chapter demonstrates how women warriors "cross the traditional boundaries of home and family to establish new possibilities and identities for themselves and others." Hughes provides an overview of women generals and other martial heroines from the Shang dynasty through Maoist China, including the famed Mulan, who is best known to Western audiences. Her materials include historical narratives, various literary genres, and film, thus covering a broad sweep of cultural production across the centuries. Hughes argues that the figure of the woman warrior has endured in Chinese culture as a role model of bravery and virtue for both men and women. In fighting for their homelands, their families, or just causes, women warriors, Hughes notes, "crossed boundaries to establish new identities for themselves in a patriarchal society." Fans of Disney's *Mulan* movies will find much to appreciate in this chapter, which greatly advances our understanding of the much broader part played by the woman warrior across centuries of Chinese history, literature, and film, a figure who appears again in chapter 9. This chapter further introduces the study of film, taken up again in chapters 6, 7, and 9.

Gender and theatrical roles and cross-dressing are vital topics in chapter 5, "Women in Male Roles: Cross-Dressed Actresses in Early Twentieth-Century China." In this chapter, Laura Xie examines the history of female actors playing male roles in the *Jingju* tradition, using the case study of Meng Xiaodong (1908–1977). In sharp contrast to the attention given to actors like Mei Lanfang (1894–1961), who is celebrated for his performance of female roles in Jingju theater, relatively little has been written about female performers of male roles, especially

those who performed in public theaters. As the foremost impersonator of male roles on the Jingju stage, Meng has an important place in the history of Chinese operatic theater. Known for her brilliant singing, her specialty playing the "bearded man" role, and her controversial offstage love affairs—one with Mei Lanfang and the other with Shanghai crime boss Du Yuesheng (1888–1951)—Meng's life and theatrical career provide an opportunity to examine the phenomenon of female stardom in early twentieth-century China. This chapter probes the complex interactions among Meng's attempts to control her own image, the commercial imperatives of the news media, and the emergence of cultural myths surrounding her persona. Xie argues that in the early twentieth century, actresses playing male roles challenged male dominance in the theatrical world and contested patriarchal cultural norms, much as did the women warriors in chapter 4. Testing the willingness of audiences to accept fluid gender roles, their performances highlighted shifting notions and ideals of masculinity in this time. Xie further emphasizes that on the individual level, the opportunity to play male roles on the stage gave female actors a pathway for gaining recognition and prestige for their craft and technique, rather than their physical beauty, though they had numerous obstacles to overcome. Xie demonstrates that after a decline in the popularity of female actors playing male roles, there was a revival of interest in female-to-male cross-dressing in Jingju in the late twentieth and early twenty-first centuries. This chapter is especially relevant for readers interested in the performative aspects of gender.

We return to film in chapter 6, "*Pavilion of Women*: Gender Politics and Global Cultural Translatabilty," where Jinhua Li delves into complex questions of global media consumption, the flows of texts and resources, and deterritorialization in relation to transnational film production. The case study in this essay is *Tingyuan li de nüren* (2001) by Hong Kong director Ho Yim (b. 1952), a Chinese-language adaptation of Nobel Prize laureate Pearl S. Buck's novel *Pavilion of Women* and the first joint production between a major Hollywood studio and a Chinese government–owned studio. Li considers film remakes in particular to be situated "at a critical juncture where axes of representation, gender, power, and identity converge and clash." Li demonstrates how transnational, border-crossing film adaptations by their very nature are contested sites for the intersection and interaction of the presumed dichotomies of global/local, west/east, transnational/national, Eurocentric/polycentric, masculine/feminine, and center/periphery. Li argues that despite the filmmakers' assertion that

Tingyuan li de nüren tells a story of women's emancipation, this avowedly feminist message is ultimately undercut by the visual narrative. Through careful analysis of various cinematographic elements, this chapter shows the strong contrast between the diegetic articulation of women's pursuit of individual freedom and gender equality, on one hand, and the cinematography, on the other, which never places women in positions of agency. Li argues, "the film's narrative is constantly at war with its discourse." She further argues that Eurocentric and androcentric discourses are evident at multiple levels in the film: linguistic, structural, and cinematographic. This chapter shows the discrepancy in reception of the film in China and the United States and argues that the filmmakers' attempt to achieve "global cultural translatability through local media literacy" was superficial at best. Li concludes that despite this co-production's unprecedented experimentations in form and content, the bifurcated cultural politics of global media translatability ultimately resulted in the subordination of the feminist potential of the female protagonist's narrative to deeply embedded masculine Eurocentrism. This chapter contributes to our understanding of Pearl Buck, one of the chief architects of Western understandings of China in the twentieth century and a figure we meet again in chapter 9.

Continuing our foray into film studies, chapter 7, Yanhong Zhu's "Gendered Screens: Women, Space, and Social Transformation in the Works of Contemporary Chinese Female Filmmakers," examines the films of two women directors, Peng Xiaolian (1953–2019) and Xu Jinglei (b. 1974), as representatives of two generations of Chinese filmmakers. Setting their works in the context of a broader rise of female directors since the 1990s, and especially the 2000s, this chapter focuses on the directors' cinematic depiction of space, specifically domestic space, urban space, and the space of artistic creation. Discussing representative films, Zhu analyzes the relation between representations of spatial conditions and changing gender roles in contemporary Chinese society. She argues that both directors use space in their films not merely as the physical settings for their narratives but as a vehicle to probe the effect of processes of social transformation on the spatial order of contemporary Chinese society. Space also serves as the site for the formation of female consciousness. Supporting Lingzhen Wang's contention that Chinese women's cinema defies "uniform interpretation," Zhu concludes that female filmmakers in contemporary China have found various pathways for demonstrating their individual agency and reconfiguring gender roles while engaging with a spectrum of aesthetic conventions. This chapter also includes

a brief discussion of Peng's musings on the affordances of digital and celluloid film. Comparing digital film to *Shikumen* houses, Peng argues that "despite their glory, digital data can also be lost when the equipment breaks just like the *Shikumen* houses." As experiences prove fleeting, so do the digital representations of these experiences.

Following in the intellectual footsteps of Emily Georgiana Kemp, the subject of chapter 1, Shelley Drake Hawks is an artist and a student of Chinese art, and her work in chapter 8 brings us forward with an insightful survey of "Women in Chinese Visual Arts over the Past Century." Hawks argues that even though men still dominate the contemporary art scene in China, feminism has played a role in the development of the visual arts since the early twentieth century. As she shows, in the early twentieth century, China's newly established art academies in Shanghai and other cities began to welcome female students, initiating profound changes down the line as women became professional artists or stayed at the academies as teachers. The novel perspectives they brought to art and art education challenged gender stereotypes of the time. Hawks discusses in detail ten diverse artists and examines whether and how feminism is influencing the development of their works and broader trends in art history. Prompted by Chinese women artists, this chapter asks whether feminism, as broadly understood in Europe and North America, is a productive lens for analyzing the lived experiences of Chinese women. Like Kemp, Hawks seeks to understand the range of Chinese women's experiences on their own terms. She concludes that "Chinese women artists have coalesced into a powerful force for innovation," as reform-minded female artists have joined with their male counterparts to challenge gender bias and redefined notions of beauty and strength. Through her survey of artistic works, as well as interviews with artists, Hawks demonstrates how women artists "have introduced new subject matter, fresh techniques, and materials to Chinese art." For readers unfamiliar with contemporary Chinese art, this chapter provides a stimulating overview.

Turning our attention to herstory, Jessica A. Sheetz-Nguyen's contribution in chapter 9, " 'Lessons for Women': From *The Good Earth* to *Leftover Women*," builds on the author's experience teaching Chinese women's history for over a decade. This chapter offers a model for instructors who want to develop curricula addressing how Chinese women's lives have changed dramatically between 1844 and 2000. Sheetz-Nguyen aims to provoke readers and students to confront tough questions head-on through comparative inquiry. "For example, what did it mean for a woman to bear

an infant girl in the fourth century? What does it mean for her to bear an infant girl in the twenty-first century? How might their situations have changed for their daughters?" This chapter provides readers with a rich survey of texts and films, as well as suggestions for comparative materials dealing with European and North American history in the same timeframe. Sheetz-Nguyen covers a broad sweep of history, beginning with Confucius and ending with the contemporary moment, and suggests how we might reconfigure "history" as "herstory." This chapter again shows the key influence of Pearl Buck, whose 1931 novel, *The Good Earth*, was highly influential through its theatrical and film adaptations, and we meet the figure of the woman warrior examined in chapter 4. Departing from more familiar material, Sheetz-Nguyen's discussion of the contemporary phenomenon of "leftover women," in particular, covers a subject that has drawn recent media scrutiny but has received less scholarly attention to date. Like the discussion of sexual violence in chapter 2 and gender-fluid roles in chapters 4 and 5, readers will find much in Sheetz-Nguyen's examination of leftover women to think through issues at the forefront of cultural politics today.

All together, these chapters provide a new window onto Chinese women, their lived experiences and fictional representations, across a broad spectrum of literature (Chinese and non-Chinese), theater, film, and the visual arts. They provide food for thought on border crossing across multiple dimensions, as manifest in travel writing, translation and cross-cultural adaptation, transnational capital flows and collaborative production, cross-dressing, or contestations of gender roles or notions of normative sexuality. Building on a robust tradition of scholarship on women in China, which saw a special flourishing in the 1990s, this volume adds to our knowledge on women as individual actors and agents across time and space. The chapters are written for a general audience and will be of interest to scholars of China and nonspecialists alike.

Over a century after Conger's *Letters from China, Crossing Borders and Confounding Identity* prompts us to ask pressing questions about the need and demand for scholarly work dedicated to the study of Chinese women. In what ways do Chinese women continue to constitute a particular field of study? To what degree do Chinese women continue to be marginalized, even doubly marginalized, in European and North American academia? In media and popular culture? What does it mean to speak of herstory a half-century after this term was coined? As I wrote in an earlier critique of the construct of the "traditional Chinese woman" in

Western scholarship, "the study of women, or gender, in China must be a two-way process: Western theory must be incorporated into the study of China and research on China must be used to generate particular theories of gender from the ground up, theories that could either inform or challenge general theories of gender"(Teng 143). This goal, I argue, remains as relevant today as women, in China and beyond, continue to confront systemic inequality and hierarchy around the world.

Works Cited

Conger, Sarah Pike. *Letters from China: With Particular Reference to the Empress Dowager and the Women of China*. McClurg, 1909.

Kemp, Emily Georgiana. *The Face of China*. Special ed. no. 20. Chatto & Windus, 1909.

Teng, Jinhua Emma. "The Construction of the 'Traditional Chinese Woman' in the Western Academy: A Critical Review," *Signs: Journal of Women in Culture and Society*, vol. 22, no. 1, 1996, pp. 115–51.

Chapter 1

Emily Georgiana Kemp

An Early Twentieth-Century Traveler's Perspective on the Heart-Mind of China

DONA M. CADY

The Master said: "Having studied, to then repeatedly apply what you have learned—is this not the source of pleasure? To have friends come from distant quarters—is this not a source of enjoyment? To go unacknowledged by others without harboring frustration—is this not the mark of an exemplary person (*junzi* 君子)?

—Confucius 1.1

Women writers whose works speak to a cross-section of readers have long defied categorization, and one such woman is Emily Georgiana Kemp (1860–1939), prolific writer, gifted artist, fearless traveler, and interfaith advocate. A woman very much of her time, she was deeply religious but also a firm advocate for women's rights, certainly understandable as one of the first graduates of Somerville College, Oxford. Inspired by fellow alpinists and her two missionary sisters, Kemp traveled widely throughout Asia (principally China), writing, painting, and commenting on the culture and religious practices of the people she met. From these travels and the resulting six books, she was awarded the Grande Metaille en Vermeil

by the French Geographical Society,[1] all while displaying a remarkable openness to all things Asian, particularly Eastern religions, despite the loss of family members in the Boxer Rebellion (1899–1901). A founding member of the World Congress of Faiths, translator of a German book on Buddhism, funder of the first and only nondenominational chapel at Oxford University, "intrepid traveler in the far East and a friend of China" (Somerville Chapel memorial plaque), Kemp's feminist yet interfaith perspective provides a multifaceted window through which to examine the people, place, and religions of China.

To better understand her unique perspective, a look at Kemp's early life is essential. Emily Georgiana Kemp was born in 1860 to wealthy Baptist cotton mill owner George Tawke Kemp and his wife, Emily Kelsall Kemp. They lived in Rochdale, England, on the outskirts of Manchester. Kemp writes that Beechwood was home to four other lively and strong-willed sisters—Jessie, Constance, Lydia, Susannah Florence—and one younger brother, George (*Reminiscences of a Sister* 9). Raised by a mother who was loving yet diligent in "religious instruction," she and her siblings did not suffer under harsh discipline. As Kemp writes, "we were not unduly punished, but strict punctuality, truthfulness, obedience and good manners were exacted" (9), traits evidenced later in life throughout her travels—she did like her timetables! (Morris-Suzuki 101). That religious education influenced two sisters—Jessie and Susannah Florence, or Florence, as she was called—to become missionaries in China. Kemp, though deeply religious and intensely interested in the missionary work of her sisters and others, never felt truly called to that life—although she did take medical training in hopes of contributing to medical missionary work despite some delicacy of health (Batson 83).

Her early education was unusual in its breadth of subjects. She writes that her parents were "anxious that we should be good linguists, and have as thorough an education as possible, so we all learned French from a very early age, then German and Italian, but I regret to say, *not* Latin" (Kemp, *Reminiscences of a Sister* 10). While the girls pursued the usual dancing and painting, the "greatest attention was devoted to history, especially English and French history, and politics" (10). Kemp, quite talented at painting, later pursued it at the University of London Slade School of Fine Art under the tutelage of Alphonse Legros (Moulin-Stożek and Gatty 11). Her parents were close friends of Quakers John Bright and Richard Cobden, British liberal politicians who founded the Anti-Corn Law League (*Reminiscences of a Sister* 10). A keen supporter

of the suffrage movement and a sharp business mind, Kemp's mother Emily passed on the belief to her children that women were capable and strong and should be advocates for education and social change. As Kemp noted, "the present Feminist movement has had its foundations well and truly laid in many parts of the country by such women as my mother" (28).[2] From Baptist Chapel meetings to visits with her indulgent grandparents to intellectual arguments "on a wide range of subjects" under the tutelage of "a rabid man-hater" Swiss governess, who was "quite a character," Kemp's mind "developed" (12). With dialogue, argument, and difference of opinion encouraged in the family (14), Kemp explored ideas and issues of the day, building a foundation for open and critical thought later developed at Oxford and exercised throughout her travels. Somerville Principal Helen Darbishire noted in her memoriam for Kemp that "as a student she was outstanding by her energy and vigour as well as by her gifts and enthusiasms" (10).

It was not just open and critical thinking that were encouraged in the family; imagination was encouraged as well. Kemp recounts, "We lived in a world of imagination, and our chief joy was to listen to never-ending stories" from *The Fairchild Family* to *The Thousand and One Nights* (*Reminiscences of a Sister* 13). Though noting in *Chinese Mettle* that she hated to write (11), imagination and storytelling were in her blood.

Even with her imagination and the family's wealth, Kemp was not isolated from harsh reality as "from the early days [we were] initiated into the sorrow and suffering of humanity. 'Uncle Tom's Cabin' made us realize something of slavery and its appalling misery; our parents took us to visit the sick, both in their homes and in the infirmary; we pricked texts for the blind every Sunday, and we often went to a ragged school built by my grandfather" (*Reminiscences of a Sister* 14). This concern for others coupled with a keen interest in medical work prompted her to serve in Belgium and France during World War I as *directrice* with the French Red Cross at two hospitals,[3] one being the Hopital Temporaire d'Arc-en-Barrois. She received a British medal and the Victoria Cross, as well as three French medals: "*Medaille d'Honneur des Epidemies* (with *Ministere de la Guerre* reverse); Medaiile de la Reconnaissance francaise [*sic*] (also from Ministerre de la Guerre) and *Medaiile d'Honneur pour Actes de Courage et Devouement* (from *Ministere de l'Interieur)*" (Sepoyjack).

Her parents also valued traveling, spending their holidays exploring Europe, North Africa, and the Middle East. Her mother "did not miss going abroad not once in over 40 years" (*Reminiscences of a Sister*

30), and her father died while on a trip to the Nile (24). The connection to Egypt was long-standing as she and her family were listed as supporters of the Egypt Exploration Fund during the years 1892–1911 (Egypt Exploration Fund). In their travels, the family "frequently went off the beaten track and were encouraged to study different races and the conditions of life" (Kemp, *Reminiscences of a Sister* 30). Certainly, it was something Kemp took to heart as she later explored the culture and peoples of China, the Koreas, and even the Amazon (Kemp, *Mary* 11). After attending boarding school in Germany where she and her sisters regularly explored Europe, Kemp entered Oxford University in 1881 as one of the first classes at Somerville College (Darbishire 10), where she continued to develop her keen intellect and interest in travel along with her classmate Emily Coombs, who later set out as a medical missionary to China in 1897 (10). Emily Kemp, though a woman of her time, lived an unusual life for her era.

What, then, brought Kemp to China? Was she one of Virginia Woolf's restless, indomitable English spinsters who were constantly "packing up and going off . . . penetrating even to China" (24–25)? Or Mary Louise Pratt's "Spinster Adventuress" escaping a restrictive home life (168)? No. Exploring new vistas and engaging with different cultures was a family occupation. Her sister Florence's quest for social justice led to the destination of China. When older sister Jessie sailed home to recover from missionary work in India (Edwards 235), Florence particularly "fixed on China" to "atone for the wrong" England had done to that country through the opium trade (Kemp, *Reminiscences of a Sister* 20). In Shanxi alone,[4] Kemp estimated that 90 percent of the men, women, and children were opium smokers (*Face of China* 83).[5] Eleven years later, in 1893, Kemp joined her sisters for a year in Taiyuan, Shanxi (38), as a nanny for their three children. As she writes, there she "fell under the spell of the marvelous people and marvelous land" of the celestial empire and tried to "set down faithfully the things I have seen, that they may lead others to study China for themselves" (*Face of China* vii). Kemp continues to write some twelve years later in *Chinese Mettle* that while "pleasure is the main lure to China, and a sort of basilisk fascination which is quite irresistible. . . . [I] am consumed with a desire that people should know what is now going on in China. My rooted conviction is that the future of the world depends largely on what happens in China during the next decade. This is the decisive hour" (11).

Kemp moves to that decisive hour throughout her writings on China. From the opening chapter in the 1909 *The Face of China* to the 1921 *Chinese Mettle*, Kemp places the people and the country center stage. As Pratt notes in *Imperial Eyes*, "arrival scenes are a convention of almost every variety of travel writing and serve as particularly potent sites for framing relations of contact and setting the terms of representation" (77). Kemp does not disappoint. She begins *The Face of China* with the pronouncement that "my first voyage to China was unspeakably distasteful" (1). Even so, as her boat weathered a typhoon and then emerged from the storm to enter the paradise of Hong Kong, she observes that "The first introduction to a new country, if it happens to be when the faculties are specially quickened, makes an indelible impression, and from this time China has been to me a land of infinite charm and beauty. The more I have seen of it, the more I have realized its fascination; even its ugliness is interesting" (1). To Kemp, that ugliness becomes immediately apparent in Shanghai as Western business folk at the end of a feverish "time is money" day stroll down the Bund, relaxing and "sitting on benches, which are labeled 'European only'" or "strut about" the segregated public garden (9). Labeling these prejudicial practices "an offensive piece of insolence," Kemp acidly writes that "a large number of Europeans" living in China have this attitude, so that not long ago the public garden "notice might have been seen, 'No Chinamen or dogs admitted'" (9–10). Emily Georgiana Kemp does not suffer views like this kindly.

Whether Kemp's first contact with China, is as Doreen Massey notes, "articulated moments in networks of social relations" that create improvisational yet "unique points of intersection" within a "global sense of place" (154), Levine's "emergent systems of social relations" (625), or as Pratt writes, productions of "contact zones" (8), Kemp's writing is not overly engineered to produce a stylized version of China readymade to appeal to a European audience. Although she may be influenced positively by letters from her sisters on their missionary experiences in China, Kemp balances what Sutapa Dutta terms "assertions of British pride with . . . [a] sense of belongingness and differences in the larger frame" of travel (9). This, though, does not make her (as it does for many female travel writers) inordinately conscious of her Britishness and all things British (*Face of China* 9). Although she takes great pride in such familiar imperial efficiency as a British postmaster in Tsinan or British higher educational efforts in China, Kemp takes equal delight in the similar

as in the dissimilar. The smoky chimneys of Jinan and roadside hedges may remind her of home, but she is equally delighted at a sumptuous repast with the innumerable little dishes, followed the next day by the presentation of "a fascinating assortment of Chinese paints, each done up separately in the neatest box. We came away much impressed by the indescribable charm of Chinese manners, and many a time afterwards I felt how *gauche* we were in comparison" (103). For her time and not-withstanding Edward Said's suggestion on Orientalist travel writers and their preconceived cultural representations (67), Kemp is remarkably free from imperialist cultural stereotypes.

Her writing conveys what she sees—open, entertaining, yet realis-tically measured, whether it be a country scene of a donkey sporting "a pair of ornate blinkers, bright blue cotton with protuberant black eyes surrounded by a white line" or "whole families working together; a tiny child lying naked, basking in the sun, the women (despite their bound feet) as busy as the men" (*Face of China* 22). Following the sage advice from Marcus Dods to "write up your diary day by day, and don't disap-point your publisher and the public who wait to get some experience of unknown China at second-hand" (270), Kemp does so, presenting her material so readers can follow with her—not a distanced secondhand—but alongside. We, along with her, hear the swift coming of a pony "heralded by the tinkling of bells" (*Face of China* 23), "a shepherd lad piping a mel-ancholy ditty to his sheep under the clear blue sky" (84), or the "riotous party of rats in the loft above" which, showing no respect for "British face or form," crash down in a "sort of stampede" (243). Within the nineteenth-century globalization and, as Roy Bridges put it, the creation of "one world" (67), Kemp creates intimate relational situations within her narratives, drawing readers into the China she is growing to know and love. She gives practical advice on traveling from how to bargain for silks to the choice of Yangtze boating for a bit of spice, danger, and scenery to avoiding painfully bold rats in December. She also describes the people and scenery in engaging and often humorous, self-deprecat-ing ways. From putting up with a prehistoric chicken destined for her cooking pot to the price of £34 to hire eighteen coolies from Yunnan to Bhamo for thirty-three days (*Face of China* 245–46), there is little if any "majesty of all she surveys" with Emily Georgiana Kemp. She is as in Paul Fussell and Brian Murry's categorization, an explorer, a genuine traveler, not a tourist of clichés (Murry 7–8) or a "mere parcel" tourist comfortably situated for the entirety of the journey in a train compart-

ment. According to Wolfgang Schivelbusch, "the traveler who sits inside that projectile ceases to be a traveler" (58–59, qtd. in Youngs 7–8). In *The Face of Manchuria*, Kemp even prides herself "a genuine traveler" (3). She and her companion, Mary Meiklejohn MacDougall,[6] escape the confines of the typical sights for the attraction of the less traveled road, and to Kemp that makes all the difference!

Throughout her journeys, Kemp "welcomes the unpredictable and embraces the form*less*," traversing with ease "between the inchoate impression on the one hand and the commonplace cliché on the other" (Murry 7–8). As Kemp notes in the introduction to *Chinese Mettle*, "my book must seem strangely paradoxical. The mutable jostles the immutable, and—as in life itself—all sorts of things get mixed up together" (12).

Kemp's "mixed-up" or multiperspective quality of writing is neither all "inchoate impression" nor "commonplace cliché," nor, for that matter, masculine or feminine, social or political. It is a "relationship between imagination and experience and between travel and its record" (Youngs 2), and as Sara Mills concludes, "considered within the discursive frameworks within which it was produced and received" (199). Kemp does not solely "adopt Mills' male adventurer hero model" (161), nor does she speak solely in Schaffer's metaphors of femininity" (44). She may be paradigmatic and privileged, typical of many a Victorian and early twentieth-century explorer who are fortunate in terms of wealth and interest. Yet she is also, using Gilbert and Gubar's terms, a "representative" of the exceptional woman traveler rather than an "idiosyncratic" one (17). Emily Georgiana Kemp mapped her own itineraries,[7] hired guides, arranged schedules, climbed Mt. Tai, traversed the Yellow Sea, survived the Terek-Dawan Pass, and fought off bandits, rats, and sleepy pigs with self-deprecating joie de vivre and sangfroid. The list goes on.

Often the first woman—and even non-Chinese—in an area, her travelogues become our truth; her words and paintings, our authority. Kemp is not one of those women who use sketching and writing "to authenticate their experiences" (Dohmen 51) or "to speak with author-ity . . . wear a disguise" (Schaffer 103, qtd. in Mills 44). Kemp has no need to authenticate who she is. She has no need of a disguise, for as a graduate of Somerville College, as an appointed Fellow of the Royal Scottish Geographical Society, and as a recipient of medals for service and valor, she is indeed a scholar, a woman of merit, a critical thinker, and the woman her mother and family encouraged her to be—an exceptional woman creating her own destiny through strength of mind and character,

"re-negotiating and challenging the boundaries assigned to them because of gender" (Stockham 86). In other words, she uses "agency not as some abstract or undefined expression of autonomy, but in . . . self-promoting complicity and willful discursive self-formulation" (Woollacott 338, qtd. in Maddrell 17). Kemp's self-portrait that begins the reader's journey in *The Face of China* is of a bespectacled mature woman, intense of gaze, confident, and garbed in a Chinese scholar's robe. This image places the reader "in the artist's position—through their involving intensity of look" (Cummings 5–6). We see Kemp through the agency of her own eyes. She uses her self-portrait to support her view of herself in this world and to create a personal relationship, welcoming the reader to share her experiences in seeing the face of China and ultimately its heart-mind.[8] (See figure 1.1.)

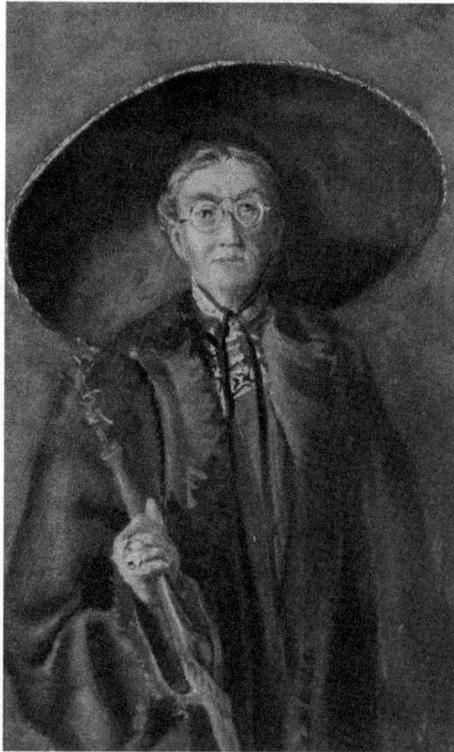

Figure 1.1. Emily Georgiana Kemp, *Chinese Portrait of Author as "Female Travelling Scholar."* Watercolor painting. Photograph used with permission of the Principal and Fellows of Somerville College, Oxford.

The people and the intimate portraits of China are what draw Kemp in. Capturing with an artist's eye the sights, sounds, and colors, she moves from scene to scene. One of the first scenes she describes of China is in old Shanghai:

> We threaded our way through a maze of lanes till we came to the centre of the town—the original of the celebrated willow pattern—and as picturesque a spot, in the mellow evening light, as you could possibly imagine. A weed-covered pond, fringed by willows, surrounds the group of tea-houses, which are reached by a zig-zag bridge, across which passes a ceaseless stream of blue-robed passengers: gentlemen carrying their birds out of an airing; mothers with babies in their arms, wearing gaily coloured caps surmounted by scarlet tufts; coolies with heavy loads; children dangling sundry purchases, such as a bit of meat or vegetables, from the end of a string or blade of grass—a fascinating throng to watch, if not to be absorbed into!" (*Face of China* 5–6)

Kemp is absorbed into the scene. She even paints it. She translates through perspective and color the culture of China for the reader. Her observations become ours. "There is no monolithic, imperialistic or imperialized location and no solidly bounded identity, authorial narrative, or geographic" (Morgan 4). Instead, improvisational negotiated spaces create a relationship between the writer and the reader, and in Kemp's case, the additional connection with her co-creational art.

It is this co-creative relationship that Kemp nurtures throughout her writings and in her paintings. As Kemp describes imaginatively with "pen and brush" (*Mettle* 222), what she sees, we see, and Kemp sees the personal, the people, the humorous, the religious, the social, and the political. For her, there is nothing wrong with refocusing her eye on the unpredictable and the form*less*, the intimate and the relational, mostly eschewing the "mastering" majestic survey so often manifest in travel writing and sketching. Her writing breathes with the intimate, the relational that connects emotionally and intellectually with the reader. It is the improvisational relationship with the unpredictable and the form*less*, or as Gillian Rose notes, "the strategies of position, scale, and fragmentation" that is "all important for challenging the particular structure of the [geographical] gaze" (112).

We can see Kemp's "geographical gaze" clearly in how she moves her description from order to disorder, often inserting comic irony into the mix (Kato 145). Yet it is not irony aimed at her beloved China; it is humor often aimed at herself or Europeans. Kemp recounts one such case when her friend, carried in a rickety wheelbarrow, was unhappily "tipped into a sea of mud, and as she happened to be carrying a basket full of eggs, she suddenly found herself in a 'Yellow Sea'" (*Face of China* 21).

Kemp's watercolors also reflect the geographical gaze. Although they are in some way "quaint compositional vignettes" (Kato 149)—idyllic scenes filled with soft earth colors, willow pattern blue, and mellow evening light[9]—they also document times of change. She does not shy away, through words and color, from an opium den in Shansi, changes in dress, communities brought to chaos by European occupation, or a dead baby wrapped in a wisp of straw cast out in a garbage heap at the foot of the Korean Gate in Liaoyang. Furthermore, Kemp particularly invites us to gaze solemnly at the latter in the sketch alongside her with the words "and you may see as we did" (*Face of Manchuria* 42). We do. We see. In text and note, Kemp informs us that the cultural practice of infant abandonment is even active in large cities like Beijing. Kato notes that this elegiac scene and its description may be a nod to the deaths of her sister Jessica, her husband, Rev. Thomas Pigott, and their son, Wellesley, at the hands of the Boxers in Taiyuan in 1900 (Kato 149). Perhaps. However, we should be less inclined to see this as a nod to that tragedy, for throughout her books, Kemp is clear and measured when mentioning their deaths. She does not sentimentalize, for in her view, earthly death is never final.

Certainly we can see that Kemp writes and paints with the aim of sharing the heart-mind of China with her readers. Yi Wu, writing on the Emily Kemp Collection for the Ashmolean Museum, contends that "from the westernised noble court official to the young illiterate labourer, Kemp's pen and brush depicted a country in transformation through its people. The ardour toward people from different backgrounds was presented in her artworks with equivalent attention to detail, which she believed to represent their style of life, or, what's more, their state of mind. . . . All these elements produced a unique and accurate depiction of the local culture."

We can see Chinese culture, the style of life, and even their state of mind in the watercolor portraits and landscape paintings throughout Kemp's work. Her portraits reveal characters through position and gaze.

As with most formal portraiture, her subjects never smile, but according to her, they also express personality in the position of their feet: "Much has been written about character as seen in the human hand, but I think a character study of feet might still be written, even when the feet are disguised by boots or shoes" (*Face of China* 30). Though we do not see the feet of the efficient and scholarly *Mr. Ku*, we do see that he returns the viewer's gaze directly—very much in the style of Kemp's self-portrait (106). This contrasts with the standing "self-complacent" pose of the *Court Official*, who, with left hand on hip and feet akimbo, gazes ahead but slightly off-center. If the eyes (and feet) are windows to the soul, we are locked out. His formal dress of splashes and stripes of red and blue with striking yellow imperial dragons, completed by a helmet with red plume, must tell us who he is (30). The angled viewing of the stiff seated postures of the *Official* and *Lady of Quality* (100), hands and feet precisely placed, reveal a gracious formality of the court; though Kemp bemoans that owing to make-up and illness, the Lady of Quality was "a very difficult one to paint," resulting in a "wooden expression" (101). Perhaps that is why after the lady's generous dinner and next day parting gifts, Kemp includes a bit of personality to the lady by painting "her charming little black pug" (101) stretching up against her knee. These portraits contrast decidedly from the straight-on painting of the confidently smirking *Tiger Brave*, head slightly tilted and one foot tucked unceremoniously behind the other. As one of the celebrated Tiger Brave soldiers, his character is his outfit. Garbed from head to toe in yellow striped with black that includes "little pink-lined ears which stood erect, and ferocious black eyes, and white fangs, and a red tongue hanging out" (85), Tiger Brave knows his "alarming costume" (85) renders all other weapons unnecessary—except good roaring shouts and an ordinary knife. Kemp is so impressed she procures a copy of the outfit and brings it home, much to the admiration of Mr. Chamberlain, "who made a telling use of it later on in describing the tactics of 'the opposition'!" (85–86).

Unlike her portraitures, landscapes for Kemp provide the opportunity to connect in many ways with the canons of Chinese pictorial art, founded on the principles of Daoism, Buddhism, and Confucianism. She is familiar with these philosophies through her explorations and observations in-country, lectures, visits to university collections, conversations with her elite network of scholars and missionaries, and academic texts. Particularly helpful for Kemp were her readings of Herbert H. Giles's *Religions of Ancient China* and Arthur H. Smith's *The Uplift of China*. Added to that

canon was her translation from German of Heinrich Hackmann's 1905 *Der Buddhismus* or *Buddhism as a Religion* ("Buddhism as a Religion" Somerville Chapel Blog) where, in the 1909 English edition, he offers thanks most likely to Kemp as a "very congenial translator in a lady who herself is personally acquainted with the Far East, having travelled in China twice for a considerable time" (ix). Noting in *The Face of China* that she will not "burden the reader with footnotes" (ix), Kemp weaves the philosophical and historical contexts of these religions into her narratives and her art, often borrowing directly from these sources, including quotes and exact lines to explain and demonstrate these philosophies to her readers.

With regard to Chinese pictorial art, Kemp writes, "the first and most important of their six canons is 'the Life movement of the Spirit through the Rhythm of Things' [which] possesses a marvelous vitality and poetic imagination" (*Face of China* 100). This Life, this Spirit, this Rhythm is a fundamental principle of Daoism and a circular process of "self-generation and self-production" (Moeller 108), or as Livia Kohn writes:

> The Dao . . . is characterized as the natural ebb and flow of things as they rise and fall, come and go, grow and decline, emerge and die . . . [in] clearly visible patterns of nature and society . . . [that show] how things develop in alternating movements of yin and yang, how they always move in one direction or the other . . . Nature is a continuous flow of becoming that ranges between latent and manifest, circular and linear, back and forth—part of and supported by the ineffable Dao at the center. (24)

Kemp is also familiar with Lawrence Binyon's 1911 *Flight of the Dragon*,[10] which analyzes theory and practice in Chinese art and elaborates on these rhythms and relationships of life: "And with rhythm in our minds, we are led to think, above all, of the relation between things . . . the relation between one form and another and between one colour and another. Man is not an isolated being; it is by his relation to others and to the world around him that he is known and his nature made manifest" (22). This cyclical, co-creative relationship of life rhythms is a fundamental aspect not just of Daoism but of Buddhism and Confucianism as well. Whether it is the Daoist free and easy wandering toward beco*ming*, the Buddhist spontaneity of the *now* in creative-responsive engagement, or the Confucian hierarchical network of familial identities and roles, the

interdependence of all things and the place in that interdependence is a key aspect of Chinese landscape art.

Kemp incorporates this philosophy and the co-creative relational constructs of Chinese landscape forms into her landscape paintings, particularly those of the sacred mountains. She states as much on a sketching visit to a Buddhist monastery outside of Liaoyang: "I sat down to sketch shortly after our arrival, and the scene was precisely the one to charm a Chinese artist of the old school. I found myself insensibly imitating the reproductions I possess of work done by noted artists of three hundred years ago" (*Face of Manchuria* 53). Kemp's watercolors, the *Buddhist Monastery*, *Tai Shan*, and the *Summit of Mount Omi*, among others, express the principle of the S curve and its rhythm, which has roots in Daoist, Buddhist, and Confucian principles. Stanley Murashige points out that the Great Mountains in Chinese landscape painting have "ordered aspect . . . that take the form of relationships of hierarchy, symmetry, reciprocity, and cycle, and all of these obtain graphic form through the rhythmic movement of the S. Similarly, the transformative, spontaneous, and changing aspect of the mountain emerges in the proliferation of this same S curve" (339).

In common with Northern Song and later landscape paintings, Kemp sets her mountains on a central axis and uses the S curve as "a place of spatial ambivalence, a place of spatial possibility" (Murashige 353). As in her travel writing, her landscape paintings are improvisational negoti- ated spaces in continuous transformation. In *Buddhist Monastery* reddish brown and green washes swirl back and forth, rising above the monastery "pitched aloft in inaccessible looking spots, terrace above terrace" (Kemp, *Face of Manchuria* 52–53) and filling the crags and cervices of the living mountain. The painting *Tai Shan* highlights the S curve through its thin, winding 6,600 steps that swirl up the sacred mountain, following the unseen "rocky bed of the stream" (Kemp, *Face of China* 49). Boulders, thick with vegetation in rich blues, greens, and browns, flow into washes of pale and smooth tones. Pine trees, straight and lofty, rise above the white clouds and mists that swirl round the cream stone that anchors the upper diagonal corner, leading the eye up to the pink Gate of Heaven and temple reached by a steep S curve of the last 1,000 steps—"I counted them," Kemp writes! (48). Although Kemp is most often concerned with the intimate, she can do the grand view, though without the "majestic- of-all she surveys" language: "The view from the summit, which is but a gentle ascent from the Gate of Heaven, was absolutely glorious—range

upon range of mountains, countless villages dotted over the forty miles of plain and in the folds of the hills, and above all the winding, shining river, going away, away, away, till it was lost in infinite space" (51).

The Great Mountain in Kemp's watercolor *Summit of Mount Omi* also has physical grandeur and "reveals the intrusion of human sensibility and perception into the mystery of nature" (Murashige 356) for as the *Linquan gaozhi*,[11] a twelfth-century text on landscape painting, instructs, "Mountains are large things. Their forms should rise tall and upright; they should appear strange and perilous . . . they should circle back and forth without bound; they should be dignified, simple, honest and sincere; they should be heroic; they should have spirit and vitality; they should be serious and solemn; they should survey their surroundings" (634, qtd. in Murashige 356). Kemp's *Summit of Mount Omi* is all that. Rising 11,000 feet from billows of clouds and clothed in frost and snow, the mountain anchors the entire right side of the painting. Kemp writes that "shifting mists revealed crags and abysses . . . and the mountain-top was a dazzling vision of loveliness emerging from a vast ocean of clouds. . . . Standing on the edge of the summit, you look down a precipice of more than a mile, and we could only feast our eyes on the ever-changing scene, the clouds looking as if they were boiling up from some hidden cauldron, now concealing, now revealing the peaks of distant mountains" (*Face of China* 190–92). (See figure 1.2.)

We see the summit along with Kemp. With the inclusive "you," she invites us to travel alongside, participating in this co-creative and ever-changing experience of the mountain. As she understands after painting the mountains, it is not a Chinese mountain form of the imagination where " 'form' is quite subsidiary to 'spirit' . . . in order to express some more important truth" (Kemp, *Mettle* 90). Kemp realizes that the mountains of China are "natural," dynamic recurring rhythms infused with spirit and life, and that "it is after all only our ignorance that makes us so misjudge them" (90).[12]

Just as ignorance of Chinese art forms causes misjudgment and misunderstanding, unfamiliarity and misconceptions of Eastern religions cause many to impose Western standards onto Eastern concepts. On the whole, Kemp is remarkably free from conventional cultural biases and takes the religions of China on their own terms. She combines her observations of Daoism, Buddhism, and Confucianism often in the same sentences, understanding that even for Chinese it could prove difficult to untangle the intertwined practices. While Kemp incorporates these forms into her

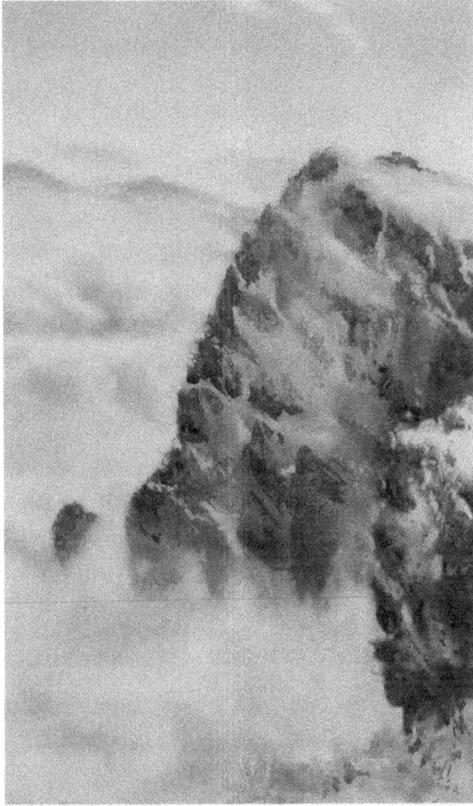

Figure 1.2. Emily Georgiana Kemp, *Summit of Mount Omi*. Watercolor Painting. Photograph used with permission of the Principal and Fellows of Somerville College, Oxford.

paintings, for the most part, she lets the religions speak on their own without overwriting them with cultural overtones; however, translations of James Legge and others, who use Christian terms for non-Christian concepts, influence her interpretations and understanding.[13]

Kemp's scholarly grounding in Buddhism in one instance, though, comes in direct conflict with the reality of practice and translation in China. When encountering a blind Buddhist nun in Liaoyang, Manchuria, known for her many years of meditation, Kemp is appalled that rather than being able to discuss "the great problems of life, both this life and the next . . . she seemed entirely ignorant of Buddhist philosophy, and took refuge in futile platitudes" (*Face of Manchuria* 49). Kemp, the

scholar, *Der Buddhismus* translator, and World Congress of Faiths member, expects action and connection of belief to the greater world. How is this nun, this monastery, actively alleviating suffering for their community? Alas, Kemp does not get the deep discussion and philosophical exchange she expects on the great problems of this life and the next. Even with regard to the future, the nun only adds, "We die, and there is nothing more" (49). Whether from Kemp's limited understanding of Chinese or from difficulties in translation, she is disappointed "to find how utterly ignorant they are of anything beyond the externals of their religion" (49). However, to the Buddhist practitioner, the dying, the nothingness, *is* action. Hackmann details this concept in the very Buddhist text Kemp has translated: "Behind every blossoming forth is a fading; behind every attainment, a loss; behind every life, death" (9). He continues, "To be so free from suffering, and thereby to cease from an existence which is within the range of our experience and conception—that is all we need as human beings" (16). It is the no-thing*ness* of the Dao for "we are each a gathering of several kinds of 'spirit' or subtle forms of energy that leave the body at death and return to their separate and proper places in the cosmos. . . . In China, change was not understood as an illusion but as the basic condition of all things" (Hershock 37). What Kemp fails to understand is that the nun, a life-long practitioner of Buddhism, has no need for deep, philosophical discussion. As in much of China then and now, practice is religion. Practice over philosophy.[14]

There are times, though, that Kemp does not focus on discussing the philosophical and on-the-ground connections between religions, and that is when she is on a traveler's schedule. At a famous Buddhist monastery, most likely Wénshū, known for its stunningly preserved architecture and circular doorways, Kemp receives permission from the abbot to paint this characteristic Szechwan detail. The abbot, eager for a deep scholarly exchange, "began discussing our respective religions, which he said were exactly the same. While agreeing as to their fundamental principle being the same, I felt unable to discuss their differences, being somewhat inattentive, I fear, owning to my endeavor to get on with the sketch as rapidly as possible" (*Face of China* 167). The abbot is out of luck. The attraction of the scene and the need of the genuine traveler to record supersedes the religious scholar in Kemp. Practice over philosophy.

Kemp is in her element when discussing Confucianism. Approaching Qufu, the birthplace of Confucius, Kemp describes in detail the procession to the "Holy of Holies of Confucianism,"[15] the temple complex and

its generous park, reached by a "celebrated avenue of cypresses" (*Face of China* 55). Catching her attention are the series of fine buildings only about two hundred years old owing to having been twice destroyed by fire. Though somewhat in disrepair since no priests see to the upkeep (60), the temples are decorated with distinctive colored and carved eaves, capped entirely in green and orange tiles—the orange being reserved only for Confucian temples (56). "Hoary cypresses" tower above courtyards filled with "stone tortoises or mythical beasts" balancing carved tablets that rise eight to ten feet from their backs (56). In the central temple, surrounded by "fine old bronzes . . . and handsomely embroidered curtains partly shrouding him," sits Confucius, flanked by the figures of Mencius and grandson Zisi with a group of six disciples seated behind (57). It is a setting worthy of the cultural importance of Confucius, and Kemp knows it. Sourcing Giles, she reinforces the importance of Confucius by comparing him to Buddha: "Buddha has love and pity for the sorrows of humanity drowned with every other feeling, and he resolutely refused to use his powerful intellectual faculties for any other purpose than to lessen suffering, and eventually to rid the world of it. Confucius, on the other hand, allowed his intellect free play, and it appears to have led him to look with tolerance, and a certain measure of acquiescence, on the religious beliefs of the age" (58).

This religious viewpoint connects solidly with Kemp's interfaith interests. Despite the teaching, sacrifices, and worship, Kemp, quoting Giles again, writes that, "Confucianism is rather a system of ethics than religion" (*Face of China* 57) and that "the most important features of his teaching are the high ideals which he inculcated for the ruling of the State, and the stress he laid on the obligations of men to their fellow-men, even more than on their obligations toward God" (58–59). She does not judge or crush her descriptions with a heavy-handed Christianity.[16] This "take" on Confucianism as a system of ethics, high ideals, and obligations to fellow humans rather than toward a religious deity is actually quite contemporary in its approach. Kemp notes that "Confucius merely accepted (and that only to a limited extent) the religion of the age and country in which he lived, and he added to it a code of morals dealing largely with the government of the State. He said, 'I am not an originator, but a transmitter'" (57–58).

These obligations of men to their fellow men, which mirror roles and relationships of the family, serve as a model for relationships with the community, the state, the emperor, and the cosmos. Kemp underscores

this by observing, Confucius "strongly advocated the duty of reverence and sincerity" (*Face of China* 59) and taught the five cardinal virtues of "righteousness, benevolence, politeness, discernment of good, and sincerity" (59). This is a very convenient way to promote strong bonds with the state as well. If, according to Confucius, we are defined by our roles and relationships, then how should we properly or perhaps appropriately meet those roles and responsibilities? As Kemp notes, for Confucius, the particular relationship, "the obligations of men to their fellow-men" (58) is the key. And so it is. Henry Fingarette additionally points out, "For Confucius, unless there are at least two human beings, there are no human beings" (qtd. in Rosemont and Ames 139). Each relationship, then, is unique, and Confucius's teachings often speak to the particular relationship to determine appropriate action. How should we act in *this* particular situation, with *this* particular person, at *this* particular time? The answers to those questions determine the action. These relationships and interactions between people are never static; they are always changing, co-creational—always becom*ing*. Although she does not use that term, Kemp would agree. Throughout her books she constantly catalogs the relational changes of herself and the changes of others with family, community, government, and the natural/spiritual. In each of those relationships, in every situation, she does her best to act appropriately. Whether it is calling a meeting of more than sixty Hindi and Muslim traders and arranging a scientific study resulting in 5,000 doses of medicine for their distressed pack animals or providing medical care for the trackers of their junk heading up the Yangtze, Kemp takes pleasure in her relational travels, applying what she has learned and sharing it, not for at-home fame but to encourage others to learn more about China, its people, and its culture. Is this not the mark of an exemplary person (*Junzi* 君子)?

If Confucianism is about appropriate, robust, co-creative relationships, what about the relationship of women in its hierarchy? Confucius most likely took the prevailing kinship attitudes on women for granted. Kemp finds those gender relationships sadly lacking. While Chinese women may have "marked strength of character, and evidently as Mrs. Poyser [of *Adam Bede* fame] so truly remarked,[17] 'God made 'em to match the men,'" Kemp notes that Confucian teaching was used by men as "the best way of counteracting this inborn self-will and strength of character" (*Mettle* 175). Kemp does not agree that "it is the law of nature . . . that woman should be kept under the control of man and not allowed any will of her own" or that women "are of a lower state than men and can never attain

to the full equality of them" (175).[18] She definitely does not agree that "the aim of female education therefore is perfect submission, not cultivation and development of the mind" (175). Ever the feminist, Kemp sees this misogynistic language and treatment as a failing of Confucianism and to some extent the state. Any teaching promoting the belief that "'all women are born radically stupid,' or, as the women themselves frequently put it, 'We are only wooden-heads'" (*Face of China* 58–59), needs to be addressed head on, and Kemp does so. She details the "graphically set out" duties, education, and attitudes toward men listed in *The Ritual of Chai* and counters with great satisfaction that despite prescribed behavior, Chinese women had opportunities to study and learn as "there is no mean list of women writers in the field of belles-lettres" (*Mettle* 176) including one who wrote on the "dynastic history in the fifth century" and another some eighteen centuries ago, a treatise on women's education (176).

In *Chinese Mettle*, Kemp is particularly keen on present-day Chinese women and students, writing that "it has been my good fortune to meet some of the finest of the new school. They are taking a high place and winning the respect and consideration not only of their own countrymen, but of British, French, and Americans by their ability, their singleness of purpose, and undaunted determination" (177).[19] Often products of mission education, these women of "great promise" became part of the student movement or the New Culture movement, advocating for "self-determi-nation, self-government and [elimination] of sex prejudice" (200–201).

Cataloging examples of women who have studied and succeeded in their chosen fields against great odds—with a bit of British educa-tional pride peeping through—Kemp singles out one particular woman, Miss Pao Swen Tseng (Zeng Baosun),[20] who exemplifies the traditional and the modern. From a long-standing honorable family that included an "enlightened grandmother" who saved her from bound feet and a great-grandfather who was a regular visitor at St. James, Zeng was the recipient of extraordinary familial support and open-mindedness. Beginning her study of Chinese history at the age of ten, within an astonishing two years she had become a Chinese classical scholar, ruining her eyesight in the process (*Mettle* 178–79). She then pressed for a Western education, traveling a thousand miles from home in Changsha to the Mary Vaughn High School in Hangzhou, where she explored Christianity, yet mindful of filial piety, she queried her Confucian father for approval. Her open-minded father advised her to study Christianity's European opponents. She did and stayed of the same mind.

As a Confucian Christian feminist, Zeng credits her grandmother's insistence of following the Confucian way for grounding her in Chinese culture. Thomas L. Kennedy, translator of her memoir *Confucian Feminist*, writes of Zeng:

> She took it as her duty to be informed of the traditional teachings of Confucianism and to put them into practice in daily living. This is demonstrated in many ways: the importance she placed on loving relationships within her extended family and with her many close friends; her unwavering faith in the power of education to strengthen the moral fiber and wisdom of those who place their trust in it; her lifelong intellectual reliance on the classical literature from which the teachings of Confucianism are derived; and her determination, when faced with choices, to do what was right rather than what was profitable. (Zeng 158–59)

Kemp continues recounting Zeng's remarkable journey as an exemplary new woman. In 1912, Zeng traveled to England to study at Blackheath High School and later at Westfield College (*Mettle* 179), choosing "the University of London because women and men were truly equal there" (Zeng 54). It is here Zeng first meets Kemp, who is impressed by her "deep seriousness" (*Mettle* 179) of mind and purpose as well as her great popularity with other students. Kemp notes that "Chinese girls always seem to get on well in England, and to fit in easily with our idiosyncrasies" (180). Zeng is the first Chinese women to graduate from the University of London, earning a bachelor's of science degree with honors in botany. After an additional course on educational methods at St. Mary's College, Zeng returned to China at the age of twenty to start I-Fang, a modern Chinese school for girls on the site of her old home, which had been partially restored to the family after the 1911 revolution. The school's name, I-Fang or "The Garden of Fragrance," as well as the school motto of "Loyalty and Sympathy," are closely associated with Confucian philosophy—still a bedrock of familial and national relationships. Kemp observes that through a combination of tradition and the innovative educational practices of debates, community service, sports, honor system, and eventually co-education, Zeng's school succeeds in "setting a new standard among the schools at Changsha" (181). Kemp uses this point to illustrate the drive and purpose along with the strong roots of tradi-

tional and familial bonds of these new, young women, a tension that is certainly played out in the May Fourth movement where Zeng's school is one of two that did not strike—although she was in general sympathy with the students (184).

Focused on the growth of her school in the midst of widespread unrest, did Zeng ignore aspects of the authoritarian Chinese state, the elite landowner abuses, and the later nationalist government short-comings? Yes. Zeng is like Kemp, when, "as in life itself—all sorts of things get mixed up together" (*Mettle* 12). As Kemp puts it, 'There is a use for eyelids as well as for eyes'" (*Face of China* vij). Though they may at times blink, Kemp, like Zeng, is drawn to the heart-mind of China with its Confucian emphasis on the foundational importance of *renqing* 人情 or human emotions within networks "created and maintained diligently by all forms of social exchanges, of gifts, labor, services, [and] respect" (Zhang Yanhua, qtd. in Ames 114). Like Zeng, Kemp is drawn to the practice of Confucian personhood because of this emphasis on felt relations, which interestingly connects quite well with modern feminist philosophies of care in contrast to ideals of cool-headed rationality.

While an advocate for greater understanding and felt relations among the world's religions and cataloging the positive, the successes of feminist thought, education, and action in her books, Kemp also records the negatives. She notes that girls often had to dress up as boys to travel to their schools safely (*Face of China* 168), and even recounts—somewhat dispassionately—the trafficking and brutal treatment of young slave girls that continued throughout her years of travel (112). Kemp reserves her most biting comments, though, on Islamic (Mohammedanism) treatment of women. Detailed mainly in the brief *Wanderings in Chinese Turkestan*, her opinion and interactions with individual people she meets are open and accepting, including a sketching visit to the local mosque in Yarkand (Xinjiang, Uyghur Autonomous Region of Western China) where thousands of men—"but no women" she adds (14–15)—celebrate the feast of Eid at the end of Ramadan. With regard to women and Islam, however, she takes exception: "One is everywhere confronted with the dark side of this faith—its cruel degradation of women, and the horrible ravages of disease caused by that fact" (15). She later critiques:

> The women are not thought much of in this country: reference has already been made to the bill of divorcement by which the husband may get rid of the wife within twenty-four hours of

the marriage! Mohammedanism is certainly not the religion
for women, and the new spirit of progress observable in its
views of women, granting them not only the possession of
a soul, but the chance of education, which is specially seen
in India (owing to its contact with Christianity) has not yet
penetrated to Turkestan. (28)

To Kemp, a feminist and a supporter of women's rights and education,
this systemic practice against women demands more than her usual
measured and open tone. Yet she feelingly writes that "people's kindly
dealings with us in Chinese Turkestan will always remain engraved on
our memories" (31). The individual people and the relationships—the
renqing, the human emotions—are key.

Kemp's genuine interest and acceptance of the people she meets in
her travels underscores her openness to different cultures and beliefs, par-
ticularly religious beliefs. Reinforced through her network of like-minded
international scholars like Henry Norman Spalding, Albert Schweitzer,
and Sir Francis Younghusband, her collaborator on the World Congress
of Faiths, she promoted greater interreligious understanding and respect
(Moulin-Stożek and Gatty 96–99). Kemp's "fervent but broad-minded
view on religion" (102) was exceptional for the time and inspired her to
donate funds for the first nondenominational chapel at Oxford University.
Despite controversy with Somerville College on the building's location,
design, and interior—Kemp had sidebar conversations with workers on
Christian iconography, ordering them to include images unauthorized by
the college—the chapel was and still is intended as "A house of prayer for
all peoples."[21] It remains unconsecrated (103–4) to any one faith tradition
and is a testament to Kemp's ultimate vision and Somerville College's
commitment to interreligious understanding.

Kemp's commitment to interreligious understanding, though, does
not a Christian evangelist make. For her, the geography, the art, the
culture, and the sheer pleasure of travel draw her to China (*Mettle* 11).
Kemp is not looking at China with solely imperialistic missionary eyes,
and certainly not with an evangelistic agenda, as Rachel Bright argues.
With scant (if any) references to Kemp's interest and comments on
Eastern religions, Bright assigns Kemp the role of evangelist first and
traveler second: "the Christianization of China and the support of the
Christianization of China was the end goal of Kemp's Writing" (117).
While Kemp notes the importance of medical missionaries and details

throughout her travelogues, the effective benefits of Christian medical community work (they certainly provided useful personal connections and logistical waystations along her travels), she balances her conviction of this work with her great scholarly interest and genuine openness to the religions of the East.[22]

The majority of her work focuses on other topics, not evangelism. In fact, as the Somerville College Chapel post "Reading" notes:

> It is because of her love for travel, and the countries she visited, particularly China, that her memorial plaque in the Chapel reads "friend of China" as opposed to "missionary", and why her books are given over to documenting her travels rather than giving an account of evangelization. An unfavorable review of her first book published in the *Burlington Magazine* in 1909 states: "Slightly attached to sundry evangelizing bodies, she shows a moderate interest in the Christianizing of the Chinese, and a much livelier interest in their country, manners and customs. On these she chatters shrewdly and agreeably, according to her own fancies."

Kemp was an adventurer and traveler, a chronicler of cultures, not an evangelist.

In her last few chapters on China, Kemp comments on its youth, their rejection of the past amid social and educational reform, and their "critical spirit which leaves no problem unstudied" (*Mettle* 192). She provides a salutatory caution to the West: "Judgement is being passed on the results of our civilization, and the future shaping of China's destiny depends largely on that judgement" (192). Yet she is quite hopeful and champions this new spirit in China, for despite difficulties in uneven standards in mission education, national currency irregularities, and gross military mismanagement, she sees positive change. She encourages those in the West to assist: "For we have the right of brotherhood in all world movements, and there is an infinite variety of mutual service possible to those who have undergone and are still undergoing the pangs of a new birth. My task has been to draw pictures with pen and brush, and my consolation in the inadequacy of its fulfillment is the poet's view that 'a man's reach should exceed his grasp'" (222). Kemp's reach does not exceed her grasp. From her first view of the celestial empire, "a land of infinite charm and beauty" (*Face of China* 1) to her last view of a China infused

with a new spirit, Kemp reminds us once again that the human emotions of *renqing*—relationships between individuals as well as nations—are key in creating a harmonious world, a world of heart-mind.

Emily Georgiana Kemp, writer, explorer, artist, feminist, and interfaith advocate, was a woman with a keen eye, a sharp pen, and a willing brush. Her descriptions and paintings through six books of travel tell of her love of China and its people, yet also chronicle what she sees as failings. Juxtaposition and reflective magic appear in her Chinese mirror. Like the Chinese, whose "gaze is turned inward rather than outward . . . shedding light . . . on man himself, his progress and welfare, both in this world and in the next," Kemp looks deeply at the people, place, and religions of China with her "poet's view" (*Mettle* 222). She breathes authenticity into her actions and scholarship, for as Derbishire advises, "Work your way inside your subject, not think you can learn from the outside" (5). Kemp does learn from the inside—the heart-mind of China. She passes through the Dragon Gate, again and again, following her own wish in the *Face of China*, "If only we could turn round and go all the way back again!" (viii). Her journeys become ours so that we, too, "can go on understanding more and more, seeing further and more clearly" (5) the face and heart-mind of China.

Acknowledgments

I express my gratitude to Dr. Anne Manuel, the Librarian, Archivist and Head of Information Services, and Katherine O'Donnell, Assistant Archivist, as well as the Principal and Fellows at Somerville College, Oxford for granting access to the Emily Georgiana Kemp Archive. Further thanks go to Collections Managers Sarah Mitchell and Alessandra Cereda and the staff in the Eastern Art Study Centre at the Ashmolean Museum of Art and Archaeology, Oxford, for their help in arranging multiple viewings of the Emily Georgiana Kemp Collection before it was transferred to Somerville.

Notes

1. Kemp was the first woman awarded the Grande Metaille en Vermeil for her work, in particular *Chinese Mettle* (Wu).

2. At age fifteen, Emily Kelsall Kemp laid the first stone for the clock tower commonly known as Big Ben at the New Parliamentary buildings. Although it would be desirable to connect this to her interest in politics and as a push for "female access to Parliament"—which would very much be in keeping with her temperament and beliefs—it is most likely that Emily Kelsall Kemp was chosen because she was the sister-in-law of the architect, Samuel Morton Peto, and concern of cost overruns may have steered politicians and officials from this official duty (Rix). However, in later life, Emily was involved in liberal politics, passing a feminist perspective to her children. Her son, George, was a liberal MP who championed women's suffrage in Parliament and argued "when he moved the second reading of the women's enfranchisement bill, 5 May 1911, that 'the nation suffers a loss by the exclusion of capable women from the power to select Members of Parliament'" (Rix).

3. As noted by poster Carmania on the Emily Georgiana Kemp thread at Women and the Great War Forum, "The 30th Annual Somerville Students' Association dated November 1917 includes the following entry: KEMP, EMILY . . . 1914, Organiser and Registrar of Hospital for French soldiers at Arc-en-Barrois. 1915, Formed aux. Hospital of 70 beds. 1916, worked for 18 months as Masseuse in French Military Hospital, Paris. Organized and took responsibility for canteen and rest rooms for French soldiers in Verdun zone (to continue till end of war)." A subsequent post by Rosefields qualifies some of this information: "In December 1914 she traveled to France in the company of Lady Kathleen Scott to secure a suitable building (Chateau d'Arc-en-Barrois) in which to place an organized staff of trained nurses, surgeons and volunteer male orderlies/ambulance drivers—the hospital service being provided to the French medical department for the care of sick and wounded French soldiers. The hospital was opened in January 1915. Kemp was appointed 'registrar' of Hopital Temporaire—a job description limited to the registration of soldiers admitted to the hospital. (This position was not at all commensurate with the title, 'Directrice,' which was held by Miss Madeline Bromley-Martin.) Kemp resigned within several weeks and withdrew her financial support from Hopital Temporaire. She remained in the village of Arc-en-Barrois and took temporary charge of a newly founded convalescent soldiers' hospice facility (60 beds). She terminated her service there in April 1915. Her subsequent service in France does not seem to have been well-documented." Kemp writes in *Reminiscences of a Sister* that her brother-in-law Dr. Edwards joined her "during the summer of 1915 to go and care for the French wounded in my little English hospital at Arc-en-Barrois, where he acted as resident officer" (120–21). Sepoyjack reports that two of the French medals are dated 1919, indicating there was significant subsequent service in France.

4. Outside of quotations, pinyin spelling is used to refer to place names in China.

5. Unlike Isabella Bird, who swept away all traces of the disastrous effects of opium in her Singaporean travelogues (Morgan 47), Kemp, using her own observations and official reports (*Mettle* 80), criticizes the British and Chinese governments' policies, trade practices, and many local provinces "where the land is one great poppy garden for the opium trade" (159). She praises the efforts of the governor of Shanxi, Feng Yu Hsiang, in Hunan and medical missionary efforts, including painting one striking watercolor of an opium recovery refuge in Shanxi (*Face of China* 80).

6. Morris-Suzuki notes that "it was only a chance discovery that enabled me to identify her name in full: Mary Meiklejohn McDougall" (22).

7. Marcus Dods notes in his 31 August 1907 letter to Kemp, "I wonder how you and Miss Macdougall are employed—mainly, I fancy, in examining maps and determining routes" (270).

8. According to Hans-Georg Moeller, the term "heart-mind" (*xin* 心) is not two separate words. "The ancient Chinese word for the 'mind' was *xin*—which literally meant the heart. The heart was believed to be the seat of the mind and the center of mental activity. Therefore *xin* is nowadays usually translated into English as 'heart-mind'" (Moeller 150). Peter Hershock writes that "the written character [*xin*] actually depicts a human heart and refers to a functional nexus of bodily forces, thoughts, and emotions" (84). For a Confucian philosophical perspective, Roger Ames describes *xin* as "a continuing, symbiotic process . . . [with] an emotional, spiritual, and intellectual aspect. The *xin* is the dense locus of feeling and thinking that is invested and expressed in the broad fields of roles and relations that constitutes each of us" (60).

9. This style and use of color are in keeping with the gendered art training and practice at Slade (Kato 149).

10. Kemp uses a quote from Binyon's *Flight of the Dragon* on the title page of *Reminiscences of a Sister*: "The Soul identifieth itself with the wind which bloweth where it listeth, with the cloud and the mist that melt away in rain and are drawn up again into the air, and this sovereign energy of the soul, fluid, penetrating, ever-changing, took form in the symbolic Dragon" (Binyon 33).

11. The *Linquan gaozhi* or *The Lofty Truth of Forests and Streams* is a text from the twelfth century by Guo Si containing the landscape teachings of Guo Xi.

12. This openness to the "Other" and the fusion of Chinese pictorial arts in her landscape paintings distinguishes Kemp as a travel writer and may have prompted her to single out the Daoist god of literature as the emblem on the cover for *The Face of China* with explanations quoted from Justus Doolittle's *The Social Life of China* (221).

13. James Legge translates *Tian* 天, *Di* 帝, and *Shangdi* 上帝 as Heaven (288). Herbert Giles notes that there are two terms in ancient Chinese literature that seem to be used indiscriminately for God. "One is *T'ien* which has come to include the material heavens, the sky; and the other is *Shang Ti*, which has come to include the spirits of deceased Emperors . . . Reference to *T'ien*

is usually associated with fate or destiny" (13, 16). Roger Ames and Henry Rosemont Jr. note that missionaries who translated Chinese texts imprinted their Judeo-Christian traditions onto the translations (282), thus influencing generations of readers. They argue that *Tian* should not be translated because "normal English rendering as 'Heaven' cannot but conjure up images derived from the Judeo-Christian tradition that are not to be found in China; and 'Nature' will not work either. . . . *Tian* is both what our world is and *how* it is" (46–47). Kemp is influenced by translations of the day and with her deep personal beliefs in Christianity; she uses Judeo-Christian references for non-Christian concepts balanced by her moderate and even-handed presentations of Daoist, Confucian, and Buddhist beliefs.

14. It is interesting to note that Kemp as scholar follows this episode with the remark, "The Taoist monks, on the contrary, boast many men of learning, and have more conception of real religion. I understand this is also the case in other parts of the Chinese Empire" (*Face of Manchuria* 49)—although she does not elaborate on specific conversations or examples. In *Chinese Mettle*, she observes that "in the long run it is not so much theory as practice that will influence young China in its religious beliefs" (195).

15. This capitalized phrase, a nod to the Judea sacred inner temple, where only high priests attended, provides a familiar association for readers to understand non-Western temple arrangements.

16. In reference to the personal veneration of Confucius, Kemp uses the term "cult" (*Face of China* 59)—but only once in all of her books—and it is a term taken directly from Giles (41). It is certainly not a term one normally associates with Kemp.

17. Kemp draws from Mrs. Poyser's remarks in the George Eliot novel *Adam Bede*, vol. 3, p. 305.

18. Kemp observes that in Yunnan Province, the Lolos value the birth of a girl more highly than a boy (*Face of China* 177).

19. This is in keeping with Hsiao Ch'ien's meditations on post-war culture (21–23).

20. Besides taking a decided interest in Zeng, Kemp also actively kept in touch with Chinese students studying in the United Kingdom through the Anglo-Chinese Friendship Society (*Mettle* 21) and was said to have known each and every one (*Darbishire* 11). It wasn't only students from China whom Kemp took an interest in. She also contributed to the appeal by the principal of Guzerat College in India to help pay Cornelia Sorabji's outstanding college debt so she could continue her studies at Somerville College, Oxford. Records list Kemp's funding at £5 along with others such as Florence Nightingale at £5.5 sterling ("Cornelia Sorabji's Birthday").

21. Moulin notes in an article for *Somerville Magazine* that the chapel "interior represents a compromise between a traditional chapel, and the radical concept of a multi-purpose building for use by those of all faiths. The College

Council authorized Kemp's chosen biblical phrase 'A house of prayer for all peoples' (Isaiah 56) to be written in Greek on the outside of the chapel. This was meant to indicate openness to those of all religions and beliefs. The engraving in the vestibule dedicating the building to Christ, on the other hand, was placed by Kemp without permission, following a number of disagreements with the Principal, Helen Darbishire. Members of the College Council were told that the stained-glass window designed by George Bell was to be abstract. The window installed, however, shows two female figures dressed wearing chasubles and stoles: one holding the lamp, a symbol of truth; the other a mirror, a symbol of learning. Despite the skepticism of Darbishire and others, Kemp saw no conflict between the chapel's function as a place of prayer for all faiths, and this Christian symbolism. She argued that in all her lifetimes of engagement with other cultures, the figure of Jesus was revered by all of the world's religions" (12). In light of Kemp's experiences and observations of the religions of China and her World Congress of Faiths adherence, it is unsurprising she had no difficulty reconciling the nondenominational function of the chapel with Christian symbolism: "it is not unusual for a Chinaman to profess all three religions at the same time, or by turns" (Kemp, *Face of China* 59). For in Kemp's view, as she passionately writes in a 1 November 1932 letter, "the special meaning of the place is <u>Life</u>, & that it may inspire those who use it to 'Live, each according to the light you have.'"

 22. Kemp acknowledges that, "It may be thought that I have said a great deal—too much in fact—about mission work in this book, but that is inevitable, because the reforms initiated in Chinese life are practically all due to missionary activity" (*Mettle* 207). Kemp particularly mentions mission work with regard to education and subsequent reform activity.

Works Cited

Ames, Roger T. *Confucian Role Ethics: A Vocabulary*. Hawai'i UP, 2011.

Ames, Roger T., and Henry Rosemont Jr. *The Analects of Confucius: A Philosophical Translation*. Ballantine Books, 1998.

Batson, Judy G. *Her Oxford*. Vanderbilt UP, 2008.

Binyon, Laurence. *Flight of the Dragon*. John Murray, 1911.

Bridges, Roy. "Exploration and Travel Outside Europe (1720–1914)." *The Cambridge Companion to Travel Writing*, edited by Peter Hulme and Tim Youngs, Cambridge UP, 2002, pp. 53–69.

Bright, Rachael M. *China as I See It: The Resident Writing of British Women in China, 1890–1940*. 2008. Temple University, PhD dissertation.

"Buddhism as a Religion Translated by E.G. Kemp, 1910." Somerville Chapel Blog, 31 May 2013, https://blogs.some.ox.ac.uk/chapel/2013/05/31/buddhism-as-a-religion-translated-by-e-g-kemp-1910/. Accessed 10 November 2019.

Carmania. "Emily Georgiana Kemp." Women and the Great War, Great War Forum, 14 January 2014, https://www.greatwarforum.org/topic/205073-emily-georgiana-kemp/. Accessed 28 May 2019.

Ch'ien, Hsiao. *The Dragon Beards versus The Blueprints*. Pilot P, 1944.

"Cornelia Sorabji's Birthday Marked with Display of 1889 Funding Document." Alumni: Somerville College, 15 November 2018, https://www.some.ox.ac.uk/news/cornelia-sorabjis-birthday-marked-with-display-of-1889-funding-document/. Accessed 10 November 2019,

Cummings, Laura. *A Face to the World*. William Collins, 2014.

Derbishire, Helen. *Somerville College Chapel Addresses and Other Papers*. Headley Brothers, 1962.

Dods, Marcus. *Later Letters of Marcus Dods, D.D.*, edited by Marcus Dods, Hodder and Stoughton, 1911.

Dohmen, Renate. "Material (Re)collections of the 'Shiny East': A Late Nineteenth-Century Travel Account by a Young British Woman in India." *Travel Writing, Visual Culture and Form, 1760–1900*, edited by Mary Henes and Brian H. Murry, Palgrave, 2016, pp. 42–64.

Doolittle, Justus, Rev. *Social Life of the Chinese*, vol. 1. Harper & Brothers, 1865.

Dutta, Sutapa. "Introduction." *British Women Travellers: Empire and Beyond, 1770–1870*, edited by Sutapa Dutta, Routledge, 2020, pp. 1–17.

Edwards, E. H. *Fire and Sword in Shansi*. Fleming H. Revell, 1903.

Egypt Exploration Fund. *Report of the General Meeting*. Kegan Paul, Trench Trubner, 1892–1911.

Gilbert, Sandra M., and Susan Gubar. *No Man's Land: The Place of the Woman Writer in the Twentieth Century*. Yale UP, 1988.

Giles, Herbert A. *Religions of Ancient China*. Archibald Constable, 1905.

Hackmann, Heinrich. *Buddhism as a Religion*. Probsthain, 1910.

Hershock, Peter D. *Chan Buddhism*. Hawai'i UP, 2005.

Kato, Daniela. "Two Women Travelers across a Contested Landscape: Emily Georgiana Kemp and Yosano Akiko in Northeast China." *Studies in Travel Writing*, vol. 22, no. 2, 2018, pp. 142–61. https://doi.org/10.1080/13645145.2018.1493816.

Kemp. Emily Georgiana. *Chinese Mettle*. Hodder and Stoughton, 1921.

———. *The Face of China*. Special ed. no. 20. Chatto & Windus, 1909.

———. *The Face of Manchuria, Korea and Russian Turkestan*. Chatto & Windus, 1910.

———. Letter to Helen Darbishire. 1 November 1932. Emily Georgiana Kemp Papers, Somerville College Library, Oxford. Manuscript.

———. *Mary, with Her Son Jesus*. Golden Vista P, 1930.

———. *Reminiscences of a Sister, S. Florence Edwards, of Taiyuanfu*. Carey P, 1920.

———. *Wanderings in Chinese Turkestan*. Old Westminster P, 1914.

Kohn, Livia. *Introducing Daoism*. Routledge, 2008.

Legge, James. *The Chinese Classics*, vol. 1. Clarendon P, 1893.

Levine, Caroline. "Strategic Formalism: Toward a New Method in Cultural Studies." *Victorian Studies*, vol. 48, no. 4, 2006, pp. 625–57. http://www.jstor.org/stable/4618909.

Maddrell, Avril. *Complex Locations: Women's Geographical Work in the UK 1850–1970.* Wiley-Blackwell, 2009.

Massey, Doreen. *Space, Place, and Gender.* U Minnesota P, 1994.

Mills, Sara. *Discourses of Difference: An Analysis of Women's Travel Writing and Colonialism.* Routledge, 1991.

Moeller, Hans-Georg. *Daoism Explained: From the Dream of the Butterfly to the Fishnet Allegory.* Open Court, 2006.

Morgan, Susan. *Place Matters: Gendered Geography in Victorian Women's Travel Books about Southeast Asia.* Rutgers UP, 1996.

Morris-Suzuki, Tessa. *To the Diamond Mountains: A Hundred-Year Journey through China and Korea.* Rowman & Littlefield, 2010.

Moulin, Daniel. "Cracking the Chapel Code." *Somerville Magazine*, 2013, pp. 12–13.

Moulin-Stożek, Daniel, and Fiona K. A. Gatty. "A House of Prayer for all Peoples? The Unique Case of Somerville College Chapel, Oxford." *Material Religion*, vol. 14, no. 1, 2018, pp. 83–114, http://doi.org/10.1080/174322 00.2017.1418478.

Murashige, Stanley. "Rhythm, Order, Change, and Nature in Guo Xi's Early Spring." *Monumenta Serica*, vol. 43, 1995, pp. 337–64. http://www.jstor.com/stable/40727070.

Murry, Brian H. "Introduction: Forms of Travel, Modes of Transport." *Travel Writing, Visual Culture and Form, 1760–1900*, edited by Mary Henes and Brian H. Murry, Palgrave, 2016, pp. 1–18.

Pratt, Mary Louise. *Imperial Eyes: Travel Writing and Transculturation.* Routledge, 2008.

"Reading Emily Georgiana Kemp's Books." Chapel History: The Life of E.G. Kemp. Somerville College Chapel Blog, 19 September 2011, https://blogs.some.ox.ac.uk/chapel/2011/09/19/reading-emily-georgiana-kemp%e2%80%99s-books/. Accessed 10 November 2019.

Rix, Kathryn. "From Rochdale to Westminster: Emily Kelsall and the New Houses of Parliament." Parliamentary Archives: Inside the Act Room, 26 May 2020, https://archives.blog.parliament.uk/2020/05/26/from-rochdale-to-westminster-emily-kelsall-and-the-new-houses-of-parliament/. Accessed 26 June 2020.

Rose, Gillian. *Feminism & Geography: The Limits of Geographical Knowledge.* Polity P, 1993.

Rosefields. "Emily Georgiana Kemp." Women and the Great War, Great War Forum, 14 January 2014, https://www.greatwarforum.org/topic/205073-emily-georgiana-kemp/. Accessed 28 May 2019.

Rosemont, Henry Jr., and Roger T. Ames. *Confucian Role Ethics: A Moral Vision for the 21st Century.* V & R UP, 2016.

Said, Edward W. *Orientalism.* Vintage Books, 1979.

Sepoyjack. "Emily Georgiana Kemp." Women and the Great War, Great War Forum, 14 January 2014, https://www.greatwarforum.org/topic/205073-emily-georgiana-kemp/. Accessed 28 May 2019.

Stockham, Karen. "The 'Feminine Stamp' in Women's Mountain Travel, 1808–1910." *Women Rewriting Boundaries: Victorian Women Travel Writers*, edited by Precious McKenzie Sterns, Cambridge Scholars, 2016, pp. 79–104.

Woolf, Virginia. *Street Haunting.* Westgate P, 1930.

Wu, Yi. "The Emily Georgiana Kemp Collection." Eastern Art at the Ashmolean Museum, Ashmolean Museum, 18 July 2017, http://blogs.ashmolean.org/easternart/ 2017/07/18/ the-emily-georgiana-kemp-collection/. Accessed 28 May 2019.

Youngs, Tim. *Travel Writing in the Nineteenth Century: Filling the Blank Spaces.* Anthem P, 2006.

Zeng, Baosun. *Confucian Feminist: Memoirs of Zeng Baosun (1893–1978).* Translated and adapted by Thomas L. Kennedy, American Philosophical Society, 2002.

Chapter 2

Women's Agency at the Close of Ming Dynasty China

Vulnerability, Violation, and Vengeance in
Ling Mengchu's Vernacular Short Stories

Marla Hoffman Lunderberg

The short story by Ling Mengchu, "Wine Within Wine: Old Nun Chao
Plucks a Frail Flower; Craft Within Craft: The Scholar Chia Gains Sweet
Revenge," was first published in 1628 in Ling's *Slapping the Table in
Amazement, First Collection*. Written in vernacular Chinese, the collection
was designed to appeal to a popular audience at the close of the Ming
dynasty (Hanan 140). This particular story, although sometimes grouped
among the more erotic of Ling's tales,[1] offers serious reflections on life
and ethical values in a culture challenged by economic and political
chaos.[2] The one story is written in two parts (as are most of the tales in
Slapping the Table) that recount similar events with distinctly different
features at key moments in each account. The heroines of each section
are introduced as icons of perfection: Madame Ti is portrayed as "chaste
of disposition, sparing of frivolous words, a woman of uncommon virtue"
(Ling, "Wine" 910), and Lady Wu is said to be "fair beyond all praise,
though chaste of disposition" (Ling, "Wine" 917).[3] Both women experience
physical assaults, violations of their bodies that parallel the violations of

43

traditional value systems faced by the people living in a culture in chaos at the close of the Ming dynasty. The characters represent the vulnerabilities experienced by women at the close of the dynasty and the multiple ways a woman can respond to those who take advantage of her vulnerability. In Ling's story, a woman might succumb to her assailant, accepting and even coming to desire his presence in her life; alternatively, she might depend on her community to help her exact revenge against the one who has wronged her.

Vulnerability

The challenges to the women in Ling's story are both internal and external. Madame Ti and Lady Wu are vulnerable to desire, a challenge to the Buddhist ideals that were important to Ming culture.[4] Madame Ti's desire to own beautiful pearls is quite different from Lady Wu's desire to bear a son. However, as the parallel portions of the story unfold, the women's desire renders them vulnerable to an abusive extramarital sexual relationship. Furthermore, in both parts of the story, the culture that demands that upper-class women live in seclusion renders them more vulnerable exactly because of their seclusion, especially in light of the husbands' absence from their wives' everyday lives.

In spite of Madame Ti's reputation for chaste behavior, Ling's story presents her desire for beautiful pearls as a fatal flaw. When a young man named T'eng asks Ti's friend, the nun Hui-ch'eng, how he might plan a liaison with the married Madame Ti, Hui-ch'eng responds that the virtuous Ti is unlikely to be interested in such a liaison and that she "does not seem to be especially fond of any material objects" (Ling, "Wine" 912). After pressure from T'eng to reflect further, Hui-ch'eng finally observes, "Several days ago she did ask me to find for her some pearls of superior quality. In fact she repeated this two or three times. But this is the only thing of the kind" (912). The "only thing of the kind" turns out to be enough to bend Madame Ti's virtue.

Ling's storytelling method acknowledges the difficulty for readers to imagine a virtuous woman suddenly abandoning her virtue for a string of pearls, no matter how beautiful. Ling's narrator interrupts the story with an objection to the direction the story seems to be taking: "Storyteller! Do you mean to say that one could actually broach such a subject directly before a lady of good family?" (Ling, "Wine" 913). Indeed, Hui-ch'eng

is more subtle than to suggest a simple trade of sexual availability for material gain; instead, she suggests that Madame Ti might purchase the pearls at a bargain rate—or even at no cost at all—if she were to help a young man through a difficult stage of his career. Hui-ch'eng declares, "There is a certain young official who has fallen from his position due to the calumny of an enemy, and begs of you this one kindness, that you plead on his behalf before the Bureau of Personnel, and request a restoration of his post, for which he will gladly part with these pearls" (913). The nun's ploy, however, operates on a brilliant recognition of human nature and human desire: she makes sure that Madame Ti has touched the pearls, has examined them and held them, and has considered the threat of them being offered to someone else (913) and has thought to herself, "these pearls are as good as mine already" (914). Madame Ti's virtue fails to sustain her because, in the end, she is only human, with an all-too-human susceptibility to desire.

Lady Wu's desire for a child, a son, is different from Madame Ti's for pearls and marks her as a very different kind of character. The desire for a child is nonetheless a human desire that makes evident Lady Wu's vulnerability. Lady Wu's friend and confidante, the old nun Chao, takes advantage of this desire as she entices Lady Wu to leave the security of her home. Chao tells Lady Wu that the prayers and incense she has been offering at her home to the bodhisattva Kuan-yin are not as effective as those she might offer while reciting from a special scroll at Chao's convent. Because of Lady Wu's desire for a child, she fasts and prays and enters the convent in a weakened, vulnerable state.

Madame Ti and Lady Wu are similar in another vulnerability: the desire for marital companionship. Their husbands live and work far from home, rendering service to the dynasty. When the stories take place, Madame Ti's husband is "in the north on an official mission" (Ling, "Wine" 912) and Lady Wu's husband, a young scholar, is "employed as a tutor in the private academy of a great house far away, so that a period of several months often passed in which he could not return home" (917). Many of Ling's stories allude to the challenges faced in the Ming dynasty by men who sought government positions by taking civil services exams. Ling himself passed the first-level exam but never advanced further, so his life experience is reflected in his writing (Hanan 141). In this story, Ling responds not to the pressures experienced by traveling scholars and government officials but to the pressures experienced by the men's wives. The vulnerability due to the geographic separation can be read as

problematic in terms of Confucian values: both couples find it difficult to render filial piety because of the distance imposed by the dynasty on their relationship. In Confucian ideology, the dynasty itself suffers when the family unit suffers.[5]

Both Madame Ti and Lady Wu live in a culture that expects upper-class women to be secluded from society. Indeed, in another of Ling's stories, this expectation is stated directly: "Generally speaking, female members of good families rarely leave the seclusion of their homes" (Ling, Story #23, 490). In Madame Ti's case, the expectation of seclusion is stated by way of her apology for participating in a community celebration: "Now in those days it was the custom every year for the ladies and gentlemen of the capital to throng to the West Lake for spring outings. Even the most noble families joined the procession, their curtained carriages forming an unbroken train as they went. And so Madame Ti as well could scarce help but observe the custom and join the procession" (Ling, "Wine" 910). Madame Ti's experience outside of the walls of her home is exactly as dangerous as her culture might warn, for it is at this spring festival that a young man, T'eng, finds himself "unable to tear his eyes from her" (910).

Like Madame Ti, Lady Wu is expected to limit her exposure to the world outside her home; even a brief moment spent in the outside world leaves a woman vulnerable. Lady Wu's exposure occurs after she has visited with Chao, as she walks Chao to the door. Lady Wu gets only as far as "the threshold of her gates" (Ling, "Wine" 918) when she encounters a man running down the street. In spite of the fact that she "lost no time in retreating inside and hiding behind the gate," and even though she quickly "shut the door and returned to her chambers" (918), the damage cannot be undone: her venture to the threshold of her home has set in motion a dangerous series of events.

The social requirement of seclusion, with its expectation of protecting women from the outside world, appears in these stories instead to increase women's vulnerability. Women, Ling's stories intimate, are curious about the world outside the walls of their homes, no matter their willingness to participate in the cultural expectation that they be secluded.[6] Although the words from Story #23 begin "Generally speaking, female members of good families rarely leave the seclusion of their homes," the passage continues by revealing women's desire to experience the world: "*Upon the advent of a festival when spring is at its height, they would be only too happy to find an excuse to go outdoors in search of amusement*" (Ling, *Slapping* 490,

emphasis added). A world where women want to see what is outside the walls of their homes is particularly threatening for those who have not been allowed to prepare for experiences beyond those boundaries. Thus, a careful reading of Madame Ti's story allows a reader to discern early hints of her vulnerability. When Madame Ti joins the crowd at the West Lake spring outing, she is not only seen by the young man T'eng, she plays an active role in seeing him as well: "Madame Ti also lifted her eyes now and then and noticed his engaging manner" (Ling, "Wine" 910). The story is quick to dismiss this insinuation, and through its hasty dismissal, draws all the more attention to it: Madame Ti "noticed [T'eng's] engaging manner, *but since she had no mind for such things, she thought no more of him*" (910, emphasis added).

In the second part of Ling's story, women again appear to be curious about the world outside of their homes. Old nun Chao, at least, believes that the women in her sphere of influence are frequently lonely, and this general loneliness provides the excuse for introducing the scoundrel, Pu Liang, to Lady Wu. That is, whether or not Lady Wu herself is lonely, Chao believes that loneliness is the experience of most women. Readers learn this at the worst possible moment, as Chao offers a half-hearted apology for having introduced Pu Liang to Lady Wu: "Seeing that my lady was living in solitude and most likely feeling rather desolate, I felt that it would be far better for you in the time of your youth to have companionship and not let the springtime of your life pass by in vain" (Ling, "Wine" 929). Madame Ti and Lady Wu both suffer because of their inexperience, their loneliness, and their culture's expectation that seclusion is safer than exposure to the world.

Madame Ti and Lady Wu are also vulnerable to false pretenses of friendship through the machinations of a nun who is trusted as friend and confidante. Hui-ch'eng befriends and betrays Madame Ti by convincing Ti that it is safe to leave her home, visit Hui's convent, and spend time alone with T'eng. Hui-ch'eng is herself vulnerable to avarice, one form of the desire presented in this story as the source of all pain in human life. T'eng ingratiates himself with the nun by handing her a gift of silver while claiming an innocent motive for his visit, declaring, "I have long esteemed the purity and virtue of your honored sanctuary" (Ling, "Wine" 911). Readers are informed that Hui-ch'eng is "quite versed in the ways of the world" (911), and she certainly asks herself the right questions: "Such a handsome young man, what does he want with an old nun like me?

To give me such a kind gift with no special request" (911). Yet once the silver is in her hands, Hui-ch'eng is swiftly willing to betray her friend.

Hui-ch'eng is less villainous than Chao of the second part of the story. Where Hui's desire for silver opens the door to her wrongdoing, Chao's embodiment of the desiring self is her own lust. Ling writes: "Such nuns as this were on intimate terms with [Pu Liang, the man who rapes Lady Wu], serving him now as panderer, now taking a share in his diversion" (Ling, "Wine" 918). Chao not only provides the venue for the encounter between Lady Wu and Pu Liang, she even drugs Lady Wu to make her available to the rapist. After the rape, Chao wishes her own physical desires might be fulfilled, "throwing herself on top of [Pu Liang]" (926) and expressing frustration when he is not immediately prepared for another sexual encounter. These nuns embody the desire that Buddhism teaches is the source of human suffering—desire for silver, desire for attention, desire for sexual favors. The nuns are deceptive in their offers of friendship and spiritual guidance. Both are weak in their resistance of the machinations of a man who asks a favor. Both recognize the corrupt nature of the man's request, they (briefly) voice resistance—and in the end give in to the illicit male desire.

The stories of Madame Ti and Lady Wu are remarkably similar: they are tales of desire, loneliness, and betrayal as well as tales of sexual vulnerability. Madame Ti enters the Cloister of Calm Delight to gain some beautiful pearls, and thanks to Hui-ch'eng's schemes, Madame Ti encounters the desirous T'eng. Lady Wu fasts and prays at the temple of Kuan-yin in hopes of getting pregnant with a son, and thanks to Chao's schemes, she is raped in the temple. Despite the almost hypnotizing similarities between the stories, the two women respond differently to the violence perpetrated against them.

Accepting the Assailant

Women in Ling's stories undergo violence of many kinds. Being forced to marry against their will, being kidnapped, being forced to work in a brothel, or being betrayed and sexually assaulted are some forms of violence endured by his characters. When faced with assault, women in Ling's stories demonstrate several forms of response. Some of these are internalized responses to the aggression they have experienced; others are physically and spiritually forceful methods of reclaiming the subjec-

tivity taken from them through an assault. Madame Ti and Lady Wu respond very differently to how illicit male desire is imposed on them, one embracing her assailant and the other seeking vengeance.

Madame Ti internalizes her response to injustice, first as she finds herself attracted to her assailant and later by wasting away due to her longing for him. Partway through being assaulted by the "dashing youth by the name of T'eng" (Ling, "Wine" 910), Madame Ti finds herself "overcome with alarm and affection" (916)—simultaneously fearful of and attracted to the young man. "She wanted to cry out," Ling writes of the assault, "but realized that it was of no avail. She wanted to refuse him, but how could she resist his two arms clasped tightly about her?" (916). Madame Ti's initial fear and paralysis are not difficult for a twenty-first-century reader to comprehend. More difficult to interpret, however, is the devotion she quickly develops toward her assailant. "Every evening a side door to her house was opened to receive him within; so that not a night did she spend in solitude. Madame Ti nourished a deep love for him within her breast, and fearing only that she would lose his favor, spared no efforts to do his bidding" (917). Madame Ti's extramarital companionship is eventually blocked, to her great misery: "Her husband, hearing some faint report, placed her under strict surveillance, forbidding any visits to her. Madame Ti, unable to bear her longing, took sick and died" (917). One wonders about the details the story does not reveal: does the long-absent husband hold any desire to reestablish a relationship with his wife? Does his surveillance indicate renewed marital attentiveness, or is he simply punishing his wife for her illicit desire and preventing her from continuing her affair? In any case, Madame Ti dies—quite abruptly—of unrequited desire.

Madam Ti's response to her assailant can best be understood in the context of other stories from Ling's *Slapping the Table* collection. In particular, her physical attraction to T'eng can be compared to the experience of Dizhu in Story #2. Like Madame Ti, Dizhu is a beautiful young woman married to a man who is absent from her life when the story takes place. Also like Madame Ti, Dizhu finds herself quickly and surprisingly attracted to a man who takes advantage of her lonely and helpless situation. "Stealing a glance at [this man]," Ling writes, Dizhu "found him to be a handsome and attractive young man and instantly took more than a little liking to him" (Ling, Story #2, 48). Finally, like Madame Ti, Dizhu finds greater satisfaction with her assailant than she had found with her husband. In Madame Ti's case, we read, "Though

Madame Ti, for her part, was not unfamiliar with conjugal matters, she had never known this realm of experience, so her delight was without limit" (Ling, "Wine" 916). As for Dizhu, "The truth of the matter is that although Dizhu had been married for two months, she had never experienced such sensual pleasure, because her husband, Pan Jia, was no expert" (Ling, Story #2, 51).

Ling's storytelling gives voice to the concern that readers—apparently seventeenth-century as well as twentieth-first-century readers—might express in response to the extramarital desires of these supposedly model women. His narrative style—simulated oral storytelling—interjects conversation between the author/storyteller and the reader, as if the story is being told to an audience that can interrupt and ask questions.[7] In both stories, the interjections acknowledge, even lead, the reader's questions about the women's moral choices. In Madame Ti's story, the storyteller's interruption guides readers' questions about an exchange of pearls that appears to be a quid pro quo payment for sexual favors:

> Storyteller, she can hardly tell such a decent lady point-blank that the man wants that kind of favor in exchange for the pearls, can she?
> Gentle reader, please be patient. The nun, with her gift of the gab, will surely ease into the subject her way. (Ling, Story #6, 119)[8]

In Dizhu's story, the interruption likewise acknowledges questions that readers might find themselves asking when discovering the details of Dizhu's newfound pleasure:

> Storyteller! How could the Pans do nothing about their daughter-in-law's absence, thus effectively giving her license to enjoy herself with another man?
> Dear audience, this story has two threads. I can't very well pursue both of them simultaneously, can I? Now let us turn to the Pan family. (Ling, Story #2, 51)

In both tales, the simulated oral storytelling guides readers to question the morals of these supposedly model women. At the same time, the narrative device deflects questions through a request for the readers' patience and a change of subject.

The portrayal of Madame Ti's sudden, surprising—and troubling—desire to deepen the encounter that begins as an assault is consistent with the framework created in many *xiaoshuo*, or vernacular, Chinese stories. The sexual encounters in these stories are generally told from a "basic male orientation of erotic description" (McMahon 229). As Keith McMahon argues: "The male perspective creates the fantasy of . . . an acquiescent woman, who despite protest secretly wants to make love anyway" (229). This fantastical point of view makes it difficult to discuss this part of the story and sort out the right questions to ask of the encounter. What might we think of the space the story makes for Madame Ti to act as an agent of her own best interests? How do we understand or critique her response to the events of the story without blaming the victim? One way to approach this problem is to compare Madame Ti's story to Lady Wu's and other stories in Ling's collection.

The death of Madame Ti—from unrequited desire—is a common theme throughout Ling's collection. Ti's death resembles the death of a character from another story, Miss Wang, who has a heart attack on the way to her parentally enforced wedding. The wedding would have prevented her from marrying the man she desired. When commanded to marry the man her parents have chosen, she suffers a heart attack and dies (Ling, Story #9, 182). Some of Ling's characters take a more active role in evading a life of unfulfilled desire. Lady Wu's initial response to recognizing that she has been raped is to consider suicide. "I have reported the matter to my lord," she says after telling her husband of the events that have taken place, "and my own business is now done. Let me use the sword in my lord's hand to end my life here and now" (Ling, "Wine" 927). Lady Wu does not, finally, take her own life, but in Story #9, Sugeshili does (188). Like Miss Wang, Sugeshili has been told that she must marry one man when she desires another. Alone for a short while in a sedan chair transporting her to her new home, Sugeshili strangles herself instead of submitting to the unwanted marriage. It is not insignificant that her tool for self-harm is her footbinding cloth; the story reveals that "she had untied her foot wraps and strangled herself" (Ling, Story #9, 188).[9] The women in Ling's stories seek various methods of escaping the ways life traps them, and death, either actively sought or experienced as passive suffering, is one method of escape.

Still, there is a significant difference between a character who wastes away from unfulfilled desire and one who takes an active role in evading an unwanted liaison. Sugeshili's appropriation of the means of

her subjection—her footbinding cloths—in refusing to be subjected to an unwanted marriage symbolizes this difference. Wu's wish to take an active role in ending her life is one early indicator of the major difference between her character and Madame Ti, and her turn from plans of self-harm to vengeance are an even clearer indicator of their differences.

Vengeance

Ling's commentary on the tale of Madame Ti is modest, with any criticism voiced by his abrupt silence at the close of Ti's tale rather than through any overt moralizing. Ling's sympathies lie instead with Lady Wu. Unlike Madame Ti, Lady Wu seeks revenge against her assailant. She gets that revenge with the help of her husband and the goddess she honors, the bodhisattva Kuan-yin. Constructed through its emphasis on relationships, Lady Wu's story becomes a tale of vengeance as one step on a path toward social reintegration.

Understanding the value of relationship to normative Chinese ethics is key to understanding the difference between Madame Ti and Lady Wu. Madame Ti is defined as an individual ("a radiant beauty that defied equal" [Ling, "Wine" 910]), but the radiance of Lady Wu's character is defined through a relationship: she and her husband "lived in perfect harmony, taken to one another like fish to water, bound by ties of mutual respect and love such that never a harsh word passed between them" (917). When Lady Wu recognizes that she has been raped, her first thought is of her marriage: "she thought mournfully of her husband and her sobs broke into tears before she retired in utter despair" (925). Her love for her husband is what prevents her from succumbing immediately to her despair: "She would fain have ended her miserable existence, but she could not bear the thought of never again seeing her lord" (925). The marital relationship is so strong that it is honored by Kuan-yin. The scholar Chia is far from home when his wife is assaulted, but he is warned in a vision from the bodhisattva to return home to help Lady Wu. In fact, Ling's emphasis on defining Lady Wu through her filial commitment appears in the way her experience of being raped is different from that of Madame Ti. When Lady Wu has been drugged and her assailant is attacking her, her unconscious self reinterprets her experience: "Lady Wu lay limp, her body offering no resistance, as if in a vague, misty dream. Although she did have some slight consciousness, she mistakenly imagined

that she was at home with her husband, and so, unable to distinguish white from black, she submitted to this indignity, for a time abandoning all restraint" (924). Lady Wu's experience, unlike that of Madame Ti, is thus imagined within the realm of marital relations. Upon waking from her drugged state, however, Lady Wu is horrified to discover the reality of the assault she has endured and what this represents to her character, her marriage, and her engagement in her community.

Along with her husband, the scholar Chia, Lady Wu recognizes the impossibility, for a woman who has been raped, of securing justice through public institutions. Chia notes the challenge this way: "This wrong cannot be avenged in the open. If I were to act openly there would certainly be talk in the courts, and it would be impossible, eventually, to conceal the truth. Then there would be a noisy dispute and your name would be stained" (Ling, "Wine" 928). The act of admitting to having experienced the rape victimizes the woman. In response to this challenge, the couple devises a plan to punish the rapist in secret. Their plan is violent. They murder Pu Liang's accomplices, old nun Chao and Chao's assistant. They frame Pu Liang for these murders: Lady Wu seduces Pu Liang and bites off his tongue, and the fragmented tongue is placed in the mouth of the murdered junior nun as a (false) clue pointing to the murderer. Because of his injury, Pu Liang is prevented from speaking up in his own defense, just as the type of injury sustained by Lady Wu has prevented her from speaking up in her own defense. The revenge plot thus mirrors the original crime.

Lady Wu's vengeance is enacted in league with her husband. In Ling's tales, women—even those women who take action—often take action with men. A heroine of another tale, Lu Huiniang of Story #16, likewise works with a male accomplice to right an injustice. In Lu's case, her husband is the assailant from whom she must escape. He has used Lu as bait to lure innocent men, far from their homes, to a scam marriage and a robbery. As Lu explains,

He makes out that I'm a widowed cousin planning to remarry and that he's the matchmaker. . . . Each time he tricks one such man into the deal, he sends me to the wedding ceremony. The next day, he comes with a gang of thugs, accuses the man of ensnaring a woman from a decent family, and takes me back, along with all of the man's possessions. The victims are afraid of being caught in brushes with the law while they're on the

road. So they swallow the humiliation and keep their mouths
shut about the scam. (Ling, Story #16, 325)

Cultural norms make it impossible for Lu to seek justice openly. She
is beholden to the husband who treats her as a pawn for his nefarious
purposes, and the men who have been robbed likewise find themselves
humiliated and silenced by the circumstances. Lu is best able to seek
justice outside of the law with the help of a male accomplice.

The marvelously self-motivated Lu Huiniang, the creator of her own
escape plan and her own vengeance plot, seeks her own accomplice. The
night after her (sham) wedding banquet with a successful young scholar,
Shen Canruo, Lu takes stock of the scholar in her bedroom and decides
to trust him with the story of her plight. "I've often wondered if I was
condemned to do this the rest of my life" (Ling, Story #16, 325), she
tells Shen. Shen listens to Lu's story and follows her advice, thus allowing
Shen and Lu to escape from Lu's husband and his gang of bandits. Not
only does Lu get revenge, she also creates a new life with Shen.

Like Lu, Lady Wu plays an active role in seeking freedom from
oppression. She is creative and convincing in faking an interest in Pu
Liang when she talks with Chao after the assault. With Chao's help,
she meets with Pu Liang and pretends to accept his embrace, until the
moment is right and she can suddenly give "vent to her dammed-up
wrath . . . clamping her teeth deep into his tongue" (Ling, "Wine" 930).
This piece of Pu Liang's tongue convicts him, in the eyes of his commu-
nity, of his crimes. Lady Wu does not lead the action to the same extent
as does Lu—Lady Wu is following the lead of her husband, who has
commanded, "if you wish to clear your soul of this matter and avenge this
wrong, you must agree to everything I say" (928)—but hers is nonetheless
a much more active response to assault than Madame Ti's.

Lady Wu's husband is not the only member of Lady Wu's community
to aid her in seeking vengeance; Lady Wu's devotion to the Kuan-yin
builds another sort of support forged through relationship. From the
beginning of the story, Lady Wu is devoted to Kuan-yin, the goddess
of mercy (Ling, "Wine" 918). In her husband's absence, Lady Wu has
spent time embroidering a tapestry of Kuan-yin, which she has mounted
on a scroll and hung "in an immaculate room in a quiet corner of the
house, where she burned incense before it each morning and evening"
(918). It is to Kuan-yin that Lady Wu prays for a son (921), and it is
to Kuan-yin that she dedicates a two-day fast before reciting her sutra

(921). After the assault, Lady Wu prays to Kuan-yin for vengeance: "Your disciple bears a mortal hatred in her breast and looks to the power of the Bodhisattva for vengeance" (925). The goddess delivers, sending a vision to Wu's husband that sends him home to help his wife. The story closes by praising the "superior wisdom of the scholar and . . . the intervention of the goddess Kuan-yin" (933), both of whom support Lady Wu in her anguish and provide her with a community through which she can be reintegrated into her society.[10]

Other stories in Ling's collection likewise showcase Kuan-yin's support for family connectedness and social integration. Story #8, with a plotline about surprising benefits that can result from generosity to a stranger, highlights how Kuan-yin supports families in distress. The main character, Chen Dalong, suffers when his wife and her younger brother disappear en route to visiting their ailing grandmother. When Chen finds them and his family is reunited, the story demands attention not so much to the friend he has made through his earlier generosity but to Kuan-yin's role in orchestrating the family reunion. The family had prayed to Kuan-yin before Chen's wife and her brother had departed on their journey (Ling, Story #8, 170), and after his wife's disappearance, Chen honors the bodhisattva's birthday with a journey to her statue in Hangzhou (173). As she does for the scholar Chia and Lady Wu, the bodhisattva responds to Chen's dedication, sending a vision to him confirming a reunion with his wife (173). A hurricane throws Chen's ship off course, a crowd of pirates take him prisoner, and a pirate captain remembers a long-ago meal that Chen has shared with him—these all play a role in the bodhisattva making good on her promise and reuniting Chen with his wife and brother. The family's declaration, "The bodhisattva [Kuan-yin] is truly responsive to prayers!" (177), follows a multigenerational reunion of Chen's family. The bodhisattva has reintegrated the lost wife into her community—although in this case, the woman is a minor character (we never enter into her thoughts or feelings) compared with the attention Ling gives to Lady Wu's thoughts and feelings.

Another of Ling's tales portraying the work of the bodhisattva fighting injustice perpetrated against women is told in Story #24. In this tale, a beautiful young woman named Night Pearl has been spirited away from her family by an old, debauched sorcerer. Night Pearl's parents are dedicated to Kuan-yin—their years of dedicated prayers and their journey to Kuan-yin's shrine led to Night Pearl's birth in the first place (Ling, Story #24, 509). Night Pearl herself remains stubbornly chaste and dedicated

in prayer to Kuan-yin throughout her imprisonment at the hands of the sorcerer (514–15). Although the sorcerer attempts to seduce Night Pearl rather than take her by force, he eventually grows impatient and prepares to assault her. At the point of the assault, the story divides itself between the prayers of the daughter—she "kept praying silently to the bodhisattva [Kuan-yin] for rescue and protection" (516)—and those of the parents: "O Bodhisattva so responsive to prayers, you blessed us with this daughter in answer to our prayers. Now that she's been snatched away by a sorcerer, if you don't go to her rescue and return her to us, why didn't you refuse to give her to us in the first place? Please manifest your divine power!" (517). The family's dedication is rewarded, and Kuan-yin answers their prayers. The next morning, the townspeople see that an unusual pole has been erected at the top of a nearby mountain. A young scholar volunteers to investigate and discovers several women trapped in a cave at the top of the mountain and also finds the skeletons of the sorcerer and his assistant nearby. Kuan-yin, the townspeople discover, has rescued Night Pearl along with the other young women who had been held captive by the sorcerer. The pole that drew everyone's attention had come from the nearby temple and the bodhisattva had used it in "manifesting her divine power" (519).

Once their daughter has been rescued, Night Pearl's parents do as many parents in fairy tales seem to do: they offer their daughter as reward to the man who has rescued her. Quite astonishingly, given storytelling traditions, the man resists their "gift." With terms that acknowledge and resist the way this storytelling trope steals agency from the women involved, the man explains to a judge,

> I did this out of curiosity about something out of the ordinary. I had no marital intentions. If I accept this marriage offer, uninformed outsiders will take me to be a greedy man with ulterior motives. What a loss of face that will be for me! Moreover, I was just telling Your Honor about Miss Qiu's fortitude in protecting her chastity. If she were to become my wife, those words of mine can be construed as selfishly motivated. With what little learning I have, I value honor, integrity, and self-respect above all else. Therefore, I won't venture to oblige you. (Ling, Story #24, 522)

The young scholar recognizes the irony of rewarding a woman for preserving her chastity by forcing her to marry a man she had never previously met. Yet Ling's story does not resist for long the pressures placed on women

by their societies. The judge joins with Night Pearl's parents in insisting that the couple be wed. Night Pearl's voice, so present in her prayers to Kuan-yin to protect her from the lascivious sorcerer, is silent during these marriage plans. In the end, this young scholar's words, however extraordinary, seem more directed at preserving himself from being accused of being selfish than of preserving Night Pearl's continued chastity.

In these stories, the bodhisattva Kuan-yin defends women who have been assaulted and returns them to relationship with their loved ones. Kuan-yin's work, like the work of these women's husbands and families, creates a community of support that allows women to resist injustice, recover from wrongs that have been perpetrated, and renew their relationships with their society.

The path of community support is the primary path for seeking justice for women in these Ming dynasty stories—and yet it is not the only path. Ling's stories include an account of multiple "women knights-errant of olden times" who were "among the legions of disciples, male and female, of their school of martial arts" (Story #4, 80). Ling's stories of women who seek revenge includes one of a woman who does so on her own—although disguised as a man.

In Ling's Story #19, it is no accident that the reader's first introduction to Xie Xiao'e is that she is "as strong as a man" (392). The young woman whose father and husband are killed by pirates when she is only fourteen (393) proves herself persistent and resourceful in seeking vengeance for their deaths. After a prolonged effort to discover the names of the two pirates who murdered her loved ones, Xie disguises herself as a man, working the wharf district as a hired hand for years to find where the pirates lived:

> Day in and day out, she hung around the wharf and hired herself out to boatmen who were looking for help. While on board, she gave her all and never loafed on the job. . . . So she became popular as a hired hand, and she was not picky. She took all job offers. Soon, she got to know all those who worked on merchant boats. When she went to the lavatory, she took extra care not to give herself away. Wherever her boat went, she would go ashore and make inquiries all around. Several years went by with no progress. (Ling, Story #19, 398)

Xie's constancy is eventually rewarded: she discovers the whereabouts of the family of one of the murderous pirates, the Shen family. The reputation

she has earned as a good worker serves her well, and she is hired as a domestic servant for the family. She gradually gains such trust in their service that she becomes the "closest confidant" for the head of the clan: "she was the one who handle all his money and valuables" (Ling, Story #19, 399). But knowing the identity of the one guilty man, Shen Lan, does not satisfy Xie. Her vengeance will not be complete until she uncovers the whereabouts of the second man, Shen Chun, as well. So she waits, continuing in service for two more years until she gets her opportunity. Shen Chun visits Shen Lan, and Xie encourages their feasting and their drinking until the villains are incapacitated. Shen Chun remains just sober enough to stumble to bed, so Xie locks the door to his room to keep him out of the way while she takes action against Shen Lan, who is so drunk that he has lost consciousness. Xie beheads him.

Xie Xiao'e does not have male family members to help her after she has been assaulted. Instead of relying on her father or husband, she undertakes on her own the long process of discovering how to get vengeance. This is remarkable, and perhaps so countercultural that Ling doesn't write this as a woman's story: to complete her task, Xie does so not only in male attire but as if she were a man. In doing so, she is indeed remarkably independent, yet her exceptional story, like the others in Ling's collection, in the end proves the rule of women's vengeance being executed with community support. It is true that Xie's various communities are temporary rather than permanent, but in each phase of her life, she survives because of the relationships she forges. When the pirates attack her family's boat, she falls off the boat, drifts with the current, and arrives at "the side of a fishing boat, as if she was being assisted by divine beings" (Ling, Story #19, 393). A poor fisherman and his wife pull her out of the water, revive her, and offer her the opportunity to live with them—but not wishing to be a burden, she leaves. She settles for a while at a nunnery, where a kind abbess takes care of her, but a dream in which her father and husband tell her a riddle with the names of their killers motivates her to leave the convent to seek an answer to the riddle. With the help of an eminent monk and a wise judge, Xie solves the riddle, enabling her to focus her search for the men who killed her loved ones. Even as she kills Shen Lan, she recognizes that she cannot complete her vengeance alone, so she enlists the help of Shen's neighbors and the local judicial system to help her complete her quest and regain her family's possessions from the Shen home (Ling, Story

#19, 403–7). At each stage of her journey, this remarkable independent woman is sustained by a community of supporters. Only at the very end of her life, having accomplished her revenge and joined a nunnery, does her independence become permanent. She takes the vows of a mendicant nun, and after she travels south, "no one knew what happened to her later" (Ling, Story #19, 410).

Women in Ling's stories are vulnerable to assault of many kinds and they respond in different ways to the violence perpetrated against them. Those who take vengeance against their assailants do so in the context of a supportive community, which is consistent with a Confucian emphasis on the importance of relationships. The shape of their community varies: Lady Wu is supported by her husband, Lu Huiniang gains the support of her future husband, and Xie Xiao'e depends on multiple temporary communities that guide her effort to wreak vengeance on those who have wronged her. Many of Ling's characters are nurtured by Kuan-yin, whose presence offers a community of a different sort in these women's lives. What is consistent in these various stories is how these women are restored to wholeness through vengeance.

Context: Late Ming Dynasty

Madame Ti's desire and her death represent one possible reading of the Ming dynasty's loss of moral authority and political power in the early seventeenth century—a very different reading than readers can glean from Lady Wu's continuing connection with her husband and from the couple's efforts to enact vengeance on the man who has violated their trust. In one case, a woman who has been violated seems to have little recourse other than to accept her assailant and then die. In the other, desire is moderated, Confucian values are maintained, and the family manages to continue its filial commitments in spite of the violence perpetrated against it.

Ling Mengchu's story, published in the waning years of the Ming dynasty, offers a glimpse of multiple paths forward not only for a woman whose innocence has been violated but also for a dynasty under pressure. Ling's story seems to ask whether the nation will succumb to the pressures of the violation of its traditional values or whether it might instead find a path to maintain its values in spite of the assaults exerted on it. In

other ways, Ling made clear his hopes to preserve the dynasty's future. In 1643, he wrote an account detailing how to protect the dynasty, and in 1644, he died fighting a rebel force (Hanan 140). Other writers in the late Ming era likewise described moral action through the individual conscience. Patrick Hanan writes, "The major strain of fiction in the 1640s, under the foreign threat, was Confucian moral heroism. Writers rejected the alternative values of reclusive withdrawal and romantic abandon and subordinated the claims of the individual self to social duty. . . . Their morality proceeds from conscience, not the social stimuli of shame or vainglory; their heroes persist in principled behavior despite the taunts of their peers" (162). Recent decades have seen widespread interest in scholarship in English on cultural definitions of women's virtue in the Ming and Qing period. Examples include Kimberly Besio's examination of adaptations of the Wang Zhaojun legend in the Ming period and Wai-yee Li's work on the relationship between portrayals of women and "larger historical processes" (93). This interpretation of Ling's "Wine Within Wine" story follows in the critical path forged by Besio's and Li's works.

Ling is known as a moralizing writer (Hegel xii), and sometimes his moralizing can be cloying. However, at the close of the episode with Lady Wu, the questions he raises are sensitive on both psychological and political levels. The story asks its readers to consider the justice of the vigilante vengeance by which Lady Wu's rapist is executed, not for the crime he committed (the rape) but for one he did not commit (the double murder of a nun and her novice). Was justice served? And, Ling asks, was justice served for Lady Wu herself, who lived silently for the rest of her life with the knowledge that she had been violated? The sensitivity of these questions reflects on how the nature of "woman" was imagined by one writer at the close of the Ming dynasty. It opens a window onto life at the close of the dynasty. In the midst of famine, banditry, and changing power structures, how can a person best respond to cultural chaos? On what basis can ethical decisions be made? A passive response leads to death. Although an active resistance to injustice might seem to result in greater satisfaction, harm to the woman, to the family, and to the community has nonetheless taken place. In 1628, the future offered the possibility of both responses, although by 1644, the Ming dynasty had fallen and Ling had lost his life in its defense. After 1644, Ling's tales no longer offered possible paths for the dynasty, yet they continued

to imagine ways that women in seventeenth-century China could shape their lives and their relationships.

Notes

1. In his introduction to the Yang and Yang translation of Ling's stories, Robert Hegel notes that "Wine Within Wine" was published in the collection *In the Inner Quarters: Erotic Stories from Ling Menchu's Two Slaps*, translated by Lenny Hu, in collaboration with R. W. L. Guisso (Arsenal Pulp P, 2003). See notes to Hegel 873, note 17.

2. On the chaos at the end of the Ming dynasty, see Ebrey 212–16 and Brook 238–59.

3. Quotations from this story, unless otherwise noted, are from the translation in *The Columbia Anthology of Traditional Chinese Literature*, edited by Victor H. Mair (Columbia UP, 1994). Ling's work has gained substantial recent attention among English-speaking scholars, and quotations from other stories in Ling's collection are from the recent translation *Slapping the Table in Amazement: A Ming Dynasty Story Collection*, translated by Shuhui Yang and Yunqin Yang (U Washington P, 2018).

4. On the notion of desire and Buddhism in China, see Hurvitz and Tsai, 415–16.

5. On the connection between family and state, see, for example, *Analects* 1.2: "Among those who are filial toward their parents and fraternal toward their brothers, those who are inclined to offend against their superiors are few indeed." In de Bary and Bloom 45.

6. See Ko, *Teachers*, on the complex relationship between women's willingness to submit to cultural expectations and their evident longing to overcome the "confinement" of a "lifelong cloistered existence" (225).

7. On this convention in Chinese narrative, see Zhao 44–45.

8. Part of this passage is quoted already from the Mair edition, in the context of the "Wine Within Wine" story. Here it is quoted at greater length, and in comparison to another story from the Yang and Yang translation, and so the Yang and Yang translation is used.

9. This is not the only story where Ling highlights the footbinding of high-status Chinese women. In one story, a maidservant "washing foot-binding bandages at the riverside" is grabbed and tied up with the very bandages that represent her service to the aristocracy (Ling, Story #2, 63). In another, the only clue to an impostor's identity is that her feet are much too large for her to be the princess that she claims to be (Ling, Story #2, 38). See Ko, "Body" for a multi-layered interpretation of footbinding in seventeenth-century China.

10. For further background on Kuan-yin in Chinese literature and culture, see Yü.

Works Cited

Besio, Kimberly. "Gender, Loyalty, and the Reproduction of the Wang Zhaojun Legend: Some Social Ramifications of Drama in the Late Ming." *Journal of the Economic and Social History of the Orient*, vol. 40, no. 2, 1997, pp. 251–82.

Brook, Timothy. *The Troubled Empire: China in the Yuan and Ming Dynasties.* Belknap P, 2010.

De Bary, Wm. Theodore, and Irene Bloom, compilers. *Sources of Chinese Tradition*, 2nd ed. Columbia UP, 1999.

Ebrey, Patricia Buckley. *The Cambridge Illustrated History of China*, 2nd ed. Cambridge UP, 2010.

Hanan, Patrick. *The Chinese Vernacular Story.* Harvard UP, 1981.

Hegel, Robert E. "Introduction." *Slapping the Table in Amazement: A Ming Dynasty Story Collection. Ling Mengchu (1580–1644).* Translated by Shuhui Yang and Yunqin Yang. University of Washington Press, 2018, pp. xi–xviii.

Hurvitz, Leon, and Tsai Heng-Ting. "The Introduction of Buddhism." *Sources of Chinese Tradition*, edited and compiled by Wm. Theodore de Bary and Irene Bloom, 2nd ed. Columbia UP, 1999, pp. 415–32.

Ko, Dorothy. "The Body as Attire: The Shifting Meanings of Footbinding in Seventeenth-Century China." *Journal of Women's History*, vol. 8, no. 4, 1997, pp. 8–27. https://doi.org/10.1353/jowh.2010.0171.

———. *Teachers of the Inner Chambers: Women and Culture in Seventeenth-Century China.* Stanford UP, 1994.

Li, Wai-yee. "Women as Emblems of Dynastic Fall in Qing Literature." *Dynastic Crisis and Cultural Innovation: From the Late Ming to the Late Qing and Beyond*, edited by David Der-wei Wang and Shang Wei, Harvard University Asia Center, 2005, pp. 93–150.

Ling Men-chu'u. "Wine Within Wine: Old Nun Chao Plucks a Frail Flower; Craft Within Craft: The Scholar Chia Gains Sweet Revenge." *The Columbia Anthology of Traditional Chinese Literature*, edited by Victor H. Mair, Columbia UP, 1994, pp. 909–33.

Ling Mengchu. *Slapping the Table in Amazement: A Ming Dynasty Story Collection*, translated by Shuhui Yang and Yunqin Yang, U Washington P, 2018.

———. Story #2: "Yao Dizhu Flees from Disgrace Only to Incur More Disgrace; Zhang Yue'e Uses a Mistake to Advance Her Own Interests." *Slapping the Table in Amazement: A Ming Dynasty Story Collection*, translated by Shuhui Yang and Yunqin Yang, U Washington P, 2018, pp. 37–64.

———. Story #4: "Cheng Yuanyu Pays for a Meal at a Restaurant; Lady Eleventh Explains Swordsmanship on Mount Cloud." *Slapping the Table in Amazement: A Ming Dynasty Story Collection*, translated by Shuhui Yang and Yunqin Yang, U Washington P, 2018, pp. 79–97.

———. Story #6: "Zhao the Nun Drugs a Beauty into a Stupor; Jia the Scholar Takes Revenge in a Brilliant Move." *Slapping the Table in Amazement: A Ming Dynasty Story Collection*, translated by Shuhui Yang and Yunqin Yang, U Washington P, 2018, pp. 115–40.

———. Story #8: "General Wu Repays the Debt of One Meal; Chen Dalang Reunites with Two Loved Ones." *Slapping the Table in Amazement: A Ming Dynasty Story Collection*, translated by Shuhui Yang and Yunqin Yang, U Washington P, 2018, pp. 160–77.

———. Story #9: "In the Director's Garden, Young Ladies Enjoy a Swing-Set Party; At Pure and Peaceful Temple, Husband and Wife Laugh and Cry at Their Reunion." *Slapping the Table in Amazement: A Ming Dynasty Story Collection*, translated by Shuhui Yang and Yunqin Yang, U Washington P, 2018, pp. 178–92.

———. Story #16: "Zhang Liu'er Lays One of His Many Traps; Lu Huiniang Severs a Bond of Marriage." *Slapping the Table in Amazement: A Ming Dynasty Story Collection*, translated by Shuhui Yang and Yunqin Yang, U Washington P, 2018, pp. 310–27.

———. Story #19: "Li Gongzuo Ingeniously Reads a Dream; Xie Xiao'e Cleverly Snares Pirates." *Slapping the Table in Amazement: A Ming Dynasty Story Collection*, translated by Shuhui Yang and Yunqin Yang, U Washington P, 2018, pp. 391–410.

———. Story #23: "The Older Sister's Soul Leaves Her Body to Fulfill a Wish; The Younger Sister Recovers from Illness to Renew a Bond." *Slapping the Table in Amazement: A Ming Dynasty Story Collection*, translated by Shuhui Yang and Yunqin Yang, U Washington P, 2018, pp. 483–502.

———. Story #24: "The Old Demon of Yanguan County Indulges in Debauchery; The Bodhisattva on Mount Huihai Puts the Evil Spirits to Death." *Slapping the Table in Amazement: A Ming Dynasty Story Collection*, translated by Shuhui Yang and Yunqin Yang, U Washington P, 2018, pp. 503–23.

McMahon, Keith. "Eroticism in Late Ming, Early Qing Fiction: The Beauteous Realm and the Sexual Battlefield." *T'oung Pao*, vol. 73, nos. 4/5, 1987, pp. 217–64.

Yü, Chün-fang. *Kuan-Yin: The Chinese Transformation of Avalokiteśvara*. Columbia UP, 2001.

Zhao, Henry Y. H. *The Uneasy Narrator: Chinese Fiction from the Traditional to the Modern*. Oxford UP, 1995.

Chapter 3

A Flight of Cultural Imagination in Heian Japan

The Image of Yang Guifei in *Genji monogatari*
and "Chang hen ge"

C ATHERINE R YU

This study seeks to delineate the figure of Yang Guifei (719–756), arguably one of the most memorable and important women in the history of Tang China (seventh–tenth century), as a literary motif in Heian Japan (ca. eighth–twelfth century). In particular, this study elucidates the ways Murasaki Shikibu uses the image of Lady Yang as recalled in Bai Juyi's (772–846) celebrated verse "Chang hen ge" ("Song of Everlasting Sorrow," 806) in *Genji monogatari* (*The Tale of Genji*, ca. eleventh century), a masterpiece in the Japanese literary tradition. I do so by probing the significance of how this Japanese author transforms the image of Yang via the figure of a *maboroshi*, a Japanese rendition of *daoshi* or *fangshi* (i.e., the Daoist wizard in "Chang hen ge"), that links the desires of the dead and the living in Bai's poetic imagination.

More specifically, this study approaches "Chang hen ge" as a poem where the poet memorialized the tragic love between Chinese Emperor Xuanzong (685–762) and his consort, Lady Yang Guifei—two of the main figures associated with the An Lushan Rebellion (755–763), a pivotal event in the premodern history of Silk Roads led by General

An of Sogdian origin[1]—while viewing *Genji monogatari* as a work of fiction reimagining that tragic love in the context of Heian Japan. By illuminating the significance of Yang Guifei ultimately as an "untenable" archetypal figure of the ideal woman in Murasaki Shikibu's writing, this study aims to contribute to the ongoing discourse on "Chang hen ge" and *Genji monogatari* in their respective fields of cultural and literary studies in the expansive conceptual framework of Silk Road studies. The present study concretely demonstrates how not only objects and people but also intangible literary motifs and their attendant ideas moved through Silk Roads, transforming a local society's worldview and cultural production in the process.[2]

The "Chang Hen Ge" Paradigm

While "Chang hen ge" has long been recognized as a subtext for *Genji monogatari*, the nature of this textual relationship has not yet been fully considered through a larger conceptual framework of Silk Roads and a close look into the transcultural imaginary disseminated along the routes. Broadly speaking, conventional critical practices investigate the relationship between *Genji monogatari* and "Chang hen ge" by searching for Murasaki's use of the Chinese source as direct quotations, allusions, or resonances. Patterns found in such occurrences throughout the work—especially when the hero of each of the three generations in the story loses his beloved and remains inconsolable—have been rightly interpreted as evidence of Murasaki's creative use of "Chang hen ge," in particular its essence, *kanshang* (heartache) as a thematic focus of her work, written in Japanese vernacular as opposed to Chinese (the official language of the time),[3] with pronounced lyricism in its overall tenor.[4]

In contrast, this chapter focuses specifically on the function of the *maboroshi* as a lens through which to delineate how Murasaki uses, by navigating through and negotiating time, gender, and linguistic divides, what I would call the "Chang hen ge" paradigm. By this I mean a conceptual template for narrating an amorous relationship—a template that originated from Bai Juyi's poetic imagination, looking back on a mid-eighth-century event in Silk Road history and presenting it as a story set in an earlier time, Han China. In essence, this study brings into focus Murasaki's narrative conceit of and strategies for transforming this

template, of foreign origin, into a naturalized idiom for representing the psychological interiority of fictional characters in early eleventh-century Heian Japan, the far eastern terminus of Silk Roads, approximately 250 years later.

From the outset, it is important to recognize that as a discursive entity, the figures of a Daoist wizard in the Chinese source text and in the Japanese narrative are fundamentally different. The figure of a *daoshi* or *fanshi* in "Chang hen ge" is an entity that also existed outside Bai's poetic work. In the early ninth century when he composed the verse, numerous Daoist practitioners, known specifically as *daoshi* or *fangshi*, could be found in person and in the records, which date back to the Han dynasty (206 BCE–220 CE). In fact, in the Chinese cultural context, a *daoshi* or *fanshi* presents a familiar figure associated with a variety of roles such as necromancer, sorcerer, magician, seer, conjurer, wizard, or immortal.[5] Hence, even though the role of a Daoist wizard, specifically as a messenger who brought back Lady Yang's mementos from the land of the dead, stems from the poet's flight of imagination, this figure still carried multiple layers of resonance and signification for the poet and the audiences of his time, that is, about half a century after the An Lushan Rebellion, when the impact of this catastrophic event still governed and shaped the reality of their everyday lives.[6]

The figure of a Daoist wizard in *The Tale of Genji*, however, has no similar historical counterpart or precedent in the Japanese cultural context. Etymologically speaking, the precise origin of the term *maboroshi* (variously translated into English as a wizard, seer, and others) is yet to be determined. This noun—potentially composed of two or three components, *ma-boroshi* (alternatively, *ma-poroshi*) or *maho-ro-shi*—could be a hybrid Chinese-Japanese term or a compound noun in the Japanese vernacular.[7] It is likely to be a semantic translation of the term *daoshi* or *fangshi*, introduced to Japan through such textual sources as Bai Juyi's "Chang hen ge," his other well-known poems, or Buddhist sutras. Given that the world depicted in *The Tale of Genji* does not exhibit even a slightly tenuous historical relationship with the An Lushan Rebellion, the *maboroshi* figure imbued with a primary meaning of "phantom" and "sorcery" can only be a purely imaginary being of foreign textual origins. As will be seen, Murasaki's focused investment in *maboroshi* as the figure of an Other—an unbound being outside the received notion of Japan and China, reality and dream, time and space—serves as a concrete example

of cultural translation that took place at the far eastern terminus of Silk Roads, Heian Japan, and this study highlights the unique texture of such acts of translation.[8]

The Poetic Flight of the Figure of a
Maboroshi in *Genji Monogatari*

In "Chang hen ge," the Daoist wizard mediates the two tragic lovers, Emperor Xuanzong and Lady Yang Guifei. The flight of this wizard soaring up to heaven and diving down deep into the sea in search of Lady Yang's soul, followed by his meeting with her on the island of Pengulai, constitute the last third of this verse of 120 lines, taking up 840 words. From the land of the dead, he brings back for the grieving emperor her hairpin, together with her private message that only the emperor would understand. That is how Bai Juyi memorialized the emperor's excessive love for Lady Yang, who had been blamed as a direct cause for the An Lushan Rebellion, conventionally viewed as a breaking point in the history of Tang China, destablizing the hegemony of Han China due to the encroachment of the Other, as represented by the figure of An Lushan, a Sino-Sogdian.

In *Genji monogatari*, comprising 54 chapters (well over 1,000 pages in modern English translations), the term *maboroshi* appears only three times: once in chapter 1 and twice in chapter 41. As scholars and critics have routinely observed, the reigning Emperor Kiritsubo, father of the eponymous hero Genji, includes this term in chapter 1, when he expresses in a *waka* of thirty-one *morae* (Japanese court poetry, a precursor to *haiku* composed of seventeen *morae*), his longings for his beloved Kiritsubo Intimate, who passed away about two or three months before, when their son, Genji, was only three years old. In chapter 41, which depicts the last year of Genji after the passing of Lady Murasaki (Murasaki no Ue), the love of his life, the term *maboroshi* is used as the chapter title and appears later in his *waka*. The story of the post-Genji generation, dominated by Kaoru and Niou (Genji's putative son and grandson, respectively), begins in chapter 42 and ends in chapter 54, even though the term *maboroshi* does not appear in this last portion. As will be seen, chapters 1, 41, and 54 form a rich textual site to examine the author's creative use of the "Chang hen ge" paradigm as she depicts the amorous relationships, which become increasingly complex and more challenging

than prior ones, between the hero of each generation and his beloved, all fashioned after the image of Yang Guifei, covertly and overtly.

Chapter 1: The Figure of Yang Guifei in the First Generation of an Amorous Hero in *Genji*

When viewed from the totality of *Genji monogatari*, the initial appearance of the *maboroshi* has to be memorable enough that it can be recalled when the same figure resurfaces forty chapters later, approximately half a century later in the tale. Not surprisingly, the stage for the first appearance of the *maboroshi* is laboriously set from the very beginning. General knowledge of the An Lushan Rebellion is presented as already part of the collective consciousness that girds the realm of *Genji monogatari*. In the opening paragraph, the reader immediately learns about Kiritsubo Emperor's infatuation with Kiritsubo Intimate, a low-ranking consort, followed in the second paragraph by the court ministers' concerned response to the situation: "From this sad spectacle the senior nobles and privy gentlemen could only avert their eyes. Such things had led to disorder and ruin even in China, they said, and as discontent spread through the realm, the example of Yōkihi [Yang Guifei] came more and more to mind, with many a painful consequence for the lady herself; yet she trusted in his gracious and unexampled affection and remained at court" (Murasaki, *Tale* 3).[9] In this way, the story of Emperor Xuanzong and Lady Yang is initially highlighted in *Genji monogatari* as a cautionary tale for Emperor Kiritsubo's excessive love for his consort. Significantly, the ministers' shared concern over the deteriorating moral landscape of the realm is delivered in prose. This particular linguistic modality underscores the author's use of the political discourse, emphasizing the impersonal, collective, and objective nature of the ministers' admonition.

By contrast, a prelude to the emperor's versification unfolds through the sympathetic gaze of Myōbu, a lady-in-waiting. She has returned to the palace after delivering an imperial message to Kiritsubo Intimate's mother, who, like the emperor, remains inconsolable over the loss of her daughter. To Myōbu, the emperor appears in this way: "Lately, he had been spending all his time examining illustrations of "The Song of Unending Sorrow" commissioned by Emperor Uda, with poems by Ise and Tsurayuki; and other poems as well, in native speech or in Chinese, as long as they were on that theme, which was the constant topic of his conversation"

(Murasaki, *Tale* 10). In this vignette of the emperor's private mourning, the author generates an intimate association between him and "Chang hen ge" by physically surrounding him with aesthetic representations of this Tang verse. His profound appreciation of and preoccupation with the visual renditions of the poetic realm that resembles his situation conveys the extent and the magnitude of Emperor Kiritsubo's grief for his loss. At the same time, by bringing up such well-known personages from Japanese history as Emperor Uda (867–931, r. 887–897), Lady Ise (875–938), and Ki no Tsurayuki (872–945) and their poetic responses to the Chinese verse, Murasaki situates Emperor Kiritsubo's deep engagement with "Chang hen ge" in historically established Japanese cultural practices vis-à-vis this particular verse of foreign origin.[10] His deep emotional identification with "Chang hen ge" universalizes his grief and longing beyond the linguistic boundaries of "native speech and Chinese." In such a way, Murasaki uses the Tang verse as a source of solace, aesthetic rumination, and personal recollections for her fictional character of Emperor Kiritsubo, that is, the first amorous hero of this expansive tale spanning three generations.

Only after setting up the narrative situation thoroughly steeped in the layered poeticity of "Chang hen ge" does the author present the Emperor Kiritsubo's own *waka*, in which the figure of a *maboroshi* first emerges. Upon Myōbu's presentation of Kiritsubo Intimate's hair ornaments, given as a memento by her grief-stricken mother, the emperor composes this verse: "O that I might find a wizard to seek her out, that I might then know / at least from distant report where her dear spirit has gone" (Murasaki, *Tale* 11). What this verse poignantly expresses is, in essence, not necessarily his longing for the lady. Rather, it is the distance that separates him from his Chinese counterpart, Emperor Xuanzong, who at least had a Daoist wizard at his disposal. From Emperor Kiritsubo's perspective, the Myōbu who has just returned with the hair ornaments cannot adequately play the role of a *maboroshi* for she had met merely with the late Kiritsubo's mother, not the soul of the lady herself. The impossibility of having access to a true *maboroshi* doubly emphasizes the irrecoverable loss of his beloved.

In this vignette, it is important to note that the emperor's emotions are conveyed through the language of *waka*. Instead of succumbing to the power of his raw emotions, Emperor Kiritsubo is forced to contain and shape his overwhelming grief through *waka*'s moraic measures of five-seven-five-seven-seven and its poetic diction. The overall tone of his verse is heightened by the use of *gana*, an emotive particle that marks

the ending of the poem. This particle, desiderative in its function, simultaneously amplifies his wish for and the absence of a Daoist wizard. In this sense, Emperor Kiritsubo's verse, murmured only to himself, serves as his private language of desire and despair, while the absent figure of a *maboroshi* signifies an emblem of his irrecoverable loss. Together they differentiate him from Emperor Xuanzong in "Chang hen ge." In this way, Murasaki brings into sharp focus the private and affective dimension of the emperor's relationship with Kiritsubo Intimate, which was initially presented by his ministers' moral rebuke of Emperor Xuanzong's excessive love for Lady Yang.

Poetically speaking, Murasaki's use of "Chan hen ge" in Emperor Kiritsubo's versification differs from how the previous generation of celebrated poets used the same verse. The emperor's verse captures his own perspective, even though the poetic conceit is borrowed from "Chang hen ge." This is in great contrast to Lady Ise and Tsurayuki, historically well-known court poets of an earlier era mentioned in the passage previously noted. These Heian poetic luminaries historically composed verses on the topic of "Chang hen ge" by momentarily inhabiting the subjectivity of Emperor Xuanzong or of Lady Yang, or by directly translating a line from the verse into *waka*. In fact, immediately after presenting the emperor's verse, the narrator describes how he observes subtle differences between Lady Yang and Kiritsubo Intimate in each artwork, that is, the minute differences only the emperor, with his intimate knowledge and experience with the dead, can decipher. This impossibility of recapturing the figure of his lost love through artistic substitutions, visual and poetic, thus turns into another cause of his unending sorrow. The narrator describes the emotional state of the emperor as *tsukisezu urameshiki*, which is a Japanese rendition of the title of "Chang hen ge." After having thoroughly displayed the interiority of Emperor Kiritsubo mediated by the poetic idioms of the Chinese verse, the extended scene of the emperor's private mourning deep into the autumnal night finally comes to an end.

What allows the reader to gradually relate to the emperor's heartfelt grief is not simply the personal nature of his poetic emotions or the poignancy of the situation. Rather, it is the author's use of his poetic voice in the story. In fact, the verse under discussion is the first instance when the reader experiences the intensity and authenticity of the emperor's emotions. This voice is markedly different from that of his first direct speech, which was his adamant refusal to grant leave to the gravely ill Kiritsubo Intimate: "You promised never to leave me, not even

at the end," he said, "and you cannot abandon me now! I will not let you!" (Murasaki, *Tale* 5). His blunt words of control, "I will not let you!," are expressed in an even more emphatic way in the original Japanese, *eyukiyarazu* (adverb *e* + verb + negation, signifying the impossibility of the action described), conveying more of the emperor's desperate wish to stop the lady from leaving him (literally, "you cannot swiftly go [away]"), rather than withholding his permission to let her go. The second occasion for the reader to encounter the emperor's direct speech is in the scene of his private audience with Myōbu, which ends in his versification. By the time of this audience, that is, two to three months after the lady's death, the emperor has come to recognize the full, direct, dire consequences of his impetuous passion for all involved, as well as his responsibilities for those remaining—her aged mother and their son, Genji, now only three years old. When he murmurs the verse to himself, he is no longer the man who was once blindly in love with Kiritsubo Intimate—a man incapable of feeling except for the power of his own emotion. He has now turned into a man capable of empathy. Not surprisingly, for the rest of his life this emperor remains a character of deep understanding and grace. At the same time, the figure of Yang Guifei and the significance of the figure of a *maboroshi* in *Genji monogatari* have not fully emerged yet, and for that, we must turn to chapter 41 and beyond.

Chapter 41: The Figure of Yang Guifei in the Second Generation of an Amorous Hero in *Genji*

The term *maboroshi* recurs in chapter 41 for the first time since its initial appearance in chapter 1. In the intervening chapters, the original narrative thread in chapter 1 has run its course, while continuously resurrecting and reviving the figure of the late Kiritsubo Intimate in a long chain of substitutive heroines, as if Emperor Kiritsubo's unfulfilled desire to bring his beloved back from the land of the dead had turned into an unconscious textual desire. It begins with the emperor's newly found love in a youthful princess, Fujitsubo, the spitting image of Genji's mother; then, Genji's own bewildering passion for his stepmother, Fujitsubo; followed by Genji's discovery of her niece, a young Murasaki, who resembles Fujitsubo. It is this Murasaki (age forty-three), whom Genji had raised to be his ideal woman since around age ten, for whom he is now in deep mourning in chapter 41. As such, this chapter is poised between the deaths of the

two main characters in *Genji monogatari*: Murasaki's death in chapter 40 ("Minori" or "The Law") and Genji's own demise, which is merely evoked in the following chapter known solely by its title ("Kumogakure" or "Vanished into the Clouds") with no content.

Significantly, the reappearance of the term *maboroshi* takes the form of the chapter title, triggering a set of anticipations in the mind of the reader, who remembers it from chapter 1, about how the *maboroshi* figure will reemerge. In other words, this motif has gained significance in the fictive realm of *Genji monogatari*, apart from its foreign textual origin, "Chang hen ge." The gratification of the reader's anticipation is delayed until toward the end of this short chapter, approximately twelve pages in length, which chronicles Genji's grief over the course of a year after Murasaki's death. In effect, this chapter resembles a traditional twelve-paneled screen of annual rituals and festivals, while combining the passage of time with the hero's deepening grief that pervades all aspects of his life. The reader thus first becomes thoroughly familiar with all the shades of his mourning by the time the *maboroshi* figure finally makes its appearance. It occurs so late as in the Tenth Month, when Genji composes this verse: "O seer who roams the vastness of the heavens, go and find for me / a soul I now seek in vain even when I chance to dream" (Murasaki, *Tale* 776). At first glance, the verse, which directly addresses a seer (*maboroshi*), expresses Genji's desire to receive tidings from Lady Murasaki's soul, similar to Emperor Kiritsubo's poem conveying his longing for the late Kiritsubo Intimate, though the latter did so through the very absence of the *maboroshi*. Yet so late into the year, the function of the *maboroshi* as a mediator between Genji and Murasaki's soul has already been performed by other means in his earlier poems. The poetic exchanges Genji had with his son Yūgiri in the Fifth Month, for example, pointedly spoke of the cuckoo bird as a messenger between the living and the dead and as an emblem of memories of the past. In other words, the poetic power of Genji's verse here does not lie in the novelty of the idea expressed through the *maboroshi* motif in chapter 1 but in the accrued weight of his deepening longing and grief voiced by this particular figure.

To begin with, Genji's stance vis-à-vis the *maboroshi* figure becomes clearer from the context in which he composed the poem. The direct poetic stimulus is his chance sighting of "wild geese passing aloft" (Murasaki, *Tale* 776), and the narrator describes his emotion at the moment as "he envied them their wings" (776). The original Japanese makes it clear

that he envied "even" their wings as indicated by the particle *mo* (*kari no tsubasa mo*), narrowing the object of his envy specifically to the birds' wings. Significantly, Genji likened himself to "crying geese" in his previous poetic exchanges with Lady Akashi (one of his secondary wives) in early spring, the prescribed season in Japanese poetry for this bird. Moreover, the notion of *maboroshi* as the figure of a "plumed man" in his poem is conceptually closely associated with the images of warbler, cuckoo, geese, fireflies, and gossamer that all appeared in his early poetic exchanges with other characters. Such classic Japanese poetic idioms are all connected to and reinforce the idea of aerial mobility and agility associated with the *maboroshi* figure.

Put differently, the Daoist wizard in Genji's verse is a culmination of all the bird-related imagery and its associated ideas developed in chapter 41 up to this moment. His brief appearance, in the shortest month depicted in a rather noneventful chapter, thus constitutes nothing less than a poetic event, especially in the totality of this narrative, even though the verse itself lacks the potency of grief, which requires sustained energy on the part of the mourner. Instead, an early winter poem, Genji's verse simply points to the inevitable: his own demise—emotional, psychological, and physical. His charge to the *maboroshi* is precisely to visit (*tazune yo*) where Murasaki's soul has gone and now dwells (*tama no yuku kata tazune yo*). It is not necessarily because he does not know where her soul is. Rather, it is because he himself cannot go there just yet, and her soul does not visit him even in his dreams. As the narrator pointedly observes immediately after the *waka*, "The months and days continued to slip by, and soon nothing could distract him from his grief" (Murasaki, *Tale* 776). The remainder of the chapter focuses on his final preparation for his eventual death.

By seamlessly combining the poetic imagery of geese imagery with the figure of a *maboroshi* in his verse, the author demonstrates the extent to which this foreign-inflected figure has become part of Genji's poetic idiom and sensibility. In fact, his heightened desire for flight, in direct proportion to the weight of his despair, is what differentiates Genji's verse from his father's. The first two lines of Genji's verse—*Ōsora o kayou maboroshi* ("O seer who roams the vastness of the heavens")—allude to the signature attribute of a Daoist wizard: his ability to fly, that is, his unrestrained freedom of aerial mobility throughout the vastness of the heavens. At the same time, this Daoist figure becomes connected with the topos of a dream (*yume*), a well-recognized trope of transience and

illusion in the Japanese poetic tradition and in Buddhist ideology. In Genji's poem, these two terms appear next to each other: *maboroshi* at the end of the second line and *yume* in the beginning of the third line. Even though they are not grammatically connected, their physical contiguity reinforces their semantic connotations. This term *maboroshi* in Japanese diction is also interchangeable with another term, *yume maboroshi*, meaning "illusion" in the Buddhist sense.[11]

In chapter 41, Genji is thus shown as a man who cannot yet see the illusory nature of love and life, deeply marred as he is in his blinding and consuming grief for the absence of his beloved. Even the death wish implicit in his verse is another expression of his tenacious desire, in contradistinction to the soul of Lady Murasaki, finally "liberated" from his binding love for her, which did not allow him to grant her sole wish in her life: to take the tonsure in her later years. The Buddhist idea of illusion thus notable in his verse can be connected to the significance of the title of the preceding chapter, "Minori." This term refers to dharma, the quintessential Buddhist truth that all things are impermanent, while pointing directly to Murasaki's death. Similarly, "Maboroshi" further amplifies the deepening Buddhist overtone of *Genji monogatari* as a whole. Hence, this Buddhist undercurrent, adumbrated in the author's use of the term *maboroshi* as the chapter title and in Genji's *waka*, further reflects the extent to which Murasaki has integrated the initially foreign motif into a meaning-making system internal to the realm of *Genji monogatari*. As will be seen, this Buddhist notion of illusion implicit in the combined connotations of *yume-maboroshi* becomes thematically central to the rest of *Genji monogatari*.

Chapter 54: The Figure of Yang Guifei in the Third Generation of an Amorous Hero in *Genji*

The figure of a *maboroshi* resurfaces in the final chapters of *Genji monogatari*, commonly known as the Uji chapters. These chapters, in an increasingly darkening tone, tell the story of how Kaoru becomes irrevocably entangled in the lives of all three daughters of the Eighth Prince. Kaoru, born to the Third Princess and the late Kashiwagi (the eldest son of Tō no Chūjō—Genji's rival, friend, first cousin, and brother-in-law) is known to the world as the son of Genji and the Third Princess, a young niece of his whom he had married in his later years at the bequest of his

half-brother, Emperor Suzaku. Kaoru's life thus unfolds under the murky shadows of his concealed paternity. Similarly, the paternity of Ukifune is hidden from the world: she is an unrecognized daughter, the youngest, of the Eighth Prince (one of Genji's half-brothers). The last five chapters of *Genji monogatari* trace the unraveling of a secret union between Kaoru and Ukifune, the characters positioned at the receiving end of the two previous generations' karmic retributions. *Genji monogatari* finally comes to a full stop in chapter 54, evocatively titled "Yume no ukihashi" or "The Floating Bridge of Dreams," thereby intricately blending the ideas of desire, death, dream, transience, phantom, and connection, all of which have come to be associated with and articulated through the very figure of a *maboroshi* from the beginning to the end of the narrative.

What characterizes these final chapters of *Genji monogatari* is the pronounced absence of the term *maboroshi*. Yet as will be seen, it is not so much that this figure disappears in the final chapters as it remains as an unnamed but crucial part of the Kaoru character, a veritable anti-amorous hero. The initial equation between Kaoru and the *maboroshi* figure emerges in chapter 49 (Yadorigi or "The Ivy") from a delicate revelation and negotiation of conflicting desires between Kaoru and Naka no Kimi, the second daughter of the Eighth Prince and the wife of Prince Niou (Kaoru's friend, rival, and nephew). At the same time, she—a spitting image of her late sister, Ōigimi, Kaoru's first true love—is now the object of his affections. Ōigimi's dying wish, as she starved herself to death in defiant refusal to give herself to Kaoru, was that he transfer his love to her sister. Since her death, Kaoru has come to regret not having honored Ōigimi's wishes, and he finds himself increasingly falling in love with Naka no Kimi.

Kaoru expresses to Naka no Kimi, during the course of their rare private conversation at her Nijō residence, his impossible wish to find a substitute for Ōigimi, and in this context the figure of a *maboroshi* emerges for the first time in the Uji chapter:

> He glanced mournfully outside. It was dark by now, and insect cries were the only sound that reached him. Shadows shrouded the garden knoll. There he remained, leaning quite at his ease against a pillar and arousing only consternation within. "If love ever had an end," he murmured, and so on; then he said, "I give up. The Village of Not-a-Sound: that is where I long to go, and never mind if your hills offer no proper temple,

because I would make a doll in her likeness there, and paint her picture, too, and pursue my devotion before them."

"It is a very touching desire," she said, "but disturbing, too, because alas, it brings to mind a doll in a lustration stream. And I worry, too, that the painter might only want gold."

"You are right," he replied. "In my eyes no sculptor or painter could do her justice. It is not that long since a sculptor's work brought petals fluttering down from the heavens: that is the sort of genius I need." (Murasaki, *Tale* 954–55)

In this passage, Kaoru's allusion to Emperor Wu, who had made paintings and sculptures of his beloved Lady Li, reminds the reader of Emperor Kiritsubo, who pointedly observed that even the Chinese paintings of Yang Guifei failed to capture the unique loveliness of his beloved, Genji's late mother. Kaoru's desire for a genius, in the original Japanese (*hege no takumi*, literally "a superb craftsman of the other world"), is not directly associated with "Chang hen ge," although conceptually it is similar to a *maboroshi*.

The figure of the Daoist wizard in "Chang hen ge" becomes more pointedly alluded to in Kaoru's response to Naka no Kimi's revelation about Ukifune:

"Speaking of a doll image of her [Ōigimi], I now remember a very strange thing, something quite incredible"

. . .

". . . but those who knew us both say we looked quite different, so that it is difficult to imagine how my visitor, for whom the resemblance is so much less plausible, should have it to so astonishing a degree."

He thought that he must be dreaming. . . .

Her talk of that close resemblance struck him particularly, and he was intensely curious. "Is that all? You might as well tell me the whole story." It was a distressing one, though, and she could not bring herself to do so.

"I will tell you where she is, if you wish to go to her," she said, "but I actually know very little. And if I told you too much, you know, you might only be disappointed."

> *"I would gladly give my all to travel out onto the ocean to seek the place where her spirit dwells, if you told me to do so, but in this case I doubt that I shall feel that strongly.* Still, I know that I would prefer a doll to remaining comfortless, and in that spirit I might well accept her as my buddha of the mountain village." His tone was urgent. (Murasaki, *Tale* 955; emphasis added)

In this conversation, Kaoru is the one who draws out the idea of a *maboroshi* from Naka no Kimi's plain words, "I will tell you where she is, if you wish to go to her." The equation that Kaoru suggests between himself and the Daoist wizard in "Chang hen ge," is, however, filled with conflicting wishes and desires. His conditional declaration of his half-willingness to seek out Ukifune mirrors Naka no kimi's words, also uttered in the conditional tense. Moreover, even as he makes a direct reference to the action of the Daoist wizard in "Chang hen ge" (e.g., "to travel out onto the ocean to seek the place where her spirit dwells"), Kaoru does not mention the word *maboroshi*, as if to suggest that he cannot yet commit himself to this role. If he does seek out Ukifune, his action should be seen only as an expression of his steadfast commitment to the memory of Ōigimi and of his willingness to carry out Naka no Kimi's wish. Yet the narrator's keen observation about the urgency in his tone accurately reflects his actual wish to visit Ukifune, rather than his contradicting desires expressed in a string of convoluted sentences.

The apparent, or feigned, reluctance on Kaoru's part to take on the role of a *maboroshi* he has suggested, however, is indicative of how the author uses this figure to underscore Kaoru's peculiar situation: unlike the amorous heroes of the previous generations, who could genuinely and openly mourn for their beloved precisely because there was definite closure to their relationships, such clearly tangible closure is not yet possible for Kaoru. Moreover, in his mind the boundaries—physical and emotional—between the objects of his affections (i.e., Ōigimi and Naka no Kimi) are rather porous. They are fused rather than being substitutes for one another. Similarly, he cannot openly embrace the news of Ukifune without merging her with Ōigimi. In fact, when he responds to Naka no Kimi's proposal to "seek the place where her spirit dwells," the referent of "her spirit" in this context could be either Ōigimi or Ukifune. Furthermore, by presenting himself as a reluctant but potential *maboroshi* to seek out Ukifune as a substitute for Ōigimi, he inadvertently relegates her already to the land of the dead.

Ukifune's connection with death becomes more firmly established in Kaoru's perception of her upon his first encounter with her. Toward the end of chapter 49, during his visit to the Uji residence, Kaoru happens upon the Ukifune party returning from a pilgrimage to Hatsune, a Buddhist temple, and he peeps into the room where Ukifune was resting:

> This time the young lady sat up when roused, and when she looked shyly away from the nun, *he* got a perfect view. Her beautiful eyes and the line of the hair at her forehead irresistibly recalled that face that he had never actually seen very well, and he wept as so often before. Her voice when she answered the nun was very like her half sister's at Nijō.
>
> What a dear, dear girl! He exclaimed to himself. To think that I have gone so long without even knowing about her! I could not be indifferent to any relative, even one still lower in station, whose looks were so similar, and this one, although unrecognized, is most certainly His Late Highness's daughter! He was filled with boundless love and happiness now that his own eyes had told him so. He wanted to go to her, right now, to taste the joy of saying, "But there you are! You are alive!" *No wonder that Emperor was disappointed, the one who sent the wizard to Hōrai and got back only a hairpin,* but he knew that this girl, even if not the same, promised real consolation. He and she must have shared a bond of destiny from the past. (Murasaki, *Tale* 970; emphasis added)

The excess of emotion and words characterizes Kaoru's ecstasy upon discovering Ukifune's striking resemblance to Ōigimi. Because of his inability to view Ukifune as anything other than Ōigimi's substitution, his "discovery" of her is meaningful only so far as it signifies the return of Ōigimi from the land of the dead, hence his words: "But here you are! You are alive!" He immediately reiterates his joy of welcoming Ōigimi back to life by filtering it through the idioms from "Chang hen ge," similar to what happened when he was initially informed by Naka no Kimi about Ukifune's existence. Yet Kaoru still does not apply the term *maboroshi* to himself, as if wishing to emphasize instead only on the equation between himself and the emperor. That is, his delight is now measured by what Emperor Xuanzong, to whom the Daoist immortal had brought back Lady Yang's hair ornaments, could not have experienced. Through the emphasis on Kaoru's combined role of Emperor Xianzong–

maboroshi vis-à-vis Ukifune, the author transforms the "Chang hen ge" paradigm to capture the complexity of his emotions at the moment of this "otherworldly" discovery.

Notably, Murasaki further alters the "Change hen ge" paradigm to generate a peculiar narrative situation in which Ukifune is both literally and symbolically half dead, after her failed attempt to die by throwing herself into the Uji River. Kaoru is in turn transformed into a remorseful lover full of regret over her disappearance. However remorseful he may feel, Kaoru does not cut the picture of a grief-stricken lover like Emperor Kiritsubo and Genji. Since he was secretly involved with Ukifune, he can mourn her death only in private. Even so, his self-reflections are not guided by the raw pains of having lost his beloved but by his detached self-serving logic and need to save his public face.

At the end of chapter 53, "Tenarai" or "Writing Practice," for instance, the news of Ukifune's whereabouts and of her having taken the tonsure finally reaches Kaoru. Even when given this chance of potential redemption, Kaoru remains a cautious, if not reluctant, lover, carefully weighing all options. "He pondered the matter day and night. What mountain village can she be living in? How am I to go quietly about finding her? I suppose the best thing would be to go and see His Reverence and hear from him what actually happened" (Murasaki, *Tale* 1110). Kaoru's dreadful apprehension even as he finally seeks out Ukifune—now a nun whose image is an aberration of that of the "doll" of his first love that he had in mind—is the polar opposite of his uncontainable excitement over his initial discovery of her striking resemblance to Ōigimi, an excitement pointedly expressed through the idioms of "Chang hen ge." Murasaki's transformation of the "Chang hen ge" paradigm is further evident in chapter 54, the finale of *Genji monogatari*. Whereas Emperor Xuanzong received a secret message from Lady Yang that only he could understand, Kaoru does not even receive a single word from Ukifune. By abandoning his plan to find her, Kaoru consigns her to oblivion, simply thinking that she must be taken care of by another man. His immediate decision to give up his search in response to her silence leads to the irreversible death of their relationship, anticlimactically ending this long and sprawling narrative. Kaoru's noncommitment to Ukifune as his beloved testifies the extent to which the author has transformed the "Chang hen ge" paradigm to imagine a different kind of amorous relationship between man and woman.

In fact, the sheer untenability of the "Chang hen ge" paradigm by the end of *Genji monogatari* is not simply due to Kaoru's failure to finally and fully step into the role of an amorous hero by performing the role of the *maboroshi* with more persistence and commitment. Instead, the paradigm breaks down largely due to another component of the equation: Ukifune's refusal to be part of Kaoru's circuit of desire, or more broadly, the circuit of male desire. In great contrast to the initial stages of their relationship, she is no longer merely a passive object of desire around which Kaoru could build his fantasy. Ukifune, now a nun living in a convent in the mountain village of Ono, is physically and spiritually removed from the secular world. Symbolically, she dwells in the realm of the dead, as it were, and in that sense her situation resembles that of Lady Yang, who dwelled in Penglai, an island of immortals. Similar to her Chinese counterpart, Ukifune can still be reached even in her hideout, but wholly unlike Lady Yang, her desire can be neither known nor negotiated. By absolutely refusing to recognize and speak to her younger brother, who came to visit her as Kaoru's messenger, she forecloses any possibility of further communications, uttering not even a single word for Kaoru.

What the dissolution of the "Chang hen ge" paradigm ultimately reveals is the singularity of Ukifune as a heroine in *Genji monogatari*. In the original "Chang hen ge," Yang Gueifei remains, even beyond death, as Emperor Xuanzong's ideal woman whose love for him is in perfect harmony with his. Similarly, the first heroine in *Genji monogatari*, Genji's mother, Kiritsubo Intimate, is modeled after Lady Yang, for she died in her unquestioning acceptance of and response to Emperor Kiritsubo's desire. Likewise, Murasaki, Genji's most beloved, died without ever asserting her own desire to renounce the world because she has internalized Genji's need to prioritize his desire over her own. It is only in death that the soul of Lady Murasaki does not respond to his desire and does not visit Genji in his dreams.[12] As the tale moves toward the end, the gap between male and female desire increasingly widens to the point of being unbridgeable and irreconcilable.

Of all the heroines in *Genji monogatari*, Ukifune is the only one who has ultimately grown not only to recognize the validity of her own desire but also to express it, regardless of what others may think of her. In fact, Ukifune's adamant refusal to speak to her younger brother signifies a pivotal moment that precipitates the rapid dissolution of a potential Kaoru–Ukifune reunion, thereby bringing the narrative to an abrupt halt.

Even more so than when Ukifune succeeded in taking full tonsure by relentlessly persuading His Reverence during the absence of his sister, a self-appointed adoptive mother for Ukifune at the nunnery, everyone around the young woman is thoroughly scandalized by her obdurate refusal to recognize her younger brother. Despite addressing Ukifune in honorifics, the nuns voice their dismay with such direct reproaches expressed through a combination of strong words and the emphatic particle *koso*, for example, *yo ni shirazu kokoro tsuyoku owashimasu koso* (literally, "she indeed possesses such unprecedented stubbornness") and *sasuga ni mukutsukeki onkokoro ni koso* (literally, "How incredibly outlandish your comportment is"), which are respectively rendered in Royall Tyler's translation as "Who ever heard of anyone so brazenly stubborn?" and "Your attitude is really quite frightening" (Murasaki, *Tale* 1118). The fact that Ukifune has been transformed into a character of such an unbending will does not necessarily mean she does not regret still being alive or that her life is no longer filled with sorrows. While being resigned to have been brought back to life against her will, Ukifune is resolved not ever to become mired in any love entanglement, even though her heart may sometimes still be stirred by the memories of her former life. Her emergent sense of self as such consequently renders irrelevant the figure of a *maboroshi* whose main function in "Chang hen ge" is that of a mediator linking the lovers who are physically separated but emotionally unified, that is, according to the desire of each relevant man.

Notably, in her current state, Ukifune's primary protector and provider is the nun who has adopted her, and it is this nun whom Ukifune offended most gravely by refusing to follow her advice to speak to her younger brother. Ukifune's extreme measures to defend herself against the unanticipated intrusions from Kaoru, even in her spiritual retreat, further alienate her even in the community of well-meaning nuns. The only person whom Ukifune truly longs to know about is her mother, even though she is determined not to ever show her changed appearance to anyone, especially her mother.[13] This further increases her self-imposed sense of isolation.

Even though Ukifune still cannot completely remove herself through sheer strength of will from male desire by isolating herself from the secular world, as a nun who is still in the process of recovering from prolonged spirit possession, she has at her disposal an effective means for negotiating her position vis-à-vis any unwanted overtures from men or any social intercourses with others. Her new position is in great contrast to her former situation, where she had no means of protecting

herself—body and mind—as evidenced time and again when Niou and Kaoru physically took her to places of their choosing and inscribed her into their discourse of love as they wished.

Only through such extreme measures of isolation can Ukifune—a young woman of extraordinary beauty—at least occupy, however momentarily and precariously, a physical, mental, and emotional space of her own, though ironically in the guise of spirit possession (i.e., paranormally induced illness) and in the habit of a nun, that is, two socially recognized and sanctioned modes of feminine existence in the realm of *Genji monogatari*. By amplifying Ukifune's perilous state in the final chapter, the author adumbrates that while dissolving the "Chang hen ge" paradigm is not an answer to resolving the fundamental contradictions with which female characters are forced to shape their lives, lifting that paradigm illuminates the struggles and pains specific to female characters who decide not to embrace such contradictions simply to privilege male desire as a given in life.

Conclusion

As this study has shown, the ultimate significance of Murasaki Shikibu's transformation of the "Chang hen ge" paradigm emerges fully only after *Genji monogatari* has come to an end. By meditating on the nature of desire and illusion in the key amorous relationships over three generations that have ended tragically in some way in *Genji monogatari*, Murasaki creatively deconstructed "the Chang hen ge" paradigm based on Bai Juyi's recollection of the An Lushan Rebellion. In the process of reconfiguring elements of this episode in Silk Road history, Murasaki foregrounded the fundamental contradiction in Bai Juyi's conceit of an archetypal love relationship: it cannot be sustained when female desire does not mirror, or is subsumed into, male desire. Kaoru's failure to recognize even the remote possibility that Ukifune has a desire of her own, separate from his, is thus Murasaki's clear-eyed comment on the blind and delusional nature of male desire. By illuminating the author's use of the "Chang hen ge" paradigm in *Genji monogatari* through the *maboroshi* figure central to both works, this chapter has brought into focus the ways an intangible literary motif, the figure of Yang Guifei, circulated along the Silk Roads and ultimately was transformed into a fictional heroine of a fundamentally different nature.[14]

Notes

1. An Lushan, born to a Sogdian father and a Uyghur Turk mother, provides a compelling reason to consider the An Lushan Rebellion not just a political rupture in Tang China but a key event in the history of the Silk Roads, of which cosmopolitan Tang China was a part. The ethnic group known as the Hu hailed from Central Asia, including Sogdians, whose descendants no longer exist. For a more detailed account of the historical roots of multiethnic Tang China and the significance of the An Lushan Rebellion in Tang identity formation, see Chamney.

2. The earliest record of the arrival of Bai Juyi's poetry in Japan is thought to be 838 in Dazaifu, a major portal to the Asian continent, when a copy of *Poetry and Prose* by Yuan Zhen and Bai Juyi was included in a shipment from Tang China (Smits 170). By the mid-ninth century, Bai's poetry had become extremely popular among Heian aristocrats. The channels and modes through which his poetry was transmitted to Japan are varied and complex. Initial transmissions were likely to have been done orally, and some individual poems were introduced piece by piece before the manuscripts of his collections came to be known in Japan. As was the case with other forms of cultural transmission, Bai Juyi's poetry reached Japan through Korea, and some of the Japanese monks and scholars who studied in Tang China brought it back when they returned. For instance, the monk Egaku (active 835–864) is known to have brought with him the *Collected Works of Bai* (*Hakushi monju*). Sei Shōnagon (ca. tenth–eleventh century), author of the celebrated *The Pillow Book*, mentions this work specifically as a superior collection. The daughter of Sugawara no Takasue, the author of *The Sarashina Diary* (mid-eleventh century) and an ardent reader of *Genji monogatari*, mentions having received a copy of "Chōgonka" ("Chang hen ge") retold from the original one by Bai Juyi (Sugawara no Takasue 24–25). Such textual records attest to the sustained popularity of Bai's poetry and "Chang hen ge" in particular in Heian Japan.

3. Atsuko Sakaki points out that a greater degree of variation from the original narratives are introduced in *waka* (Japanese court poetry) and *wabun* (Japanese prose) than *kanshi* (Chinese poetry) and *kanbun* (Japanese prose written in Chinese). All five Chinese imperial consorts analyzed by Sakaki are based on Bai Juyi's poems: Wang Zhajun, Li Furen, Yang Guifei, Shangyag Baifaren, and Lingyuan Qie. The very fact that these Chinese imperial consorts became famous in Japan through Bai Juyi's poetry is another indicator of the popularity of this celebrated poet. For a fuller exploration of this topic, see Sakaki.

4. "Heartache" is one of the three poetic categories articulated by Bai Juyi, and "Chang hen ge" is considered to fall in this category. For a more detailed explanation of Bai's poetry style and its effect on the style of *kanshi* in the mid-Heian period, see Konishi 150–88.

5. Given the long history of heterogeneous and multifaceted religious practices in Tang China, the supernatural attributes and powers often associated with Daoist immortals might have been inflected with those associated with Zoroastrianism, for instance, which were introduced to and practiced in Tang China during the reign of Emperor Taizong (626–649). In fact, An Lushan was attributed with supernatural powers as all official Chinese accounts of his birth speak of his divine origin. He was thought to have been the result of immaculate conception (Chamney 20) and was recorded to have performed some rituals with a Sogdian community of merchants (32).

6. Chamney, for one, argues for a new understanding of the An Lushan Rebellion as an outcome shaped by the escalated xenophobic tenor of Tang China rather than as the cause of the xenophobia, which then transformed the cosmopolitan Tang into the xenophobic Tang (Chamney 95–97).

7. I thank Sasha Vovin for his explanation about the likelihood of the term *maboroshi* being of foreign origin because a majority of Japanese native roots are usually composed of two syllables. Therefore, words with more syllables are likely to be some kind of a compound. Although it is beyond the scope of this work to trace the precise etymological development of this term in Japanese cultural history, it suffices to note that by 1081, there are several attestations of the phonetic spelling of *maboroshi* in Heian texts, indicating that this term was then in circulation. Personal communication, 15–17 July 2010.

8. Even though the phrase "Silk Roads" does not appear in *The Tale of Genji*, the term *kara*, which is most closely associated with China, designates faraway places outside Japan. Japan's intimate connections with the culture of the Silk Roads are best illustrated by a plethora of treasures safeguarded in the Shōsōin, built as the primary repository of the Tōdai-ji, a chief Buddhist temple in the capital Nara during the eighth century. This repository still houses around 9,000 precious items (blue glass cup, lacquered ewer, textiles, musical instruments, furniture, mirrors, and more) that traveled all the way from the Eastern Roman Empire, Sassanian Persia, India, and China. For more detailed information about the Shōsōin, see *Guide to Shōsōin Research*.

9. All English translations of Genji monogatari cited in this study are from Royall Tyler's 2001 translation of *The Tale of Genji*. All literal English translations of key passages from the original work included in this study are by the author.

10. One of the ways of composing *waka* based on Chinese poetry is to take one line of a Chinese poem and "translate" it into a *waka* of thirty-one *morae* in Japanese. *Waka* composed in such a manner is known as verse-topic *waka* (*kudaishi*). A "screen *waka*" (*byōbu waka*) is another way, where poems are composed on a topic depicted on a screen. Lady Ise, who is mentioned in the passage cited, was a poet well versed in screen *waka*, and in a handful of her "Chang hen ge"–inspired *waka*, she assumed the poetic persona of Yang Guifei

and expressed her emotions. For more information about *waka* practice vis-à-vis Chinese poetry, see Konishi 188–99.

11. This is necessarily not the case with the same two terms in Chinese, *daoshi/fanshi* and *meng* (dream), even though they also appear together in "Chang hen ge."

12. In *Genji monogatari*, as in many other Heian and premodern narratives, dreams serve as a conduit between the living and the dead. In *Genji monogatari*, the souls of the departed, especially those with lingering regrets, or those who have concerns for the safety of those left behind, appear through spirit possession and dreams. In this *monogatari*, Lady Rokujō, a high-born lady neglected by Genji, is arguably one of the most memorable characters for spirit-possessing Genji's ladies multiple times while she was alive and then appearing in his dreams beyond her death. See chapters 4, 9, and 40, which include episodes of spirit possession by Lady Rokujō. Her spirit possession of Lady Aoi, Genji's principal wife, during her pregnancy is reimagined as a Nō play in the fourteenth century and remains one of the most important pieces in the Nō repertoire. For an extensive analysis of this play, see Brown 37–81.

13. Ukifune's self-perception as a nun in terms of her sartorial transformation is a complex topic that deserves a separate study. Her repeated comments on her sense of shame and her refusal to show her altered appearance to anyone who has known her former self should not be taken at face value, especially when Kaoru expresses a similar sense of shame, if not revulsion, even imagining her in her altered state. A related issue is whether she regrets her decision to take the tonsure. It is important to note that despite her initial discomfort with her changed appearance (particularly her hair), Ukifune does gradually find some degree of peace as expressed in this way: "She [Ukifune] cheered up a little now that she had at least done what she wished to do, exchanging pleasantries with his Reverence's sister and also playing Go. She was attentive to her devotions and quite apart from the Lotus Sutra read a great many other scriptures as well. Still in the season of deep snows, when no one came to the house at all, she found very little to lighten her mood" (Murasaki, *Tale* 1105). Ukifune's depressed mood during the hard winter months in this village is not unique to her, as it is commonly experienced by others in similar situations. What is of note is a sense of the routines established in her life as a nun and the unprecedented degree to which she has been able to avail herself socially. This is suddenly disrupted with the intrusion of Kaoru's wishes to discover her in her Buddhist retreat.

14. Far beyond *Genji monogatari*, the figure of Yang Guifei has continued to inspire generations of cultural producers in Japan. Further transformations and depictions of the life of Yang Guifei include the Nō play *Yōkihi* (ca. fifteenth century) by Komparu Zenchiku and the puppet play *Yōkihi monogatari* (ca. seventeenth century). Wai-Ming Ng succinctly captures the wide reach of Yang Guifei in the Japanese cultural imagination, when he states: "In Japan,

Yang Guifei was like a heroine with a thousand faces, presented as a Chinese court lady, a Japanese deity, a Buddhist bodhisattva, an immortal, a politician, a political refugee, and an assassin. At first glance, the legend of Yang Guifei in Japan sounds implausible, but it is very rich in historical meaning, and provides a good example demonstrating how imported Chinese traditions were localized in Japan" (43). See also Graham's earlier scholarship (*Yang* and "Consort") on the Yang Guifei legends in Japan.

Works Cited

Brown, Steven T. *Theatricalities of Power: The Cultural Politics of Noh*. Stanford UP, 2001.

Chamney, Lee. *The An Shi Rebellion and Rejection of the Other in Tang China, 618–763*. 2012. University of Alberta, Edmonton, MA thesis. https://era. library.ualberta.ca/items/d0d042f4-42df-407d-add7-567543d720a1.

Graham, Masako Nakagawa. *The Yang Kuei-Fei Legend in Japanese Literature*. Japanese Series vol. 6. Edwin Mellen P, 1998.

———. "The Consort and the Warrior: Yokihi Monogatari." *Monumenta Nipponica*, vol. 45, no. 1, 1990, pp. 1–26.

Guide to Shōsōin Research. Trustees of Princeton University, 2022, https://shosoin. princeton.edu. Accessed July 1, 2010.

Komparu Zenchiku. *Yōkihi (Imperial Consort Yang)*. Caliber Cast and The Noh. com Editorial Department, 2017. http://www.the-noh.com/en/plays/data/ program_083.html. Accessed 15 July 2020.

Konishi, Jin'ichi. *A History of Japanese Literature: The Early Middle Ages*. Translated by Aileen Gatten, edited by Earl Miner. Princeton UP, 1986.

Murasaki Shikibu. *Genji monogatari*. Japanese Text Initiative, University of Virginia Library, 1999. http://jti.lib.virginia.edu/japanese/genji/original.html. Accessed 15 June 2020.

———. *The Tale of Genji*. Translated by Royall Tyler. New York: Viking, 2001.

Ng, Wai-Ming. *Imagining China in Tokugawa Japan: Legends, Classics, and Historical Terms*. SUNY P, 2019.

Sakaki, Atsuko. "Archetypes Unbound: Domestication of the Five Chinese Imperial Consorts." *Proceedings of the Association for Japanese Literary Studies*, vol. 2, 2001, pp. 85–100.

Sei Shōnagon. *The Pillow Book*. Translated by Meredith McKinney. Penguin Classics, 2007.

Smits, Ivo. "Reading the New Ballads: Late Heian *Kanshi* Poets and Bo Juyi." Edited by Stanca Scholz-Cionca. Wolfram Naumann zum 65, Geburtstag. Otto Harrassowitz, 1997.

Sugawara no Takasue no Musume. *The Sarashina Diary*. In *Diaries of Court Ladies of Old Japan*. Translated by Annie Shepley Omori and Kochi Doi. Houghton Mifflin, 1920.

Chapter 4

Women Generals and Martial Maidens
China's Warrior Women in History, Literature, and Film

CHERYL C. D. HUGHES

Warrior women of China do not conform to the unfortunate and erroneous Western stereotype of the Chinese woman as meek, mild, and obedient; they are instead seductive, wily, and dangerous. These women take their place alongside men as their equal or even superior in terms of martial skills and accomplishment. They cross the traditional female boundaries of home and family to establish new possibilities and identities for themselves and others.

China has a long history of telling stories about remarkable women, from the great historian Sima Qian of the Western Han dynasty (206 BCE–24 CE) up into the mass-produced collected biographies of remarkable women and court beauties of the Qing dynasty (1644–1911). Even Mao celebrated the warrior women of his revolution and delighted in the opera, ballet, and film *The Red Detachment of Women*. But what the scholar finds is that fact and fiction can be intertwined in Chinese culture. The categories of reality and myth may be confused in Chinese history, literature, and film. This chapter provides examples of some of the most astonishing women as they have come down in Chinese history, literature, and film and attempt to draw a clearer line between the real or diegetic worlds of Chinese martial women.

Different types of women warriors have emerged over hundreds of years of Chinese history. Royal women, like Queen Fu Hao of the Shang dynasty (1600–1066 BCE), fought for their husbands and directly commanded imperial troops. Courtesans, like Liang Hongyu, married and became generals (1102–1153) of the Song dynasty (960–1279). Several dutiful daughters and wives like the "Women Generals of the House of Yang" and the military tactician Mu Guiying also appear in the Song dynasty. The peasant Feng Shuyan (1919–2005) became an officer in Mao's Red Army and lived as an honored soldier into the twenty-first century.

Women warriors are individually unique but not an uncommon phenomenon in the history of ancient China and in the present day. One woman warrior in ancient China for whom there is ample material evidence is Fu Hao (d. ca. 1200 BCE) of the Shang dynasty, one of the wives or consorts of King Wu Ding, the twenty-first king of the Shang. She is the "earliest known woman warrior in the world" (Michigan Shaolin Wugong Temple). Her military prowess can be known with some certainty by the grave goods in her completely intact tomb in Anyang, Henan Province, excavated in 1979. In Shang-era oracle bone inscriptions, Fu Hao is described explicitly as a military general and a priestess who oversaw religious rituals, but despite the many legends about her martial exploits, by the early part of the twentieth century the historicity of Fu Hao was in great doubt until the unearthing of her tomb (Buckley). The more than 1,500 objects in her tomb indicate a soldier of renown. Among these were ninety daggers and dozens of arrowheads, long-range bows, sabers, long bladed-swords, short swords, helmets, shields, and pikes—all weapons with which she would have been adept (Ebrey 26–27). Most impressively, her tomb also contained four battle axes, which were efficient weapons and indicated the highest military distinction (Childs-Johnson 21).

Fu Hao earned her military prominence by leading an army of 13,000 men to defeat the barbarians crossing into Shang territories. She commanded two successful campaigns in the north before her husband deployed her to deal with the Yifang on the southwest. In her fourth campaign, she fought successfully alongside Wu Ding against the Bafang. She died not long after this final deployment, and the king was so despondent over the loss of his queen-consort that he gave her a military funeral and buried her with sixteen slaves to serve her in the next life (Ebrey 27). Perhaps her four battle axes were to commemorate her four successful military campaigns.

Grave goods and written records are often able to substantiate the historical reality of warrior women in China. Indeed, women make up a number of the soldiers in the terra cotta armies in the graves of various Chinese emperors. More recent than Fu Hao was Shang Yang (390–338 BCE), who addressed in his book, *The Book of Lord Shang*, the best way to deploy troops. He recommended, "The strong men were to serve as the first line of defense against the enemy, the strong women defend the forts and build traps, and the 'weak' soldiers [of both sexes] control the supply chain" (250–52). Such writings make it clear that women routinely served in the armies.

Medieval China also had its martial female warriors. "The medieval Chinese are known to be heavily patriarchal, but even such a culture produced many formidable women warriors. . . . Daughters of prominent military families trained in the martial arts. Wives of generals were often chosen for their battle skills" (Khoo 1). One woman warrior of the Song dynasty was Liang Hongyu, the daughter and granddaughter of Song generals, born in today's Anhui Province ("General Liang Hongyu"). Although talented in music and dance, Liang Hongyu was trained in the martial arts by her father (Peterson 273). Her father's failure in battle brought about his execution, plunging the family into destitution. After the fall of her father and the incursions on the border by the Jin, the family moved south with the imperial court. Liang Hongyu became an entertainer for the troops, perhaps even a prostitute. In 1121 she married Han Shizhong, a field officer in the emperor's service, and together they became a formidable team. She was the tactician who directed the efforts and movements of her husband and his troops through the clever use of drums and signal flags. Liang Hongyu and her husband were able to blockade the Jin forces, which outnumbered the emperor's forces by a factor of twelve. Unfortunately, after a month and a half of being held back, the Jin troops and ships broke free with the aid of treachery and superior numbers. The victory Liang Hongyu and Han Shizhong had won turned into defeat as the Jin escaped. Nonetheless, because of her bravery and ingenious use of drums and flags, Liang Hongyu, with her perhaps unsavory past, became a national heroine. She is always depicted as a beautiful, slender woman with the elaborate coiffure and costume of an entertainer, but with a weapon in hand or a drum before her. Her drums were meant to build up the morale and martial spirit of the soldiers, as well as direct troop movements.[1]

Another instance of military women is found in the Yang family. "No group of women in Chinese history has commanded so much prestige and respect as the ladies of the Yang family. They are revered as great patriots who were willing to lay down their lives for the sake of their country" (Cai 149). There is evidence of a military family by the name of Yang from the Song period in the remains of two temples dedicated to the family of General Yang Ye. The ancestral temple in Lutijian village contains images of not only Yang Ye and his wife but also his twenty-two children. Scholar Ouyang Xiu noted a tombstone carving that referenced the Yang family. "Father and son were famous generals" (Idema and West, xii). The Song dynasty was in constant battle with the Khitan Liao dynasty (907–1125). The Liao recruited a Song adviser who developed the Heavenly Gate, a military maneuver of seventy-two moves that was supposed to be invincible. The Liao taunted the Song with a challenge to defeat the Heavenly Gate within 100 days or withdraw from their newly conquered territories in the north. Through treachery at the Song Court and fierce fighting on the battlefield, five of the eight Yang family generals were killed, one was captured, and one fled the battlefield for a monastery; the final surviving Yang general was Yang Yanzhao. The women of the family, including his mother, wife, two sisters, and three of his brothers' widows joined him in the rest of the campaign. It is this group of women warriors whom Mu Guiying joined after marrying into the family. According to Sue Wiles, Mu Guiying is generally considered to be a character of legend (342); nonetheless, she has captured the imagination of generations of Chinese men and women. In the late 1950s and early 1960s, there was an all-female Mu Guiying brigade in the Jiangnan region of China.

According to her legend, Mu Guiying was the daughter of the man who had devised the Heavenly Gate and thus she held the secret to unlocking it. Yang Yanzhao sent his young teenage son to locate her and bring her back. Fact and/or fiction maintain that Mu Guiying challenged the young man to a series of sword duels, and should he lose, he was required to marry her ("Mu Guiying"). He lost three duels and became a willing bridegroom. However, she was reluctant to leave her mountain home, and he returned to his father without her. His father ordered his execution for failing in his assigned duty. When Mu Guiying came to her husband's rescue, General Yang demanded the solution to the Heavenly Gate. He gave her troops whom she led out to burn and destroy the food supplies for the Liao army; she then attacked the Liao base camp

after starving the Khitans for several weeks. As a reward, she was made a general in the Song army. Another legend has her giving birth during some subsequent battle (Song).

While earlier women generals who led male soldiers into battle tended to be aristocratic women, Hong Xuanjiao was a peasant from the province of Guandong and one of several female military leaders to command all-female battalions during the Taiping Rebellion (1850–1864) (Mao 71). She was the sister of Hong Xiuquan, the leader of the Taiping Heavenly Kingdom and the self-proclaimed younger brother of Jesus Christ, and the consort of Xiao Chaogui, king of the West Taiping held territories. The rebellion was both religious and nationalistic. Hong Xiuquan hoped to spread a syncretic Chinese Christianity and drive the Manchu, non-Chinese Qing dynasty out of power. As the sister of the rebellion's leader and the wife of another important rebel leader, Hong Xuanjiao was at the center of planning and executing the rebellion. Her greatest victories were at Crowing Cock Mountain and Niubailing. Eye-witnesses describe her as

> a stunning beauty, of no more than thirty. . . . She was extra-ordinarily valiant and had hundreds of women under her command. . . . During battle she wore light makeup and was armed with a pair of twin swords which were so sharp the edges resembled sparkling ice. She rode a chestnut horse saddled with a woolen blanket. She was slender with a light complexion. . . . She was a magnificent sight, often taken for an immortal as she waved her white arms to direct her women soldiers, jade trinkets tinkling at her waist. . . . Her swordsmanship mesmerized the whole army. (Mao 72)

After the fall of the rebellion, Hong Xuanjiao completely disappeared from history. Hong Xuanjiao, as a rebel, was nearly unique among women warriors whose battle exploits are celebrated in China. While there were a few stories of rebel or outlaw women, most of the tales about women warriors in China are of aristocratic women who fought for the dynasty in loyalty to the emperor. They lived virtuous lives dedicated to loyalty to the emperor and piety toward fathers, husbands, sons, and brothers. The values of the warrior women of China—loyalty, piety, and excellence—are common, but their deeds are most uncommon; this remains true for the warrior women of history as well as those of literary heritage.

Mulan is one of those persons of popular Chinese culture whose historicity cannot be proven or disproven, despite various towns claiming to be her birthplace and displaying her tomb. Some scholars place her in the Han dynasty (208 BCE–220 CE). Unlike the women discussed already, Hua Mulan concealed her gender by cutting or hiding her hair and dressing in men's clothing. Mulan first came to the West in Maxine Hong Kingston's 1976 memoir, *The Woman Warrior*, but she first entered the written record in "The Ballad of Mulan," in approximately 568 CE, in a collection of poems meant to be recited to musical accompaniment in the *Musical Records Old and New*, written by Zhi Jiang of the southern Chen dynasty (557–589 CE). From an oral folk tale, the recorded ballad has a mere 300 words and gives the barest of outlines that remains essentially constant throughout retellings over the centuries and across genres. The Zhi Jiang volume is lost today, and the most distant extant record of the Mulan ballad was collected during the Song dynasty by Guo Maoquin in *Collection of Music-Bureau Poems*. However, Guo cited the sixth-century record as his source for the ballad. Guo inserted another Mulan poem immediately after the original. Its author was a Tang dynasty (618–906 CE) court official, Wei Yuanfu. Most authorities agree that the ballad originated in the fifth or sixth century at a time when the Northern Wei (386–534/5) were constantly at war. It tells the tale of a young woman who took her aged father's place in the conscription of soldiers. She rode off in disguise as a young man to serve in the Wei army for twelve years, fighting invading barbarians. "There have even been efforts to identify the military event in the poem with the famous battle in which Emperor Taiwu of the Northern Wei defeated the invading Rouran army in 429 (CE)" (Feng 231). The emperor learned of her valor and martial skill and asked her to come to court so he could reward her. When asked what she would like as a reward, she asked for a swift horse to take her home to her family, where she resumed her place as a dutiful daughter.

Mulan grew so popular that the subject of the sixty-two-line poem became the inspiration for great literary output, including a novel by Zhang Shaoxian written during the Ming dynasty (1368–1644 CE) and a play by the great Ming painter, poet, and dramatist Xu Wei, titled "The Heroine Mulan Goes to War in Her Father's Place." By then, the earlier Mulan of unknown ethnic background and heritage had become a fully Han Chinese maiden with firm Confucian values and anachronistically bound feet. Mulan is also the subject of contemporary Chinese opera and ballet, as well as several memorable films. Thus, as Mulan moved from

history, to legend, to literature, to stage, and ultimately to film, her story became more and more embellished along the way.

Mulan's march through the arts is an appropriate place to begin discussion of the literary warrior women of China, because whether her existence was material or mythological, the modern audience meets Mulan in her diegetic space. This narrative space allows for tremendous expansion of the Mulan story and, on occasion, its telescoping down, as in the 1998 animated Disney version. Twenty-two years later, Disney Studios released a live-action version of Mulan. It introduced a new generation of little girls to the amazing story. The original sixth-century poem portrays Mulan as a somewhat dreamy girl who is lackadaisical in her household duty. As the poem opens, she is supposed to be weaving at the loom, yet "you don't hear the shuttle's sound, you hear only Daughter's sighs." Even so, she is a faithful daughter to her aged father who has no grown son to take his place in the conscription lists. She buys herself a spirited horse, a bridle, a saddle, and a long whip, which she takes on her 10,000-mile "business of war." She returns after twelve years, her hair a cloud, white from the stress and strain of her soldier's life. Once home, she "take[s] off [her] wartime gown and put[s] on [her] old-time clothes." She does her make-up and goes out to greet her comrades, who are "amazed and perplexed. Traveling together for twelve years, they did not know Mulan was a girl." How could they, after all: "The he-hare's feet go hop and skip, the she-hare's eyes are muddled and fuddled. Two hares running side by side close to the ground, how can they tell if I am he or she" (Feng 235). This is the Mulan of the original poem. Under Tang writer Xu Wei, Mulan, in addition to her filial piety, became an exemplar of Confucian loyalty to the throne. Her Tang tale is told in the third person and ends not with the image of the rabbits running side by side, but as follows:

> How laudable is Mulan's virtuous integrity,
> Serving as a model of the monarch's subjects.
> Her unswerving loyalty and filial devotion
> Will be remembered even after thousands of years. (Feng 234)

Her virtuous integrity is an important factor in Mulan's tale. Zhang Shaoxian writes of her, "Fighting outside the Great Wall for twelve years and while doing so she has not only remained loyal and filial, but she has managed to return with her chastity intact. For all these reasons, Mulan can truly be considered the foremost hero among women. Thereupon, she

was given the title 'chaste and filial lady of first rank'" (S. Zhang 126). Although Mulan may transgress social norms in defense of the kingdom, she must remain sexually unsullied to serve as a role model for young women. She may be an unconventional role model, but as a role model, she must remain conventional in important socially reinforcing ways.

Xu's Mulan gains a family name, Hua, and her military exploits, especially her successful campaign against the bandits led by Leopard Skin of Black Mountain, become more central. Xu asserts "that women warriors, often stronger than men, 'can stand upright on their two legs between heaven and earth'" (Feng 234) He provides one scene where Mulan unbinds her feet, which had a "phoenix-head point, and puts on her soldier's boots that made of her foot a "floating barge" (Mann 847). In the story she worries about unbinding her feet and how that might affect her later matrimonial prospects. Xu describes Mulan as "about seventeen or eighteen years old, having a charming face with her hair decorated with flowery combs" (qtd. in Dong 40). It is clear that "[b]eing heroic does not undermine Mulan's femineity" (Dong 69). Dong makes it clear to point out that Mulan's female conventionality (her flowery hair ornaments) is on display alongside her more transgressive unconventionality (her soldier's boots).

In Zhang's novel, the bandits become an organized army of rebels against the throne, making their defeat by Mulan a politically important event. In Feng's view, this puts Mulan on the side of divine order against the forces of chaos (Feng 235). So zealous is she for the emperor's cause, Mulan attempts to win over a woman from the rebel forces by proposing to arrange for her safety and security by wedding her to Mulan's own betrothed.

In an anonymous 1732 Qing novel, *The Legendary Story of a Girl Who Is Loyal, Filial, Heroic, and Chaste*, Mulan becomes a Han Chinese serving Emperor Taizong (627–649). Unable to take care of her aged parents in filial piety and serve the emperor at his court by royal command, she kills herself. She requests that her body be buried in her family tomb with her parents, but that her heart be taken to the emperor as a mark of her devotion. "The message that this pathetic ending conveys is that only in death can the 'Confucian' Mulan preserve her integrity as an obedient daughter, loyal subject, and chaste virgin" (Feng 236). As Dong Lan puts it, "Mulan's tale, despite its journey across time, geography, and cultures, continues to be about a young woman's transgression. The meaning of the story, however, varies in relation to the historical and cultural

context in which it is retold and through its plot and moral import are reshaped" (1). For instance, Mulan in the tale from China of the 1930s is fighting Japanese aggression, yet the basic outline of the original ballad is maintained. "In the twentieth century [Chinese] propaganda for gender equality Mulan was lauded as the model woman 'who holds up half the sky'" (Dong 85). In Kingston's retelling, written in California of the 1970s, Mulan displays her feminist female agency as she pursues a personal justice and revenge and becomes an inspiration to the women characters of the novel's present day.[2]

The story of the Maiden of Yueh, or Lady Yueh, takes place during the Spring and Autumn Period (770–476 BCE) of the Zhou dynasty (1045–256 BCE) and contains no cross-dressing, as in the Mulan legends. Lady Yueh lived in the southern forests when King Goujian wanted to wage a war of retaliation against a neighboring state of the Wu. Goujian realized that his army was not trained well enough to defeat the opposing army with its superior strength and skill, but then his military adviser told him about a woman from his kingdom who had extraordinary skill with a sword. When brought before the king, who asked her who had taught her the skill of sword fighting, she replied that no one had taught her. This story is an example of the supernatural at work in the tales of women warriors and lady knights errant, or *nuxia*. *Wuxia* is a term made from two Chinese characters: *wu* pertains to martial arts, war, and military skills; *xia* is a chivalrous person, a knight. A chivalrous male skilled in the martial arts is usually referred to as a *wuxia* or simply a *xia*. A female knight errant is a *nuxia*. *Wuxia* is also a genre of fiction and film that features martial arts, chivalry, magic, and romance, with both male and female characters.

The Lady of Yueh's skill comes from nowhere, other than from in herself, being innate and even possibly divine. She teaches the officers of Goujian's army, who in turn trained their soldiers, how successfully to fight superior numbers. "The way of fighting . . . is to strengthen one's inner spirit while remaining outwardly calm and well mannered" (qtd. in L. Lee 91).[3]

Lady Yueh's exploits become enlarged as she moves through Chinese literature. By the time she became the subject of the modern master of the *wuxia* genre, Jin Yong (Louis Cha, fl. 1955–1972), she gains a name, Ah Ching (A'qing) and a mentor in the form of Grandpa White, a white ape. The white ape teaches her how to "play" with the bamboo stick with which she easily defeats eight expert swordsmen of Wu. She

also credits her manipulation of the *yin* and *yang* energy as an important factor in her ability to defeat her foes (L. Lee 91). The swordsmen had just come from a tournament where they killed the eight best swordsmen of the king of Yueh. They are invincible until they meet the goatherd girl from the mountain forest who defeats them. She goes on to defeat eighty more swordsmen, but in doing so teaches them how to fight so that when they meet the troops of Wu, "Yueh swords flashed and the Wu army was shattered." Jin ended his short story with this: "As for the Yueh Maiden, she never existed in real history. She always existed in the land of legends and there, presumably, she roams still. Doubtlessly she has performed many great deeds there, deeds which will remain unknown until some scribe comes and tells the tales as they deserve to be told."

The ancient story of the maiden of Yueh continues to provide grist for books, TV series, and movies as she has been reinvented and reinterpreted throughout the years. A sword known as the Sword of the King of Yueh was excavated from a tomb in Hubei in 1965, so legends and history perhaps come together. The sword figures in the 2006 film *The Banquet* (dir. Xiaogang Feng), loosely based on Shakespeare's *Hamlet*.

The story of "The Mysterious Girl of the Nie Family" is an excellent example of China's dangerous *nuxia* women. When Li Fang (925–996 CE) collected pre-Song fiction into the *Taiping Guanji* (*Extensive Gleanings of the Reign of Great Tranquility*), he included twenty-four accounts of knight errantry in four chapters. Seven accounts feature female protagonists, one of whom is Nie Yinniang, whose name means "Dark Lady" (Hsieh 149).

> These seven chivalrous ladies are unique characters in Chinese literature. Some of them can jump many feet high and walk on the walls like flying birds; some wield swords and daggers and are equipped with martial skills that allow them to come and go without being noticed. They are also physically stronger than ordinary men and financially independent and they are free to determine their own marriages. They work furtively at night, and they are described as enigmatic warriors who operate along according to their own rules of justice. (J. Liu 91)

The exploits of Nie Yinniang and the other lady knights errant, *nuxia*, differ from the women generals and soldiers related already, as *nuxia* usually do their work alone; they do not lead armies into battle. Their motivation is not generally patriotism but an adherence to a code of

justice that balances retribution and vengeance against evildoers with reciprocity for favors or good deeds, with honor as its highest ideal. The story of Yinniang of the Nie family is most authoritatively attributed to Pei Xing (825–880 CE) of the Tang dynasty, written when romance and gallantry began to be mixed more popularly. Written in the form of a biography, it tells the tale of the daughter of General Nie ("Nie Yinniang: Matriarch of Wuxia"). Kidnapped as a ten-year-old by a Buddhist nun, she was taken to a mountain cave in an "otherworldly" place with only wild beasts and monkeys for company. She was kept there for five years, during which the nun trained her in the martial arts to become an assassin of evil men. Given a magic pill or potion, she learns to fly and fence with superhuman skill. Without explanation for her release, the fifteen-year-old Yinniang returns to her family, where she ostensibly settles down and chooses a husband who is a simple mirror maker. Together, the husband and wife enter the service of a warlord. To demonstrate her stealthy skills as an assassin, Yinniang creeps into the opposing warlord's tent while he is sleeping and leaves a lock of her hair tied in a ribbon on his pillow, proving that she could easily have killed him. When she perceives that the local warlord is dishonorable, she switches her allegiance to another warlord whom she admires for his wisdom and integrity. She saves him from two assassination attempts and resorts to magic to save him another time when she is confronted with a swordsman of superior skill. She later retreats to the mountains, perhaps to her earlier cave, to pass on her skills to other young women. Magic is an important component of the Nie Yinniang tale. Much of the supernatural found in her story, such as physical transformations, ways of hiding weapons, and the knowledge of occult substances show up in other tales in China's literary history.

In the Yuan dynasty (1271–1368 CE) retelling of her tale, Nie Yinniang's motivation is made even less transparent than in the original short story. The anonymous author introduced doubt into her usual obedience to the point of her equivocating about an assignment to assassinate her lord's rival: "I thought my immortal teacher had actually handed down this sword skill to me in order to decapitate evildoers and punish tyrants. How can I abuse it now by turning it against an innocent one? But since I have received [my lord's] kindness I am not in a position to refuse this order" (Altenburger 77). In another version of the story, You Tong (1618–1704 CE), in his early Qing (1644–1911 CE) play, has the Buddhist nun give Yinniang a riddle to guide her when making decisions at critical points in her future: unite when you come across a

mirror; stay when you come across a magpie; hide when you come across a hole; and join when you come across an ape (Altenburger 77). The mirror foreshadows her marriage; the magpie saves her from continuing to serve an unwise warlord. She hides to overcome the expert assassin sent to kill her new lord. The reference to the ape in the riddle points to Yinniang's eventual return to the magic realm of the cave, where the apes and monkeys live, there to reunite with her fellow swordswomen.

Nie Yinniang and her tale return time and again throughout the dynasties with differing variants. She was portrayed in the role of the Buddhist nun training other young girls in the art of swordsmanship. The 2015 film *The Assassin* tells Yinniang's tale in rich color and convoluted action. In every iteration and media, she is always an instrument of social justice. The tale "Hongxian," by Yuan Jiao, is a companion piece to Nie Yinniang and first collected in the Tang anthology *Ballads of Timely Rain*, by Yuan in 868 CE.[4]

The two tales are connected through their protagonists' amazing ability to penetrate the extreme defenses of a military camp and enter the tents of sleeping commanders; consequently, these *nuxia* had the men at their mercy and could easily have killed them. Yinnniang leaves on her warlord's pillow a lock of her hair tied in a red ribbon or thread. Hongxian, which translates as "red string," steals a golden casket from a sleeping lord to give it to the military governor she serves, Xie Song (Nienhauser 1:12). Before she leaves the enemy encampment, Hongxian gathers up the clothes and jewelry of the sleeping maids in a playful and comic tease. As Nienhauser comments, "Although she was a knight errant, she was also a young girl" and therefore given to play (1:15, n. 56). But unlike many other *nuxia*, Hongxian is "not said to be beautiful" (Allen 119). She is described as being a superior person, yet her physical attractiveness goes unremarked. Hongxian's lord, Governor Xie, returns to his rival the casket Hongxian had stolen to demonstrate "his power and generosity," causing the formerly rebellious commander to become Xie's vassal, realizing as he does that his life is in Xie's hands (Edwards 245, n. 41). With this success, Hongxian retires from Xie's service to prepare herself for her next life, where "I will cleanse and purify my single and unified vital spirit" (Cai 21), because, as she explains to Xie, she "was formerly a male healer who accidently killed a woman (and her unborn twins). . . . As a punishment, he was reborn as the serving girl Hongxian" (Edwards 245, n. 41). Like Nie Yinniang's tale, the story of Hongxian is reiterated and enlarged on in subsequent tales, most notably in Liang

Chenyu's (1519–1591) play "Hongxian Steals the Golden Box." It is notable to point out that in her former life, Hongxian was a man whose punishment for a misdeed was to be reborn as a woman (Nienhauser 1:20). To be a woman was punishment in itself.

Perhaps the most disturbing tale of dangerous women in ancient China is the Tang dynasty revenge story of the wife or concubine of Cui Shensi, of which there are at least two other renditions, "Guren qi" and "Yi Ji." The female assassins in these tales remain nameless as they become the wife or concubine of a merchant, scholar, or neighbor. What remains constant in the tales is that Cui Shensi eventually finds his unnamed wife coming over the wall one night with a man's head in her hand. She explains that her father suffered a grievous injustice and was executed by a corrupt official. She goes on the say that she has waited years to be able to avenge her father, and now that she has done so, she must leave Cui Shensi and her son. Before she leaves, she goes into the house to say goodbye to her son; later, the dumbstruck father he finds that she has slit the child's throat. There seems to be some consensus that "Yi Ji" was the model for "Cui Shensi" and that "Guren qi" was based on "Cui Shensi," all of which tell essentially the same story with few alterations (Altenburger 84). It is the infanticide that is so disturbing in these iterations. Yet it is her Buddhist-like detachment that marks this knight errant, avenging swordswomen, and her dedication to family honor is what make her so noble. Nienhauser notes that the noble goal of the wife of Cui Shensi leads to her "unwomanly behavior" in killing her children (2:307). She can "act against the nature of the female sex and gender, that is, against biological and cultural determination," according to Altenburger (93). She kills her son perhaps to save him from a life of cruel discrimination as the child of a murderous mother, but Allen quotes the narrative to establish that "she has killed her son to cut off her [maternal] longing [for him]; in this none of the knights-errant of antiquity can surpass her" (118). Although she may act against maternal instincts, she acts in accord with the Confucian virtue of filial piety and the mores of a *nuxia* to avenge her family's honor. "However, given her relentless resolution for which such knights-errant as she were known, Cui Shensi's wife may very well have killed herself once she had avenged her father's murder" (N. Liu 46). If true, her suicide would be similar to that of the Confucian Mulan in the later popular Qing novel, *The Legendary Story of a Girl Who Is Loyal, Filial, Heroic, and Chaste*, as a woman torn between two equal and competing values—motherhood and filial piety

in the case of Cui Shensi's wife. What one sees in these tales is that "Female xia . . . have an aura of mystery and cruelty that far surpasses that found in stories of male xia; qualities that are only barely tempered by virtue and correctness of motives" (Hsieh 150).

The Thirteenth Sister, Shisanmei, in *The Tale of Heroes and Lovers*, by Wen Kang (1891–1962 CE) in the late Qing period (1644–1911), is one of the more fascinating characters in any Chinese novel.[5] She is another avenging daughter whose father was ruined by an evildoing general. Christopher Hamm points out that the story of Shisanmei not only has several literary adaptations but was also a popular operatic performance during the Republican period (1912–1949). More recently her tale has taken to television serializations, films, and comic books. For the communist era (1949–present), Shisanmei became the patriotic embodiment of the maiden who joined her peasant comrades in the mountains to fight against the Manchu invaders. Even the Japanese have taken her on as a manga heroine of exemplary feminine beauty, chastity, bravery, righteousness, and consummate martial skill (Hamm 335).

Because she had no brothers, her father brought her up as a boy and taught her martial skills. Her feminine training was not neglected but was taught to her by her mother. In a reference and contradistinction to the Tang tales of female *xia*, Shisanmei relates that she did not have to go to the mountains to learn her skill and neither did she learn it from a nun.

In the first third of Wen Kang's forty-four-chapter novel, Shisanmei is the main character of action. One of her most famous exploits is her rescue of the male protagonist, An Ji, from the depraved bandits disguised as monks at the Nengren temple, just as they are preparing to slit him from neck to groin. An Ji swoons, and only comes to after a red knight has slain all ten of the bandits. He is shocked to find out that his rescuer is a lovely young woman. Together they discover several captive women locked in a chamber. Shisanmei, who is actually He Yufeng, convinces An Ji to marry one of the women, Zhang Jinfeng, so that they may travel together in propriety. In the middle of a story featuring a transgressive female character, other social norms still need to be maintained. An Ji is from a Manchu bannerman's family, and the two women of the novel are lovely Han Chinese with bound feet, inappropriate consorts for Manchus, but nonetheless temptingly exotic to the Manchu bannerman. They cannot travel together unless An Ji and Zhang Jinfeng are married. According to Nienhauser, Chinese heroines were "usually presented to the readers with a description of their stunning beauty" (1:3, n. 8). Shisanmei may

be a swordswoman, but she has lost none of her feminine appeal, as she "[wears] a pair of embroidered pointed shoes, the size of which was not even three *cun*" (Altenburger 257). However, this reading is not necessarily proof of bound feet, as a servant later comments that He Yufeng's feet are naturally small. It would certainly be difficult (if not impossible) to accomplish her many daring deeds tottering on bound feet. She is able to cover great distances and perform martial feats of supernatural quality. In the latter half of the novel, He Yufeng is convinced to marry An Ji as his second wife and settle into a conventional life. In this way the *nuxia* is domesticated and the world of chaos that she represents as a transgressor of borders and a woman warrior is set right in the end and Confucian harmony reigns. This type of ending is common in the tales of female knights errant, though perhaps not particularly satisfying to twenty-first-century women.[6] The male figures in these stories, like An Ji, "are often weak and frightened figures" (Hsieh 150). On must wonder if tales of heroines "who defeat an ambitious military commissioner or praising another as a kind of moral example for society may have been meant as an indirect comment on the state of men and society" (Hsieh 150). Wiles asserts that "there can be little doubt that in the traditional mind (the leadership and prowess of these warrior women) have always been a temporary arrangement until, in the fulness of time, women resume their rightful place under the leadership of men" (343).[7]

In his analysis of the tale of Shisanmei, James Liu is very critical of the transformation of Shisanmei the swordswoman into He Yufeng the wife, a woman under the leadership of her man. "(Thirteenth sister) is a remarkable character full of noble and stern virtues of chivalry, but as (He Yufeng), especially after her marriage, she is hardly recognizable as the same person" (129). Author Wen Kang defends his drawing of the character: "One can attain a long-lasting romantic disposition only after one has been endowed with the supreme skills of a hero; one is ready to carry out a heroic career only after one has experienced the genuine feelings of love" (qtd. in Liu 157). Wen may support his lame ending, but it is the clever, skillful, and daring Shisanmei who is the heroine of television and filmed versions of her exploits, not the domesticated He Yufeng.

In translating the tales of women warriors to the screen, they lose nothing of their martial fascination and gain a great deal in visual appeal. The actresses are unfailingly beautiful, and many of them are trained in ballet, making their swordfights into choreographed balletic dances of

death. The Disney animated movie *Mulan* maintains only the outline of the tale and adds a pet dragon and a lucky cricket. Mulan sings and dances her way through the film as well as defeating the invading Huns and saving the emperor. In the Disney 2005 sequel, *Mulan II*, Mulan is domesticated by her marriage to General Li Shang, but only after one more successful campaign. Disney's animated Mulan was the image of a Chinese woman warrior most known to American film audiences until *Crouching Dragon, Hidden Tiger* became popular. *Crouching Dragon, Hidden Tiger* is a convoluted story based on the fourth novel of the Crane Iron pentalogy by Wang Dulu.[8] The Ang Lee 2000 film is beautifully photographed and stars not one but three beautiful and dangerous women: Michelle Yeoh plays Yu Shu Lien; Ziyi Zhang plays the treacherous Jen; and Cheng Pei-pei plays the assassin-thief Jade Fox. Some Western film critics found their flying over rooftops and through lush bamboo groves, running over water, and other amazing feats too farfetched to enjoy, but for others these were precisely the reasons the film was so appealing. There is a five-minute fight scene between Jen and Shu Lien where Jen wields a magical jade sword, Green Destiny, and Shu Lien must go through a dozen or more weapons to defend herself. Jen is more on the offensive than Shu Lien, but finally Shu Lien manages to get her broken sword at Jen's throat. Out of honor, Shu Lien takes her sword away, but then the devious Jen wounds her with a mortal poison. The fight is filmed from every angle in a small cave. The overhead shots are especially effective in demonstrating the choreographed acrobatics and skillfulness of the duel and the dance-like fluidity of the moves. In the film there are three *nuxia*, but only one of these is honorable and noble, Shu Lien. The other two are mere assassins and thieves. The wicked Jade Fox is killed, but Jen manages to regain her honor at the end when she commits suicide. Suicide is also the fate of the leading *nuxia* in *Hero*, a 2002 film by Zhang Yimou.

Hero is another beautifully photographed film based on the attempted assassination of the king of Qin (the first emperor of a unified China, 247–221 BCE), a popular film subject. In Zhang's film, there are five assassins: three men, Nameless, Long Sky, Broken Sword, and two women, Flying Snow and Moon. What may have seemed improbable in *Crouching Tiger* can now be established as a kind of visual hyperbole. This hyperbole is based on the written texts of ancient China, where heroes and heroines fly up walls and over rooftops and engage in single combat against far superior numbers. In *Hero*, Nameless and Flying Snow use

their swords to fend off tens of thousands of arrows from what appears to be the entire Qin army. In the most dazzling fight sequence of the film, Flying Snow and Moon, dressed in flowing red gowns, duel in a bright golden forest. Their skillful sword maneuvers and flying through the leafy tops of trees are nothing that the women in the tales of Nie Yinniang and Shisanmei have not done before. At the end, Flying Snow commits suicide on the sword with which she had just killed her lover, Broken Sword. She takes him into her arms and reaches around to push the sword through his body and into her own, impaling herself together with him. It is not clear if she kills herself because she failed to kill the king of Qin and avenge her family as she had sworn to do, or if she does so to be with her departed lover. Both are reasonable assumptions and not mutually exclusive. Of the would-be assassins, only Moon is left to mourn for those who have died.

Disney returned to Mulan in a 2020 live-action film, starring Liu Yifei. This film has Mulan donning men's clothing to become a soldier and go into battle as a substitute for her aged father, as established in the earliest of the Mulan ballad. It is a film of treachery as well as honor. Mulan, discovered as a woman and ordered to stay behind, nonetheless goes into the subsequent battle dressed in a feminine red gown with her long hair loose and swirling about her, making her stand out in a sea of men dressed in black, brown, and gray. As a woman, she is dismissed from the army and returns home to her parents. The film ends with an emissary from the emperor who presents her with a new sword and asks her to return to the army to once again serve the emperor. Her decision to go or remain at home is left ambiguous for viewers to decide her fate, an ending that appeals to the modern-day emphasis on personal choice and autonomy. Will filial piety or devotion to the emperor win?

There are other warrior women in Chinese history, literature, and film who are every bit as interesting and challenging as are those presented here. The classics of Chinese literature, *Journey to the West* (Wu), *The Story of the Stone* (Cao), and *The Outlaws of the Marsh* (Shi and Luo) all portray martial women who go beyond the proscribed precincts of the Confucian home. The woman warrior endures in history, fiction, and film to provide role models of nobility and bravery for both men and women. These women crossed boundaries to establish new identities for themselves in a patriarchal society; they fought for their country and just causes, and, while their tales may have been exaggerated beyond belief, these women generals and martial maidens are genuine heroes.

Notes

1. According to Nienhauser, drums for war were introduced to China from India in the Jin dynasty (266–420 CE) (1:3, n. 10).

2. I tell my film students that period films may teach them a little history of the period depicted and that attentive students may learn something of the period of the film's creation. For example, in the taut Western revisionist drama *High Noon*, the hero (played by Gary Cooper) is newly married and newly retired as the town's sheriff when he learns that four outlaws are due into town when their boss arrives on the noon train; they are intent on murder. The hero, out of honor and duty, pins on his badge again and stays to protect the town, even after the town's people refuse to form a posse to help him. He takes his last stand alone in the middle of the deserted street, awaiting the outlaws as the clock strikes twelve. He kills three of the would-be assassins and his new wife kills the fourth. After the sheriff throws his tin star into the dust, the couple climbs into their buggy and rides out into the sunshine as the cowardly townspeople watch in stunned silence. The 1952 film's subtext is a parable for the Red Scare blacklisting in Hollywood of real or alleged communists who were drummed out of the film industry while the timid establishment stood back and refused to come to their aid.

3. According to Lily Lee, "The Yue Woman's exposition on the art of the sword is the earliest recorded theory on the topic, and it informed Chinese martial arts theory for countless generations" (91).

4. Nienhauser discusses at length the debates on the authorship of the Hongxian tale (1:24–32).

5. There is no English translation of Wen Kang's novel. A *Tale of Heroes and Lovers* is discussed in other works, such as David Der-wei Wang.

6. The ending of the Shisanmei tale is not unlike the endings of many of Hollywood's classic western films, such as *Stagecoach*, *Shane*, and *Pale Rider*. The gunman who rides into town to save it from death and destruction at the hands of the wealthy and powerful forces of the antagonists must be exiled or domesticated through marriage. The violence the hero uses cannot be subsumed into the civilized society, so he must be domesticated, exiled, or killed. He may put the social order to rights by defeating the forces of evil, but he cannot become part of that society. The Ringo Kid, of *Stagecoach*, rides off into the desert with his fiancée, Dallas, after killing the Plummer brothers, who had been the scourge of Lordsville and had killed Ringo's brother and father. The eponymous Shane says to Joey before he rides off alone and wounded into the unknown distance, "There is no living with the killing." The preacher in Pale Rider rides back up into the mountains, from where he had originally come, like an ascending mythological Greek god.

7. The perspective on men in the societies that uphold the valor and worth of skilled and ruthless martial women, however temporarily, would be an apt and profitable study.

8. There are no official English translations of Wang Dulu's novels. There is a novelization of the film's screenplay by Justin Hill.

Works Cited

Allen, Sarah M. "Tales Retold: Narrative Variation in a Tang Story." *Harvard Journal of Asiatic Studies*, vol. 66 no. 1, June 2006, pp. 106–43.

Altenburger, Roland. *The Sword or the Needle: The Female Knight-Errant (xia) in Traditional Chinese Narrative*. Peter Lang, 2009.

The Assassin. Directed by Hou Hsiao-hsien, Central Motion Pictures, 2015.

The Banquet. Directed by Xiaogong Feng, Media Asia Films, 2006.

Buckley, Patricia Ebrey, editor. "Shang Tomb of Fu Hao." *A Visual Sourcebook of Chinese Culture*. U Washington P, 2007. http://depts.washington.edu/chinaciv/archae/2fuhmain.htm.

Cai, Zhuozhi. *100 Celebrated Chinese Women*. Translated by Kate Foster. Asiapac Books, 1995.

Cao Xueqin. *Story of the Stone*. Translated by David Hawkes. Penguin Classics, 1974. 5 vols.

Childs-Johnson, Elizabeth. "Fu Zi, the Shang Woman Warrior." *Biographical Dictionary of Chinese Women: Antiquity through Sui, 1600 B.C.E.–618 C.E.* Edited by Lily Xiao Hong Lee, A. D. Stefanowska, and Sue Wiles. Routledge, 2007, pp. 19–25.

Crouching Tiger, Hidden Dragon. Directed by Ang Lee, Asia Union Film and Entertainment, 2000.

Dong Lan. *Mulan's Legend and Legacy in China and in the United States*. Temple UP, 2010.

Ebrey, Patricia. *The Cambridge Illustrated History of China*. Cambridge UP, 2006.

Edwards, Louise. "Women Warriors and Amazons of the Mid Qing Texts 'Jinghua yuan' and 'Honglou meng'." *Modern Asian Studies*, vol. 29, no. 2, 1995, pp. 225–55.

Feng, Lan. "The Female Individual and the Empire: A Historicist Approach to Mulan and Kingston's Woman Warrior." *Comparative Literature*, vol. 55, no. 3, 2003, pp. 229–45.

"General Liang Hongyu, the Mighty Drummer and the Lady of the Nation's Peace." *Color Q World*, http://www.colorq.org/articles/article.aspx?d=asian-women&x=lianghongyu. Accessed 25 July 2022.

Hamm, John Christopher. "Reading the Swordswoman's Tale: Shisanmei and *Ernu Yingxiong Zhuan*." *T'oung Pao: International Journal of Chinese Studies*, vol. 84, 1998, pp. 328–55.

Hero. Directed by Zhang Yimou, Sil-Metropole Organisation, 2002.

High Noon. Directed by Fred Zinnemann, Stanley Kramer Productions, 1952.

Hsieh, Daniel. *Love and Women in Early Chinese Fiction*. Chinese UP, 2009.

Idema, Wilt L., and Stephen H. West. *The Generals of the Yang Family: Four Early Plays*. World Scientific, 2013.

Jin Yong (Louie Cha). "Sword of the Yueh Maiden." *Heroic Cinema*, http://www.heroic-cinema.com/eric/yuehmaiden.html. Accessed 25 July 2022.

Khoo, Cheng Poh. "Interrogating the Women Warriors War, Patriotism and Family Loyalty in *Lady Warriors of the Yang Family*." MIT4 Panel, "Asian Warrior Womanhood in Storytelling" (2001). https://web.mit.edu/comm-forum/legacy/mit4/papers/khoo.pdf. Accessed 28 July 2022.

Kingston, Maxine Hong. *The Woman Warrior: Memoirs of a Girlhood among Ghosts*. Knopf, 1976.

Kwa, Shiamin, and Wilt L. Idema, editors. *Mulan, Five Versions of a Classic Chinese Legend, with Related Texts*. Hacket, 2010.

Lee, Lily Xiao Hong. "The Yue Woman." *Biographical Dictionary of Chinese Women: Tang through Ming, 618–1644*, edited by Lily Xiao Hong Lee and Sue Wiles. M. E. Sharpe, 2014. p 91.

Lee, Lily Xiao Hong, Clara Lau, and A. D. Stefanowska, editors. *Biographical Dictionary of Chinese Women, The Qing Period, 1644–1911*. Routledge, 1998.

Lee, Lily Xiao Hong, A. D. Stefanowska, and Sue Wiles, editors. *Biographical Dictionary of Chinese Women: Antiquity through Sui, 1600 B.C.E–618 C.E*. Routledge, 2007.

Liu, James J. Y. *The Chinese Knight-Errant*. U Chicago P, 1967.

Liu, Ning. "Cui Shensi." *Biographical Dictionary of Chinese Women: Tang through Ming, 618–1644*, edited by Lily Xiao Hong Lee and Sue Wiles. M. E. Sharpe, 2014, p 46.

Mann, Susan. "Presidential Address: Myths of Asian Womanhood." *Journal of Asian Studies*, vol. 59, no 4. 2000, pp. 835–52. http://www.jstor.org/stable/2659214. Accessed 27 July 2022.

Mao, Jiaqi. "Hong Xianjiao." *Biographical Dictionary of Chinese Women, The Qing Period, 1644–1911*. Edited by Lily Xiao Hong Lee, Clara Lau, and A. D. Stefanowska, Routledge, 1998, pp. 71–72.

Michigan Shaolin Wugong Temple. "Fu Hao—Earliest Known Woman Warrior in the World." *Shaolin Temple MI*, http://shaolintemplemi.org. Accessed 25 July 2022.

"Mu Guiying—Breaking the Heavenly Gate Formation." *Cultural China*, http://history.cultural-china.com/en/48H12434H14968.html. Accessed 25 July 2022.

Mulan. Directed by Tony Bancroft and Sidney Cook, Disney Studios, 1998.

Mulan. Directed by Nico Caro, Disney Studios, 2020.

Mulan II. Directed by Darrell Rooney, Disney Studios, 2005.

Nienhauser, William H., editor. *Tang Dynasty Tales: A Reader's Guide*. World Scientific, 2010. 2 vols.

"Nie Yinniang: Matriarch of Wuxia." *Volare Novels*, https://www.volarenovels.com/page/song-of-exile/nie-yinniang. Accessed 25 July 2022.

Pale Rider. Directed by Clint Eastwood, Malpaiso, 1985.

Peterson, Barbara Bennet. "Liang Hongyu." *Notable Women of China: Shang Dynasty to the Early Twentieth Century*, edited by Barbara Bennet Peterson, He Hong Fei, Wang Jiyu, Han Tie, and Zhang Guangyu, Routledge, 2015, pp 269–75.

Red Detachment of Women. Directed by Xie Jin, Shanghai Film Studios, 1961.

Shane. Directed by George Stevens, Paramount Pictures, 1953.

Shang Yang. *The Book of Lord Shang: A Classic of the Chinese School of Law*. Translated by Jan Julius Lodewijk Duyvendak, Lawbook Exchange, 2002.

Shi, Nai'an, and Luo Guanzhong. *Outlaws of the Marsh*. Translated by Sidney Shapiro, Beijing: Foreign Language Press, 2007. 3 vols.

Song, Xinyi. "Mu Guiying: China's Pioneering and Female General of Many Talents." https://www.shine.cn/feature/art-culture/1710315709/. Accessed 25 July 2022.

Stagecoach. Directed by John Ford, Walter Wanger Productions, 1939.

Wang, David Der-wei. *Fin de Siècle Splendor: Repressed Modernities in Late Qing Fiction*. Stanford UP, 1997.

Wiles, Sue. "She Taijun." *Biographical Dictionary of Chinese Women: Tang through Ming, 618–1644*, edited by Lily Xiao Hong Lee and Sue Wiles, M. E. Sharpe, 2014, 341–44.

Wu, Cheng'an. *Journey to the West*. Translated by Anthony C. Yu, U Chicago P, 2012. 3 vols.

Zhang, Shaoian. "An Extraordinary History of the Northern Wei: The Story of a Filial and Heroic Girl." *Mulan, Five Versions of a Classic Chinese Legend, with Related Texts*, edited by Kwa Shiamin and Wilt L. Idema, Hacket, 2010, pp. 125–26.

Chapter 5

Women in Male Roles

Cross-Dressed Actresses in Early Twentieth-Century China

Laura Xie

In the late nineteenth century, women began to perform Jingju (Peking opera) publicly, with some playing male roles just as men played female roles. We are familiar with actors celebrated for their female roles—for example, Mei Lanfang (1894–1961) performed as daughters, wives, concubines, and other female characters—but little attention has been given to actresses of the early twentieth century who performed male roles in public theaters. Why did women choose to impersonate men on stage? How hard did they strive to continue the career path they had chosen? Were they successful? If so, what did their rise to stardom reveal about the early twentieth-century theater world and women's roles in it?

To answer these questions, I focus on Meng Xiaodong (1908–1977), the most famous impersonator of male roles on the Jingju stage, whose brilliant singing and romantic relationships with two powerful men—Mei Lanfang and Du Yuesheng (1888–1951)—gave her a unique place in the history of Jingju theater. By examining her life and career, we see more plainly the nature of female stardom in the early twentieth century: the complex interaction between actresses' attempts to control their images, the news media's commercial imperatives, and the development of cultural myths.

Becoming the "Man of the House"

The appearance of women actors performing men's parts was a relatively rare occurrence in China before the late nineteenth and twentieth centuries. Occasional instances of women appearing on the stage in men's clothes occurred early in the ninth century. As scholars have noted, some women played male parts in adjutant plays (*canjun xi*) during the Tang dynasty.[1] In the Yuan and Ming dynasties, a handful of actresses were known for performing both male and female roles.[2] This practice of using actresses for male roles continued until the late seventeenth and eighteenth centuries, when the Qing emperors, fearing disturbances to their carefully contrived social order, banned women from public stages.[3] In 1912, the ban against actresses was openly lifted.[4] Women were able to appear on stage once again, and some of them made their marks as male impersonators.

The reemergence of the actress in late nineteenth- and early twentieth-century China coincided with changes in the status of women in society. As the enlightenment discourse of women's liberation emerged full-blown, many magazines appearing around the turn of the twentieth century began to feature images of women in the workforce. They encouraged women to participate in the broader world outside the home by pursuing careers in education, health, and journalism. Acting was also an option for women to gain some sense of independence. It seemed that the actresses had more power and freedom than other women who stayed within their appropriate bounds because actresses sought equality in access to male roles. However, they were facing problems of their own—the acting profession had been accused of supporting prostitution and other vices of immorality—so actresses had to learn to move beyond this stigma and reclaim the dignity of the profession.[5] Actresses were still judged by their appearances, and for the majority of audience members, they were objects to be gazed at and enjoyed. The difficulties faced by a woman who cross-dressed as a man were more severe than those faced by actresses playing women. She had to resist the trappings of negative gender stereotypes and demonstrate her professional ability as a performer specializing in male roles. The conditions under which she performed could be hostile at times, and she might be viewed as less than an equal.

Why did women choose to play men's roles at all? It was usually out of necessity. While women's return to the stage was enthusiastically welcomed and their acting received tremendous applause, men and

women still did not appear together on the stage in the early decades of the twentieth century. Reports in magazines and newspapers published around that time give clues that local authorities were worried about the moral implications of bringing actors and actresses together in the same public space. The Beijing municipal government, for instance, enforced rules forbidding men and women from performing in the same plays ("Minzhengbu" 5). Such restrictions led actresses to rely on their own resources to develop all-girl troupes. The biggest problem facing the all-girl troupe was that they did not have enough actresses to cover the basic roles demanded by the plays. In 1913, the capital's daily newspaper, *Shuntian shibao* (*Shuntian Times*), published a short article on a certain actress by the name of Xiao Jufen, stating that she was obliged to drop some plays from her repertory because there were few female performers capable of casting in male roles in her troupe (Yin, "Xiao Jufen" 5). One of the strategies that all-girl troupes pursued was to revise a play by slimming down its cast size. According to theater scholar Qi Rushan (1877–1962), all-girl troupes frequently cut out minor characters whenever possible. Describing the staging of the most famous act of *Guifei zuijiu* (*Drunken Beauty*), he said that most all-girl troupes "used only one maid while there were supposed to be two" (Qi 231). He found it ridiculous that the girls presented a battle scene by covering only two minor soldier characters when the play called for eight performers (231).

To survive and compete against the all-male troupes, the all-girl troupes had to invest in cultivating versatility to compensate for cast shortages. According to another account, published in *Shuntian Times* in 1914, all-girl troupes focused on recruiting young girls and putting them through intensive training (Ling 5). The article went on to say that after some months had passed, almost all the girls could play both male and female roles. A number of the girls became specialists in male roles and would perform as *laosheng* (old, mature male) characters. They worked hard and impressed critics and audiences with the fast improvement in their acting. Another article, praised an actress's progress as a *laosheng* performer (Yin, "Jin Fengyun" 5). Originally a Qinqiang singer,[6] the actress offered to substitute for an actor who played *laosheng* roles in Jingju and worked her way up into male roles. Within a short time, she became famous as a *laosheng* performer.

Occasionally, actresses of female roles would play male roles for the sake of novelty. According to published accounts at the time, it was fairly common for actors and actresses to cross role-type boundaries at

high-profile events, such as charity performances, to draw crowds. A number of famous actresses of female roles had played the white-bearded hero, or other male roles, in *Bala miao* (*Bala Temple*).

Sometimes an actress would specialize in male roles because of her specific features—personality traits, physical stature, temperament, and so forth. An actress named Guan Wenwei wrote about her career as a male-role performer in her memoir. She described herself as a "tomboy" who very early in life wished to "become a man" (Guan 21). Her parents sent her to a master actor to learn the craft. She soon acquired the techniques for male roles. When she put on men's clothing and went on stage, she said her desire was strikingly fulfilled. In her offstage life, she had also dressed like a man.

Unfortunately, most actresses did not keep diaries or leave written records of their experiences. It is difficult to see what motivated these women to play male roles. Based on early accounts and critical reviews of female performers, we can be sure that women selected roles suitable for their natural voices and physical builds. En Xiaofeng (1887–1949), who was identified as "China's first actress of male roles," is described in some sources as "tall and having a long face" (Ju 339). She sang songs in "a loud, stentorious voice, and there are not many male singers who have this capacity" (Qiu 146). Another male-role actress, Xiao Lanfeng (dates unknown), was "a very handsome woman who liked to dress up in suit and tie" (Yu 8). It was reported that the actress had developed a close relationship with a widow and felt special feelings toward other women ("Xiao Lanfeng" 6). Obviously, for actresses who were somewhat masculine in appearance and manner, taking a male part provided an opportunity for them to pursue a career as a performer.

An actress's decision to play male roles may have also been influenced by their families. If the actress was born into a theatrical family, she was more likely to follow her family's tradition and act in the same roles as her parents.[7] A typical example is Meng Xiaodong. Since both her father and grandfather were performers of *laosheng* roles, it is not surprising that Meng was determined at a very early age to become a male-role performer wearing a beard. As mentioned in her biographical accounts, Meng's father offered himself as a role model to his daughter and actively planned her career path (Ding; Wan and Ma; Xu). Meng was sent to study with Qiu Yuexiang, her parental aunt's husband, who was also a *laosheng* actor. At age eight, she got the opportunity to play the

major *laosheng* role in *Wupen ji* (*The Black Pot*) at a private performance (*tanghui*) in Shanghai. From there, she advanced further in her career as an actress of male roles. Unlike Meng, En Xiaofeng came from a noble family. Her father was an enthusiastic theater patron and frequently invited actors, mostly the lead singers of *laosheng* roles, to visit their home and perform for them. Such enthusiasm could hardly fail to influence his daughter. Having overcome all the social restraints imposed on women of noble birth, En began as an amateur performer and eventually a professional male-role actor.

Actresses had various reasons to play men on stage: out of necessity; because of a sense of being male as expressed in their appearances, behavior, and attitudes, or backgrounds and heritage; or in a quest for monetary gain. There is no doubt that male actors ruled the stage from about 1845 when Jingju was consolidated into a coherent genre, and many significant characters were written for actors who specialized in male roles. At the turn of the twentieth century, actresses felt empowered to become the "man of the house," taking on leading roles and competing with men in a field that once belonged to them. While many actors felt threatened by the number of actresses performing male roles, audiences enthusiastically welcomed them.

The Appeal of the Female *Laosheng*

Women began to perform on stage in the late nineteenth century, and they performed a broad range of male characters. Among these characters, the most celebrated were the *laosheng* roles. The popularity of the actresses performing *laosheng* characters is evidenced in many journalist accounts and other publications. For instance, in the 1917 collection of poetry *Jingshi nüling baiyong* (*One Hundred Poems on Actresses in the Capital City*), the author included poems and biographies for his favorite actresses. The text records a total of one hundred actresses, half of whom specialized in female roles and half in male roles, and the majority of the actresses playing male roles were *laosheng* performers (Yan).

What was the appeal of the female *laosheng* actors to their audiences? Judging from contemporary descriptions of their performances, these actresses performed in very similar ways. Their repertoire included a range of *laosheng* characters, from Yang Yanhui in *Silang tanmu* (*Fourth*

Son Visits His Mother)[8] to Zhuge Liang in a series of *Sanguo* (*Three King-doms*) plays.[9] These characters were mostly loyal ministers, dutiful officers, and filial sons of ancient times, embodying the ideal of masculinity. Of course, perceptions of ideal manhood have changed over time and between different audiences. In the early 1800s, the ideal masculinity was represented by characters such as Guan Yu in *Zhan Changsha* (*Fighting at Changsha*)[10] and Huang Zhong in *Dingjun shan* (*Dingjun Mountain*).[11] While the interest of late nineteenth-century audiences in these martial plays remained undiminished, the overall trend in audience taste had moved away from military prowess to civil virtues, from a masculine ideal of the warrior to that of a humane, honorable man. Audiences were more interested in seeing moral plays and well-rounded characters with psychological complexity, such as Deng Bodao in *Sangyuan jizi* (*Abandoning the Son in the Mulberry Garden*), a man who abandoned his son to save his nephew, and Chen Gong in *Zhuofang Cao* (*Arresting and Releasing Cao*), a local official who releases Cao and joins his rebellion but then leaves when he sees Cao slaughter innocents. These plays focus on personal situations rather than battles and heroic struggles, and within them, singing is the primary means of expressing the main characters' feelings and emotions. The audience's attention was thus diverted from displays of physical prowess and drawn to displays of singing skill.

This change in taste provided a great opportunity for actresses to excel in their performances of *laosheng* roles. When performing in plays with armor and fighting, actresses inevitably fell short of the audience's expectations. Some were short and thin, and when they appeared on stage in what were originally men's costumes, for example, in full-length armor, the outfits were always too large. Others had bound feet and could not complete stage footwork as well as male actors did, which greatly affected their performances. However, in civil plays, actresses could cross-dress as men with dignity and elegance. They focused much more on expressing the feelings of a character to compensate for their disadvantages in physical build. They also focused on improving their singing.

The actresses imitated the singing styles of the most famous *laosheng* actors of the time. Since actors of the nineteenth and early twentieth centuries did not formally take women students, actresses could only learn to sing from recordings or by going to performances and taking notes. The most widely imitated was actor Tan Xinpei (1847–1917), who dominated the Jingju stage in the late years of the nineteenth and first

part of the twentieth centuries and was conferred the title "King of the Theater World" (*lingjie dawang*). Unlike his predecessors or peers, Tan had a uniquely soft and sentimental voice. While his teacher complained that his voice was "too sweet" and was like "the sound of a fallen state" (*wangguo zhi yin*) (Zhang Cixi 4), Tan's style of performance appealed to and satisfied the tastes of his literati audience. For actresses, it was simply easier to imitate Tan's style of singing than other singing styles that required more energy to produce a loud and robust sound. More importantly, imitating the star brought them a good amount of public attention—fans of Tan were interested in seeing actresses playing the star's signature plays, and the theater critics turned much of their attention to these female *laosheng* performers.

In the early twentieth century, critics' attitudes toward actresses were often conflicted. Reviews of performances of an actress playing the roles of her own sex often showed greater interest in her natural charms than in her skills. In contrast, reviews of performances by a female *laosheng* actor were more likely to comment on acting talent. One article, published in *Shenbao* (*Shanghai News*) in 1924, offers an example of these different receptions. The author mentions actresses who he thought were the best Jingju actresses of the day in Shanghai. He makes a terse comment concerning one actress by the name of Pan Xuefeng, who played the *qingyi* (demure female) roles: "She has a pretty face and a beautiful singing voice, and one of the plays she performed particularly well is *Liuyue xue* (*Snow in June*)" (Jie 310). Concerning another actress, Jin Fangchen, who played *laosheng* roles, the author obviously had a great deal more to say. He comments on her singing and acting. Her "stage presence is glamorous," and her "gait is solemn." The quality of her "voice is perfectly pure, and the articulation so clear and fluent." Her tones "are natural and heart-searching that they thrilled with every varying phase of her sensibilities" (309). The author continues to discuss the actress's capacity to perform different characters. She had played a number of roles, and no matter what she played—a learned and refined scholar or a faithful servant—she could always "portray her character accurately" (309). Such different receptions of actresses could lead one to conclude that the charm of the female *laosheng* performers did not lie in their physical beauty. Rather, it lay in their ability to embody the ideal manhood embraced by their audiences and the artistry that enabled them to depict the ideal man on stage.

The allure of female *laosheng* performers also lies in the fact that people were well aware that they were watching women play the roles of older and mature men. Critics would often remind their readers that one can still hear the voice of a woman (*ci yin*) or see a trace of rouge (*yanzhi qi*) in a certain actress. Although there was an expectation that the best female performer of *laosheng* roles would never express any quality that audiences would consider feminine, the visibility of feminine traits did not affect the audience's enjoyment. Instead, the audience took pleasure in gazing at and fantasizing about a woman's body beneath a male costume. In a biographical account of Meng Xiaodong, the author describes how fans enthusiastically attended Meng's performances. He quoted one of the fans, who said, "We rushed to the theater to watch her performance. . . . Although the costume and the whisker concealed her feminine attributes, we still very much appreciate her beauty" (Xu 86). Another fan said, "We love to hear her sing. For one thing, she is a woman, and for another, her vocal technique is flawless" (86). Although audiences congratulated the actress on her excellent skills in fictive gender production, they often liked her performance because it created space to entertain fantasies about the invisible but nevertheless known body of a woman.

Not only men but also women in an audience enjoyed watching female performers impersonating men. This is partly because women could fantasize about male characters played by female performers without feeling morally inappropriate, but even more importantly, these cross-dressed actresses inspired a new trend in women's fashion. At the turn of the twentieth century, actresses dressed in men's clothing or mannish clothing made appearances in magazines and newspapers. In 1928, the newspaper *Beiyang huabao* (*Pei-Yang Pictorial News*) produced a special issue on women's fashion and printed on the front page was a photograph of Meng Xiaodong in men's clothing with a caption saying "Meng Shiao-Tung [Meng Xiaodong], a well-known actress photographed as a gentleman in foreign dress" (see figure 5.1).

The same newspaper had featured many pictures of other women cross-dressed in men's clothing. The popularity of cross-dressed actresses was connected to the social, economic, and political changes occurring at the time. The actresses could be called "new women" because they were living in a new way—they were independent and engaged in the world outside the home. It was this attractive novelty in them that appealed to diverse audiences.

Figure 5.1. Photograph of Meng Xiaodong in men's clothing. *Pei-Yang Pictorial News*, January 21, 1928. Provided by Hytung's "Hantang jindal baokan."

Meng Xiaodong: Actresses and Image

Meng Xiaodong is often considered the most famous female performer of *laosheng* roles of all time. She began training as an actress at age five. At the age of eight, she made her debut at a private gathering in Shanghai, where biographical accounts show that the young girl was immediately recognized as a natural talent. According to an audience member who remembers many details about the event, Meng performed a scene from *The Black Pot*, and her performance received loud applause and shouts of bravo at the end. She acted in a sophisticated manner that made her performance deeply impressive. "There is no doubt," the audience member said, that "she is the most talented child actor" (Wan and Ma 10).

After her successful performance, Meng's father, Meng Hongqun (d. 1932), who was also a *laosheng* actor, set out to make his daughter an excellent actress. He sent her to study with a teacher and worked hard to find opportunities for her to gain performance experience. In 1919, at the age of eleven, Meng joined an all-female troupe as they toured Wuxi city in southern China. Upon her return to Shanghai, she began to perform at the *Da shijie* (Great World) amusement center, and after a year, in 1920, she joined the *Rongji gong wutai* (Rong's United Stage) through the recommendation of Du Yuesheng, Shanghai's most powerful underworld leader who became Meng's second husband in 1950.

In these early years of her career, Meng performed many *laosheng* roles in the traditional repertoire. She was also known for her roles in serials plays (*liantai benxi*), such as *Hong Bi yuan* (*The Marriage Affinity between Luo Hongxun and Hua Bilian*) and *Qiangbi Yan Ruisheng* (*Yan Ruisheng Gets Shot to Death*). Serial plays are very long—often divided into episodes and performed every night for several days—and they were popular in Shanghai at the time. Meng's performance brought her fame and fortune, but she soon realized that if she wanted to grow her career as a great performer, she needed to go to the north, primarily Beijing and Tianjin, where the majority of actors were trained. As a popular saying goes, "Learn your art in Beijing, become famous in Tianjin, and earn money in Shanghai." Although performing Jingju could be very profitable in Shanghai, for many people, Jingju developed and performed in Beijing was the only true theater.

On 5 June 1925, Meng made her first appearance on the Beijing stage at the *Sanqing yuan* (Three Celebrations Theater). She performed for three consecutive nights, and the play she picked for the opening

day of her three-day cycle of plays was *Fourth Son Visits His Mother*. The audience was impressed by her singing and acting. An account published in *Shuntian Times* on 10 June describes the enthusiasm and pleasure with which the first night's performance was received. According to the account, there was "thundering applause and endless shouts of Bravo" (Hua 5). In another account, published in *Shehui ribao* (*Social Daily News*) in 1925, the author raves about her performance in the play, saying, "Meng closely imitated the singing-style of the famous actor Tan. . . . She stands out as superior to other [female *laosheng* actors]" (Xin 4).

The play brought Meng fame and popularity and firmly established her reputation as one of the best female *laosheng* actors. It also marked her first collaboration with the most renowned female-role actor, Mei Lanfang. In late 1925, Meng was invited to perform at a private performance where she played alongside Mei in *Fourth Son Visits His Mother*. Meng played the part of Yang Yanhui, and Mei the wife, Tiejing Gongzhu (Princess Iron Mirror). Shortly after the performance, rumors swirled that Meng's onstage partnership with Mei had blossomed into an offstage romance. The rumors surrounding their relationship made Meng a major celebrity and shaped her image as "the finest male-role actress of her day" as well as a woman who could be a faithful wife, seek romantic love, and have a personal life.

Despite her romantic involvement with Mei, Meng's ultimate goal was to fulfill her independent career ambitions rather than acquire men's affections. An earnest young actress, she wanted a real career, and her goal was to be the best *laosheng* actor. She began her career as a clever mimic of the greatest actor of that era, Tan Xinpei. She had never seen Tan perform—he died in 1917. To learn his plays, she took well-known actors who followed Tan in singing as her teachers and asked musicians who once played for Tan to work with her. She studied hours of phonograph recordings of Tan's performances to perfect her imitation of the star singer's vocal style and mannerisms.

In 1938, Meng formally became the disciple of the famous *laosheng* actor Yu Shuyan (1890–1943). Yu was Tan's student, but he individualized his singing style and created his own style of *laosheng* performance.[12] Before following Yu, Meng was frequently compared with Yu because both were known for following Tan. Some believed that Yu resembled Tan and that to model herself on Tan, Meng should model herself on Yu first (Ban 2). Others believed that Meng was better than Yu in certain plays because she seemed to know Tan's work more accurately (Hong 2).

After Meng began following Yu, she was prepared to make the most of the experience. She was said to have watched every one of Yu's performances, and she went to study at his residence every night, even during bad weather. In five years of study with Yu, she learned more than twenty plays and was praised as having received the true transmission of her teacher's singing style. According to Ding Bingsui (1916–1980), Meng learned to sing in a husky voice (*shayin*), and her previously loud and sonorous voice had changed to one that was deep and powerful (Ding 44).

Despite the immense progress she made, Meng rarely performed publicly during this period. Her audiences were missing her, and rumors abounded about her poor health. In 1942, the magazine *Xin Tianjin huabao* (*New Tianjin Pictorial*) published a short article on her lack of appearances on stage, explaining that Meng never overused her voice and never sang when she was not in the very best condition (Da 3). Because her health was not great, she often disappointed her audiences. According to the author, Meng's approach indicated "the attitude of great artists toward art" (3).

Meng's most memorable performance was in Shanghai in 1947, and it turned out to be her last public performance. Although she was not yet forty and her future was promising, she announced her intention to retire from the stage. The performance was part of a grand fundraising event put on by Du Yuesheng to celebrate his sixtieth birthday and raise money to relieve people suffering from flooding in the southern part of China. The event lasted for ten days, and Meng performed her famous piece *Sougu jiugu* (*Searching for the Orphan, Saving the Orphan*) for two days. When she performed, thousands flocked to see her, but many could not get seats. Some in the audience came from outside the local area and traveled long distances for the event. One said, "I was in Taipei at the time and flew on an overnight flight to Shanghai soon after I heard the news. I was so lucky to catch her last performance" (Sun 103). Meng's performance created a great sensation. Shortly after, a phonographic recording was released. It quickly sold out, and people talked about it for many years. Meng, the doyen of female *laosheng* performers, had taken her final bow. In 1949, Meng moved to Hong Kong with Du Yuesheng as the Nationalists lost power in mainland China, and she married him the following year. After Du died in 1951, she lived a secluded life and never returned to the stage.

The image we now have of Meng holds contradictory elements. A strong, successful career woman, she offered herself as a role model and figure of inspiration for her female fans, encouraging them to challenge the status quo and strive for success. On the other hand, her image was also connected to ideals of conventional femininity. She has been lauded

for her beauty and glamour, and the eyes of the public have constantly focused on her romance and her close student–mentor relationship with male masters. The emphasis on her physical presence, romantic life, and relationships with mentors has unfortunately reduced her status as a successful professional woman and placed her in an inferior position to men.

Meng's status as an accomplished star actress is a dominant element in her image. She was said to be one of a few female stars who could perform the final play ("big scroll," *dazhou*) or the penultimate play ("pressing down scroll," *yazhou*) in a program alone, without a major male star opposite her, and her performances were always very successful at the box office. In a report of an interview with Meng published in the magazine *Liyan huakan* (*Liyan Pictorial*) in 1941, the author mentions her recent performance of *Searching for the Orphan, Saving the Orphan* at the *Xinxin wutai* (New-New Stage), saying that tickets for that day's performance were sold as high as seven Chinese dollars, and Meng earned "an astonishing one thousand and two hundred Chinese dollars from this performance" ("Ming kunling" 722). According to theater historians, a typical theater ticket at the time cost about one Chinese dollar, and ticket prices for a high-profile event, such as an all-star charity performance, would be roughly seven Chinese dollars (Zhang Fayin; Zhao). Clearly, Meng was on an equal footing with the more established actors of the day, and there is no doubt that she thrived in this male-dominated world.

Much of Meng's fame comes from her student–mentor relationship with Yu Shuyan. Meng was said to have resembled her teacher very strongly, not only in his singing style but also in his character and sentiments (Wang 96–110). Yu was known to have been in a bad state of health, and after his health deteriorated even further in 1929, he stopped performing.[13] He concentrated on teaching instead of performing. Very often, actors and amateur actors (*piaoyou*) gathered together in his residence to hear him talk about plays. The same thing happened to Meng. Although she left the stage in her forties, partly for health reasons, she never stopped finding ways to perfect her singing craft. In her later years, she turned her home into a salon, where amateur actors met and sang plays.

One of the two disciples of Yu Shuyan, Meng was often considered a perfect stand-in for her teacher after Yu stepped away from the public stage.[14] Those who wanted to watch Yu's plays would go see Meng. For example, a theater critic, who called himself an enthusiastic fan of Yu, wrote, "Yu rarely performed in public. There seemed a no better choice than Meng since Meng is the best *laosheng* in the style of Yu Shuyan" (Qian 1165). However, this same critic went on to claim that Meng was not at

all equal to her teacher. According to him, Meng successfully imitated her teacher's manner of singing, but she "has not yet reached perfection" (1173). When the audience heard her singing, they heard the voice they had heard before—soft, gentle, and yet so strong and clear. What was missing in her singing was great energy, boldness, and the forceful and vigorous sound necessary for singing in Yu's style. This was Meng's natural limitation.

The prestige Meng gained from the public's recognition of her as a true descendant of the great master provided her career with the kind of height that actresses who were known largely for their physical attractiveness were not able to achieve. But it also defined her place as inferior. Although she did her part well in following her teacher, some people insisted that she did not equal Yu, let alone surpass him. Perhaps Meng never wished to surpass her teacher. She was quoted to have said that Yu was the greatest actor of his time because of his personal creativity (Sun 18). According to Meng, Yu was always able to "seek new paths," "create new things out of old," and eventually create "his own style of *laosheng* performance" (18). Meng clearly knew that a good actor must not only imitate the great but build his or her own style. But she chose to imitate and follow her teacher's style and devoted herself exclusively to the transmission of his singing; because of this, her name is always associated with the master.

Meng's romance is another major aspect of her image. Her relationship with Mei Lanfang, the most famous female-role actor, and their short-lived marriage was the focus of media attention. Although Meng was often presented as a strong, competent woman, the media also created a docile, domestic image for her. In 1926, for example, *Pei-Yang Pictorial News* reported that it was rumored that Meng had become Mei's lover (Ao 2). The article included two images: one of them showing Mei in one of his plays and the other showing a photo of Meng in Manchurian dress (see figure 5.2). In the photograph, Meng sits against a backdrop, in what looks like her house, holding a small dog in her arms. The caption notes that she was "a well-known actress famous for her male-impersonations," but the editor purposely chose a picture with a home setting to downplay her role as a career woman.

Meng married Mei, and following her marriage, she disappeared from the public arena. Neither Meng nor Mei announced their marriage. This led to endless speculation, and people believed that Meng must have been very happy with her married life. In February 1929, the same newspaper published four photographs of Meng in her traditional dress with airy poses and alluring gestures (see figure 5.3).

◄ 奉軍砲火，網大威力之明證 ►
The accuracy of the Fengtien artillery bombardment shattered the strong Kuomingchun defensive line at Nankow.

The barbed wire.

The trench.

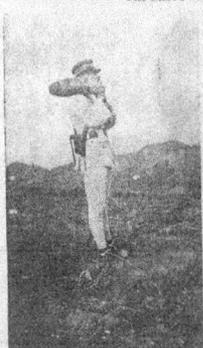

◄ 前彈之彈砲重軍奉 ►
The shell.

◄ 奉軍前視察口國民軍陣地之完好者 ►
The inspection.

（裝扮）冬小孟閣梅姓孟
Miss Meng Shiao-Tung in Manchurian dress.
A well known actress famous for her male impersonations.

Will it be a sensation if they marry.?

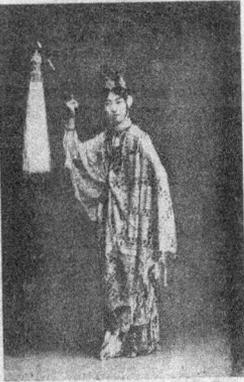

（裝戲）芳蘭梅之冬小孟榮梅
Mr. Mei Lan-Fang in one of his plays. The world-famous thespian in female impersonations.

(2)

Figure 5.3. Photograph of Meng's face, showing her with different poses and with a variety of facial expressions. *Pei-Yang Pictorial News*, February 9, 1929. Provided by Hytung's "Hantang jindal baokan."

In one, she is smiling and giving an air kiss; in another, she is resting her chin on her left hand and looking mysteriously into the camera. According to the reporter, Meng had married Mei when the photos were taken ("Xieyu xiaoying" 2). In another photo, published a month later, Meng appears to be standing with most of her weight on her right foot and her body tilted to the left (see figure 5.4). She has her right hand raised up against her chest, her eyes are cast to her left, and a wry smile breaks over her mouth. These photos seem to tell readers that Meng has wholeheartedly embraced her role as a wife.

It is hard to say how much Meng enjoyed being Mei's wife. She put her career on hold, and her title changed from "famous actress" to "Madam Mei." Again, in the same year, a couple of months later, *Pei-Yang Pictorial News* printed a photograph of Meng, taken shortly after her marriage, with a caption calling her an "ex-actress" and "now the second wife of the world-famous actor Mei Lan-fang" (see figure 5.5).

In the photograph, Meng appears to be standing against a blurry background with her head slightly tilted to the left. She is looking into the camera, her face solemn, eyes sad. The press seemed to notice that Meng's relationship with Mei was not entirely happy. It actually involved a considerable amount of anguish. Meng was not yet twenty, and Mei was in his thirties when they began their romance, and at the time, Mei already had an actress wife, Fu Zhifang (1905–1980). Mei did not formalize a marriage contract with Meng, and she was not able to go to the train station to bid him farewell when he departed for the United States in January 1930. A photo of her standing next to Mei and a friend was printed at the bottom right of a special page on the farewell to Mei in *Pei-Yang Pictorial News*, and the caption calls her "a concubine" ("Mei Lanfang yu qi qie" 3).

Meng became an innocent victim in the troubled relationship she was caught in. In February 1930, *Pei-Yang Pictorial News* printed a photo that was said to have been taken in 1928, when Meng was on board the *Hong Kong Maru* and traveling to Canton (see figure 5.6). At the time the photo was taken, the details of Meng's relationship with Mei had not yet been publicized. In the photo, Meng is leaning her elbow on the ship's rail and resting her chin in her palm with her eyes on the parting water. The photo reveals a feeling of helplessness and frustration, and it is precisely this aura of feminine helplessness that makes audiences feel sympathy for her plight.

Figure 5.4. Photograph of Meng in modern dress. *Pei-Yang Pictorial News*, February 5, 1929. Provided by Hytung's "Hantang jindal baokan."

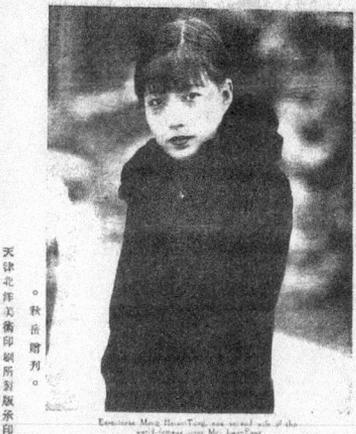

Figure 5.5. Photograph of Meng taken shortly after her marriage to Mei Lan-Fang. *Pei-Yang Pictorial News*, May 14, 1929. Provided by Hytung's "Hantang jindal baokan."

Figure 5.6. Photograpg of Meng on board the *Hong Kong Maru* and traveling to Canton in 1928. *Pei-Yang Pictorial News*, February 8, 1930. Provided by Hytung's "Hantang jindal baokan."

While the press suggested that Meng was a "victim" of an unfulfilled marriage, Meng quickly moved out of this victim phase. The breakup of her first marriage in 1931 was big celebrity news at the time. The press again began to speculate that the problem had been that Meng was unable to adapt to married life or that she had not been able to bear Mei a child. In 1933, Meng spoke of the breakup with dignity but sadness: "I was married in the practice of combined succession (*jiantiao*) [and was supposed to have equal status].[15] But Lanfang never made it clear that [I was different from a concubine]. . . . Hence, my equal status in the household was not secure. Lanfang ignored his friends' advice [to do the right things] and disregarded my opinion. He was so heartless about this situation" (Meng 1). About the after-effect of the breakup, Meng stated that she had experienced vicious, personal attacks from the public but that she held no fear from those attacks and would take legal action against the perpetrators. She proved herself to be a strong, self-directed woman who struggled against her victimization. After the breakup of her first marriage, Meng made her triumphant return to the theater, performing in several plays at the *Mingxing xiyuan* (Celebrity Theater) in Tianjin.

Meng's image is complex and contradictory. In many ways she is a progressive female figure—she played men's roles, competed with male actors, and achieved a well-deserved reputation as the greatest cross-dressed actress of all time. Her male rivals may not have liked or approved of her, but they had to take her seriously. On the other hand, she is often portrayed as a faithful and loyal student of her master and a woman victimized by an unfortunate marriage. This identification of Meng as a conventionally passive female figure rejects her challenge to the patriarchal status quo and renders her a safe model for female audiences.

Conclusion

Although many later actresses played male roles, the number of women choosing to specialize in this area decreased as the Jingju theater increasingly emphasized realism. In the late twentieth and early twenty-first centuries, there was a revival of interest in female-to-male cross-dressing. Attempts at men's roles by actresses such as Wang Peiyu (1978–) recall a tradition made famous by Meng—it was progress hard won. Actresses playing male roles in the early twentieth century explicitly challenged

male dominance in the theater and the patriarchal status quo. These women underscored the changing perceptions, ideals, and depictions of manhood; a taste for novelty; and the willingness of audiences to accept fluid gender norms. For individual actresses, playing dominant male roles on stage gave them an opportunity to gain prestige and recognition for their craft and technique, rather than for their beauty, and to enjoy a traditional male prerogative. However, they had to overcome many obstacles to gain this equality and recognition. Compared unfavorably with their male counterparts, they were often confined to regressive female gender roles associated with female objectification. Today, actresses have more opportunities than their predecessors, but the challenges they face, old and new, remain despite the achievements of actresses such as Meng Xiaodong.

Notes

1. For a concise discussion on women playing men's roles in early Chinese theater, see Zeng 31–46. For a brief introduction to the adjutant play, see Dolby 13–15.

2. Xia Tingzhi's (fl. mid-fourteenth century) *Qinglou ji* (*Green Bower Collection*) records a number of actresses who performed both male and female roles on stage in the Yuan dynasty.

3. In 1659, the Shunzhi emperor (1638–1661, r. 1644–1661) issued an imperial decree replacing singing girls in the Office of Musicians with eunuchs. Similar decrees appear frequently in the long era of the Kangxi (1654–1722, r. 1661–1722), Yongzheng (1678–1735, r. 1722–1735), and Qianlong (1711–1799, r. 1736–1705) reigns. For a brief introduction to the series of Qing decrees banning female entertainers, see Mann 126–28. See also Wang 4–6.

4. Before the ban against actresses was openly lifted, some all-girl troupes had begun to appear in cities such as Shanghai and Tianjin. The first recorded appearance of women on a major public stage in Beijing was in 1907. As reported in a 1907 article in *Shuntian Times*, an all-girl troupe was invited to perform at Rihua Theater in the foreign settlements. For a discussion on the emergence of stage actresses in the late nineteenth and early twentieth centuries, see Luo 79–82.

5. For a discussion on the challenges actresses were facing in the early twentieth century, see Cheng. See also Chou.

6. Originating in the Shaanxi province in the northern part of China, Qinqiang is one of the oldest regional opera forms. In 1779, Qinqiang actor Wei Changsheng (1743–1802) brought some actors with him to Beijing to perform Qinqiang, contributing to the spread of the opera form.

7. Male actors were the same. For example, starting with Mei Lanfang's grandfather and going on to his son, the Mei family acted in female roles for four generations.

8. Yang Yanhui was a Song dynasty general who was captured by the Liao state, where he married a Liao princess. *Fourth Son Visits His Mother* revolves around Yang's journey back to the Song to visit his bedridden mother.

9. Zhuge Liang was the prime minister of Shu-Han who used military strategies to outwit his enemies. He is a *laosheng* character in Three Kingdoms plays such as *Shi jieting* (*Losing Jieting*), *Kongcheng ji* (*Ruse of the Empty City*), *Zhan Ma Su* (*Executing Ma Su*), *Qunying hui* (*The Gathering of Heroes*), and *Jie dongfeng* (*Borrowing the East Wind*).

10. Guan Yu was the famous general who assisted the warlord Liu Bei in establishing the state of Shu-Han. Guan Yu's role type is *hongsheng*, that is, *laosheng* with a red-painted face. This character can also be played as a *jing* role.

11. Huang Zhong was also a military general serving under Liu Bei during the late Eastern Han dynasty. He is best known for his victory at the Battle of Mount Dingjun in 219.

12. In Jingju, knowledge of performance was handed down from teachers to their students. Students could make creative extensions to the established traditions, and their creations were often recognized as individual styles or schools of performance (*liupai*). For a detailed discussion on the different styles of *laosheng* performances, see Li 397–530. See also Wu.

13. Yu stopped performing in public theaters, but he still occasionally performed at charity events and private gatherings.

14. Yu's other disciple was Li Shaochun (1919–1975). Li is best known for his *wusheng* martial roles and performed Yang Bailao in the 1958 model work *Baimao nü* (*The White-Haired Girl*).

15. The practice of combined succession is an old custom—a man can succeed both his father and an uncle who has no son and can have two wives to produce heirs for both branches of the patrilineal family. The wives married in the practice of combined succession are regarded as having equal status. In contrast, a woman who enters the household as a concubine is in a subordinate position to the main wife. For a discussion of the practice of combined succession, see Tran.

Works Cited

Ao Weng. "Guanyu Mei Meng liangling hunshi zhi yaoyan." *Beiyang huabao*, 28 Aug. 1926.

Ban Jie. "Shu Tan qiang gao Meng Xiaodong." *Shehui ribao*, 27 and 30 June 1925.

Cheng Weikun. "The Challenges of the Actresses: Female Performers and Cultural Alternatives in Early Twentieth Century Beijing and Tianjin." *Modern China*, vol. 22 no. 2, 1996, 197–233.

Chou Hui-ling. "Striking Their Own Poses: The History of Cross-Dressing on the Chinese Stage." *TDR*, vol. 41, no. 2, 1997, 130–52.

Da Feng. "Meng Xiaodong weihe bu chang yanchang?" *Xin Tianjin huabao*, 24 Aug. 1942.

Ding Bingsui. *Meng Xiaodong yu Yan Gao Tan Ma.* Taipei: Dadi chubanshe, 1989.

Dolby, William. "Early Chinese Plays and Theater." *Chinese Theater: From Its Origins to the Present Day*, edited by Colin Mackerras, U Hawai'i P, 1983, pp. 7–31.

Guan Wenwei. *Nü ban nanzhuang xiju rensheng.* Taipei: Changliu chubanshe, 1986.

Hong Liao. "Meng Xiaodong yu Yu Shuyan." *Shehui ribao*, 3 July 1925.

Hua Ting. "Sanqing yuan di yi ri rouye guan ju ji: Meng Xiaodong zhi *Silang tanmu*." *Shuntian shibao*, 10 June 1925.

Jie Shi Fei Jue Fei. "Kunling shucong" (*Shenbao*, 16 Dec. 1925). *Shenbao jingju ziliao xuanbian*, edited by Cai Shicheng, Shanghai jingjuzhi bianjibu, 1994, pp. 309–10.

Ju Pin. "Ershinian qian hushang kunban zhi gaikuang" (*Shenbao* 5 Mar. 1925). *Shenbao jingju ziliao xuanbian*, edited by Cai Shicheng, Shanghai jingjuzhi bianjibu, 1994, pp. 339–49.

Li Yuanhao. *Jingju laosheng dan hang liupai zhi xingcheng yu fenhua zhuanxing yanjiu.* Taipei: Guojia chubanshe, 2008.

Ling Jian. "Lun Beijing kunjue zhi xingshuai." *Shuntian shibao*, 15 Sept. 1914.

Luo Suwen. "Gender on the Stage: Actresses in an Actors' World (1895–1930)." *Gender in Motion: Divisions of Labor and Cultural Change in Late Imperial and Modern China*, edited by Bryna Goodman and Wendy Larson, Rowman & Littlefield, 2005, pp. 75–96.

Mann, Susan. *Precious Records: Women in China's Long Eighteenth Century.* Stanford UP, 1997.

Meng Xiaodong. "Meng Xiaodong jinyao qishi." *Dagong bao*, 15–17 Sept. 1933.

"Mei Lanfang yu qi qie." *Beiyang huabao*, 7 Jan. 1930.

"Ming kunling fangwen ji—Meng Xiaodong" (*Liyan huakan*, 12 July 1941). *Liyan huakan jingju ziliao xuanbian*, edited by Chen Zhiming and Wang Weixian, Beijing: Xueyuan chubanshe, 2009, 722–27.

"Minzhengbu pizhun jingting chongding guanli xiyuan guize." *Shuntian shibao*, 24 Mar. 1912.

Qi Rushan. "Congqian xiban nannü buxu heyan." *Qi Rushan wenji*, Beijing: Kaiming chubanshe, 2010, vol. 6, pp. 230–31.

Qian Li. "Ling Meng Xiaodong suji" (*Liyan huakan*, 22 July 1944). *Liyan huakan jingju ziliao xuanbian*, edited by Chen Zhiming and Wang Weixian,. Beijing: Xueyuan chubanshe, 2009, vol. 2, pp. 1164–73.

Qiu Lao. "Liyuan jiuyi: En Xiaofeng" (*Liyan huakan*, 4 Mar. 1939). *Liyan huakan jingju ziliao xuanbian*, edited by Chen Zhiming and Wang Weixian, Beijing: Xueyuan chubanshe, 2009, vol. 1, p. 146.

Sun Yangnong. *Tan Yu Shuyan.* Taipei: Showwe Information Co., 2013.

Tran, Lisa. "From Toleration to Prosecution: Concubinage and the Law in China." *Marriage, Law and Modernity: Global Histories*, edited by Julia Moses, Bloomsbury, 2017, pp. 54–70.

Wan Boao and Ma Simeng. *Meng Xiaodong: qushu shang de chenmeng.* Taipei: Xiuwei zixun keji, 2013.

Wang Anqi. *Xingbie, zhengzhi yu jingju biaoyan wenhua.* Beijing: Dongfang chubanshe, 2011.

Wu Xiaoru. *Jingju laosheng liupai zongshuo.* Beijing: Zhonghua shuju, 2014.

Xia Tingzhi. *Qinglou ji jianzhu.* Edited by Sun Chongtao and Xu Hongtu. Beijing: Zhongguo xiju chubanshe, 1990.

"Xiao Lanfen zuide tongxing tongqing." *Xin Tianjin huabao*, 14 Mar. 1931.

"Xieyu xiaoying zhi hou." *Beiyang huabao*, 9 Feb. 1929.

Xin Xiang. "Tan Meng Xiaodong zhi *Tanmu*." *Shehui ribao*, 22 Sept. 1925.

Xu Jinwen. *Liyuan donghuang Meng Xiaodong.* Shanghai renmin chubanshe, 2003.

Yan Shi. *Jingshi nüling baiyong.* Beijing: Dumen yinshuju, 1917.

Yin Xia. "Xiao Jufen." *Shuntian shibao*, 29 Jan. 1913.

———. "Jin Fengyun da you zhangjin." *Shuntian shibao*, 16 April 1913.

Yu Liang. "Xiao Lanfen." *Jingbao*, 24 April 1934.

Zeng Yongyi. *Shuo Xiqu.* Taipei: Lianjing chuban shiye gongsi, 1976.

Zhang Cixi. "Tan Xinpei lüe zhuan." *Tan Xinpei yishu pinglun ji*, edited by Dai Shujuan, Beijing: Zhongguo xiju chubanshe, 1990, pp. 1–4.

Zhang Faying. *Zhongguo xiban shi.* Beijing: Xueyuan chubanshe, 2003.

Zhao Shanlin. *Zhongguo xiqu guanzhongxue.* Shanghai: Huadong shifan daxue chubanshe, 1990.

Chapter 6

Pavilion of Women

Gender Politics and Global Cultural Translatability

Jinhua Li

In an era increasingly characterized and challenged by global media consumption, free flow of texts and resources, and a deterritorializing transnationality in cultural production that constantly erodes the nation-state, transnational film remakes are situated at a critical juncture where axes of representation, gender, power, and identity converge and clash. As a product of the global media economy and intercultural negotiation, transnational film adaptations are by nature a contested site where the dichotomies of global/local, West/East, transnational/national, Eurocentric/polycentric, masculine/feminine, and center/peripheral intersect and inter-act. Such multidimensional and discursive transnational cultural politics serve as foundation and as a point of departure in a critical analysis of gender politics and global cultural translatability of the 2001 Chinese film adaptation of Pearl S. Buck's novel *Pavilion of Women* by Hong Kong director Ho Yim. Titled *Tingyuan li de nüren*,[1] this Chinese-language film adaptation of American fiction proves a particularly valuable and unique case study that illuminates the complexities of transcultural politics and the intricacies of sociopolitical undercurrents in the hierarchized negotiation between the global and the local, because even with its unprecedented production value as a pioneering US-China coproduction, the film was

a box office failure and received little critical acclaim. The unfulfilled transcultural potentials of *Tingyuan li de nüren* provide an invaluable lens through which larger issues that contextualize cultural exchanges between China and the United States emerge. What are the embedded cultural politics that dictates the reconfiguration of transnational texts? How are the dialectic powerful dynamics between national cinema and Hollywood reflexive of the politics of representation? In what ways is the underlying Eurocentric gender discourse symptomatic of hierarchized global media translatability? These questions demand critical investigation and theoretical attention precisely because *Tingyuan li de nüren*, as the first cinematic coproduction between major studios from the United States and China, failed to navigate the intersectionalities of gender, power, identity, and nation in the broader context of media transnationality.

Triangulating these problems of transcultural media production, representational negotiations between the global and the local, and hierarchized gender discourses, this chapter argues that despite *Tingyuan li de nüren*'s asserted theme as "women's emancipation, both in their lives and as a way of thinking" (Li and Shen), this avowed feminist theme ultimately collapses because the visual narrative fails to support its representation. In other words, while women's pursuit of individual freedom and gender equality is structurally emphasized and diegetically articulated, the cinematographic elements never put women in positions of agency. As a result, the film's narrative is constantly at war with its discourse. Careful analyses of the normative spectatorial positioning, anthropomorphic camera movements, and the strategized mise-en-scène reveal how they orchestrate to confront the audience with conflicting diegesis. Further deconstructing its self-proclaimed feminist politics, the film imposes Eurocentric linguistic hegemony and sexual objectification on the portrayal of the subaltern Chinese female protagonist, who subjugates her agency to the superior Western man. This Eurocentric discourse functions at multiple levels in the film. Linguistically, when English is adopted as a preferred *lingua franca* and a superior language for the subaltern subjects, the Eurocentric becomes the normative paradigm. Structurally, the narrative's subjugation of the female protagonist determines her otherization, as she is decisively sexualized to highlight the disenfranchised female subject as the bearer of the male gaze. Cinematographically, the camera adopts a male-centric point of view that precludes the establishment of female agency and spectatorial identification.

It should be noted that this chapter is not intended to be a comprehensive comparative reading of Buck's novel and its film adaptation, which would inevitably centralize the interdisciplinary differences between these two expressive forms. It is an examination of the film text as a transnational cultural commodity whose gender politics is circumscribed by its unique duality—a duality that manifests as a tantalizing lure of synthesizing the American and the Chinese by inscribing a Eurocentric feminist agency in an authentically represented (read: by a director and a screenwriter who are both ethnic Chinese) Chinese narrative. While this misplaced claim on cultural translatability and representational legitimacy contributes to the film's lackluster performance, this essay explores how the film fails to capitalize on the promises of its layered transcultural and representational dualities, highlighting its unsettling internalization of Eurocentric gender discourses.

Textual Migration: Transcultural Duality and Global Media Politics

Written by Pearl S. Buck in 1946, *Pavilion of Women* was first translated into Chinese in 1998.[2] Buck's unique life experience as an American author who was raised and spent thirty-seven years in China makes this novel a valuable transnational account of Chinese life in the preliberation era. Even though Buck exclusively writes in English, her "Chinese novels" are critically read as attempts to "present China from within, as the Chinese see it" (Bentley 792). Although it is arguable whether Buck's life in China translates into a Chinese perspective in her writing, the novel's unique creative background, plot, cross-cultural perspective, and narrative strategy present nuanced layers of the politics of transcultural encounters. Writing as an American impersonating a Chinese writing in English, Buck problematizes a monolithic Western approach to her texts, in the sense that her Chinese narratives call for nothing less than a transnational interpretation. Such cross-cultural perspective creates a duality that makes Buck's texts English rearticulations of her Chinese experience and Chinese narratives reproduced in English. These transnational potentials have yet to be fully realized, despite the phenomenal success of the 1937 Hollywood adaptation of *The Good Earth*, which casts Western actors as Chinese characters. Over the next six decades or so, only a lukewarm

interest remained in the adaptations of her Chinese narratives, and Buck's novels did not attract strong attention from major film studios, despite the popularity of her works among American readers and her fame as a Nobel Prize winner.

Foregrounding the intrinsic transcultural duality in *Pavilion of Women*, its Chinese-American joint cinematic adaptation *Tingyuan li de nüren* epitomizes the complicated media flow, cross currents of cultural politics, and hierarchical socioeconomic dynamics in cinematic industries between China and the United States. On one hand, the film is based on a novel about China written by an ethnic other and cultural outsider, who appropriates her Chinese experience through literary re-creation; on the other hand, the film is adapted by a Chinese screenwriter who claims cultural and social authenticity while asserting her influence as an independent American producer. Thus, *Tingyuan li de nüren* becomes a layered tale of both "outsider looking in" and "insider looking out" as it translates/adapts what is already translated/adapted (in its literal sense) by Buck.

Tingyuan li de nüren genderizes and hierarchizes the China/US dichotomy through its dramatization of China's encounter with modernity in the story of a Chinese woman's romantic relationship with a Western man. Madam Wu of the wealthy Wu family lives comfortably as she manages the family business in a small town in preliberation south China in 1938. On her fortieth birthday, Madam Wu makes a surprising announcement that she will choose a second wife for her husband, who is sexually exploitative, greedy, and insensitive. As Madam Wu savors her newfound freedom and autonomy after peasant girl Chiu'ming becomes her husband's second wife, her life changes when the American missionary André is invited to teach her son Fengmo English at Fengmo's Western-educated fiancée's request. Madam Wu finds herself increasingly attracted to André and his Western ideals, and André sacrifices himself to save Madam Wu from the atrocities of the Japanese soldiers during the Japanese invasion. After his death, Madam Wu continues to manage the orphanage that André established.

While the ethnographic subjugation of China to her Western superior is unmistakable, *Tingyuan li de nüren* demonstrates its feminist potentials with a provocative plot that further accentuates its transcultural duality. In additional to homologous yet dichotomized character parallels and a postcolonial interaction between Madam Wu and André, the making of the film provides extradiegetic discourses on the China–US dynamics.

Born and raised in China, Chinese American actress-turned-screenwriter/ producer/actor Luo Yan was a popular film actress in China before she went to the United States in search of new professional development in 1986, and her Chinese background is strategically marketed in the United States and China to promote this film's transcultural status. *Tingyuan li de nüren* engages Buck's novel into a perfect representational *tête-bêche* framework, in the sense that while Buck portrays Chinese women as an American writer in China, Luo Yan reimagines Buck's characters as a Chinese filmmaker in America. Such a contrapuntal creative process between Luo and Buck makes this transnational film adaptation a unique prism through which nuanced cultural politics, gender discourses, and representational strategies are refracted.

As the first jointly made film between a major Hollywood studio (Universal) and a government-owned Chinese film studio (Beijing Film Studio), *Tingyuan li de nüren* pioneers Chinese national cinema's aggressive participation in remapping the global mediascape and transnationalist entertainment consumption. This film is not only a significant event in the history of Sino-American cultural cooperation, it also demonstrates the Chinese film industry's attempt at exploring diversified modes of media production to promote national soft power and transnational influence in reimagining the other. Evidencing such globalizing efforts is its casting of Hollywood actor Willem Dafoe to maximize its marketability internationally, and its conscious promotion of "Asian American actors' role in Hollywood casting practices," which gave Korean American actor John Cho one of his early roles in feature films (Kokas 79).

The intricately layered texts that exemplify a textual/cultural/representational palimpsest are analogous to a cinematic infinity mirrored room, which provides an open space where previously established dichotomies such as global/local, self/other, and original/translation become fluid binaries. As the film synthesizes linguistic, media, and cultural transformations, it epitomizes the intersections between global cultural translatability and local media literacy, in the sense that while Buck's novel imagines Western readership, the film reinscribes the local within the global. This attempted reinscription in turn potentializes a cinematic and political countergaze, which aims for the represented and looked-at to disrupt the hegemony of representation. As Luo Yan explains in an interview, *Tingyuan li de nüren* promotes its global cultural translatability by adopting Hollywood's typical formulae to guarantee box office attraction, including the classic three-act structure, where the protagonists meet and separate and reunite,

casting Dafoe as a major actor for audience attraction, location shooting in Suzhou for high-quality production, and a brief visual spectacle of the Nanking massacre to impress Western audiences who are not familiar with this subject (Fang). While a predominantly East Asian cast and the location shooting appeal to its Chinese audience, the central element of its increasing local media literacy is a carefully orchestrated promotional campaign that packages the film as a celebration of Chinese women's search for freedom, brought to the Chinese audience by a real Chinese woman whose search for freedom and success in Hollywood becomes another layer of the intricate interaction of the global and the local.

Despite its record-setting production values, *Tingyuan li de nüren* encountered diametrically different receptions in the United States and in China. It was neither commercially successful nor favorably received by film critics in the United States. With a budget of US$5 million, its US box office gross was a meager $35,938. Responses and reviews from major US media ranged from sympathetic disappointment to downright criticism; at best, it is "sweepingly romantic," and at worst, it is "bland and trite" (Clark; Kempley; Koehler; Major (102); Morris; Scott; Thomas). Strategizing on its transnational cultural capital, *Tingyuan li de nüren* entered the Chinese market with confidence and ambition. In addition to advertising bombardments that spotlight the unprecedented Sino-American coproduction, this film appealed to national patriotism by emphasizing its contribution to a better international understanding of modern Chinese history and its national cultural narrative. Tagging itself as "the first mainstream Hollywood film that exposes the atrocities of the Japanese invasion of China, and the first mainstream Hollywood film that portrays the People's Liberation Army in a positive image" (Liu), *Tingyuan li de nüren* demonstrates an unmistakable intention to remain politically correct for the local market.

This marketing strategy met with passion and high expectations in China: almost all major media outlets in the ten cities that premiered *Tingyuan li de nüren* covered this event. Even China's official state newspaper, *People's Daily*, paid much interest and called *Tingyuan li de nüren* "the first Chinese made Hollywood film" ("First Chinese-Made"). *Tingyuan li de nüren* premiered in China fourteen days earlier than the advertised global premier on 4 May 2001 as a significant gesture that demonstrates the producer's high evaluation of the Chinese market. This special treatment for Chinese audiences made a remarkable commercial return, and the film enjoyed a decent start in Beijing and Shanghai, the

most significant thermometer cites in Chinese national cinema. Despite a very encouraging five-day box office gross of 500,000 RMB (US$62,500) in Beijing, contracted distributers suddenly decided to cancel the screening of *Tingyuan li de nüren* and switched to *Ziri*, a film of domestic production.[3] As a result, *Tingyuan li de nüren* did not see the commercial success it anticipated, but its experimentation on transnational cultural cooperation suggests an increasingly globalized Chinese film market that is enthusiastically catching up with its North American counterpart.

Tingyuan li de nüren's Chinese reception exemplifies regularizing global media politics in the transcultural consumption of entertainment products. When asked to comment on the audience labeling her film as the "Chinese *The Bridges of Madison County*," Luo Yan says, "both films are about sentimental love stories, and they are of the same genre. It is a pleasure that my audience makes this connection" (Li and Shen). As diplomatic as it sounds, Luo's response to the cross-cultural comparison evidences a global media discourse that is both homogenizing and paradigmatic because it is symptomatic of a normalizing gender narrative. Juxtaposing *The Bridges of Madison County*'s hypersexual romance with *Pavilion of Women*'s much more complicated interactions between a Western priest and a Chinese woman, Luo Yan's comment strategically conditions the audience's expectation, tapping into a globalized text that solidifies preexisting assumptions of a Western love story through its international circulation. This comparison effectively obscured *Tingyuan li de nüren*'s intricately layered subtext of gender dynamics and its unique transnational cultural politics, ultimately revealing its underlying Eurocentric discourses.

Translated Subaltern

Tingyuan li de nüren makes a curious decision to use English instead of Chinese as the film's language, which counteracts its attempt at cultural authenticity through location shooting and an almost entirely East Asian cast. When Chinese characters from servants and street vendors to ladies and lords in mansions all speak English in their southern Chinese hometown, it becomes apparent that linguistic (in)translatability underlies global cultural hegemony. The politics of such linguistic representation not only forces the represented Chinese in this film to become muted subalterns but also translates the subaltern's silence into a structuring absence that lies at the bottom of a linguistic "lack."

When English is chosen as a preferred lingua franca as well as a superior language for the subaltern subjects, the normative and normalizing paradigm becomes Eurocentric. As a Chinese audience watches the film that is "dubbed back" in Chinese, the awkward dis-synchronization between speakers' mouth shapes and their delivery of the lines adds to the "foreignness" of a film. Confronted with questions on this linguistic choice, Luo Yan gives this explanation: "Although this film is about a story that is set in China in the 1930s, the majority member of our cast and crew are either American born Chinese or foreigners to China (so they do not speak Chinese). Besides, we plan to distribute this film internationally, which is why English is the working language for all the dialogues in the film" ("Sino-American"). This is apparently true if cost-efficiency is the only concern. However, it is precisely her emphasis on the inevitability of English that exposes the silent subtext: English is not a choice of necessity but a choice of preference. In other words, *Tingyuan li de nüren* was never meant for a Chinese audience since it is ultimately meant for an "international audience." Nor is it meant for a genuinely international audience, who, by general principle of authenticity, would probably prefer the Chinese-speaking Chinese. Luo Yan's rationale necessarily designates English as an international language and at the same time prioritizes an English-speaking audience. That it is produced by a Chinese American and filmed on location in China is merely a necessary "translation" of Buck's Chinese landscapes into visual spectacles.

As many film critics are quick to point out, the English soundtrack is "a serious drawback" that "undercuts its impact" (Major; Thomas). Although the use of English language appears to be "commercially sensible" to some (Major), others believe that is both "painful to watch the Chinese actors struggle with their lines" (Scott) and disappointing to an audience that expects to watch it with English subtitles instead of an English soundtrack (Koehler; Major; Thomas). Sometimes, the mixed use of English and Chinese can create confusion and disjunction. For instance, when André writes down his Chinese name in Chinese calligraphy style with a brush pen on a piece of rice paper, Madam Wu exclaims, "You can write in Chinese?" and continues to talk to André in English.

What such critiques fail to recognize is the politics of representation endorsed by this linguistic anachronism, which incarnates what Shohat and Stam observe in their discussion of linguistic dominance in cinematic representation:

Although languages as abstract entities do not exist in hier-archies of value, languages as lived operate within hierarchies of power. Inscribed within the play of power, *language becomes caught in the cultural hierarchies typical of Eurocentrism.* English, especially, has often served as the linguistic vehicle for the projection of Anglo-American power, technology, and finance. Hollywood proposed to tell not only its own stories but also those of other nations, and not only to Americans but also to the other nations themselves, *and always in English.* (191; emphasis added)

As Stam and Shohat point out, English as a preferred language for Hol-lywood is first and foremost instrumental to the inscription of Eurocen-trism. Such hegemonic cultural politics becomes even more debilitating in translation. If we believe that translating is "a simple miming of the responsibility to the trace of the other in the self" (Spivak 179), then the Chinese are the linguistically castrated Others to the Anglo-American Self. The linguistic "trace" of the Other, as Spivak points out, is literally lost when the Self obliterates its voice.

English is invested with symbolic meanings and believed to be a privileged pathway to the superior Western modernism and civilization. Madam Wu invites André to teach Fengmo English because his fiancée expressly asks for it. Here, English serves as a sign of modernity as it stands for advancement, and the ability to speak English is perceived as an advantage that increases one's status in marriage. The significance of Fengmo's foreign education gains Mrs. Wu's approval and her approval of hiring an English tutor, which opens the Wu family to André. The learning of English in the film becomes an act of appropriating and exploiting the economic powers brought about by the mastery of the language. What privileges André's social status is his knowledge of Western medicine, of modern science, and his ability to speak English.

The film adaptation does not stop at the transplantation of English to China, it also moves André's birthplace from Italy to the United States, which is a familiar preference of Hollywood. Thus, André has the trinity of powers: he is sociolinguistically superior, intellectually advanced, and ideologically more civilized because of the meanings the word "Ameri-can" entails in this context. Not surprisingly, Madam Wu is a perfectly matched Other to André: she is already inferior by being a woman, and

her knowledge of modern science is almost nonexistent. When Eurocentrism ventriloquizes the subaltern in English and pushes the audience to focalize through André, the subaltern women suffer a loss of her agency in the obliteration of her voice.

This power dynamic between Madam Wu and André sets its tone as early as the scene in which they first meet. On her fortieth birthday, Madam Wu hears that her close friend, Madam Kang, is in critical condition during her labor and goes to see her in a great hurry. Stepping down from her boat and hastily running up the stairs to the Kang family, Madam Wu trips. André is also going upstairs to help the Kang family, so he catches her just in time. This scene firmly puts Madam Wu under André's male gaze. The camera takes the position of André, and uses a medium-close, high-angle, over-the-shoulder shot at Madam Wu as she looks up at André and clings to his shoulder in her desperation to regain balance. Then the camera cuts back to Madam Wu's point of view, which angles up at André in a close-up, as background music starts to romanticize the encounter. The camera stays on André's face for almost two seconds before it cuts back to a two-shot of Madam Wu and André as they look at each other. In this scene, Madam Wu is visually portrayed as vulnerable, dependent, and in need of protection and help, whereas André is the strong, genteel, polite Western man who protects. While Madam Wu is decisively sexualized to highlight the disenfranchised female subject as the bearer of the male gaze, her representational subjugation determines her otherization.

The rhetoric of the camera is always the politics of the text. As Michael Ryan and Douglas Kellner eloquently point out, "every camera position, every scene composition, every editing decision, and every narrative choice involves a representational strategy that embeds various interests and desires" (217–18). Incarnated in André, a positive image of a powerful Western man is carefully established and successfully maintained in this film at the cost of the shameless exploitation of the representation of Chinese women and the construction of an inferior social order characterized by otherness. Forced to speak the language of her superior Other, the subaltern woman relives her experience through translation and is doubly removed from her agency in articulation. Symptomatic of this underlying social-lingual power discourse, the use of English in a Chinese film (or a film about Chinese and China for that matter) is therefore isomorphic to the alienated semiotics of the camera, which

preclude the possibility of identifying with the subaltern woman and forbids her discourse, both verbally and visually.

Sexualized Narrative

The act of translation is sexualized in similar ways as the exotic representation of Chinese culture and characters in the film. The subjugation of Madam Wu's agency is realized through her act of literal translation, which effectively transforms her from the subject/gazer to the bearer of the male gaze. In this English-speaking China, apparently there are still things that need to be translated from Chinese to English, and one of them is *Huangmei xi* (黄梅戏), a traditional local drama in China that is sung in the southern dialect and performed by women only. When the town is going to have electricity for the first time, people celebrate the event by inviting a group of professional *Huangmei xi* performers to perform *Liang Zhu* for the public. It is a very popular story of a girl who disguises herself as man to be with her lover in ancient China. As they are watching it, Madam Wu translates the story for André since he does not understand the dialect. When Madam Wu watches the play with André, her gaze is that of a feminine one: her interpretation of the story to be a "girls' story" centers her femininity in this embedded meta-narrative. As soon as she begins to translate for André, Madam Wu gradually yet irrevocably positions herself not as an interpreter but as the character from the play, desiring her lover. Her feelings toward André are filtered through dialogues from the play, and as André gazes at her, Madam Wu is demure, and shy, and she avoids his eyes. In the swiftly edited shot/countershot pattern between Madam Wu and André, he is always in an extreme close-up shot whereas she is in close-up. In other words, André is always bigger and closer to the audience than Madam Wu is, which secures his position as the visual dominance.

In this scene, Madam Wu's translation of the lovers' words is invested with her own burgeoning tender feelings toward André, who is obviously aware of her superimposing her translation of the lyrics and the expression of her emotions. The blurred line between theatricality and realism disrupts the construction of Madam Wu's female "gaze." Before she reveals the end of the *Liang Zhu* story to André, he finishes the story for her, saying, "All love stories end the same, don't they?" His final comment

powerfully appropriates the "girls' story" by situating it in a male-centered system. As this story is "the same" as other "love stories," it ceases to be "a girls' story" as Madam Wu reads it. Such objectification of women as spectacle is "characteristic of the male-centered narrative" (Thornham 52). Therefore, when André facilitates a male spectatorial position that turns Madam Wu into the bearer of his male gaze, he appropriates her narrative of the story and turns it into his own masculine narrative. This act of translation produces a discourse that allows André to subjugate Madam Wu's agency in telling her narrative. Not surprisingly, *Liang Zhu*, a play by women, becomes a purloined story that deprives the women's film of its female agency and ultimately turns into a metacinematic performance for male pleasure.

André's Eurocentric dominance is further accentuated through the universality of English in the next scene. Immediately after watching *Liang Zhu*, André introduces Madam Wu, Fengmo, and Chiu'ming to what he considers a "Western *butterfly* story," *Madama Butterfly*. Significantly, when André plays a record of *Madama Butterfly* to Madam Wu, Fengmo, and Chiu'ming, he does not feel obliged to translate it for them and merely says, "Just listen," despite the fact that the opera is sung in Italian, a language none of the Chinese characters understand. Evidently, *Madama Butterfly* serves as the Western counterpart of *Liang Zhu*, and the absence of translation here presupposes the universality of Western-ness. This Western linguistic superiority is firmly reinforced visually when Madam Wu, Chiu'ming, and Fengmo all listen intently, as if they are able to intuit the lyrics without a translation.

The subjugation of Madam Wu's agency is not confined to the act of literal translation. Through spectatorial positioning and mise-en-scène, the cinematic representation of Madam Wu visually "translates" her sexual enslavement to adapt to the male scopophilic pleasure. Epitomized as a typical Chinese preliberation upper-middle-class family, the Wus exemplify what Shohat and Stam argue to be indispensable in the construction of the discourse of empire (137–40). The non-Western social and racial mechanisms are the "allegorical motifs [that] played a constitutive role in 'figuring' European superiority," without which such binaries as West/East, civilization/backwardness, and masculine/feminine are not complete (Shohat and Stam 137–40). The allegory of empire is constitutive of Eurocentrism and often structured through the rape and rescue fantasy, where the Western man saves the indigenous woman from her savage attacker.

Contrary to what the novel suggests, the film adaptation represents Mr. Wu as a sexually abusive sadist who only takes pleasure in forced

oral sex with women. Therefore, Madam Wu volunteers to find her husband a second wife mostly because she wants sexual freedom, rather than spiritual freedom, as the novel repeatedly emphasizes. On the night of Madam Wu's fortieth birthday, Mr. Wu again forces her to perform oral sex despite her unwillingness. In this scene, the camera assumes a voyeuristic position by hiding behind the bedpost. The surreptitiousness of the shots invites comparison to a hidden surveillance camera, which emphasizes Madam Wu's position as the bearer of the scopophilic gaze, or her "to-be-looked-at-ness," as Mulvey would suggest in her discussion of classic Hollywood cinematic narrative (20). Slightly shaking and blurry, the camera leads the audience into the bedroom of the Wu couple and makes them witness a scene of rape. The portrayal of Madam Wu as a victim of domestic sexual abuse naturally engenders the need for a rescuer. When André enlightens her to the Western ideals of love and happiness and becomes romantically involved with her, his positions as rescuer of the victimized Madam Wu is firmly established.

This victim and rescuer relationship is a familiar manifestation of Eurocentrism. According to Shohat and Stam, the trope of "rape and the rescue fantasy forms a crucial site in the battle over representation" (156). By the same token, for Madam Wu to be represented as an oppressed and abused victim, her husband has to assume the position of a victimizer. In the dichotomies of West/East, monogamy/polygamy, man/woman, we can always construct this sentence: the Western monogamous man saves/rescues the Eastern woman from polygamy. Instead of allowing Madam Wu to structure her discourse and center the narrative identification, such representation of heterosexual relationships actually denies her agency and autonomy as it surrenders her to the disenfranchising masculine gaze of Eurocentrism.

Contrary to the eroticized portrayal of the relationship between Mr. and Madam Wu, Madam Wu and André must have a platonic relationship, not because of André's profession as a priest but because an interracial romance could threaten the normative superiority of the West. Shohat and Stam claim that "the denial of any erotic intercourse between Europeans and Non-Europeans had the further advantage of maintaining the myth of the West's ethnic 'purity'" (157). Not only is ethnic purity maintained by the absence of visual representation of sex between André and Madam Wu—indeed, the audience is never allowed to know for sure if there is a sexual relationship between them—André's romantic but not explicitly sexual involvement with Madam Wu also restores the matriarchal Wu family to an anthropologically normative family model: a patriarch. As

André symbolically "rescues" Madam Wu from Mr. Wu's sexual abuse, he becomes in effect the "father" of this family.

This fatherly role is emphasized through André's increasingly intimate interactions with almost all of the Wu family members, which allows him to destroy what he believes to be a dysfunctional matriarchal family and rehabilitate it to a Eurocentric prototype of patriarchy. The Wu family is a matriarchy before André comes, and second only to Mrs. Wu, Madam Wu's mother-in-law and matriarch, Madam Wu is in charge and manages family business and personally arranges her husband's marriage to the second wife. Although she has never openly disagreed with Mr. Wu, Madam Wu is always able to maneuver him for her own purposes. Her passive-assertive plan of regaining personal freedom by giving her husband a second and much younger wife best illustrates her strategy of dominance through obedience. However, when Madam Wu meets André, she subordinates herself to the intellectually, morally, and emotionally superior Western man, as the latter assumes a fatherly/Fatherly figure to Fengmo. André's suggestion that Madam Wu let Chiu'ming leave at least partially caused the death of the matriarch Mrs. Wu, who dies of a sudden heart attack while scolding her son for disgracing the Wu family by mistreating his second wife and driving her away, and finally secures his own position as the patriarch of the family.

The fact that André dies to save Madam Wu from the atrocities of the Japanese invaders is another form of the rape and rescue fantasy, and this glorified sacrifice of his life effectively announces the end of the narrative even though the film still goes on for about eight more minutes. That Madam Wu lives is nothing significant in itself, nor does it reinstate matriarchy to the Wu family, because Madam Wu has been successfully transformed by André's Western ideals and beliefs and internalizes a Eurocentric perspective. What becomes significant is that Madam Wu lives to be another André, one who continues what André has been doing all the time: taking care of the orphanage children, the symbolic children of the Father/father André and Madam Wu.

Schizophrenic Cinema

The incompatibility between *Tingyuan li de nüren*'s avowed feminist theme and the cinematographic reinscription of Eurocentrism is crystalized through the desynchronization between visual and verbal narratives. When

information obtained from such vocal channels as dialogues or background sound effects conflicts with what is mediated through the cinematographic apparatus, such as the size and distance of the shot and mise-en-scène, previously buried ideologies and sociopolitically motivated text surface. In other words, the film's extradiegesis (i.e., camera movements, mise-en-scène, and its intradiegesis or storyline) are like the film's warring halves; their polarizing forces bring to light the deeply embedded cultural politics and gender discourses of the film. This double nature carries politicized implications and in turn potentializes a critical space that pries open the working of conflicting ideologies. Metaphorically, this conflict is the film text's schizophrenia, where destructive and deconstructive power results from the clashing interaction between the normalized and hence naturalized Eurocentrism in André's representation and this film's feminist gender politics and its transcultural potentials.

One scene is particularly revealing of this incongruence between the alleged theme of women's pursuit of happiness and the underlying patriarchal Eurocentric politics. Careful reading of this scene enables the viewer to discover that Madam Wu cinematographically relinquishes her agency to André, and her inferior and subordinate relationship to André becomes normalized visually. The scene happens immediately after Chiu'ming, the young second wife, attempts to hang herself but is rescued by André. In this scene, André comes to ask Madam Wu to set Chiu'ming free. The beginning shot is a slightly blurred medium close-up shot of Madam Wu, who is obviously upset about Chiu'ming's suicide attempt and the scandalous love affair of Chiu'ming and Fengmo, which is probably the reason for Chiu'ming's desperation. Taken from behind a plant, this shot impresses viewers as voyeuristic, which highlights Madam Wu's position as a fetish object. The angle and the function of this camera position are reminiscent of the earlier scene in which Madam Wu is sexually abused by her husband in the bedroom. Indeed, the voyeuristic pattern turns this scene into a reenactment of the bedroom scene—only this time Madam Wu is ideologically and morally conquered by André and is therefore deeply disenfranchised.

Cinematographically, the blurred shot subtly discourages the audience's identification with Madam Wu and precludes the possibility of a feminine perspective. As André walks into the frame and initiates their conversation, the shot/countershot convention disrupts the intradiegesis of the film by the positioning of the camera and frame composition. When André enters from top left of the frame, the camera cuts to a full two-shot

from low angle, portraying Madam Wu and André sitting face to face. This is a typical establishing shot that introduces the series of shots and countershots in a conversation. Instead of matching the eye level of the speakers as the camera cuts back and forth between them, the camera uses to use low-angle medium long shot when it cuts to Madam Wu and eye-level close shot when it moves back to André. In other words, viewers almost always "look down" at Madam Wu while they can look into André's eyes. So, when audience looks at Madam Wu, they "hide" behind the plant, but when they look at André, they are significantly closer. This visually puts Madam Wu at a further distance and emphasizes her inferiority to André, which determines of the loss of her agency.

On the other hand, the camera invites the audience to identify with André, to share his feelings, and to establish a spectatorial position that is pleasurable to male viewers. Even before he starts to speak, the camera indicates his domination and tilts down to accommodate his action as he walks toward Madam Wu and sits down. At the beginning of their conversation, Madam Wu is situated at the left half of the frame, which typically enjoys more cinematographic dominance than the right half. In the middle of the conversation, Madam Wu becomes indignant and stands up, moving to the right side of the screen, thus giving her agency back to André, who now occupies the "good" and thus more powerful side of the frame. As Madam Wu sits down at the lower right corner of the screen, André stands up from the left side of the frame and walks toward where she sits. His movement visually reinforces this change of power dynamics: he is mobile, taller, bigger, better lit, and more powerful, and she is immobile, smaller, submissive, darker, and less powerful. Madam Wu has to look up when she speaks back to André, and her vulnerability and smallness are unmistakably accentuated. Verbally, she is accusing André, saying, "Who do you think you are? Savior? You can save the Chinese children, the Chinese? Why don't you save yourself, your own country!" Visually, she is being judged and criticized by the camera the same way she is being criticized and blamed by André, and we as spectators are forced to assume the position that deprives her of her agency. André's moral indignation and didacticism echo the "rape and rescue fantasy," but this time he is trying to "rescue" Madam Wu's moral conscience and compassion as defined by normalizing and regularizing Eurocentric/Christian moral standards. Strongly appealing to the ears of an audience that is educated in Western civilization and liberal humanism, André's speech is ultimately the projection of a value system that is alien to the

accused. Therefore, as this film is firmly "rooted in a Euro-American perspective and . . . return(s) to the Hollywood tradition of representing China as an exotic land," its global cultural translatability becomes an empty promise (Zhang 291).

Tingyuan li de nüren's underlying narratives of male dominance and Eurocentric gender politics translate into another layer of global media literacy as the film's DVD cover design further solidifies André's masculinity and dominating power. Against a background of fire and smoke caused by war and destruction, André and Madam Wu are captured in their most intimate moment: this image is taken in the deserted temple, where they take shelter from a sudden rain during a walk together in the woods. Again, André is positioned at the more powerful left side and in action. Holding Madam Wu's face with his hands, André is kissing her on the forehead. Here Madam Wu is completely passive; she is merely reacting to what is done upon her. That André's kiss is on her forehead is crucial to our understanding of his Eurocentric characterization. On the one hand, it is decidedly less sexual when isolated out of context from the film; on the other hand, compared with a kiss on the lips, his kiss on the forehead does not disqualify his religious background and the Western cultural ideology he embodies, because the kiss powerfully resembles that of a priest instead of a lover. In other words, André and Madam Wu are shown less as man and woman, or Western man and Oriental woman, but as holy father and his child.

The film's attempt at obtaining global cultural translatability through local media literacy remains superficial. As mentioned, spectacles of war are used to attract international audiences and appeal to local nationalism and patriotism. Yet the DVD cover exploits the historical and local the same way a theatrical play uses props: the Sino-Japanese war is visualized as decoration to create the effect of realism. While the glorified image of a savior is enhanced by the background of flame and fire in the midst of war that ravaged the town, the visualization of war is so small and peripheral that it is entirely reduced to the background, only to foil the sentiments of relief and serenity advertised by André and Madam Wu. Such superficiality accurately captures how the political context is perfunctorily represented in the film: a brief conversation at a wedding banquet, a few words in a funeral, or a threat to join the communist army if the father must arrange the marriage for the son. The DVD cover design serves as one of the most immediate visual indicators of the film's cinematic genre and cultural appeal, so the strategically orchestrated visuals of war and

love, romance and suffering, and Caucasian man and Chinese woman create a constitutive framework where the hegemonic gender and cultural hierarchies are preconditioned if not predetermined.

As an initial experimentation on West-East popular entertainment exchanges in form (international film coproduction) and content (transnational film adaptation), *Tingyuan li de nüren*'s cultural, political, economic, and social significance cannot be overstated.[4] The pronounced discrepancy between expectations on this film's transnational appeals and its mediocre reception problematizes its global media translatability, where the feminist potentials in a woman's story are cinematically subdued and subjugated and give way to deeply embedded masculine Eurocentrism, so the promised feminist gender narratives become fragmented, discursive, and ultimately subalternized. As its English title suggests, the film allegorizes an exoticizing cinematic frame of a traditional Chinese pavilion, where Chinese women bear the Orientalizing gaze as they confront the tripartite oppression of masculinity, white ethnocentrism, and modernity. The significance of *Tingyuan li de nüren* necessarily goes beyond its market performance, because its commercial and critical failure evidences the disenchantment with its Eurocentric gender discourse in the global mediascape, and more importantly provides empirical guidelines that help future transnational endeavors navigate the treacheries of cross-cultural film coproductions.

Notes

1. 庭院里的女人 in Chinese, literally, "women in the courtyard." *Tingyuan li de nüren* was released internationally under the title *Pavilion of Women*, and I use its Chinese title to separate the film from Buck's novel.

2. The Chinese title is 群芳亭 Qun Fang Ting.

3. The reason behind this unusual decision was later reviewed by unnamed personnel from Xin Ying Lian, the distribution company in Beijing, explaining that *Ziri* (*The Purple Sun*), a film about the Sino-Japanese war, has a patriotic theme that is better suited for the International Labor Day holiday. Because of a series of diplomatic conflicts with Japan around that particular time period, the distributor believed that *Ziri* had a stronger patriotic appeal to the Chinese audience. What remains unsaid is perhaps equally, if not more, important: since the International Labor Day holiday is one of the longest holiday seasons in China, films can typically enjoy very high box office returns if they hit the theaters during this period. Being one of the corporate investors in *Ziri*, Xin Ying Liang (the distributing company) would want *Ziri* to take over the holiday season ("Poorly Regulated").

4. There have been quite a few coproduced films between the United States and China since this 2001 film. Notable among them are *The Forbidden Kingdom* (dir. Robert Minkoff, Casey Silver Productions, 2008), *The Karate Kid* (dir. Harald Zwart, Overbrook Entertainment, 2010), *Snow Flower and the Secret Fan* (dir. Wayne Wang, IDG China Media, 2011), *Man of Tai Chi* (dir. Keanu Reeves, China Film Group, 2013), *Hollywood Adventures* (dir. Timothy Kendall, Beijing Enlight Media Co., 2015), *The Great Wall* (dir. Zhang Yimou, Legendary East, 2016), *Born in China* (dir. Lu Chuan, Disneynature, 2016), and *The Meg* (dir. Jonathan Turteltaub, CMC Capital Partners, 2018). Compared with *Tingyuan li de nüren*, these films demonstrate a greater genre diversity and box office revenues that range from hugely successful to mildly satisfactory. They also engage with a wider variety of social, gender, cultural, and identity issues.

Works Cited

Bentley, Phyllis. "The Art of Pearl S. Buck." *English Journal*, vol. 24, no. 10, 1935, pp. 791–800.

Clark, Mike. "Overstuffed Plot Undermines Sexy 'Pavilion'." *USA Today*, 3 May 2001, http://usatoday30.usatoday.com/life/movies/2001-05-04-pavilion-review. htm. Accessed 3 August 2022.

Fang Zheng. "*Pavilion of Women* Arrives in Guangzhou, and Luo Yan Talks about Her Business Strategies." *Sina.com*, 26 April 2001, http://ent.sina. com.cn/m/c/41279.html. Accessed 3 August 2022.

"First Chinese-Made Hollywood Film to Show Worldwide." *People's Daily Online*, 31 Mar. 2001, http://en.people.cn/english/200103/31/eng20010331_66477. html. Accessed 3 August 2022.

Kempley, Rita. "'Pavilion of Women': Buck Stumbles Here." *Washington Post*, 4 May 2011, www.washingtonpost.com/wp-srv/entertainment/movies/reviews/ pavilionofwomenkempley.htm?noredirect=on.Accessed 3 August 2022.

Koehler, Robert. "Pavilion of Women." *Variety*, 3 May 2001, www.variety.com/2001/ film/reviews/pavilion-of-women-1200468582/. Accessed 3 August 2022.

Kokas, Aynne. *Hollywood Made in China*. U of California P, 2017.

Li Xuan and Chen Shen. "Luo Yan's Promotion for *Pavilion of Women* in Nan- jing." *Sina.com*, 26 April 2001, http://ent.sina.com.cn/m/c/41308.html. Accessed 3 August 2022.

Liu Zhen. "Luo Yan: Hailaiwu Diyiwei Zhongguo Zhipian Ren." *Chinanews. com*, 26 April 2001, www.chinanews.com/zhonghuawenzhai/2001-07-01/ txt/25.htm. Accessed 3 August 2022.

Major, Wade. "Pavilion of Women." *Boxoffice Magazine*, July 2001. https://www. yumpu.com/en/document/read/26533427/boxoffice-july2001. Accessed 3 August 2022.

Morris, Wesley. "Pavilion of Women." *San Francisco Chronicle*, 4 May 2001, www.sfgate.com/movies/article/FILM-CLIPS-Also-opening-today-2925749.php. Accessed 3 August 2022.

Mulvey, Laura. *Visual and Other Pleasures*. Indiana UP, 1989.

Ryan, Michael, and Douglas Kellner. "The Politics of Representation." *The Philosophy of Film: Introductory Text and Readings*, edited by Thomas E. Wartenberg and Angela Curran, Blackwell, 2005, pp. 213–24.

Scott, A. O. "Film in Review; 'Pavilion of Women'." *New York Times*, 4 May 2001, www.nytimes.com/2001/05/04/movies/film-in-review-pavilion-of-women.html. Accessed 3 August 2022.

Shohat, Ella, and Robert Stam. *Unthinking Eurocentrism: Multiculturalism and the Media*. Routledge, 1994.

"Sino-American Co-produced Hit Pavilion of Women Premiers." *Sina.com*, 5 Apirl 2001, www.ent.sina.com.cn/m/c/38816.html. Accessed 3 August 2022.

Spivak, Gayatri Chakravorty. *Outside in the Teaching Machine*. Routledge, 1993.

Thomas, Kevin. "Pavilion of Women: 'Pavilion' Visits the Past and Stays There." *Los Angeles Times*, 4 May 2011, www.latimes.com/archives/la-xpm-2001-may-04-ca-59067-story.html. Accessed 3 August 2022.

Thornham, Sue. *Passionate Detachments: An Introduction to Feminist Film Theory*. Arnold, 1997.

Tingyuan li de nüren 庭院里的女人 [Pavilion of Women]. 严浩. Directed by Yim Ho, Beijing Film Studio, 2001.

Zhang Yingjin. *Chinese National Cinema*. Routledge, 2004.

Chapter 7

Gendered Screens

Women, Space, and Social Transformation in the Works of Contemporary Chinese Female Filmmakers

YANHONG ZHU

"Come back! Come back!" Qiuyun, a female opera performer who excels in playing masculine roles, runs across the stage calling for Zhong Kui, a legendary demon tamer and her most celebrated stage persona, and confesses, "Ever since I was little, I have been waiting for you to come tame the demons and save me!" The painted face of Zhong Kui appears in the background and announces the purpose of his trip, "I have come specially to marry you off." "You have married me to the stage," Qiuyun responds. "Any regrets?" "No! No!" Qiuyun cries out and rushes to the back of the stage with open arms to embrace Zhong Kui, whose painted face disappears as he bids her farewell. When the camera zooms out and the lights go on, Qiuyun continues to wander on the stage, as if looking for traces of the ghostly persona who has long been an essential part of her identity.

This is the ending scene of Huang Shuqin's *Ren Gui Qing* (*Human, Woman, Demon*, 1987). Critically acclaimed as China's first feminist film, *Human, Woman, Demon* explores the predicament of women and the question of women's salvation through the tale of a female artist's journey of self-discovery. The ending scene visually brings Qiuyun and Zhong Kui—the woman and her idealized savior—in the same frame, but Zhong Kui, as Dai Jinhua argues, serves as "no more than an empty

157

and hopeless ritual of naming, an obscure utopia about salvation" (163). The claim of her marriage to the stage without regrets, although voiced as a rebuttal to the promise of salvation through marriage, is also a "bleak soliloquy on her loss of identity," because Qiuyun's artistic success comes at the expense of concealing her female beauty and becoming one with her role (Li 123).

Human, Woman, Demon is not intended to be a radical feminist outcry, but it nonetheless succeeds in expressing a distinctly female perspective. Such a personal and gendered perspective can rarely be found in China's socialist cinema, in which political ideologies usually overpower individual interests and women's cinematic representation as well as women's filmmaking are often marked by a strong tendency toward gender erasure (Cui 213). In postsocialist China, the Chinese film industry has developed immensely with the rise of market economy, but women filmmakers continue to face significant challenges in the male-dominated and commercially driven industry, so that "a subjective women's cinema," as Shuqin Cui observes, "finds scant possibilities" in China's film market (214).

Despite the challenges, many women directors followed in Huang Shuqin's footsteps. As a result, since the 1990s and especially the 2000s, many Chinese women directors, such as Li Shaohong, Peng Xiaolian, Ning Ying, Li Yu, and Xu Jinglei, have made films that focus on exploring issues pertinent to women and the questions of women's consciousness from a variety of female perspectives. This chapter aims to examine the films of two directors—Peng Xiaolian and Xu Jinglei, who represent different generations of female filmmakers in mainland China—through the lens of space, and seek to unpack how representation of spatial conditions are connected to gender relations and women's changing position in contemporary Chinese society. I argue that space in their films serves not only as a physical location where stories unfold but more importantly as a site to investigate how the processes of social transformation affect the spatial order of contemporary Chinese society and the formation of female consciousness.

Space, Cinema, Gender

Toward the end of the twentieth century, there was what scholars refer to as a "spatial turn"—the emergence and proliferation of a new mode of

spatial thinking in terms of social and cultural analyses—in the humanities and social sciences. The source of inspiration for this theoretical turn is often attributed to Henri Lefebvre's influential work *The Production of Space*, in which the traditional notion of space as a passive container is replaced with a new understanding of space as a "productive process," so that the actual process of spatial production rather than "things in space" becomes the object of our interests and space is seen as both the "product and producer" of social relations (Lefebvre 36–37, 142; Y. Zhang 2). As Soja aptly puts it, Lefebvre's space is "simultaneously objective and subjective, material and metaphorical, a medium and outcome of social life" (45).

Similar to Lefebvre's emphasis on space as a dynamic process, feminist geographer Doreen Massey, in her discussion of the intricate connection of space and place with the construction of gender relations, also stresses the significance of understanding the inherent dynamism in space. Massey insists that rather than viewing space as stasis or place as "singular, fixed, and unproblematic in its identity," the spatial "can be seen as constructed out of the multiplicity of social relations across all spatial scales," from the global to the local, from the national to "the social relations within the town, the settlement, the household and the workplace," and as a way of thinking that is tied closely to the "ever-shifting geometry of social/power relations" (4–5). Emphasizing the interconnection between space and gender because both are socially constructed and dynamic in nature, Massey contends that space and place "are gendered through and through. . . . And this gendering of space and place both reflects and *has effects back on* the ways in which gender is constructed and understood in the societies in which we live" (186; emphasis in original).

Since its inception, cinema has reflected and constructed gender relations and served as a medium through which challenges to dominant gender norms and gender inequality can be raised (Hole et al. 1). It has also been recognized as a special space that combines "objective input" and "subjective experience" and brings together "spaces of different nature," both real places and imaginative or alternative locations through cinematic manipulations (Rosário and Álvarez 1). With the spatial turn across disciplines, space has been further acknowledged "as a central methodological and analytical category" in cinema and media studies (Zimmermann 25), paving the way for new theoretical explorations of the nature and function of space in cinema. Because space and cinema represent and construct gender codes and relations, space becomes a particularly useful lens for

examining the complex relationship between cinema and space as well as the representations of gender and femininity in the cinematic space.

The ending scene of *Human, Women, Demon* features the stage, which is a theatrical space that is both confining and liberating for Qiuyun. It is at once a space where she has to hide her female identity to take on a male role and a space where she, as a female artist, can fully express her artistic skills. The double and ambiguous meaning of this space denotes Qiuyun's ultimate predicament: being caught between the traditional and the modern, harboring the impossible dream of salvation through marriage, and awakening to the ills of gender inequality and the power of artistic expression. Just like Huang Shuqin, who explores the construction of gender identity and consciousness through the theatrical space in *Human, Women, Demon*, Peng Xiaolian and Xu Jinglei also strive to examine the complex relationship between gender and space in their films.

A 1982 graduate of the Beijing Film Academy, Peng Xiaolian is usually considered a member of the fifth-generation filmmakers, along with many of her prominent classmates, including Zhang Yimou and Chen Kaige. Unlike her male classmates who won international fame with their grand historical narratives and national allegories, Peng is interested in the details of everyday life, especially women's lives, in China's changing society. In S. Louisa Wei's words, Peng is "the ultimate female auteur," as she is at once a filmmaker, a screenwriter who wrote and co-wrote the screenplays of almost all of her feature films and documentaries, and a prolific writer (157). Her feature films demonstrate a keen interest in exploring women's experience and portraying "independent and articulate female characters," who constantly struggle against the patriarchal social order in Chinese society (Wei 160).

Peng also shows a special interest in filming Shanghai, where she was born and grew up. In an interview, she says, "There are numerous stories in every corner of Shanghai. Behind each window of each house, there is a melody of life with different movements. How can I not attempt to portray them in my films?" (Houlang Dianying) The lives and fates of the female characters in her films are often intricately tied to the ever-changing city of Shanghai and its public and private spaces, seen especially in films such as her Shanghai trilogy: *Jiazhuang mei gan-jue* (*Shanghai Women*, 2002), *Meili Shanghai* (*Shanghai Story*, 2004), and *Shanghai lunba* (*Shanghai Rumba*, 2006), as well as her last film *Qingni jizhu wo* (*Please Remember Me*, 2018).

Also a graduate of the Beijing Film Academy, Xu Jinglei, almost twenty years Peng's junior, was trained in acting rather than directing. By the early 2000s, Xu was already a star, taking lead roles in popular TV series *Jiang aiqing jinxing daodi* (*Cherish Our Love Forever*, 1998) and hit films like *Kaiwang chuntian de ditie* (*Spring Subway*, 2002) and *Wo ai ni* (*I Love You*, 2002). Feeling unfulfilled as an actress, Xu decided to become a director and made two films, *Wo he baba* (*My Father and I*, 2003) and *Yige mosheng nüren de laixin* (*Letter from An Unknown Woman*, 2004). Her third feature film, *Mengxiang zhaojin xianshi* (*Dreams May Come*, 2006), is a low-budget avant-garde experimental film scripted by the famous contemporary writer Wang Shuo, featuring a single-location setting (a hotel room) and a lengthy dialogue between a female actor and a male director in which the actress expresses her frustration with acting in stereotypical roles and "pretending to be pure." In her blog introduction of the film, Xu Jinglei claims *Dream May Come* was made at a moment when she felt as if she was lost and could not find meaning in life, and that the film resonated with her own unsatisfaction with her status as an actress and served as a review of her past endeavors and a prospect for her future explorations (Xu). Her decision to become a director comes out of her determination to overcome the passivity inherent in being an actor and assert more active control over her artistic expression (Guo, "*Wenyi*" 45; Yi).

Dreams May Come also marks a major turning point in Xu's directorial career, as her next films, *Du Lala shengzhi ji* (*Go Lala Go!*, 2010), *Qinmi diren* (*Dear Enemy*, 2011), and *You yige difang zhiyou women zhidao* (*Somewhere Only We Know*, 2015), all witness a decisive popular and commercial turn. As the first female director to break the 100 million RMB box-office threshold, Xu Jinglei has established herself as one of the most prominent and commercially successful female directors in mainland China. Her films differ greatly in terms of style, genre, and subject matter, but they all, in one way or another, explore the questions of gender and female subjectivity, demonstrating Xu's conscious efforts to search for new ways to represent women and the facets of their experience.

Peng Xiaolian and Xu Jinglei have different training and backgrounds, different artistic sensibilities, and different ways of approaching women's issues in film. Using the lens of space and tracing the representation of three specific types of space—the domestic space, the urban space, and the eternal space of art—in their representative works, this chapter examines

the different ways space is constructed and represented in their films. I argue that although Peng Xiaolian and Xu Jinglei, through their cinematic representations of space, demonstrate different understanding of social transformation and its impact on traditional gender roles and women's relationship to space, both seek to create alternative sites to examine the dialectic relationship between women's victimization and empowerment, marginalization and resistance.

The Unhomely Home:
My Father and I and *Shanghai Women*

The term "the home," according to feminist geographer Linda McDowell, is probably "one of the most loaded words" (71). McDowell points out that while male theorists, such as Heidegger and Bachelard, described home and dwelling in preindustrial idyllic ways, endowing it with "connotations of shelter and security, of pleasure, and as a storehouse of memories," post-1968 feminist writers emphasized how the division of urban space into private and public arenas brought out by Western industrial capitalism had greatly affected women's lives and status, so that home "is alternatively a site of disenfranchisement, abuse, and fulfillment" (72–73). The home or the domestic space, therefore, is often seen by feminist critics as a space that embodies patriarchal values and reinforces gender differences.

Xu Jinglei's *My Father and I* and Peng Xiaolian's *Shanghai Women* explore women's experience by depicting important family relationships in the domestic sphere. *My Father and I* shows the evolving relationship between Xiao Yu and her father as she goes through various stages of her life, from teenage years to adulthood. *Shanghai Women* details the relationship between Mama and her teenage daughter, Ah Xia, as they struggle to find stable housing. These films feature a female perspective on domestic life and experience, and their narratives unfold primarily in the space of home. The home in these films, however, is depicted as a Janus-faced space that is at once familiar and strange, invoking a sense of security and belonging and a strong sense of displacement and alienation. Building on Freud's notion of the uncanny, which in German is literally the *unheimlich* (un-homely), Dwayne Avery develops the concept of "unhomely cinema" by exploring home and place in global cinema and argues that the unhomely, which "refers to the unnerving way in which the familiarity of home can quickly become alien, precarious and foreboding"

(3), should best be understood in terms of its liminality and hybridity, as it borders between the inside and outside and fuses the private and public spheres (15). Following this line of argument, the home in *My Father and I* and *Shanghai Women* can be seen as an unhomely space in which the status of women is threatened internally by domestic uncertainty and externally by forces of social change.

My Father and I is Xu Jinglei's directorial debut, and it won several awards, including the Best New Film Director award at China's most prestigious film festival, the Golden Rooster Awards, in 2003 (J. Zhang 295). The film is a female bildungsroman of its central character, Xiao Yu, whose transition from girlhood to womanhood is explored through her evolving relationship with her father, Lao Yu. Xiao Yu grows up with her divorced mother and only comes to know her father after her mother's sudden death. As Xiao Yu slowly warms up to her newly established relationship with her father, Lao Yu is imprisoned because of his involvement in the prostitution business. After he is released from prison three years later, Xiao Yu decides to get married and move to Shanghai despite her father's objections. Her marriage does not go well, and she leaves her husband and returns home pregnant. To provide a better life for Xiao Yu and her baby, Lao Yu engages in gambling. One day in the midst of a police raid, Lao Yu suffers a hemorrhagic stroke, becomes paralyzed, and loses the ability to speak. Xiao Yu takes care of her father until he dies, and the film ends when she remarries.

Using Xiao Yu as the voice-over narrator, *My Father and I* offers a unique women's perspective and reveals "the psychological depth of the female character" through a double narrative that combines off-screen background explanation and narration of emotions with on-screen actions (J. Zhang 300). As we follow the voice-over through various stages of Xiao Yu's life, it becomes apparent that her progressive growth, development, and maturity are closely tied to her relationship with her father, whose alternating presence and absence result in cycles of disintegration and reestablishment of the family. Xiao Yu's experience of home shifts between familiarity and alienation as her relationship to the domestic space changes along with the changes in her relationship with her father. After her mother's death, Xiao Yu starts living with her father, who has not been in her life before. The home that Xiao Yu is familiar with when living with her mother has suddenly become unhomely with the "intrusion" of her father. She often shuts herself in her room, and the closed door demarcates the physical separation between her and her father and

signals their emotional distance from each other. As she gradually gets to know Lao Yu through conversations and meals, the sense of familiarity slowly comes back and culminates in the scene in which Xiao Yu leans closely toward the back of her father, trying to discern his smell while he is cooking. Their physical proximity and the emotional closeness the scene demonstrate accentuate the return of the sense of home and belonging. Lao Yu's arrest and subsequent imprisonment, however, makes home unhomely again for Xiao Yu, as she is left to survive on her own, and she later decides to get married and move away. When her marriage fails, the pregnant Xiao Yu moves back home, and her father takes care of her and her newborn baby with much love and care. Home becomes a safe haven again for Xiao Yu, a place where she feels comfortable, secure, and protected. She also matures as her relationship with her father deepens, urging him to stay home rather than engaging in shady activities and claiming that her home will only be like a home when he is in it. Throughout the film, the unhomely and homely feelings alternate, and the fluidity of these changes highlights the instability of the domestic space that Xiao Yu calls home.

The instability of Xiao Yu's home comes both from the fluctuating relationship with her father and his changing status of being present or absent and from the impending yet invisible threat from the outside. To create a sense of security at home, Lao Yu strives to make money. As Shaohua Guo observes, Lao Yu represents the opportunist urban hooligan generation popularized by Wangshuo's writings in the 1980s when China started market reforms and social restructuring, but as the country continues to integrate into the global economy in the new millennium, the hooligan generation is bound to witness its own downfall ("Acting" 318–19). The public places that Lao Yu frequents, particularly the bar that he runs with his friends with the underground prostitution business and the room in which he gambles to accrue illegal wealth, ultimately become sites of tragedy, as he is arrested at the bar in front of Xiao Yu and suffers a paralyzing stroke when the police raid the gambling room. Lao Yu's presence in these precarious public places leads to his absence at home and his failure to maintain its security and stability. The domestic interior space of home, therefore, is inseparable from the public exterior space of the changing society. Struggling through the various stages of her life in her unhomely home, Xiao Yu has to negotiate the liminal space between the interior and exterior, the private and the public. In

this space, Xiao Yu gains a clearer sense of herself and responsibility, and she eventually matures and becomes the caretaker of her paralyzed father until his death.

Peng Xiaolian's *Shanghai Woman* is a tale of mother and daughter and their struggle with housing. Adapted from Xu Minxia's first-person short story "Standing at the Tail End of Teenage Years," the film follows a similar bildungsroman motif and portrays the teenage girl Ah Xia's coming-of-age journey as she moves from place to place with her mother through her marriages and divorces. Haiping Yan points out that the film "issues an intermedial move" that turns the focus from female becoming of the literary text to an embodied intermediality that combines constructed filming sites of domestic interiority and actual openings and architectural constellation of Shanghai in its cinematic rendition ("Inhabiting" 97; "Intermedial" 43–46). Within this intermedial space that defies the usual binary division between the "private home" and "public street," Ah Xia's changing relationship to others around her and her mobile presence in the city turns her into "a figure and exponent of the very mobility and differentiality of the city itself" (Yan, "Intermedial" 46).

Unlike *My Father and I*, which uses Xiao Yu as the voice-over narrator, *Shanghai Women* changes from first person in the original story to third person in the film. Peng Xiaolian once said that Xu's story made her see "a window, a suppressed family, and the unexplainable bewilderment of a teenage girl," but what really intrigued her to adapt the story into a film was the trail of behavior of the mother and daughter, as she could feel their "sense of not belonging and emotional insecurity" through their continuing process of relocating and house hunting (Ma 43). The film focuses not only on Ah Xia's coming-of-age journey but more importantly on Mama's emotional turmoil and her struggles as a woman who is never at home at her own home. While Ah Xia wrestles with the issue of home and homelessness by diving into the busy city streets on her bike, Mama is seen to be struggling primarily in the interior space of home. All three homes she has been in are unhomely. When she finds out that her husband has been cheating on her for more than two years, she cries alone in the kitchen. When she confronts him, he coldly says that she can take anything, including her daughter, but the apartment is his and has nothing to do with her. Mama moves to her mother's house with Ah Xia after her divorce, but her mother urges her to look for housing immediately as her younger son needs the house for

his marriage. To provide Ah Xia a stable home, Mama marries Lao Li. When their clash culminates in their argument over the water bill, Lao Li claims that he is the one who has paid for this apartment and accuses Mama of using him as a food stamp. Mama's ex-husband comes back to ask her to remarry him, but his comment that "Don't you just try to get a bed to sleep on?" is more than insulting.

Domestic space is "the material representation of the social order" (McDowell 72). Mama's marginalization at home and her deprivation of housing are indicative of gender inequality in contemporary China, especially at a time of rapid social change. The film demonstrates that the privatization of housing in China with the deepening of economic reform further perpetuates the patriarchal hierarchy of the society. It shows that male employees tend to get a housing subsidy from their companies to purchase and own apartments while working-class women with limited income usually cannot afford housing on their own (Wei 164). A shot of a massive housing complex that dominates the mise-en-scène accentuates Mama's emotional anguish, which the film seeks to represent, as it emphasizes the sense of homelessness in the face of abundance of homes that she has no access to. Mama's homelessness reflects precisely the prominent power inequality in the domestic space due to lack of home ownership, which consequently reinforces traditional gender roles, pushing her to cook, clean, or carry out sexual duties in marriage without being treated as an equal. While Ah Xia travels in the liminal space between the private home and public city, Mama seems to be imprisoned in the domestic space by patriarchal and economic constraints. Peng Xiaolian is particularly interested in exploring the fate of women like Mama who are caught in the middle between responsibility for her daughter and instinct to fight for herself, between traditional values and modern development. Mama's resilience and strength shines through at the end of the film when she buys an apartment of her own using the money from her divorce settlement. Although old, the apartment is situated on the banks of Suzhou River, which is a space that mediates between the old and the new. It used to be Shanghai's filthiest river, but as the city modernized, Suzhou River also underwent a significant transformation. With an apartment that sits at the river bank and overlooks the modern skyline of Shanghai, Mama has finally freed herself from the patriarchal confinement of her previous unhomely homes, embracing a new world with her own homely home.

The Modernizing City:
Go Lala Go! and Shanghai Story

The urban space of the city has always been at the center of scholarly inquiry examining the relationship between space and cinema. The urban space has been seen as a site where cinema demonstrates its close ties to the issues of modernity and social transformation. Xu Jinglei and Peng Xiaolian grew up in urban settings and are interested especially in exploring women's experience in urban spaces in contemporary China. Xu Jinglie's *Go Lala Go!* and Peng Xiaolian's *Shanghai Story* are set in the city, one in Beijing and the other in Shanghai. The urban space, however, is represented very differently in these films. Xu Jinglei focuses on Beijing's modernized cityscape to highlight its integration into the globalized world. Peng Xiaolian fixes her camera on the disappearing architectural landscape of Shanghai.

Go Lala Go! is adapted from Li Ke's bestselling internet novel *A Story of Du Lala's Promotion* and traces the career trajectory of Du Lala, who ascends from an entry-level secretary to HR manager in the fictional foreign-invested Fortune 500 corporate firm DB, as well as her romantic relationship with her co-worker David. The novel and its TV and film adaptations are immensely popular, and the hard-working Lala serves as a model for young career women who aspire to succeed in global corporations. As Leung Wing-Fai points out, the novel and its media adaptation make it possible to "reflect on the gender discourse in China's corporate office populated by a new class of white-collar women working for foreign investment companies" (131).

In contrast to the traditional, local, and private space of home explored in *My Father and I*, *Go Lala Go!* focuses on the modern, global, and public space of a foreign firm. The film opens with a collage of shots of the skyscrapers of downtown Beijing, emphasizing the modern and metropolitan appeal of the city's landscape. To further accentuate the global characteristic of the city, the film uses close-ups of the high-rises to conceal the identity of the architectural landmarks, creating a global space that is marked by its universality. Lala's career aspirations and achievements are visualized in the corporate workspace of DB, which is situated at the heart of Beijing's business center and represented as modern, organized, and populated with professionally dressed personnel. The film "emphasizes the global imaginary of middle class lifestyles" in

contemporary China, seen from the frenzied product placement from famous brands such as Lenovo, Cartier, Lipton, Nokia, and Mazda, just to name a few (Guo, "Acting" 321; Leung 133–34). With the help of Hollywood fashion designer Patricia Field, who worked on *Sex and the City* and *The Devil Wears Prada*, Lala's transformation from an office "ugly duckling" to powerful career woman is shown through her change of work attire, and the adornment of internationally renowned designer clothes and accessory goods from such brands as Gucci, Roger Vivier, Tod's, Dior, Valentino, Hermès, and others, ostensibly displays her rise in rank (Cai 84).

Lala's success signals a strong message of women's empowerment in the new urban workspace opened up by the forces of global capitalism. By deemphasizing the gender inequality and the hierarchical structure in the workspace detailed in the original novel and focusing instead on consumer lifestyle and the love story, the film adaptation seems to lose "the potential to comment on gender and power in contemporary Chinese society" (Leung 135). While glorifying the workspace of the aspiring middle class under the effects of globalization, the film also undermines its own glorification by acknowledging the forces of alienation inherent in such space. In a scene that shows DB's orientation session, the workspace is defined by its implementation of standard operating procedures, which, exaggerated in an example, gets into such details as to regulate the way one walks at work, for example—which foot starts first, how high the foot should be lifted, and how big of a stride one can take. The corporate workspace, with its universality and global characteristics and strict emphasis on stan-dardization, not only creates a sense of displacement but also suppresses individuality and true human connection. Thus, the workspace is a space of both opportunity and alienation, where career aspirations are in constant tension with personal pursuits of love and happiness. When Lala chooses to adhere to the company rule of not disclosing HR decisions to David, she ruins her relationship with him. It is not until she travels to Thailand and meets him again that they finally get back together. As spectators who enjoy the visual splendor and love plot of the film, we cannot help but look back at the new urban workspace that the film creates and reevaluate its significance. It is a space that is defined by its global quality and luxurious middle-class lifestyle, but have we, as the spectators, also become lured and displaced into "a not-so-everyday world" where we are set to "enjoy alienation itself"? Have the mediated images tapped into our desire and fantasy to the extent that our "lived space gives way to a world fashioned by Technicolor images?" (Conley 16–17).

Unlike Xu Jinglei, who explores the cosmopolitan and global character of Beijing in *Go Lala Go!* with stunning shots of modern skyscrapers, Peng Xiaolian turns her attention to the cityscape of Shanghai in transition in *Shanghai Story*. In her essay on making this film, Peng writes about her experience of taking a stroll in the city upon returning to Shanghai from her U.S. study:

> I saw that a lot of Shikuman alleyways were being demol-
> ished. When I heard the loud sound of pile driving, I almost
> dared not look that way. . . . Maybe people here all hope for
> changes—bigger or more complete changes, as if they can only
> see "progress and improvement" through change. However,
> for us who have travelled afar, we always hope that a part of
> tradition can be preserved in change. . . . Only after seeing
> numerous skyscrapers, can one appreciate the value and beauty
> of the Shikuman houses in Shanghai; only after experiencing
> other cultures, can one realize the significant impact our own
> traditional culture has on our lives. (Peng, "Meili Shanghai" 13)

In Peng Xiaolian's opinion, although Shanghai has transformed into a global metropolis, it is a shame that much of its traditional architecture is torn down, as each house has its own story and can be used to frame a film (Huang). As a result, *Shanghai Women* features grandma's Shikumen-style house, a type of residential architecture that is most quintessentially of Shanghai character. *Shanghai Story* is set in a Western-style garden house (*huayuan yangfang*), a type of private housing built mostly in the former French concession that later turned into communal residence unique to Shanghai's urban living space. The film narrates the story of a family, whose matriarch, the elderly mother, becomes hospitalized, prompting her four children, who live in different places, to get together, solve their conflicts, and form a stronger bond.

Set in the space of a Western-style house, the film evokes "nostalgia for the traditional communal space" and highlights "the uncertainty, anxiety and pain" created by Shanghai's urban transformation, shown especially at the ending of the film when it is revealed that the house is going to be demolished to make room for highway construction (Zeng 111). Li Zeng observes that *Shanghai Story* offers "a subtle commentary on the gendered cityscape" by contrasting the lives of two siblings—second sister Jingwen and third brother A Rong, revealing how globalization may have benefited the rising middle class represented by A Rong, a successful lawyer and

entrepreneur, while further marginalizing women like Jingwen, who has come back to the city after participating in the sent-down movement and is struggling to raise her daughter after her divorce (114). However, Peng Xiaolian is not interested in focusing on women's victimization, but on women's strong volition for independence. In a scene where Jingwen and A Rong clash on whether she should give up her low-income job to take care of their mother, Jingwen claims that even though her job is mediocre, she is self-sufficient. In an interview, Peng Xiaolian uses this scene as an example to argue that the premise of women's happiness is not necessarily a complete family but their independence and ability to survive in the society as individual beings (Peng and Jia 34).

Framing the film narrative in the Western-style garden house, Peng Xiaolian also attempts to look back into history and confront historical trauma, as the house itself testifies the historical trajectory of Shanghai from the early Republican period to the present. The fate of this family, who used to live a comfortable life, changed completely when the father was beaten to death during the Cultural Revolution. Peng Xiaolian's own father, Peng Baishan, was also beaten to death during the Cultural Revolution. In a memorial essay, Peng writes, "As much as I try to write, revise, and rewrite the episode of my father's death, I still cannot do it. I don't know why after thirty years I still do not have enough courage to confront those cruel days" ("Wode fuqin"). The scene in which the mother brings up the father's death with Xiao Mei in *Shanghai Story* serves a climactic moment in which the repressed memories and emotions can be released and a medium through which Peng Xiaolian revisits her own traumatic past. The pending demolition of this Western-style house, accentuated by the astounding sound of pile driving in the ending scene reveals not only the disturbing impact of globalization on the city landscape and the lives of ordinary people like Jingwen who are marginalized and displaced, but also the possible erasure of history and memory, creating a radical rupture from our personal and collective past, from tradition.

Across Time and Space:
Somewhere Only We Know and *Please Remember Me*

As a medium of moving images, cinema is an art of both time and space. A filmmaker, as Babette Mangotte points out, "constructs a 'sense of

time' and 'a sense of space' in every film," both of which "are inextricably intertwined and meshed into the fabric of film itself" (262). In the afore-mentioned films Xu Jinglei and Peng Xiaolian explore the experience of women in China's changing society primarily through the lens of space, whereas in *Somewhere Only We Know* and *Please Remember Me* they strive to create dialogues across time and space.

Xu Jinglei's *Somewhere Only We Know* interweaves two love stories of two generations, both of which are set in Prague but in different time periods, one in the present and the other in the 1940s during World War II. The film unfolds as Jin Tian travels to Prague to seek a fresh start of her life after losing her only family member, her beloved adopted grandmother, and being jilted on her wedding day. She meets and falls in love with Peng Zeyang, but their love is tested as they strive to cope with their emotional turmoil and sense of insecurity and uncertainty. Jin Tian's personal journey of self-renewal and discovery is intertwined with her search for her grandmother Lanxin's past. Through flashbacks, the film reconstructs the romance between Lanxin and Dr. Novak. As an art student helping out at a clinic in war-torn Prague, Lanxin warms the heart of Novak, who has been devastated by the assumed death of his wife and child in a German concentration camp. Just as Novak rekindles his passion for life and decides to move to China with Lanxin, he finds out that his wife is still alive. Lanxin decides to return to China by herself.

Often called *cainü* (talented woman), Xu Jinglei tends to imbue her films with a strong *wenyi* flavor, literally meaning having elements of "letters and arts." Examining the role *wenyi* plays in Xu's films, Shaohua Guo contends that while Xu's *Letter from an Unknown Woman*, an adaptation from Austrian writer Stephan Zweig's 1922 novella in the same title, uses *wenyi* elements to evoke European imaginary and cultural nostalgia to construct female agency, *Somewhere Only We Know* mobilizes *wenyi* elements to project a tourist gaze of Prague and enhance the star appeal of its actors as a response to the increasing commercialization of Chinese film market ("*Wenyi*" 46–53). Prague, however, is more than a material place representing the tourist allure of Europe for Chinese audience. As the camera pans through the city, accompanied by the most famous movement of Czech composer Bedřich Smetana's *Má Vlast* (My Homeland), shots of the buildings, streets, statues, and the Vltava River form a cinematic space that cuts across time. If time is defined by its linearity, space can be understood to operate in a way that resists the linear progression of time and acquires a sense of stability and eternity in the midst of our

temporal life. A goddess statue serves as the central artifact in the film: this is where Novak makes his promise of love to Lanxin, where Jintian and Zeyang find strength to love each other despite uncertainty over their future, and where Novak meets Jintian, wrapped in the knitted shawl he gave Lanxin almost sixty years ago. The goddess statue, with its quality of durability and translatability across culture, bridges the gaps of time and interweaves the tales of love that have crossed national and cultural boundaries. Xu Jinglei says that *Somewhere Only We Know* is a "love letter" she has written to her grandmother to "commemorate the beautiful times and love" they have had, and that the film functions as a "shared memory" of two generations (Lu 15). Written and directed with love, this film uses space to explore the essence of love, which is represented as being at once temporal and eternal. As temporal beings, humans may only be able to fulfill and materialize our love contingent on circumstances sometimes beyond our control. Even though life is ephemeral, love can be eternal, just like Prague and the goddess statue, lasting through time and transcending cultural differences and spatial distances.

While Xu Jinglei seeks to explore the eternal aspect of love in our fleeting lives, Peng Xiaolian also strives to find permanence in impermanence by preserving the legacy of our rapidly disappearing past. As S. Louisa Wei points out, apart from being a filmmaker, Peng Xiaolian is also a prolific writer, and her fiction and nonfiction writing reveals "unabashed self-reflexivity and repeated encounters with the haunting past" (170). Peng usually engages self-reflexivity in her works by re-creating "the real-life figures and events that interest her," most frequently through "remediation between film and writing" (171). If the remediated content between her memoir *Tamen de suiyue* (*Their Times*) and her documentary *Hongri fengbao* (*Storm under the Sun*, 2009) focuses on her family history and China's historical past, revolving particularly on the "Anti–Hu Feng Counterrevolutionary Clique" campaign of which her father was a victim, Peng turns her attention to the golden age of Chinese cinema and reflects on the impact that social transformation and technological advancement have on China's film industry in her final feature film *Please Remember Me* and her essay "Jiaopian de wendu" ("The Warmth of Film").

Please Remember Me examines the love and pursuit of film art by two generations. It opens with Cai Yun, a local opera performer from a small town, coming to Shanghai to pursue her dream of becoming a film star. She stays with her childhood friend A Wei, who is working with a female director on a low-budget *wei dianying* (microfilm) that explores

the lives and works of Republican-era film stars and real-life couple Zhao Dan and Huang Zongying. Peng Xiaolian's 2006 film *Shanghai Rumba*, loosely based on Zhao Dan and Huang Zongyin's real experience, serves as an earlier homage to these artists. By using the narrative structure of film-within-a-film, *Please Remember Me* offers a more comprehensive account of their love and support for each other, their traumatic experience during Cultural Revolution, and ultimately their passion and dedication to film art.

The cinematic space *Please Remember Me* creates cuts across time and space by weaving together a plethora of narrative threads, such as clips from classic films, documentary interview footage, impersonation acting, and real and imaginative dialogues between the two generations. What permeates the film is a strong sense of nostalgia for the golden age of Chinese cinema and a sense of uncertainty and frustration over the current situation. The latter is reflected by the portrayal of a female director who is marginalized in the commercialized film market (much like Peng herself) and Cai Yun, who represents the younger generation with dreams of becoming a star but no knowledge of classic cinema or the traumatic history of the recent past. The film stresses the significance of cherishing the past because it enriches our present and future, particularly by depicting Cai Yun's personal growth through her dialogues with Huang Zongying, both in real life during the interview sessions and in imagination, shown in the striking scene where she talks about her dreams to the younger Huang Zongying, who comes to life from a picture.

The most important theme this film examines is thus remembering, which echoes the title of the film. Although Peng originally had different titles in mind, she accepted the suggestion of the distribution company and affirmed that this film is indeed about remembering—remembering history, tradition, classic films, and the spirit of the earlier generation of film artists (Peng, "Jiaopian" 83). The very act of remembering reveals a sense of urgency to preserve that which is fleeting and slipping away, and the physical celluloid film, in Peng's opinion, is a perfect medium through which the ephemeral can be made to last. The film stock features prominently in *Please Remember Me*. In A Wei's work room, the numerous rolls of film and an old-fashioned projector allow him and Cai Yun to learn about the past and communicate with the film artists they admire in creative ways. Peng Xiaolian writes that when she saw the news that Shanghai Film Technology Plant, established in 1957, was about to close its last film processing line, she sadly realized that it meant "the end of

an era" ("Jiaopian" 11). In contrast to digital technology, which makes filmmaking easily accessible, the celluloid "invokes a sense of awe towards cinema" (13) and makes it material and tangible (5), capable of "freezing reality onto the film" in an instant (14).

The power of cinema, however, lies beyond its materiality. In the same essay, Peng Xiaolian laments how films such as *Wu Xun Zhuan* (*The Life of Wu Xun*, dir. Sun Yun, 1951) was used as a weapon for class struggle in the turbulent years of political movements ("Jiaopian" 32), but she also admires the perseverance of Zhao Dan, who starred in *The Life of Wu Xun* and was severely persecuted during Cultural Revolution, and she praises his and Huang Zongying's spirit of dedication and their attitude of "living-unto-death" despite adversity (81). The ending scene of *Please Remember Me*, as Peng Xiaolian explains in her essay, represents precisely this sense of living-unto-death (84). As A Wei rides his auto-bike back to the Shikumen house he rents, he sees a giant bulldozer stretching its claw and pushing down the wall of the Shikumen building, which later collapses into a cloud of smoke. The demolition of Shikumen houses reveals the disappearance of the architectural heritage of Shanghai in face of rapid urban transformation; more importantly, it symbolizes the dissolution of a particular cinematic vision. In a scene in which A Wei interviews actor Xu Caigeng from Shanghai Film Studio on the roof of a Shikumen building, Xu explains that the Shikumen houses were the homes of the ordinary folks of Shanghai in the Republican era, and the leftist filmmakers often set and shot their films here because they were interested in exploring the lives of the poor rather than the rich. The demolition and collapses of the Shikumen houses in the ending scene becomes the metaphor of the deteriorating working condition of the marginalized filmmakers like Peng Xiaolian in the environment of the increasingly capital- and profit-driven film industry in contemporary China.

Peng Xiaolian concludes her essay "The Warmth of Film" by comparing digital film to Shikumen houses and argues that despite their glory, digital data can also be lost when the equipment breaks, just like the Shikumen houses, but celluloid film can last for hundreds of years and preserve all the films from the golden age of Chinese cinema that is eternal ("Jiaopian" 110). Some may argue that digital data is safer and better for preservation, but what Peng really seeks to express here is her nostalgia for the celluloid, not merely as a format but also as a cultural experience and the values it represents. Peng Xiaolian uses her film to bid farewell to the era of celluloid, to create dialogues between

the younger and older generations of film artists, and to pay homage to the golden era of Chinese cinema in her uniquely creative and reflective ways. *Please Remember Me* testifies precisely that cinema, in celluloid or digital form, is capable of capturing and preserving the fleeting realities of the world and creating an artistic space that is long-lasting and eternal. Peng Xiaolian, as a female auteur, will forever be remembered through her films and writing.

Conclusion

Chinese women's cinema, as Lingzhen Wang contends, defies "uniform interpretation" as Chinese women filmmakers have demonstrated their agency, reconfigurations of gender roles, and articulations of aesthetic and historical understanding through diverse cinematic engagements with various forces (39). Xu Jinglei and Peng Xiaolian have different training and backgrounds, but they are both interested in exploring women's experience in their work. Through the lens of space, this chapter examines how three types of space—the domestic space, the urban space, and the artistic space—are represented respectively in Xu's and Peng's films, seeking to further illuminate the compromises and renegotiations these filmmakers need to make in the current situation, in which they have to at once respond to the demands of commercialization and their own artistic aspiration to probe deeper into the issues pertinent to women in contemporary China. Both portray the domestic space as unhomely, but their views toward the impact of modernization and social transformation on women are very different. Xu Jinglei seems to take on a more optimistic outlook by casting a forward-looking gaze at the modernized cityscape and the globalized world, which provide women with opportunities of career advancement and greater mobility despite inherent or unavoidable difficulties. Peng Xiaolian, on the other hand, seems to be more pessimistic, as the women in her films often become even more marginalized as the city moves forward in its urban transformation. Rather than looking forward to new changes, Peng often turns her attention to the historical past to resist the forces of forgetting. What these filmmakers share, however, is their belief in the enduring legacy of cinematic art. With its power of technological reproduction and artistic recreation, cinema can withstand the progression of time and create an eternal space that preserves the fleeting traces of our experience.

Works Cited

Avery, Dwayne. *Unhomely Cinema: Home and Place in Global Cinema*. Anthem, 2014.

Cai, Shenshen. *Contemporary Chinese Films and Celebrity Directors*. Palgrave Macmillan, 2017.

Conley, Verena Andermatt. *Spatial Ecologies: Urban Sites, State and World-Space in French Cultural Theory*. Liverpool UP, 2012.

Cui, Shuqin. "Searching for Female Sexuality and Negotiating with Feminism: Li Yu's Film Trilogy." *Chinese Women's Cinema: Transnational Contexts*, edited by Lingzhen Wang, Columbia UP, 2011, pp. 213–32.

Dai Jinhua. "'Human, Woman, Demon': A Woman's Predicament." *Cinema and Desire: Feminist Marxism and Cultural Politics in the Work of Dai Jinhua*, edited by Jing Wang and Tani E. Barlow, Verso, 2002, pp. 151–71.

Du lala shengzhi ji (Go Lala Go!). Directed by Xu Jinglei, DMG Entertainment, 2010.

Guo, Shaohua. "Acting through the Camera Lens: The Global Imaginary and Middle Class Aspirations in Chinese Urban Cinema." *Journal of Contemporary China*, vol. 26, no. 104, 2017, pp. 311–24.

———. "*Wenyi, Wenqing*, and Pure Love: The European Imaginary in Xu Jinglei's Films." *Journal of Chinese Cinemas*, vol. 12, no. 1, 2018, pp. 41–58.

Hole, Kristin Lené, Diljana Jelača, E. Ann Kaplan, and Patrice Petro. "Introduction: Decentering Feminist Film Studies." *The Routledge Companion to Cinema and Gender*, edited by Kristin Lené Hole, Diljana Jelača, E. Ann Kaplan, and Patrice Petro, Routledge, 2019, pp. 1–12.

Houlang Dianying (Post Wave Film). "Daoyan Peng Xiaolian: Xiezuo shi wode jiushu, pai dianying shi wode mengxiang" (Director Peng Xiaolian: Writing Is My Redemption, Filmmaking Is My Dream). *Douban dianying* (Douban Movie), 3 Dec. 2018, https://movie.douban.com/review/9798373/ (accessed 25 Sept. 2021).

Huang, Bin. "*Chenbao* dujia zhuanfang *Meili Shanghai* daoyan Peng Xiaolian: Shanghai, meidong fangzi doushi chuanqi" (Morning Post's Exclusive Interview with Peng Xiaolian, the Director of *Shanghai Story*: Shanghai, Each Building Is a Legend). *Xinwen chenbao* (Shanghai Morning Post), 20 Sept. 2004.

Jiang aiqing jinxing daodi (Cherish Our Love Forever). Directed by Zhang Yibai, Galloping Horse Productions, 1998.

Jiazhuang mei ganjue (Shanghai Women). Directed by Peng Xiaolian, Shanghai Film Studio, 2002.

Kaiwang chuntian de ditie (Spring Subway). Directed by Zhang Yibai, Electric Orange Entertainment, 2002.

Lefebvre, Henri. *The Production of Space*. Translated by Donald Nicholson-Smith, Blackwell, 1991.

Leung Wing-Fai. "Product Placement with 'Chinese Characteristics': Feng Xiaogang's Films and *Go Lala Go!*." *Journal of Chinese Cinemas*, vol. 9, no. 2, pp. 125–40.

Li, Xingyang. "The Voice of History and the Voice of Women: A Study of Huang Shuqin's Films." *Chinese Women's Cinema: Transnational Contexts*, edited by Lingzhen Wang, Columbia UP, 2011, pp. 113–31.

Lu Fang. *"You yige difang zhiyou women zhidao* reying: Xu Jinglei shuo zheshi xiangei nainai de qingshu" (*Somewhere Only We Know* in Theater: Xu Jinglei Claims the Film Is a Love Letter to Her Grandmother). *Jinri zaobao* (Today Morning Express), 13 Feb. 2015, p. 15.

Ma, Xinfang. "Peng Xiaolian yu tade Shanghai qingjie" (Peng Xiaolian and Her Love of Shanghai). *Shanghai caifeng* (Shanghai Wave), no. 2, 2013, pp. 40–43.

Mangotte, Babette. "Afterward: A Matter of Time Analog versus Digital, the Perennial Question of Shifting Technology and Its Implications for an Experimental Filmmaker's Odyssey." *Camera Obscura, Camera Lucida: Essays in Honor of Annette Michelson*, edited by Richard Allen and Malcolm Turvey, Amsterdam UP, 2003, pp. 261–74.

Massey, Doreen. *Space, Place, and Gender*. University of Minnesota Press, 1994.

McDowell, Linda. *Gender, Identity and Place: Understanding Feminist Geographies*. Minneapolis: University of Minnesota Press, 1999.

Meili Shanghai (Shanghai Story). Directed by Peng Xiaolian, Shanghai Tomson Films, 2004.

Mengxiang zhaojin xianshi (Dreams May Come). Directed by Xu Kinglei, Beijing Xianhua Shengkai Pictures, 2006.

Peng Xiaolian. "Jiaopian de wendu" (The Warmth of Film). *Jiyi de yanse* (*The Color of Memory*), Jiangsu wenyi chubanshe, 2017, pp. 1–87.

———. "Meili Shanghai" (*Shanghai Story*). *Dianying xinzuo* (*New Films*), no. 4, 2004, pp. 13–15.

———. "Wode fuqin Peng Baishan" (My Father Peng Baishan). http://mjlsh. usc.cuhk.edu.hk/Book.aspx?cid=4&tid=5310 (accessed 17 March 2020).

Peng Xiaolian and Jia Leilei. "Dushi de wenhua yingxiang yu xinli kongjian: Guanyu yingpian *Meili Shanghai* de duihua" (Cultural Image and Psycho-logical Space of the City: A Dialogue about *Shanghai Story*). *Dianying yishu* (Film Art), no. 2, 2004, pp. 31–36.

Qingni Jizhu wo (Please Remember Me). Directed by Peng Xiaolian, Shanghai Fuxing Quanya Media Co., 2018.

Qinmi diren (Dear Enemy). Directed by Xu Jinglei, Beijing Xianhua Shengkai Pictures, 2011.

Ren Gui Qing (Human, Woman, Demon). Directed by Huang Shuqin, Shanghai Film Studio, 1987.

Rosário, Filipa, and Iván Villarmea Álvarez. "Introduction: Screen Is the Place." *New Approaches to Cinematic Space*, edited by Filipa Rosário and Iván Villarmea Álvarez, Routledge, 2019, pp. 1–10.

Shanghai lunba (Shanghai Rumba). Directed by Peng Xiaolian, Shanghai Film Studio, 2006.

Soja, Edward W. *Thirdspace: Journeys to Los Angeles and Other Real-and-Imaginary Places*. Blackwell, 1996.

Wang, Lingzhen. "Introduction: Transnational Feminist Reconfiguration of Film Discourse and Women's Cinema." *Chinese Women's Cinema: Transnational Contexts*, edited by Lingzhen Wang, Columbia UP, 2011, pp. 1–39.

Wei, S. Louisa. "The Ultimate Female Auteur: Visuality, Subjectivity, and History in the Works of Peng Xiaolian." *Frontier of Literary Studies*, vol. 11, no. 1, 2017, pp. 157–79.

Wo ai ni (I Love You). Directed by Zhang Yuan, Xi'an Film Studio, 2002.

Wo he baba (My Father and I). Directed by Xu Jinglei, Beijing Cultural Development Co. Ltd., 2003.

Xu, Jinglei. "Mengxiang zhaojin xianshi: yipian chidao de daoyan chanshu" (*Dreams May Come*: A Belated Introduction from the Director). Xu Jinglei's Weibo Blog, 11 Oct. 2006, http://blog.sina.com.cn/s/blog_46f37fb5010005hs.html.

Yan, Haiping. "Inhabiting the City: Tropes of 'Home' in Contemporary Chinese Cinema." *China Review*, vol. 13, no. 1, 2013, pp. 93–115.

———. "Intermedial Moments: An Embodied Turn in Contemporary Chinese Cinema." *Journal of Chinese Cinemas*, vol. 7, no. 1, 2013, pp. 41–61.

Yi, Lijing. "Xu Jinglei: Daoyan zhege juese rangwo xiangge nüqiangren" (Xu Jinglei: Being a Director Makes Me Feel Like a Strong Woman). *Southern People Weekly*, 18 April 2006, http://finance.sina.com.cn/leadership/crz/20060418/22012510559.shtml.

Yige mosheng nüren de laixin (Letter from an Unknown Woman). Directed by Xu Jinglei, Polyhuayi Media of China, 2005.

You yige defang zhiyou women zhidao (Somewhere Only We know). Directed by Xu Jinglei, Beijing Xianhua Shengkai Pictures, 2015.

Zeng, Li. "Living for the City: Cinematic Imaginary of the Cityscape in China's Transnational Films." *Critical Arts*, vol. 15, no. 1, 2011, pp. 102–17.

Zhang, Jingyuan. "To Become an Auteur: The Cinematic Maneuverings of Xu Jinglei." *Chinese Women's Cinema: Transnational Contexts*, edited by Lingzhen Wang, Columbia UP, 2011, pp. 293–310.

Zhang, Yingjin. *Cinema, Space, and Polylocality in a Globalizing China*. U Hawai'i P, 2010.

Zimmermann, Yvonne. "Advertising and Film: A Topological Approach." *Films That Sell: Moving Pictures and Advertising*, edited by Bo Florin, Nico de Klerk, and Patrick Vonderau, BFI, 2016, pp. 21–39.

Chapter 8

Women in Chinese Visual Art over the Past Century

SHELLEY DRAKE HAWKS

Male and female represent the two sides of the great radical dualism. But, in fact, they are perpetually passing into one another. . . . There is no wholly masculine man, no purely feminine woman.

—Margaret Fuller, *Woman in the Nineteenth Century* (qtd. in Kornfeld 176–77)

Margaret Fuller (1810–1850), American feminist and author of *Woman in the Nineteenth Century*, considered female and male to be equal and integral to one another, like "the tenor and bass in music" (qtd. in Kornfeld 186). Over two millennia earlier, *The Yellow Emperor's Classic of Internal Medicine* had similarly argued for respecting "to an equal extent" the complementary principles of yin/feminine and yang/masculine (*The Yellow Emperor's Classic* 126). Was Fuller's thinking informed by ancient Chinese concepts of yin and yang? Possibly indirectly. As a member of Transcendentalist circles, Fuller engaged with Asian ideas through her reading and from discussions with Ralph Waldo Emerson and Elizabeth Peabody (Buell 169–98; Marshall 424–25). Educated by a severe father to develop a "male intellect," Fuller described herself as having "a man's ambition and a woman's heart." She theorized that all people have both

male and female parts. She anticipated that the two proclivities inside of her would gradually combine into "a radiant, sovereign self" (von Mehren 185). Had she known of the yin-yang diagram, a circle with a spot of male energy on the female side and one with female energy on the male side, Fuller might have recognized convergence between her theory and Chinese cosmological notions.

Fuller called for a "two-fold growth" in every person, combining female and male characteristics. She defined positive male qualities as "energy, power, and intellect" and female ones as "harmony, beauty, and love" (Fuller, qtd. in Kornfeld 186) Expanding woman's sphere of action and aspiration, she argued, would bring a new era of human thriving. Woman and man would become larger-souled. She prodded men in her orbit—such as Emerson and Nathaniel Hawthorne—to live and feel with emotion; and female friends, to converse with confidence and substance (Mitchell 10, 67–68; Richardson 240–41; Silver 51, 64–65).

Although Daoist notions of gender fluidity and gender equality were present in China for centuries, constraints on women in Chinese civilization were even more serious than those imposed on Fuller in nineteenth-century America. Li-Hsiang Lisa Rosenlee argues that Chinese culture has been open to positive attitudes toward women, but historically, women have been devalued (5). The strong preference for sons, the patrilocal marriage system dispersing brides to their husbands' households, the sequestering of women inside the home, and women's unpaid labor, lack of formal education, and bound feet made China's patriarchal system one of the world's most repressive. Despite these obstacles, many premodern Chinese women lived creative lives, some even rising to be recognized as artistic talents (Weidner 13–16). Women in early China before neo-Confucian orthodoxy set in had a more balanced position in relation to men than was possible in the later imperial period (Raphals 4, 9). The big change in women's status occurred gradually in the context of the dire situation China faced after the Opium Wars (1839–1842) and the popular rebellions of the nineteenth century. China's reformers and revolutionaries, mostly men, rallied around "the woman question." In 1897, Liang Qichao called women's lack of education "the root cause" of China's weakness (qtd. in Hershatter 61). During the first decades of the twentieth century, China's newly established art academies in Shanghai and other cities welcomed women for the first time.

Profound changes in Chinese art followed; women joined art academies as students and stayed on as teachers. Their fresh perspectives challenged gender stereotypes. However, even in contemporary times, China's art world

remains overwhelmingly male (Teo, *Rewriting* 13; Kee 348–49; L. Chen). In 2016, artist Lin Tianmiao said that she believed there was no feminism in China. "Mao said that women hold up half the sky, but we have not reached that level" (Lin, "No Feminism"). In a 2013 interview, another female artist, Yu Hong, said that feminism was little understood in China until 1995 (Yu). Despite their skepticism, Lin and Yu have vaulted to the top of the avant-garde art world in recent years. Their rapid rise suggests a positive trend for women artists. China seems to be at a crossroads, with a women's movement emerging, yet considerable obstruction remaining. Art historians must strive to overcome the inherent bias in favor of male artists if they are to reveal the full richness of female contributions.

This chapter argues that feminism in Chinese art has not been absent over the past century. If we take a broad view of feminism as a movement toward equality for women, we find improvement in the representation of women and in women's status in China (Hershatter 232, 279). However, a careful look at feminism in China requires considering the philosophical concepts and historical experience making China's feminism distinct from feminism as it emerged in the West (Lin, "Wrapped"; Mann, *Gender*) According to Nathan Sivin, a profoundly different view of the body as a "congerie of vital processes" informs the Chinese imagination (qtd. in Ha 432). Man and woman are shifting categories on a continuum rather than in opposition. Thus, we see more proclivity among Chinese thinkers to consider male/female as a dialectic pair, always in relation, rather than as one gender in isolation (Zhang 129). In addition, the overwhelming emphasis on the family over the individual in Chinese culture affects the destiny of women in complex and powerful ways, negatively and positively. In ancient China, the woman was subsumed by her role in the family; she was wife, mother, daughter, or daughter-in-law more than an individual person (Rosenlee 47). Today, family duties still press harder on women than on men. Chinese culture has long celebrated women who sacrifice their own needs for the sake of the group (Carlitz 104–7). As we shall see, a recent development has been the training of daughters so that they develop their life potential, inside and outside the home. In addition, marriage has become less restrictive for women.

Some feminist scholars like Marjorie Topley blame the yin concept for providing the theoretical justification for confining women to a passive role in society (qtd. in Rosenlee 68). Pioneering Chinese feminist He-Yin Zhen (1884–ca. 1920) also believed that institutions, customs, and even metaphysical abstractions spawned "insidious social hierarchies" justifying the oppression of women in China (Liu, Karl, and Ko 14). Indeed, to

break out of the patriarchal structure, Chinese women have had to side-step the misguided view that a virtuous woman is always synonymous with yin, the female principle associated with yielding or receiving. As Rosenlee has argued, the actual theory of yin and yang does not require a woman to fully equate herself with yin and always recede in favor of men. Yin and yang are of equal importance, perpetually in motion, and in dynamic exchange with one another. They are "pivots of transformation" in a certain direction toward an approximation rather than an absolute (Miller 61). In ancient writings, yin and yang are "often cross-gender and beyond gender" (Rosenlee 65). The consummate person, male or female, alternates between yin and yang to maintain balance, reconcile opposites, and achieve excellence in life (Hall and Ames 93).

To gain insight into traditional attitudes of gender still operating in mid-twentieth-century China, we begin with an intriguing image of a woman and a man painted by Cheng Shifa (1921–2007) in 1980 (see figure 8.1). A few years prior, folklore subjects like this—with no

Figure 8.1. Cheng Shifa, *The Excursion of the Zhongnan Mountain Jinshi Scholar*, 1980. Ink and color on paper, 70 cm. × 48.5 cm. Image © Ashmolean Museum, University of Oxford EA2015.56.

obvious endorsement of socialism—put Cheng in jeopardy. During the Cultural Revolution (1966–1976), his style of painting fell out of favor, and he was treated harshly (Hawks, *Art* xi, 3–14). By 1980, the mood had shifted. Cheng painted this lively duo as a gift for art historian Michael Sullivan and his wife, Khoan, to honor their visit to Shanghai (Sullivan, *Modern* 19, 62). The male figure in this painting is none other than demon queller Zhong Kui, here more pleasant in appearance than is typical. Celebrated for his ability to expel noxious influences, Zhong Kui became a popular subject for Cheng in the aftermath of the Cultural Revolution (Ru 7–8). The female figure is presumably his younger sister, about to be married off to his best friend, Du Ping. According to legend, Zhong Kui arranged for the marriage to repay Du Ping for an act of kindness. In life, Zhong Kui committed suicide after he was cheated out of his first-class rank on the imperial exams. Du Ping collected his friend's remains and arranged for a proper burial. Now a member of the spirit world, Zhong Kui has taken time off from killing demons to return on New Year's Eve to reward Du Ping with his younger sister, who may be a spirit herself (Luk 42–52, 82, 137, 147; Tsai 11–16).

This folk theme provides the occasion for Cheng to show his masterful technique combining color, splashes of ink, and freehand brushwork. He typically started his paintings by splashing ink somewhat randomly, then transforming each ink spot into something specific as he went along (Cahill; Chi). Note how vividly Zhong Kui and his sister contrast and yet intersect. Both ride animals whose necks curl emphatically in opposite directions. Plump and bearded Zhong Kui smiles broadly as he faces the viewer. His poor donkey strains under his weight. A thick and assertive brushstroke defines his hat, shoulders, and boots—the attire marking his status as a scholar. His sister—her personal name unspecified—raises a flower to appreciate its fragrance. With her hair exquisitely decorated, her face pale, and her body subsumed in a silk robe, she embodies "the languid beauty" portrayed in many Qing-era paintings: "delicate physique, oval face, shapely eyebrows, almond eyes, sloping shoulders, and slender waist" (Nie 292). She waits behind her brother in graceful silhouette. This is a map of harmonious relations in a Confucian system. Zhong Kui's sister is dutifully marrying her brother's loyal friend, thus tying two families together in a permanent bond. Cheng's painting affirms traditional notions of marriage as an arrangement between families and resonates philosophically as an expression of the union of yin and yang. Zhong Kui's sister functions as a symbol more than as a specific person. She is

yin in a relational pair, yielding rather asserting, subordinate rather than domineering. In the literati tradition, Cheng's gift of this painting to the Sullivans signals a double wish: for the couple's marital happiness and for durable ties of friendship with like-minded connoisseurs of Chinese art.

Another painting of a wedding by the male oil painter Wang Yidong (b. 1955) reflects a similar interest in representing yin and yang in dynamic exchange, although here the woman is primary rather than secondary (Wang Yidong; Wang Xiaoye) (see figure 8.2). A generation younger than Cheng Shifa, Wang Yidong spent his youth in the countryside informed by the ideals of collectivism and state socialism. Under Mao, the Communist Party encouraged women to move beyond their domestic roles to join political struggles. Rural women received new recognition as agents of socialist transformation (Hershatter 232). After the shift toward capitalism in the 1980s, Wang Yidong achieved commercial success for his mysterious portraits of beautiful Chinese women in a precisely rendered Realist style (Andrews and Shen 290; Burris, *Beijing* 125). Today, his palette of vivid red still evokes socialist realism, the mythic and heroic style of painting favored during the Mao period. However, his work is not political so much as cinematic, suggesting affinity with film director Zhang Yimou, who cast rural female protagonists in movies like *Red Sorghum* (1988) and *The Road Home* (1999). Wang Yidong's festive red color scheme suggests the vitality of traditional village life still found in remote pockets of China's interior (Wong 14–15).

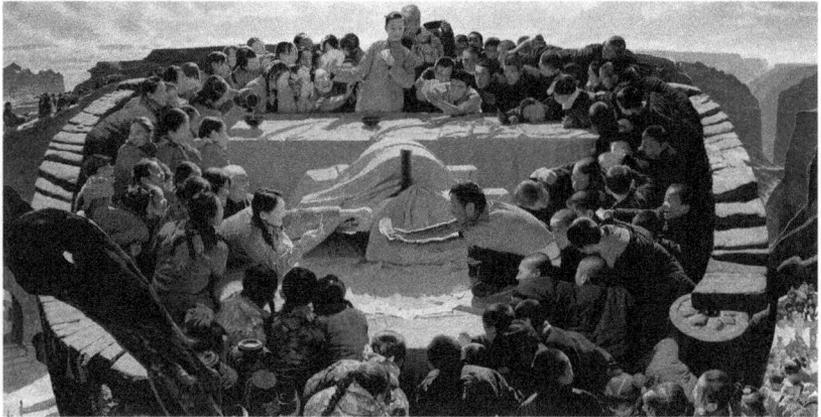

Figure 8.2. Wang Yidong, *Taihang Happy Event*, 2014. Oil on canvas, 180 cm. × 350 cm. Photograph supplied by the artist and reproduced with permission of the artist.

The painting illustrated in figure 8.2, *Taihang Happy Event* (2014), depicts more than 120 people in a circular formation. Wang Yidong says that he naturally thought of the yin-yang relationship in Chinese philosophy during the drafting stage for this painting. He decided to strengthen the feeling of the circle to create a theatrical stage for his wedding scene and its symbolic content. Wang organized male and female models, actual rural youth, to sit in a stone tower playing a card game, with girls on the left wearing red and boys on the right wearing black (Wang Yidong). Although women and men are largely separated, there is integration at the top of the circle with a bride in front of the groom; in the circle's middle, a boy and a girl stretch their arms to share cards and advance the game. With its many arcs, the composition suggests swirling; the long horizontal table at the center stabilizes the picture. At one end of the table, a girl pours water from a jug; at the other end, a boy is napping. Far below the stone tower on a sunlit terrace, Wang pictures himself working at his easel (Wang Yidong).

Wang Yidong made many drafts of this scene over a six-year period. He undertook such a long preparation as a personal quest to put all of his effort into one seminal painting to commemorate his sixtieth birthday. He arranged the composition to show "the mutual attraction and connection" between males and females (Wang Yidong). The stone mill for grinding grain at the center and the old tree leaning out of the picture set up the feeling of a metaphor. Here we see the visual expression of China's communal culture, a positive legacy worth preserving and strengthening. Significantly, Wang placed the bride in the forward position, with the groom less distinct, standing behind. Judging by their happy expression, the girls are winning the card game. The bride stands confidently at the apex of the gathering in charge of the festivities. Her raised arms point upward—signaling a rise in women's stature looking toward the future (Wang Yidong).

Earlier in his career, Wang painted single figures, typically female, against dark backgrounds, in a style reminiscent of Western oil painters Rembrandt, Vermeer, and Millet (Burris, *Beijing* 125; Hefner Collection 106; Sullivan, *Art* 233; Wong 12–13). One of his most beautiful portraits features his now deceased wife, Li Luwei, also an artist, in 1986 (see figure 8.3). The couple met when they were studying oil painting at what is now the Shandong Institute of Art. Wang Yidong was from a family of military officials and Li Luwei from a family of intellectuals, at a time when those two social classes were quite distinct, and class labels greatly

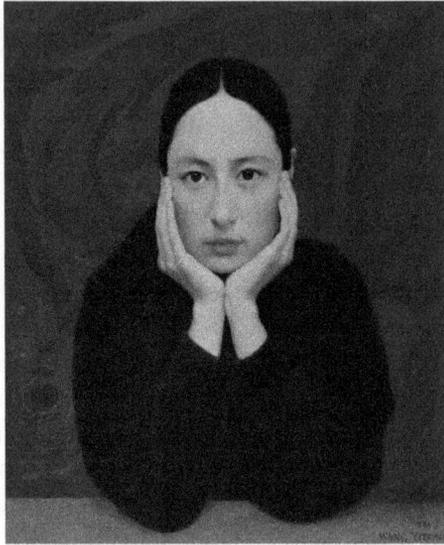

Figure 8.3. Wang Yidong, *Portrait* (of his late wife Li Luwei), 1986. Oil on canvas, 55 cm. × 60 cm. Photograph supplied by the artist and reproduced with permission of the artist.

affected one's future prospects. When the two art students fell in love and decided to marry, the decision caused dissatisfaction in their families, but the couple refused to be deterred (Wang Xiaoye). Expectations around marriage had changed, even in rural areas. By the 1970s, youth hoped to choose their own spouses based on romantic love rather than submitting to their family's preferences (Hershatter 225).

In this portrait, Li Luwei's face, encircled and held up by her own hands, becomes a metaphor for the New Chinese woman, a college graduate who took charge of her destiny, pursued the ideal of art, and married for love. Behind her, Wang Yidong placed the image of a "flying *apsaras*," an angel-like figure associated with the Dunhuang cave grottoes. The apsaras concept came from India along the Silk Road, where its Buddhist features mixed with China's native philosophy of Daoism. An apsaras flies without wings and is trailed by streaming garlands. According to the artist's daughter, Wang Xiaoye (b. 1984), the apsaras symbolizes "a yearning for freedom." She explains that "the reason why my father chose such an image as the background is that, in addition to the need of composition and coordination, he probably unconsciously thought my mother was a woman like the flying apsaras" (Wang Xiaoye).

Wang Yidong captured his wife's direct gaze as she modeled for him. Like the beneficent face and flowing garments in the background, this contemporary woman is pure and aloft like the apsaras. He portrays both her physical beauty and her inner dynamism. Her graceful appearance accords with traditional Chinese notions of female virtue, but she also projects independence, confidence, and gravitas. Her husband portrays her as fully present in an intimate moment. Her hands seem like the husk supporting a flower, the subject matter she was known for painting (Wang Xiaoye). In this portrait, Wang Yidong calls us to celebrate the New Chinese Woman's soaring potential.

Wang Xiaoye also modeled for her father's portraits when she was still in primary school. Her personal favorite is a portrait chosen for the cover for a 1992 issue of *Children's Literature*, a famous magazine in China (see figure 8.4). Wang Xiaoye says that her teachers and classmates were surprised to see her in the picture wearing traditional-style clothing. The action indicated by the painting's title, *Startled Bird*, is only implied by the child's curious expression as she lifts her eyes, suggesting sights and sounds beyond what is depicted on the canvas. One wonders whether

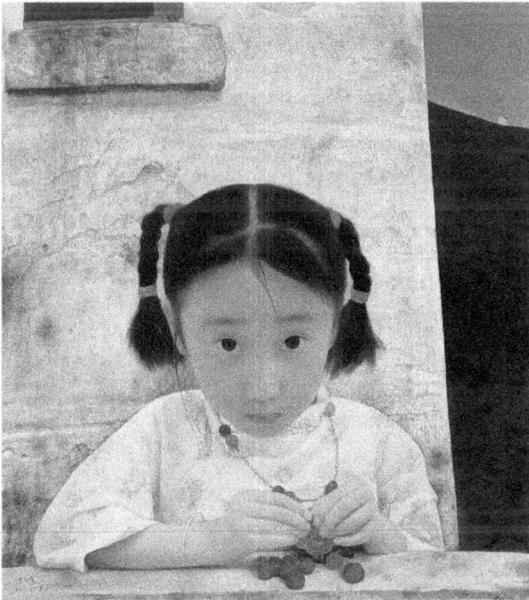

Figure 8.4. Wang Yidong, *Startled Bird* (portrait of his daughter Wang Xiaoye), 1991. Oil on canvas, 100 cm. × 90 cm. Photograph supplied by the artist and reproduced with permission of the artist.

she is a startled bird in some poetic sense. According to the magazine's explanation, Wang Yidong enhances the impact of his art by arranging the eyes of the child in the painting to meet the gaze of the viewer in a direct and intimate manner (Jiu 128). The child holds a "longevity lock" necklace, a charm parents give to children to "lock their life," so that they will grow up safe from harm (Wang Xiaoye). This painting expresses a slight edginess. With a wall in front and high wall behind her, obscuring all but a slice of the horizon, the scene suggests that a young girl faces imposing challenges, despite a father's strong wish for her to flourish.

The trend toward one-child families in China since the late 1970s strengthened a tendency already prevailing in some intellectual families of fathers giving their daughter's education the full attention once reserved for sons. The One-Child Policy of 1979 needlessly and tragically led to abortions or abandonment of unwanted daughters (White 151–52, 263). However, in households welcoming daughters, parents poured resources into their daughters' futures. For the first time in Chinese history, a daughter in a household with no sons became the exclusive focus of her family's aspiration for the future. Unlike in traditional times, when a daughter was always expected to move away from her birth family to join her husband's household, the new circumstances allowed daughters to continue living with their birth family regardless of their circumstance. In the paintings and life experience of another artist, Wang Huaiqing (b. 1944), and his daughter, Wang Tiantian (b. 1974), we see reflections of this significant social and cultural change. Wang Tiantian remains an integral member of her birth family. Father, daughter, and wife/mother Xu Qinghui are all artists, supporting each other in a tight-knit family system. Wang Huaiqing supports his daughter's career, exhibiting his art with hers in a two-person 2001 exhibition titled *Commencement and Combination*; Xu Qinghui designs art catalogues and handles household matters; and Wang Tiantian supports her father by helping him with technology, book designing, and English translation, in addition to painting her own artwork (Wang and Wang; Wang Tiantian).

Wang Huaiqing has been recognized globally as a leading contemporary artist (Yiu 40–45; Andrews and Shen 211–12; Burris, *At Work* 134–43 and *Beijing* 129). Wang Huaiqing is nine years older than Wang Yidong. The two oil painters (who share a surname but are not related) became close friends when they spent several years in the United States together in the 1980s. Wang Huaiqing began as a muralist painter in the Realist style; however, in recent decades, he has become known for his

spare abstract art (Hefner Collection 10, 19, 23). His huge canvases of disassembled Chinese-style furniture "spring to life as if enchanted" (Lee 116). They suggest archetypes for our collective consciousness, disrupted and "homeless" in the present era. The paintings of Wang Huaiqing's daughter, Wang Tiantian, differ greatly from her father's in style and mood (Hawks *Lotus* part 4). Whereas his images are serene, austere, and monochrome, hers are whimsical, youthful, and colorful. She thinks of human figures as forming a "psychological biography" reflecting the life experience and consciousness of youth in the new millennium. Says Wang Tiantian: "I've never tried to avoid his influence, but I simply have a different story to tell" (qtd. in Burris, *At Work* 152)

In previous times, the child and the parent would paint in a similar style, the junior emulating the elder. Indeed, Wang Huaiqing supervised Wang Tiantian's training in traditional-style brushwork when she was a child, but even from a young age, she did not follow his style, nor did her father expect her to. In former times, a young artist apprenticed under a master, copied the master's brushwork, and continued to paint in the "school" of their teacher as a sign of respect. Now the art curriculum in China promotes originality. Wang Tiantian graduated from the Central Academy of Fine Arts in Beijing in 1997 and earned a master of fine arts at New York University in 2001. Fluent in English since she was immersed in a New Jersey high school from 1987 to 1988, Wang Tiantian's outlook reflects not only her time abroad and fine arts training but also her connection to youth fashion and the internet (Wang Tiantian).

Wang Tiantian's 2002 lithograph *She* shows a contemporary young woman with both arms raised and hands clasped at the top of her head, striking a pose of nonchalance (see figure 8.5). Although Wang begins her creative process with a study of live models, this female subject is not very individualized. *She* seems an emblem of the whole millennial generation stretching across the globe. Wearing athletic pants and a tight-fitting shirt, *She* casually reveals her navel, an unfussy gesture reflecting youth culture. One shirt sleeve is bunched up. Her hair hangs in no special arrangement. Her clothing's bright redness, the color of good fortune, promises a happy future, but the short, curved brushstrokes defining the clothing's outlines signal restlessness. In the Chinese painting tradition, clothing was an especially significant conveyor of meaning (Mann, *Gender* 115). Here the contemporary woman wears her clothes with a sense of abandon, even indifference. Her face registers no specific emotion; however, her clothing is alive with expressiveness, proclaiming her emphatic membership

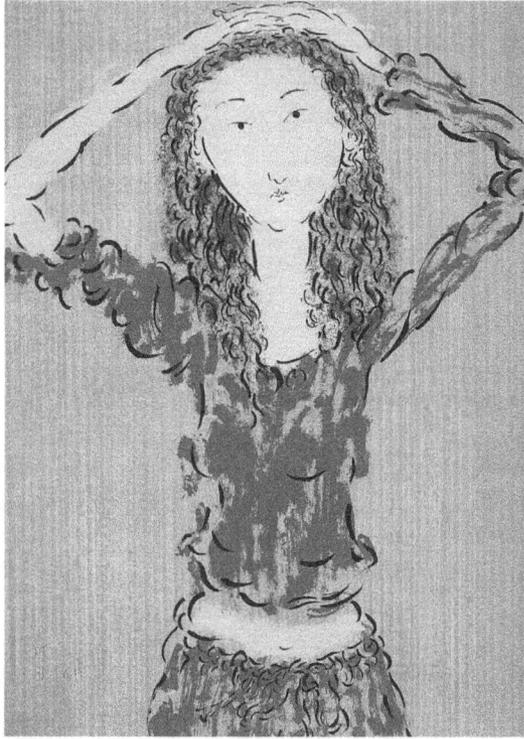

Figure 8.5. Wang Tiantian, *She*, 2002. Lithograph, 76 cm. × 56 cm. Photograph supplied by the artist and reproduced with permission of the artist.

in the present moment. Referring to Chinese women at the beginning of the twentieth century, Louise Edwards describes choices of hairstyle and clothing as "performances of one's level of modernity" (Edwards 12).

Another life study from 2002 called *Madam Butterfly-no. 2*—pictures a young woman, this time with three heads, one with closed eyes, and all facing a different way (see figure 8.6). The butterflies around the woman are actual specimens, fragile creatures symbolizing romantic love and spiritual freedom. The three heads call to mind a person of supernatural power—a bodhisattva or a Hindu goddess—looking out in all directions. Wang Tiantian explains that these heads represent multiple selves inside a single woman. *Madam Butterfly* celebrates a woman's complexity, her hope for love, and her "butterfly dreams" of a beautiful, unrestricted life (Wang Tiantian).

In the early 2000s, Wang Tiantian created whimsical nude drawings in pencil and ink of young women in various psychological moods. Some

Figure 8.6. Wang Tiantian, *Madame Butterfly-no. 2*, 2002. Pencil on paper, silk, butterfly specimens, 75 cm. × 85 cm. Photograph supplied by the artist and reproduced with permission of the artist.

lie on the floor, turned on their bellies, crossing their legs impudently, their faces relaxed and sassy; others stand awkwardly, self-conscious about their nudity, modestly covering their breasts and genitals. Here we see more development of her "psychological biography" reflecting the full range of female personality. Her nude females are not sexualized; rather, they are spunky twenty-somethings projecting attitude (see figure 8.7). Tiantian weaves contemporary nudes into an experimental form of traditional Chinese painting. On hanging scrolls made of rice paper and silk, she intersperses the nude females with traditional motifs such as flowers and ornate rocks, calling them *Three Beauties*. There is a hint of humor as Wang Tiantian cuts across cultural boundaries. Nude life-drawing came from Western art. Chinese artists painted nudes for the first time in the early twentieth century. Wang Tiantian translates this once foreign subject into a Chinese medium and offers a twenty-first-century perspective on it (Wang Tiantian). Says Wang: "There was no boundary

Figure 8.7. Wang Tiantian, *Venus-no. 1*, 2005. Ink and brush, pencil on paper, ink and color on silk scroll, 176 cm. × 66 cm. Photograph supplied by the artist and reproduced with permission of the artist.

in my head" (Wang Tiantian). Her ink-brushed nudes are not so much sensuous bodies as lively and complex personalities revealing a contemporary mindset. Some seem contented; others, indifferent or bored, as they acknowledge being looked at.

Next we look at another female painter, Xi'an-based artist Shi Dan (b. 1956), whose father, Shi Lu (1919–1982), served as her teacher during her early teens. Shi Lu, a leading artist during the 1950s and early 1960s, was in poor health at the time. Unjustly persecuted during the Cultural Revolution, he never fully recovered. Although he lived with schizophrenia, he painted magnificently. His calligraphy and brushwork in private paintings took on a special character, becoming a vehicle for crying out his sorrow. He encouraged both his daughter, Shi Dan, and his son, Shi

Guo (b. 1953), to become artists. Giving them both a painting called *Goddess of Beauty*, their father admonished them in its inscription: "Only Socialize with Beauty. Never Marry Ugliness" (Hawks, *Art* 192–93 and *Lotus* part 3). Since then, Shi Dan and Shi Guo have separately written biographies about their father. Shi Dan says she particularly admires her father's late-in-life paintings when his style became vividly personal and semi-abstract. She wants to learn from her father's spirit but not copy his style: "However, I do want to receive many spiritual things from him. . . . Spiritual things should be passed from one generation to the next, but as for specific painting techniques, I should find my own personal style" (Hawks, *Lotus* part 3)

Now vice chair of the Shaanxi Artists Association, a position once held by her father, Shi Dan paints grand abstract paintings evoking lotus flowers, the night sky, and wind gusts. Under titles such as *Great Wind Song* (see figure 8.8) and *Golden Time*, these exploding worlds of light and shadow feature streaks of fire and crashing waves. Browns,

Figure 8.8. Photograph of Shi Dan, *Great Wind Song*, 2015. Ink and color brush painting, 7.3 × 2.4 meters. Photograph supplied by the artist and reproduced with permission of the artist.

golds, greens, and grays intensify and fade, vibrate and transform into thunder. Shi Dan's imagery ignites strong emotion, from joy to sorrow. For example, in her series called *The Last Poplar*, a single tree shoots up from the ground, sparkling with life. An autumn glow surrounds it. Though dazzled by the poplar's beauty, the viewer contends with the chilling realization suggested by the title—that before us stands the very last of its kind on Earth (*Gaoyuan* 39). Critics praise Shi Dan's work as "full of tension," "tragic in color," and "far from the pleasing appearance of traditional flower and bird painting" (*Gaoyuan* 3). During the Maoist era, practically anything unsettling in public art was unacceptable; only bright optimism about Mao's policies was permitted. Today, Shi Dan's turbulent depictions of nature are generating excitement in intellectual circles (*Gaoyuan* 1–6, 11).

Shi Dan is a founding member of an all-woman artistic alliance called the Five Eyebrows Painting Society in Xi'an city, Shaanxi Province. A male supporter, poet Shen Qi, gave the group their name based on an ancient phrase meaning that a woman is no less than a man: 巾帼不让须眉 "Scarves need not give way to beards and eyebrows" (*Gaoyuan* 1, 17). In ancient times, women wore ceremonial headscarves; men were associated with beards and eyebrows. Court women typically shaved their eyebrows and painted them on with cosmetics. Though not absent, a woman's finely crafted eyebrows were not necessarily "real." Thus, scarves became a proxy for women, while eyebrows, despite both genders having them, came to connote only men. That these five contemporary women call themselves eyebrows affirms their claim to an equal status with men. Their alliance gave them greater visibility than if they had exhibited individually, attesting to the value of women banding together to compete for opportunities to exhibit or travel.

Shi Dan and her four colleagues—Zhang Xiaoqin, Fu Xiaoning, Han Li, and Shi Ying—have made Five Eyebrows their feminist banner. Since the group's founding in 2005 following encouragement by male painter Wang Yanlin (b. 1940), the Five Eyebrows have exhibited together, creating new works in conversation with each other. In 2013, the five traveled to Europe to visit museums and make sketches of Western art. Born in the 1950s and trained in top art academies, the women continue to leverage their common life experience, inland location, and friendship to realize their personal dreams for art (*Gaoyuan* 94–96). Their obscurity for so many years, largely a consequence of male bias, gave them space to mature, insulated from commercial pressures and the limelight. In a phrase resonating with Wang Tiantian's image of *Madam Butterfly*, a 2015

catalogue of the Five Eyebrows Painting Society describes the previous ten years as the time when the artists grew into "butterflies," and opened "their faces" (*Gaoyuan* 10). They consider their alliance an open association, calling on women artists to rely on each other to grow and thrive despite continuing male dominance (*Gaoyuan* 17).

One of China's most watched and admired female artists, the neo-Realist oil painter Yu Hong (b. 1966), puts her relationship with her daughter Liu Wa at the center of her artwork. A recent painting epitomizes Yu Hong's dreams for her daughter's future (see figure 8.9). The artist pictures herself reclining on a couch, holding Liu Wa, still a child, above her. Liu Wa's long-limbed body rests on her mother's raised arms and knees. In this happy scene, the daughter imagines that she can fly; her mother, full of hope and devotion, supports her aspirations. Yu ascribes central importance to motherhood, calling it "a matrix of life" (Yu and Sans). She describes meeting her newborn daughter's eyes for the first time. In that moment, she felt the weight of her responsibility to guide her daughter to becoming an independent person. In many of Yu's paintings, mother and daughter ride the difficulties of everyday life together, such as in her painting *Everyday Life—I Am in the Water* (2011)

Figure 8.9. Yu Hong, *Self-portrait with daughter Liu Wa*, from the series *Half-Hundred Mirrors*, 2018. Acrylic on canvas, 100 cm × 120 cm. Photograph supplied by the artist and reproduced with permission of the artist.

with mother and daughter swimming nude or *Watching the Wave* (2016), where the pair is seen from the back as a tidal wave rises before them (Ninety-nine Art).

At the beginning of her career, Yu organized her paintings into a series called *Witness to Growth*. She set out to chronicle every year of her life with Liu Wa starting from Liu Wa's birth in 1994 (Guggenheim). The paintings often appear in three panels with a painting of mother and daughter next to a newsprint or a photo of a momentous public event of the same year. In this way, Yu's art connects personal history to political history. For example, a recent addition shows former President Donald Trump apparently holding two babies with a dividing line in between to suggest his policy of separating babies from their parents at the US-Mexico border. In the middle panel, Yu appears with a solemn expression, casting a shadow against a wall, as she looks toward her daughter in the next panel. There, Liu Wa asserts her independence not to be viewed; instead, she does the viewing behind the lens of a camera. Liu Wa is now an artist herself. Across the many years of the *Witness to Growth* series, we see Liu Wa change from an infant to a young woman and Yu developing as an observer and actor in the parenting drama, cherishing and nurturing her daughter, and other girls of the so-called Me Generation (Yang 83–84).

Some of Yu's recent paintings feature adolescent girls performing gymnastics, a sport her daughter enjoyed. Yu sees these unnatural stretches as a metaphor for how young girls must strive to adapt to China's rapid development (Rhazi; S. Wang, "Yu Hong"). "Looking at them twist their undeveloped bodies into all these challenging positions, I was reminded of how much people have to change themselves to adjust" (Sheng, *Fresh Ink* 88–89). In a 2016 painting called *Mortal Coil*, a young woman in a short skirt performs the splits. Her splayed legs form a bridge across a dangerous chasm with an urban skyline in the background. Yu describes such paintings as "visual opera," superimposing the psychological states and personal histories of women living through social upheaval. She considers every woman who models for her as "a little sample of society" (Yu and Sans). She refers to the anxiety-ridden life captured on her canvas as Saha, a Buddhist term meaning the world of pain to be endured. Although there is a tragic quality to the dark tempests raining down on human figures in her paintings, Yu insists that joy is to be found there, too. The women find meaning and companionship crossing through the

turbulence (Ninety-nine Art Network). They grow, and even flourish, despite the chaos of contemporary existence.

When she began studying oil painting in 1984, Yu was the only woman in the academy's program; all the others were men. She first came to the public eye internationally when she starred in a 1993 underground movie called *The Days* (*Dongchun de rizi* "Winter and Spring Everyday Life"). Director Wang Xiaoshuai cast her in a role resembling her actual identity: a poor art student at the Central Academy of Fine Art in Beijing married to another art student, Liu Xiaodong, her real-life husband (All-China Women's Federation). In the movie, Yu's character gives up her career to support her husband's ambitions. In real life, Yu chose similarly: to prioritize child-rearing and domestic responsibilities while her husband's career soared. She might have chosen the path of many career-minded Chinese women, counting on grandparents to raise their child. Instead, Yu chose to prioritize motherhood and make mothering a central subject in her artwork.

Yu's husband, Liu Xiaodong (b. 1963), also a figurative oil painter, is one of the avant-garde's most visible artists (Burris, *At Work* 56–65). Like his wife, Liu feels it is his duty to "reflect upon what is happening in society" (Sheng, "Liu Xiaodong" 69). In one of his most acclaimed projects, Liu collaborated with filmmaker Jia Zhangke (b. 1970) during the early 2000s to record the final days of the old city of Fengjie, as it was about to be submerged by the rising Yangzi River during the Three Gorges Dam construction. On an abandoned building's rooftop, Liu painted construction workers and coal miners stripped to their underwear as they played cards. He painted a life-size mural of them as Jia produced footage of the scene for his movie *Still Life* and a short feature *Dong* (Wu, *Displacement* 26–32). Liu's art career has been spectacular. It would be easy for her celebrity husband to steal the limelight; however, Yu has managed to keep her art separate and independent from his. Hao Sheng, curator of *Fresh Ink: Ten Takes on Chinese Tradition* in 2010, invited Yu Hong and Liu Xiaodong to participate in the Boston show without initially knowing they were married to each other (Doran 44). According to photographer and curator Jon Burris, who requested an interview with her circa 2010, Yu insisted on being interviewed separately from her husband, even though their art studios are physically next to each other (Burris interview and *At Work* 186–93). Yu's skill in oil painting knows few rivals. Her female gaze on female subjects is unusual in Chinese art.

It is a perspective increasingly sought after by collectors. Her fame may eventually eclipse her husband's.

Contrasting Yu Hong's experience as a female artist with that of two earlier women with a similar art academy training demonstrates the degree of social change China has experienced over the past century. One of China's first modernist painters, Pan Yuliang (also read as Pan Yulin, 1895–1977) had her career in China shattered for painting female nudes from live models. She was forced to resign as art professor at Nanjing Central University in the mid-1930s (Clark; "A Lonely Legacy"; Teo, "Modernism" 66–70 and *Rewriting* 43–56). An uninhibited woman like Pan faced severe pressure to conform to society's view of proper femininity. Rumors swirled about her personal history. Orphaned, and by some reports sold to a brothel in her teens, Pan Yuliang was the second wife/concubine of a prominent revolutionary. Her husband, Pan Zanhua, maintained two households, one in Anhui Province, and the other with her in Shanghai, where a neighbor introduced her to oil painting. Pan enrolled at the Shanghai Art Academy in 1918, the first year the pioneering school opened to women. There she trained in Western oil painting and life drawing from nude models, a skill fundamental to her future that made her susceptible to scandal.

In 1922, Pan became the first Chinese woman artist to win an official scholarship to study in France. After training and exhibiting widely in France and Italy, she returned to China in 1928, riding high as one of China's top Western-trained oil painters (Teo, *Rewriting* 42–46). She was appointed dean of Western art at the Shanghai Art Academy and lecturer at Nanjing Central University and was honored with several solo exhibitions, a rarity for a woman at that time. Within a decade, her innovative style made it dangerous to paint as she wished. In 1937, she returned to France. Though she remained in Europe for the rest of her life, she continued to express love for her husband and homesickness for her native soil. An active member of the Paris art community, Pan painted prolifically yet sold very little ("A Lonely Legacy"). Upon her death, she asked that her large stash of paintings be sent to China. Her wishes were honored in the 1980s. Today, most of her paintings are housed in the Anhui Provincial Museum, and her pivotal contribution to modernist art is starting to be fully recognized ("Pan Yulin").

Like Yu Hong, Pan Yuliang chronicled her life in paintings and even painted herself nude. Uninhibited and adventurous, she typified the self-appraising modern woman, a dream cultivated in Shanghai publications during the 1920s (Edwards 155, 167–71). Her works are psycho-

logically rich and convention-busting; the reader is referred to Phyllis Teo's insightful scholarship for more analysis than can be included here (Teo, *Rewriting* 73–75). One of Pan's most significant contributions was her graceful portrayal of Asian and African female bodies, enriching and broadening the Western canon's standard of beauty. She was fearless in celebrating the female form, breaking taboos such as picturing a nude mother breastfeeding a child. Pan's lack of modesty in presenting breasts, buttocks, and bulging bellies was radical even in the context of avant-garde circles in Paris ("Art of Chinese Master"; V. Chen; Teo, "Modernism" 70–78 and *Rewriting* 80–82). On canvas, Pan created sensuous, all-female worlds open to same-sex desire. Her female nudes are brushed fluidly and whimsically, with an elegant line informed by her background in Chinese ink painting and her study of Matisse and possibly Degas.

Like many ambitious Chinese painters of her generation, Pan aspired to synthesize Western life drawing and Asian brushwork into a new art form. In a 1953 nude from her Paris period, she achieved such a fusion (see figure 8.10). The mysterious seated figure is naturalistically rendered

Figure 8.10. Pan Yuliang (also read Pan Yulin), *Nude*, 1953. Oil on canvas. © Copyright of the artist. Musée Cernuschi, Paris, France © RMN-Grand Palais/ Art Resource, New York.

on a mattress and coverlet. Yet with face hidden and one raised leg, the nude's mountain-like torso and draped limbs resemble topography from a Chinese landscape painting. The black outlines of her body and cascading hair resemble her signature in the painting's upper left corner, where the calligraphy for Liang 良 seems to extend beyond what is typical, as if the Chinese character, like the nude, is stretching out a limb.

Pan's clothed self-portraits show her to be a woman of confidence and authority despite her melancholy. Some self-portraits seem staged to suggest a more demure, conventional persona than she was in life (Teo, *Rewriting* 93–97). In one of her most famous, she appears in a dragon-patterned *qipao*, China's slim-fitting national dress. She is seated near chrysanthemums, a symbol for purity and perseverance (Teo, "Modernism" 92 and *Rewriting* 92, 103) (see figure 8.11). Pan gazes directly at the viewer, with her head tilted softly and her eyes sorrowful and sympathetic.

Figure 8.11. Pan Yuliang (also read Pan Yulin), *Self-portrait with Chrysanthemums*, 1940. Oil on canvas, 64 cm. × 92 cm. Anhui Museum Collection. Photograph supplied by and reproduced with permission of the Anhui Museum, China.

Perhaps she intended this 1940 portrait as a farewell statement. World War II made life uncertain for her and for her husband in China. The Japanese army had captured China's coastal cities, and the Nazis threatened Paris. Pan likely prepared this canvas as a testament to the love she professed to her husband in correspondence. Another self-portrait, a 1931 oil painting called *My Family*, reflects her predicament before she left China. Later destroyed, it is known only through illustration. In it, she pauses for a moment as she sits at her easel, painting a family portrait. Her husband and stepson look over her shoulders with supportive expressions admiring her work in progress (Teo, *Rewriting* 82–84). Pan looks out through dark spectacles toward the viewer from the middle of the picture, asserting her self-worth as an artist and her centrality as a valued family member.

Xiao (pronounced Shiao) Shufang (1911–2005), another pioneering woman artist of the same generation, steadily developed her talent but hardly called attention to herself. In fact, her manner was so deferential and quiet that she tended to be upstaged by her famous husband, painter and art administrator Wu Zuoren (1908–1997). However, the grit and determination required for a woman of her generation to achieve professional success in the art field should not be underestimated. In childhood, Xiao did not adhere to traditional expectations for a girl at all. An unusual situation in her family gave her a freer upbringing than most girls at the time. She was the fifth of six daughters born to a fairly prosperous family. Her mother shaved Xiao's head in childhood and dressed her like a boy, partly because Xiao's hair was sparse anyway and partly because her parents wanted a son and did not have one. She was permitted to play with boys and be active and naughty (Dong 11). Unfortunately, tuberculosis struck Xiao at the age of thirteen and reoccurred throughout her life (Dong 16). Living with chronic illness deepened her love for drawing. She credits her uncle Xiao Youmei, a musician, for supporting her wish to pursue advanced training. When she graduated from the Beijing National Art School in 1929, she was one of three women to do so (Dong 19).

The strength of Xiao's contributions to the art field received insufficient public notice until her ninetieth birthday in 2001, when she was honored with a large solo exhibition at the National Art Museum ("Flower Painter's Life"). In 2018, the museum hosted another solo retrospective of her painting ("Delicate Character"). In the same year, the Central Academy of Fine Arts, Beijing, the school where she and her husband taught for many decades, co-sponsored a show honoring the talented couple's

"various performances" while "taking the same path" (Sue Wang, "First Encounter'"). Xiao's name is almost always mentioned in conjunction with her husband's, although for the first half of her career they were not married to each other, and her painting style is completely unlike his. They became acquainted as classmates in 1929 while studying under Xu Beihong. Both went to Europe independent of each other during the 1930s—she to Switzerland and England, and he to France. After they met again in Shanghai sixteen years later, their mutual mentor Xu Beihong cheerfully presided at their wedding, a second marriage for both, and hired them as art instructors at the Central Academy of Fine Arts in Beijing.

When I met Xiao at her Beijing residence in May 1995, I talked to her mostly about her husband, who was ill at the time and died a few years later. I regret my failure to focus on her accomplishments. She gave me several books on her husband's art and a catalogue of her own paintings as a parting gift (*Xiao Shufang*). The purpose of my visit was to interview artists persecuted during the Cultural Revolution to ask whether they painted privately at home while it was dangerous to paint anything besides Maoist propaganda. Xiao was careful not to discuss anything political during my interview, so I did not address her work, or her husband's, in my book on the "art of resistance" (Hawks, *Art*). Only later did I learn that she also suffered considerably during the Cultural Revolution. Her home was ransacked by Red Guards as many as four times. She withstood those attacks alone, worrying about her husband constantly, while he was confined to a makeshift jail in the art academy (Sullivan, *Art* 153–54; Wan, *Bonds* 275–76). According to her biographer Dong Yan, Xiao expressed regret that her generation of artists lost their most vigorous and creative years to the turmoil (Dong 119).

A memoir written by her student, art historian Wan Qingli, offers a sensitive account of Xiao's kindness and effectiveness as a teacher when he attended the Central Academy during the early 1960s (Wan, "Chun yu" 264–66). On the first day of life-sketching class, Wan remembers that Xiao already knew the personal background of each student. At that time, she was fifty-two years old and still suffering from tuberculosis. Nevertheless, she walked from easel to easel for four hours, explaining the theory of composition and perspective, offering encouragement, and providing concrete recommendations. According to Wan, most art faculty at the time gave ten minutes of instruction then left students to work on their own; Xiao, ever a conscientious teacher, never left the classroom. Throughout the semester, she enriched instruction by planning outings to museums and inviting colleagues to her classroom to introduce their specialties to students.

Xiao's gracious personality and cheerful character seem echoed in the fresh and bright atmosphere of her flower paintings (Wan, "Ronghua" 256, 262). Her unique style crystallized during the 1970s when she began to break the rules of traditional bird-and-flower ink painting to infuse it with the bold color palette and Western perspective absorbed from her watercolor training. Xiao carefully studied the actual object—flowers such as irises, azaleas, and lilacs—yet idealized what she observed. In her paintings, she imbued plants with a more buoyant attitude and dramatized the vividness of their color, adding depth and foreshortening to blossoms, and elongated leaves, to enhance their expressive power (Wan, "Ronghua" 259–61). On many of her best works, such as *Flying Flowers as the Rain* (1982) illustrated in figure 8.12, she invited her husband to

Figure 8.12. Xiao Shufang, *Flying Flowers as the Rain*, 1982. Wu Zuoren, Calligraphy of painting's title, 1982. Ink and color on paper, 79 cm. × 59 cm. Photograph supplied by Wu Ning, general secretary, Wu Zuoren International Foundation of Fine Arts and reproduced with Wu Ning's permission.

add his monumental calligraphy, announcing the painting's title across the top of the paper (*Xiao Shufang*). Their creative partnership registers in this soulful painting—a joint expression of beauty in the face of adversity.

Another artist couple, Lin Tianmiao (b. 1961) and her husband, video artist Wang Gongxin (b. 1960), faced a dangerous and uncertain political atmosphere after they returned to Beijing following eight years in New York. During the 1990s, after the June 4, 1989, Tiananmen Square protests ended in bloodshed, avant-garde artists in China had no public exhibition spaces open to them. They exhibited their daring experimental art in private apartments for small groups of friends. In 1995, Lin drew on her background as a textile designer in New York and her childhood experience working with cotton thread to create a stunning installation called *Proliferation of Thread Winding*. She conceived it to coincide with the landmark United Nations Fourth World Conference on Women in Beijing (Chiu, "The Body" 13). Viewers entered a private bedroom with a twin bed in the middle. On a pure white bed cover, Lin arranged thousands of needles in a thick cluster resembling female pubic hair. Hundreds of white cotton threads ending in balls cascaded from the bed to a bare floor, creating the effect of a web. From a clothes hanger attached to the ceiling loomed a giant pair of men's trousers, so long that the pant legs' unfinished hems hit the floor in ripples. Lightly pricked with needles too, the white pants looked hairy like male skin. The two presences—female and male, horizontal and vertical—suggested sexual tension and an aggressive encounter (Guo 21–22). Lin's use of contrasting materials like undyed cotton thread and sharp needles produced a "beautiful but ominous" sensation (Wu, *Contemporary* 227).

Since that time, Lin has fearlessly mounted protest works, many in museums abroad, but some in China, as opportunities allow. Her critiques are largely social. She reacts against the materialism and waste of resources she sees in contemporary life (Lin, "Wrapped"). In a collaborative video installation with her husband at the Shanghai Biennale called *Here? Or There?* in 2002 (see figure 8.13), Lin challenged the demolition of traditional architecture in China's cities—the thoughtless razing of centuries of history in an all-out push to become modern. For this project, she created nine sculptures of faceless women from fiberglass, fabric, and thread. Some wore high collars and capes with long transparent sleeves, others wore bridal veils. One sculpture had a long trailing black braid. All commanded attention with their bulk and grace, yet their abundant hair made them seem feathery. Their protruding bellies or chests made of balls

Figure 8.13. Lin Tianmiao and Wang Gongxin, *Here? or There?*, 2002. Color photograph, 95 cm. × 78 cm. © Lin Tianmiao and Wang Gongxin. Courtesy Galerie Lelong & Co.

or cylinders suggested pregnancy or engorged breasts. Lin assembled these emphatically female bodies in front of computer-altered photographs and videos produced by Wang (Burris, *At Work* 43). In the imagery projected on the wall, the sculptures appeared to dance in traditional-style court-yards, as if spirits had reoccupied their ancestral homes. Over a speaker, the crash of a wrecking ball could be heard.

Lin's project of binding female figures in spools of thread can be interpreted positively or negatively. She says that she experiences a variety of emotions while wrapping because "the work takes a long time." "I have all these feelings: smothering, protecting, and transforming" (Lin, "Lin Tianmiao Speaks" and "Wrapping"). In several installations from 2000 and 2001, Lin placed a digital photograph of her own nude body with threads attached. She altered the photo so that she appeared bald; not long after, she shaved her hair in real life, as though to purge thread from her body. She explained: "I feel stronger with short hair" (Chiu, "The Body"

18). In another interview, she said that threads signify "the numerous habits and traditions that . . . serve to constrain us" (Burris, *At Work* 40).

Another installation called *Mothers!!!* exhibited in Beijing's Long March Space in 2008, featured fabric sculptures—this time of middle-aged women, all nude, in satiny white. Lin says she likes to depict middle-aged bodies like her own because "they bear . . . the impact of love, the impact of children, and the impact of marriage" (Chiu, "The Body" 18). The installation portrays a seldom acknowledged dark side of motherhood. Within her constructed torture chamber, children are strangely absent. One woman's body is connected to wires and tubes; a second is severed with innards spilling out; a third has an exploding head extended to the ceiling. These horrific scenes are somehow made palatable by the artist's decision to deploy a white color scheme. Like snow covering grime, the satiny environment muffles the protest. The fabric-covered bodies seem to reflect an existential anguish beyond the theme of motherhood. Indeed, Lin rejects the label "feminist" as "too restrictive" to fully interpret her work (Cascone; Kee 359–65). She prefers to describe her art as informed by "a woman's inward-looking eye" (Lin, "Lin Tianmiao").

We gain perspective on women of Chinese background living in the West through the art of American Wen-hao Tien (b. 1964). She constructs living sculptures from plants and other materials to explore her identity as a first-generation immigrant living in Cambridge, Massachusetts. Tien came to the United States from Taiwan during the late 1980s to pursue graduate studies. She came by choice to seek "a more utopian place, one of openness where diverse cultures fuse." Now settled in America with her husband and son, Tien still "feels out-of-place even after living in the US for thirty years" (Tien 2, 10). Her *Weed Out/Weed In Project* in 2017 grew out of her need for dialogue with her community about being a "modern nomad" (see figure 8.14). Her intermedia art challenges xenophobia and calls for more respect for all forms of life in the natural environment as well as in society.

In digital photographs, Tien documents her process of actively shaping her local world. Gardening is an important means for her to connect with the Earth and the cosmos. The Chinese notion of "unity of person and universe" 天人合一 informs her artistic practice. She explains that identity in the Chinese cultural tradition "exists in the ecology of our environment" (Tien 4, 19). To affirm this "fluid and collective identity" across all forms of life, she scavenges unwanted, nondescript plants from construction sites, cracks in the sidewalk, or highway overpasses,

Figure 8.14. Wen-hao Tien, *Weed Out/Weed In Project*, 2017. Photography by Peter A. Crawley. Reproduced with permission of the artist and the photographer.

replanting them in soil beds on her cart for transportation to her studio. These plants become her protagonists in a larger story of migration. Even the tiniest has agency and dignity. These self-seeded plants migrate, in some cases, from distant continents and push down their roots to claim a home. Tien writes: "I realized that what people treat as weeds in an urban environment contain a large range of species. Some are native, but many arrive via birds, wind, clothing, suitcases, cars, or boats" (Tien 5).

Tien plants a variety of species in the same soil in no special order. Through trial and error, she discovers which plants thrive together. Sometimes the plants establish strong interconnections, joining their roots; other times, a bald spot appears where the plant community does not cohere. For her 2017 installation at New Art Center in Newton, Massachusetts, she "weeded plants in" to form a 7 × 11-foot indoor living sculpture—her metaphor for an open society. There was a sound component to her installation, which she called *The Weed Word Machine*. It whispered migratory words—foreign terms now assimilated into English like the Italian word for goodbye: *ciao*.

For Tien, weeds provide a metaphor to challenge fellow Americans to consider important questions: What or who do we dismiss as a weed? How can a diverse population live together? What does "home" mean?

In a multicultural society, how do you communicate? In the beginning, the weed is unknown and unrecognizable; over time, each species can be discerned and named. Through her research, Tien determined that she had found sixty species, with about half classified as nonnative plants. To her, each migratory plant calls to mind a nomad like herself claiming a home (Tien 11–14).

Tien's philosophy of living an observant life and welcoming chance encounters is informed by Chinese calligraphy. Part of the joy of using brush and ink relates to happenstance—the accidents one cannot predict, but which become meaningful, in a daily cultivated practice. How one's brush touches the paper influences the direction ink puddles or water spills. Working with live plants—watching them grow under varied conditions—satisfies her love for process and her embrace of nature as her collaborator (Tien 22). In exploring her "melancholic feelings of being out-of-place," she found "home" in "a floating life of foraging and gardening" (Tien 30).

For another living sculpture called *Nomad II* in 2018, Tien planted a garden inside a decades-old leather suitcase purchased from a second-hand store near her home (Tien, interview). Seeking a container for her plant materials, she purposely looked for suitcases from the World War II era to memorialize the dislocation precipitating her family's exodus from China to Taiwan. In one suitcase, she discovered the name of its previous owner from tissue inside. It once belonged to a Japanese woman named Michiko Takaki (1930–2014) and still bore a tag from the Yale University Anthropology Department. After some investigation, Tien learned that the suitcase's deceased owner was a pioneering anthropologist who spent four years from 1964 to 1968 conducting field research on a tribe of head-hunters in the northern Philippines. Takaki successfully learned the aboriginal language of the Kalinga people and became one of the rare foreigners accepted to live among them.

For Tien, this chance discovery of Takaki's suitcase linked her to a kindred nomad, another Asian woman who migrated across continents to pursue knowledge and bridge cultures. The suitcase became Tien's muse for contemplating both the adventure and pain of a traveling existence. Tien excavated more of the lost owner's history. Takaki's hard-won research on the Kalinga people was never published except in manuscript form. The anthropologist died in a nursing home without a fitting memorial (Tien, interview). Tien's reuse of Takaki's suitcase as part of her intermedia art honored this female predecessor whose brave crossing of borders had not been sufficiently recognized.

As this brief survey has shown, Chinese women artists have coalesced into a powerful force for innovation. Reform-minded artists—both men and women—have challenged bias against women and redefined what constitutes beauty and strength. Women have introduced new subject matter, fresh techniques, and materials to Chinese art. Despite hardship and discrimination, many women artists, especially those from artist families, have risen from obscurity and proven that they are equal to men. Margaret Fuller's prediction still rings true: women and men become larger-souled as women's aspirations are given full sway. Provided they receive equal access to training, mentorship, and exhibition opportunities, Chinese women will continue to climb to the peak of the art profession and may soon match men in influence and number. Obstacles to equality remain, but it seems too harsh to consider feminism as barely present or ill-suited to China, when Chinese artists' contributions to a woman's full flowering have been so vibrant.

Works Cited

All-China Women's Federation. "Yu Hong and Her Witness Growing Up." *Women of China*, 3 Aug. 2006, http://www.womenofchina.cn/html/node/79842-1. htm.

Andrews, Julia F., and Kuiyi Shen. *The Art of Modern China*. U Cal P, 2012.

"The Art of Chinese Master Pan Yu-Liang (1895–1977)." *Portrait of World Chinese Masters*, n.d., https://www.lingnanart.com/2013_ChineseMaster/ PanYuLiang/Master_panyuliang.htm (accessed 22 Oct. 2019).

Buell, Lawrence. *Emerson*. Belknap Harvard UP, 2003.

Burris, Jon. Interview. Conducted by Shelley Drake Hawks, 10 March 2019.

———. *At Work: Twenty-Five Contemporary Chinese Artists*. Beijing: Foreign Languages P, 2011.

———. *Beijing Days*. Beijing: Foreign Languages P, 2008.

Cahill, James. "Gazing into the Past Lecture Series: Lecture Two on Cheng Shifa, 2015." *YouTube*, 9 June 2015, https://www.youtube.com/watch?v=ZL GI3voNsno.

Carlitz, Katherine. "Desire, Danger, and the Body: Stories of Women's Virtue in Late Ming China." *Engendering China: Women, Culture, and the State*, edited by Christina K. Gilmartin, Gail Hershatter, Lisa Rofel, and Tyrene White. Harvard UP, 1994, pp. 101–24.

Cascone, Sarah. "This Artist Gathered 2,000 Words for Women—And Now, She Wants You to Walk over Them." *Artnet*, 16 Oct. 2017, https://news.artnet. com/art-world/lin-tianmiao-carpet-galerie-lelong-1113395.

Chen, Lydia, dir. *Art in Smog*. 2018. *YouTube*, 10 Jan. 2021, https://youtu.be/ KNRlgYUOgvA.

Chen, Vita. "In Praise of Life—A Many-Flowered Rose in a Desert." *China Guardian Newsletter* 124, 6 March 2019, http://www.cguardian.com/en/ zxzx/jdgg/jdtx/2019/03/11838.shtml.

Chi Ke. "Cheng Shifa huaji xu" (Cheng Shifa Painting Collection Preface). *Cheng Shifa jinzuo xuan* (Cheng Shifa Recent Selections), edited by Xu Zhenshi. Beijing: Renmin meishu, 1981, n.p.

Chiu, Melissa. "The Body in Thread and Bone: Lin Tianmiao." *Lin Tianmiao: Bound Unbound*. Text by Melissa Chiu, Guo Xiaoyan, and Lin Tianmiao. Milan: Charta/Asia Society, 2013, pp. 13–15.

———. "A Conversation with the Artist." *Lin Tianmiao: Bound Unbound*. Text by Melissa Chiu, Guo Xiaoyan, and Lin Tianmiao. Milan: Charta/Asia Society, 2013, pp. 17–19.

Clark, John. "Pan Yuliang Chronology." *Asian Modern*, 2013, http://cdn.aaa.org. hk/_source/digital_collection/fedora_extracted/45815.pdf.

"Delicate Character—Centennial Commemorative Exhibition of Ms. Xiao Shu-fang's Watercolor Paintings." Art Museum of Beijing Fine Art Academy, 2018, http://english.bjaa.com.cn/exhibit.html?hcs=11&clg=163&exhibit=12.

Dong Yan. *Huashen Bainian—Xiao Shufang* (Flower Spirit Hundred Years—Xiao Shufang). Beijing: Zhishi Chanquan, 2011.

Doran, Victoria. "Behind the Scenes of 'Fresh Ink.'" *Orientations*, Oct. 2010, pp. 42–49.

Edwards, Louise. *Citizens of Beauty. Drawing Democratic Dreams in Republican China*. U Washington P, 2020.

"Flower Painter's Life Palette." *China Daily*, 27 Aug. 2001, http://www.china. org.cn/english/18141.htm.

Gaoyuan, Gaoyuan: Di wu jie zhongguo xibu meishu zhan zhonggguohua niandu zhan tuanti yaoqing zhan. Wu mei huashe zuopinji (Plateau, Plateau: The Fifth Invitational Exhibition of Western China's Chinese Painting Organization. Artworks of The Five Eyebrows Painting Society). Xi'an: Shaanxi Provincial Art Museum/National Art Museum, 2015.

Guggenheim Museum. "Artist Profile: Yu Hong." *YouTube*, 27 Nov. 2017, https:// www.youtube.com/watch?v=IA4IkNk1T90.

Guo Xiaoyan. "The Defiant Narratives of Lin Tianmiao." *Lin Tianmiao: Bound Unbound*. Text by Melissa Chiu, Guo Xiaoyan, and Lin Tianmiao. Milan: Charta/Asia Society, 2013, pp. 20–23.

Ha, Marie-Paule. "Double Trouble: Doing Gender in Hong Kong." *Signs*, vol. 34, no. 2, 2009, pp. 423–49.

Hall, David L., and Roger T. Ames. *Thinking from the Han: Self, Truth, and Transcendence in Chinese and Western Culture*. SUNY P, 1998.

Hawks, Shelley Drake. *The Art of Resistance. Painting by Candlelight in Mao's China*. U Washington P, 2017.

———, dir. "The Lotus and the Red Star." *YouTube*, 14 Feb. 2018, part 3: https://www.youtube.com/watch?v=BElANbgnyhM; part 4: https://www.youtube.com/watch?v=87VRQ8Uk9_o&t=342s.

Hefner Collection. *Through an Open Door: Selections from the Robert Hefner III Collection of Contemporary Chinese Oil Paintings*. Portfolio Editions, 1997.

Hershatter, Gail. *Women and China's Revolutions*. Rowman & Littlefield, 2019.

Jiu Ah. "Fengmian xinshang: Wang Yidong yu tade nongcun xiaoniu" (Appreciation of our cover: Wang Yidong and His Rural Young Girl). *Ertong Wenxue* (Children's Literature), no. 170, 1992, p. 128.

Kee, Joan. "What Is Feminist about Contemporary Asian Women's Art?" *Contemporary Art in Asia: A Critical Reader*, edited by Melissa Chiu and Benjamin Genocchio. MIT P, 2011, pp. 347–65.

Kornfeld, Eve. *Margaret Fuller: A Brief Biography with Documents*. Bedford Books, 1997.

Lee, De-nin D. *The Night Banquet: A Chinese Scroll through Time*. U Washington P, 2010.

Lin Tianmiao. "Lin Tianmiao." Interview conducted by Monica Merlin. *Tate*, 2013, https://www.tate.org.uk/research/research-centres/tate-research-centre-asia/women-artists-contemporary-china/lin-tianmiao.

———. "Lin Tianmiao Speaks to Artnet News about the Art of Endurance." Interview conducted by Sam Gaskin. *Artnet*, 1 Oct. 2015, https://news.artnet.com/art-world/artist-lin-tianmiao-artwork-336164.

———. "'No Feminism in China': An Interview with Lin Tianmiao." Interview conducted by Luise Guest. *Culture Trip*, 24 Oct. 2016, https://theculturetrip.com/asia/china/articles/no-feminism-in-china-an-interview-with-lin-tianmiao/

———. "Wrapped Up: An Interview with Lin Tianmiao." Interview conducted by Sun Yunfan. *China File*, 24 Sept. 2012, https://www.chinafile.com/wrapped-interview-lin-tianmiao.

———. "Wrapping and Severing" (1997). *Contemporary Chinese Art: Primary Documents*, edited by Wu Hung and Peggy Wang, Museum of Modern Art, 2010, p. 197.

Liu, Lydia H., Rebecca E. Karl, and Dorothy Ko. "Introduction: Toward a Transnational Feminist Theory." *The Birth of Chinese Feminism: Essential Texts in Transnational Theory*, edited by Lydia H. Liu, Rebecca E. Karl, and Dorothy Ko. Columbia UP, 2013. 1–26.

"A Lonely Legacy of Pan Yuliang." *China.org*, 7 Sept. 2007, http://english.china.org.cn/english/culture/223285.htm.

Luk, Yu-ping. *Ren Bonian's Zhong Kui Paintings*. 2004. University of Hong Kong, PhD dissertation. http://dx.doi.org/10.5353/th_b3056831.

Mann, Susan L. *Gender and Sexuality in Modern Chinese History*. Cambridge UP, 2011.

Marshall, Megan. *The Peabody Sisters: Three Women Who Ignited American Romanticism*. Houghton Mifflin, 2005.

Miller, James. *China's Green Religion. Daoism and the Quest for a Sustainable Future*. Columbia UP, 2017.

Mitchell, Thomas. *Hawthorne's Fuller Mystery*. U of Masschusetts P, 1998.

Nie Chongzheng, "The Qing Dynasty." *Three Thousand Years of Chinese Painting*, edited by Yang Xin, Richard M. Barnhart, Nie Chongzheng, James Cahill, Lang Shaojun, and Wu Hung. Yale UP and Foreign Languages P, 1997, pp. 251–97.

Ninety-nine Art Network. "Suopo zhi jing: Yu Hong bixia na min gan cui ruo wu zhu zhen cheng de—renxing" (Suffering World: Yu Hong's Brush Captures the Frail and Helpless Reality of—Human Nature). *Ninety-nine Art Network*, 4 Mar. 2019.

"Pan Yu Lin." *PanYulin.org*, n.d., http://www.panyulin.org/biography.php?lang=en (accessed 21 Oct. 2019).

Raphals, Lisa. *Sharing the Light: Representations of Women and Virtue in Early China*. SUNY P, 1998.

Rhazi, Thomas, dir. "The Laughing Heart: Yu Hong." *YouTube*, 15 July 2013, https://www.youtube.com/watch?v=XatjtwXevhg.

Richardson, Robert D. *Emerson. The Mind on Fire*. U California P, 1995.

Rosenlee, Li-Hsiang Lisa. *Confucianism and Women: A Philosophical Interpretation*. SUNY Press, 2006.

Ru Jie. "Ti Cheng Shifa lishi renwu hua" (On the Topic of Cheng Shifa's Historical Figure Paintings). *Cheng Shifa Shuhua. Lishi Renwu* 5 (Cheng Shifa Calligraphy and Painting. Historical Figures vol. 5). Hangzhou Gushan: Xiling Yinshe, 1980, pp. 1–16.

Sheng, Hao. "Liu Xiaodong." *Orientations*, Oct. 2010, pp. 66–69.

———,*Fresh Ink. Ten Takes on Chinese Tradition*. Museum of Fine Arts, 2010.

Silver, Ariel Clark. *The Book of Esther and the Typology of Female Transfiguration in American Literature*. Lexington Books, 2017.

Sullivan, Michael. *Art and Artists of Twentieth-Century China*. U California P, 1996.

———. *Modern Chinese Art: The Khoan and Michael Sullivan Collection*. Ashmolean Museum, 2009.

Teo, Phyllis. "Modernism and Orientalism: The Ambiguous Nudes of Chinese Artist Pan Yuliang." *New Zealand Journal of Asian Studies*, vol. 12, no. 2, 2010, pp. 65–80.

———. *Rewriting Modernism. Three Women Artists in Twentieth-Century China: Pan Yuliang, Nie Ou and Yin Xiuzhen*. Leiden UP, 2016.

Tien, Wen-hao. *Navigating a Private and Public Dialog with Nature: Between Field and Studio*. 2019. Lesley University College of Art and Design, MA thesis.

———. Interviews. Conducted by Shelley Drake Hawks, Feb.–Dec. 2019.

Tsai, Chun-Yi Joyce. *Imagining the Supernatural Grotesque: Paintings of Zhong Kui and Demons in the Late Southern Song (1127–1279) and Yuan (1271–1368) Dynasties*. 2015. Columbia University, PhD dissertation, https://academic-commons.columbia.edu/doi/10.7916/D8RR1X2W.

von Mehren, Joan. *Minerva and the Muse: A Life of Margaret Fuller*. U Massachusetts P, 1994.

Wan, Qingli. *Bonds of Memory: Wan Qingli's Collection of Chinese Art Given by His Teachers and Friends*. Exhibition catalogue. Hong Kong Museum of Art and Leisure and Cultural Services Department, 2013.

———. "Chun yu qian ru ye run wu xi wusheng. Xiao Shufang Laoshi jiaoxue jiaoren wangshi zhuiyi" (Spring rain slips into the night moistening things delicately and silently. Remembering Teacher Xiao Shufang's way of teaching), 1991. *Huajia yu Huashi: Jindai meishu cong gao* (Painter and Painting History: Modern Art Manuscripts). China National Academy of Fine Arts Press, 1997, pp. 263–68.

———. "Ronghua dan ren, chuoyue ju jian tianzhen. Xiao Shufang de huihua yishu" (You see the benevolence and innocence in the person. Xiao Shufang's painting technique), 1979. *Huajia yu Huashi: Jindai meishu cong gao* (Painter and Painting History: Modern Art Manuscripts). China National Academy of Fine Arts Press, 1997, pp. 256–62.

Wang Huaiqing and Wang Tiantian. *Commencement and Combination: Wang Huaiqing/WangTiantian Artwork*. Exhibition catalogue. La Peniche Investment Consulting, 798 Art Bridge Gallery, and Baiyaxuan Culture and Art Institution, 2008.

Wang Tiantian. Interview. Conducted by Shelley Drake Hawks, Mar.–Aug. 2019.

Wang, Sue. "'The First Encounter' and 'Same Path': Exhibition of Wu Zuoren and Xiao Shufang Opened at the National Art Museum of China." *CAFA Art Info*, 28 Sept. 2018. http://en.cafa.com.cn/the-first-encounter-and-same-path-exhibition-of-wu-zuoren-and-xiao-shufang-opened-at-the-national-art-museum-of-china.html.

———. "Yu Hong." *CAFA Art Info*, 2 Nov. 2016, http://en.cafa.com.cn/yu-hong.html.

Wang Xiaoye. Interview. Conducted by Shelley Drake Hawks, June–Aug. 2019.

Wang Yidong. "Liaoliao *Taihang Xishi*" (Talking about *Taihang Happy Events*). Beijing, 2014. http://wangyidong.com/wangyidong/archive.html (accessed 22 Oct. 2019).

Weidner, Marsha. *Views from Jade Terrace: Chinese Women Artists 1300–1912*. Indianapolis Museum of Art and Rizzoli, 1989.

White, Tyrene. *China's Longest Campaign: Birth Planning in the People's Republic, 1949–2005*. Cornell UP, 2006.

Wong Chun Li. "Portraying the Nostalgic Sentiments for Yi Meng Mountains. A Tribute to Painter Wong Yi Dong." *Wong Yi Dong* (Wang Yidong). Hong Kong: Suzhai, 1993, pp. 12–17.

Wu Hung, with Jason McGrath and Stephanie Smith. *Displacement: The Three Gorges Dam and Contemporary Chinese Art*. Smart Museum of Art, U Chicago, 2008.

Wu Hung. *Contemporary Chinese Art: A History (1970s–2000s)*. Thames & Hudson, 2014.

Xiao Shufang Huahui (Xiao Shufang's Flower and Plant Painting). Edited by Zheng Jingwen and Shi Jun. Fine Arts P, 1993.

Yang, Yan. "Yu Hong." Interview conducted by Yifawn Lee. *Orientations*, Oct. 2010, pp. 82–85.

The Yellow Emperor's Classic of Internal Medicine. Translated by Ilza Veith. *Images of Women in Chinese Thought and Culture: Writings from the Pre-Qin Period through the Song Dynasty*, edited by Robin R. Wang. Hackett, 2003, pp. 123–29.

Yiu, Josh. "Introduction—From the Forgotten Garden: Wang Huaiqing's Art, Life, and World." *Wang Huaiqing—A Painter's Painter in Contemporary China*, edited by Wang Tiantian. Ediciones Poligrafa/Seattle Art Museum, 2010, pp. 22–45.

Yu Hong. Interview conducted by Monica Merlin. *Tate*, 7 Nov. 2013. https://www.tate.org.uk/research/research-centres/tate-research-centre-asia/women-artists-contemporary-china/yu-hong (accessed 3 Aug. 2022).

Yu Hong and Jerome Sans. Labels photographed by Feier Ying at Yu Hong's *The World of Saha* art exhibition at the Long Museum, Shanghai, 9 Mar.–5 May 2019.

Zhang Yunyi. "'The Westward Spread of Chinese Philosophy' and Marxism." *Frontiers of Philosophy in China*, vol. 6, no. 1, 2011, pp. 114–33.

Chapter 9

"Lessons for Women"

From *The Good Earth* to *Leftover Women*

Jessica A. Sheetz-Nguyen

From the age of the oracle bones to contemporary times, gender rules in China have constrained the lives of women and men. In studying the social history of China, turning the lens of history to "herstory," a term coined in the 1970s, redirects the traditional male narratives of war, politics, and economics to that of women's compliance with social rules shaping fertility, maternity, family duties, education, and property rights (Tucker 17). Moreover, for millennia the scales of social equity favored men. However, women also played a role in shaping and implementing rules of deportment, which becomes apparent in exploring their life stories. Undoubtedly, the rationale and social structures supporting footbinding, concubinage, and fertility laws make accounts of women's lives in China different from those in the West and require a nuanced understanding.

This chapter offers an original interpretation of "her stories" in Chinese history by examining intersecting social frameworks of time and space in text, literature, film, and art for use in high school and college classrooms. By taking an intersectional approach, the power of time-based and gendered social rules of engagement reveals extraordinary women with deep strengths and newly developing constructions of self-worth that conflict with the traditional relational Chinese culture (Ames and

Rosemont 27). The transition from the imperial world to the present, accelerated in the mid-twentieth century with Mao Zedong's social and political reconstruction of society, provides the historical context in which to study the "long march" of her stories toward gender equity. Examining herstory from the time of the oracle bones to the era of leftover women in the world's most populous country enriches our knowledge of what it means and meant to be a woman in China.

From Histories to Herstories

Classical reference works published in English offer a backdrop for analyzing women's history in China. The *Cambridge History of China* (edited by Denis Crispin Twitchett, John King Fairbank, Albert D. Dien, Keith N. Knapp, and Willard J. Peterson) spans China's history from the third century BCE to the death of Mao Zedong in 1976. The collection includes fifteen volumes currently edited by Albert E. Dien and Keith N. Knapp. Of those, Jen-der Lee addresses "Women, Families, and Gendered Society" in the volume on the Six Dynasties, 220–589 CE (Jen-der Lee 443–59). An excellent essay, also in the *Cambridge History* by Susan Mann, "Women, Families, and Gender Relations," explains the condition of women during the Qing dynasty (Mann 428–72). Single-volume histories of China include the magisterial *Rise of Modern China* by Immanuel C. Y. Hsü, the first Chinese American historian who dedicated the volume to Professor John K. Fairbank. The text is so revered that publishers released the sixth edition in 2000. This comprehensive volume offers thorough coverage from 1644 to the return of Hong Kong to China in 1997. According to Hsü, the return of Hong Kong "marked the end of foreign imperialism in China, the decline of the British Empire, and the rise of China" (Hsü 982). Although he weighs in on women's and dissident history elsewhere, his text does not address women's history or issues. Fairbank also inspired Jonathan Spence, a British scholar who studied with him at Harvard. Spence followed Hsü's outline in *The Search for Modern China*, now in its third edition. Unlike his predecessors, Spence addresses women's status throughout the text, setting his work apart from other survey histories of China.

Narrowing the focus to the political history of the past two hundred years, eminent scholar Jack Gray published *Rebellions and Revolutions: China from the 1800s to 2000*. Shortly before Gray died, the *China Quarterly*

printed his outlined notes for his study of Mao (1893–1976), in which he makes four significant suggestions for further study (Gray, "Remembering" 661). First, Gray argues that China's rich overarching traditions make it difficult for Western intellectuals to see its history for what it is rather than what they would prefer it to be. Second, this history needs to incorporate Chinese culture and the struggle of a socialistic enterprise to combat poverty. Third, although the deeply seated role of Confucianism underpinned patriarchy, it did not significantly influence state power. By contrast, Confucianism shaped private as opposed to public life in modern times, which explains why, in part, untangling women's history in China proves to be challenging. Fourth, family relationships that include the histories of women do not precisely parallel political history, even though the Maoist state tried to unseat the traditional hierarchical relationships. In short, the state outlawed footbinding, instituted universal education, legislated new marriage laws, and managed to alleviate the worst rural and urban poverty. While, family planning policies instituted from the mid-1970s reinforced preferences for male children, leading to a disparity between the sexes and creating a new set of family formation issues.

Herstory or Women's History

Hence, for clarification, the classical volumes of political history allot limited space to women's history, so turning the lens to focus on women changes the picture. Young historians who came of age after the first rush of attention to women's history in the 1970s found inspiration in essays published by Joan Wallach Scott in *Past and Present* in the 1980s. Her scholarship continues to inform us and urges us to address women's agency in the "often silent and hidden operations of gender which are nonetheless present and defining forces of politics and political life" (Scott, "Women" 156).

Very significantly, even surprisingly, in the first issue of the academic feminist journal *Signs* (1975), Julia Kristeva wrote: "On the Women of China." This prescient essay examines the critical place of Mao's marriage laws and the impact the laws had on the old agrarian society in the decades after 1950 (Kristeva 59). In the 1986 volume of the *American Historical Review*, Scott expands her earlier assertions to include race. She claims, "Gender must be redefined and restructured in conjunction with a vision of political and social equality that includes not only sex

but class and race" (Scott, "Gender" 1075). Recognizing that race, ethnicity, and gender are active components of analysis, Scott's interpretation advances the argument from the binary male-female split into a broader inquiry into relationships of power. The argument is that power shapes and reshapes social equality and inequality. How power shapes women's lives in Chinese history appears in publications that build on Scott's thesis. In a 2008 volume of *The American Historical Review*, Gail Hershatter and Wang Zheng published "Chinese History: A Useful Category of Gender Analysis." Their essay outlines multiple measures by which to interpret gender history in China. They find three threads weaving through historical, political, economic, and anthropological writing: kinship practices, whether the women were members of the Communist Party, and whether the women who were members of the All-China Women's Federation served their sisters well. This new perspective was based on recently released archival materials, includes a review of pertinent literature, and unfolds historical arguments for women in China (Hershatter and Zheng 1405–6). Building on Kristeva, Scott, Hershatter, and Zheng, this chapter relies on history to underpin the narrative, which not only depends on the feminist historians but also on journalists, fiction writers, and artists who established helpful guideposts and recounted lifeways. In so doing, the narrative seeks to tease out and merge women's hidden and unhidden voices so they can be heard and appreciated in new, helpful, and empathetic ways.

The Beginnings of the Cultural and Moral Landscape

From the ancient past to the present, the moral and cultural landscape marks the site for studying human relationships in China. However, the far-reaching tendrils of rules for women are often hidden or unexamined. Scott's instructions are to understand the realm of female agency amid these occluded strictures and expose the "silent and hidden operations of gender" ("Women" 156). In traditional Chinese culture, gendered ties start with the family, expand in relational concentric circles, and create the rules necessary for society's functioning. Such instructions for leading a good life appear on oracle bones dating to 1200 BCE from Henan Province. Robin R. Wang explains the era of oracle bones in her scholarly work *Images of Women in Chinese Thought and Culture*. The National Museum of Scotland contributes to our understanding by displaying a collection of

inscribed bones, which show kneeling women symbolizing their humble place in society and the ubiquitous "unfortunate" infant girls. Nonetheless, Wang's findings emphasize complementarity between men and women and celebrate female virtues and family harmony, values that persisted for two millennia (Cao; R. Wang 2–3).

Contemporary scholarship shows that the preference for male offspring in a patriarchal society continued to shape Chinese women's lives for millennia despite the framework for complementarity and reverence for the family. In *Between Birth and Death*, Michelle King argues that gender choice and female infanticide appear in written records near the end of the Shang dynasty, the era of the oracle bones (1600–1046 BCE). The *Shijing* (ca. 1000–600 BCE), a compilation of poetry, selectively recommended ending a female infant's life with her first breath and celebrating a son's birth (King 4). The most used definition for infanticide was "to drown girls" (5). Although infanticide was not reserved for wealthy households, King's analysis suggests that even if an infant girl survived in a wealthy household, she nonetheless faced a lack of education that inhibited her intellect. Bound feet constrained her physical activities. The bride price measured the value of her life. Upon receiving a bride price payment, the girl's family transferred their daughter to her spouse's household. Lacking protectors, she was subjected to physical and emotional abuse. Maids, regarded as property by the household, became her friends. As a wife and mother, she lived out her days in the private-walled spaces of a family compound, separated from others by steep thresholds and large solid wooden doors (167).

In the fifth century BC, Confucius (551–479 BCE), compiler of the *Shijing*, also articulated instructions for families in the *Analects*. According to Henry Rosemont Jr. and Roger T. Ames, in *The Classic of Family Reverence*, the Confucian family sits at the center of a concentric circle: children honor their parents and relatives, both living and dead. They argue that *xiao*, the foundation of Confucianism, can be translated as "family responsibility," "family reverence," "family feeling," or "family deference." Confucius taught that reverence for one's family was part of the moral and spiritual cultivation needed to become a consummate human being or *ren*. Moreover, without *ren*, one could not become an exemplar or *junzi* (Rosemont and Ames 1).

Feminists who study Confucianism point to this phrase: "The Master said: Of all people, girls and servants are the most difficult to behave. If you are familiar with them, they lose their humility. If you maintain

a reserve toward them, they are discontented" (Li and Wang 67). Five centuries later, the extraordinary Chinese intellectual Ban Zhao (45–116 CE) penned a manners book titled *Admonitions for Women* or *Precepts for Women* or *Nüjie*. The lessons addressed imperial and gentry women, saying that the first rule of deportment demanded humility. Robin Wang translates Ban Zhao's rules as follows:

> On the third day after the birth of a girl, the ancients observed three customs: (first) to place the baby below the bed (on the floor); (second) to give her a potsherd [a symbol of domesticity] with which to play; and (third) to announce her birth to her ancestors by an offering. Now to lay the baby below the bed plainly indicated that she is lowly and weak and should regard it as her primary duty to humble herself before others. To give her potsherds with which to play indubitably signified that she should practice labor and consider it her primary duty to be industrious. To announce her birth before her ancestors meant that she ought to esteem as her primary duty the continuation of the observance of worship in the home (for both ancestors and parents). (R. Wang 179)

Whether Ban Zhao described rules already in place or prescribed new ones for success, the precepts gained acceptance. "Womanly qualifications" meant women vowed obedience to her father before marriage, to her husband after marriage, and to her son after the death of her husband. This demand for loyalty cemented patriarchal authority. Moreover, the four virtues—morality, proper speech, modest behavior, and diligent work—compelled daughters, unlike sons, to strive for harmony and order in the family (R. Wang 184–85).

The third-century Zhang Hua (232–300 CE) parodied Ban Zhao's *Precepts* in "Admonitions of the Instructress to Court Ladies." The instructions appear on a pre–Tang period silk scroll, which hung in the imperial households up to the turn of the twentieth century. The embroidered images appear on nine panels (originally, there were twelve). The fine needlework imparted lessons like the Ten Commandments on stone slabs in Jewish temples, or frescoes, paintings, and statues in Christian churches. Modern records confirm that the Qianlong emperor exhibited these silks (Kosek et al.; Hironobu).[1] The scroll provides a visual representation of elite Chinese women, which like the *Admonitions*, explains social expectations that did not apply to brothers, sons, husbands, and fathers.

During the seventh century Tang dynasty, *The Analects for Women*, or *Nü Lünyu*, articulated more specific guidelines, addressing behaviors seen as infractions of an imperial moral code. Song Ruoxin and Song Ruozhao composed twelve books and expanded on Ban Zhao's *Admonitions*. In Book One, "On Deportment," chaste women should follow these precautions.

> Don't turn your head and look while walking. Don't show your teeth while speaking. Don't move your knees while sitting. Don't sway your dress while standing. Don't laugh out loud when happy. Don't shout when angry.
>
> Indoors or out, men and women should be in separate groups. Don't peep beyond the outer wall, and don't go beyond the courtyard. Hide your face when watching something. When going outside you must cover yourself.
>
> Don't give your name to a man who is not your relative. Don't become friendly with a woman who is not from a good family. Only by being decorous and proper will you be a [proper] person. (R. Wang 329)

In short, Ban Zhao's *Lessons*, the *Admonitions* scroll and *The Analects for Women* originated with Confucius and were reinterpreted and re-echoed across the centuries. The constraints placed on infants, girls, and women also appeared in eighteenth-century texts read by gentrified and imperial women. The libraries cultivated cultural and class differences between peasant and elite women and provided scholarly women, such as Liu Xiang, with sources to compile *Biographies of Exemplary Women*. Unlike men's biographies, feminine texts extolled moral qualities, such as filial piety and sexual purity (Mann, *Precious Records* 204–5). The next hundred years saw the educated dowager Empress Cixi (1835–1908) ascend to power as she checkmated her opponents like the mistress of a chessboard. Her progressive endorsement of girls' education marks the hiatus between the past and modernity, as literacy gave way to the entry of women into the public sphere and the steady rise of the Chinese women's movement after her death in 1908 (Li and Wang 66–82; Scott 156).

History from the Top Down: the Dowager Empress

Shortly after the Opium Wars (1840–1844), women became more visible to the public through the press and popular literature, supplying archival

materials with written accounts of their lives. Some scholars resist or diminish the power of biography, calling it a top-down approach to history and claiming that biography limits understanding of an era because a single person's life pales when compared with the larger whole. Well-known figures may have had a checkered background; however, without passing judgment on what they did or did not accomplish, whether they were nourishing and fruitful or vile and exploitative, we can say that wealthy Chinese women lived within the structure of a fully entrenched culturally defined patriarchal hierarchy. Women such as the Empress Dowager lived in a society with limited power far exceeding their contemporaries. Further, understanding the broader landscape of history through an account of an individual's life serves as a rich introduction to an era. In *Empress Dowager Cixi*, Jung Chang documents the lives of royal women, explaining power struggles and how rank functioned to privilege some women over others. She shows how Cixi used her viable son to gain control of the state bureaucracy, a world tightly controlled by men and eunuchs (Hershatter, *Women and China's Revolutions* 10; Hsü 184–95).

Late nineteenth-century court members and international diplomats would concur with Jung Chang, who argues that Empress Dowager Cixi launched modern China. In 1901, according to an Englishman at court, Cixi issued an edict commanding that schools and colleges adopt a Western-style curriculum (Headland 362). In 1902, after the Boxer Rebellion, Cixi lifted bans on intermarriage between Han and Manchu couples. The same decree encouraged Western-style education for women and warned against binding women's feet (J. Chang, *Empress* 326–27). Of Manchu stock, Cixi believed bound feet were unnatural and strongly disapproved of this practice. She refused to allow most Chinese women with "three-inch golden lilies" or bound feet into her palace compound. She made an exception for Lady Miao, her Chinese painting instructor. Nonetheless, Cixi still required the teacher to unbind her feet before entering her private quarters. Despite her progressive vision, the patriarchal bureaucrats rejected her requests for modernization despite her rank, power, and opposition to footbinding and women's education (Headland 233).

Cixi's reforms for women also relate to Chinese opera, a folk-art form that she patronized. Between 1889 and 1894, she commissioned an opera based on a story dating from the tenth to the twelfth century titled *The Warriors of the Yang Family*. Traditionally, women performed mannequin-like roles as part of the chorus. In this opera, however, women play hero-warriors. Cixi translated the folk tale into *Kunqu*, the

oldest, most refined form of Chinese opera that includes drama, music, poetry recitals, and ballet.[2] As the producer, she tasked Lady Miao with assigning lead roles to women. Hence, under Cixi's leadership, women performed the *"Female" Warriors of the Yang Family*, now among China's most beloved operas (Chang, *Empress* 179).

At the end of Cixi's reign, Mary Gaunt, an English woman, wrote, "She was the best republican of us all . . . for she freely gave up her position that China might be free" (Gaunt 77). The Qing dynasty (1644–1911) had nearly ended when Cixi died in November 1908; high politics ensued with a power struggle. Her three-year-old grandnephew P'i-u succeeded to the throne with his father, the second Prince Chǔn, acting as regent (Hsü 416). The Western-educated Sun-Yat Sen (1866–1925) formed the new republic on 1 January 1912 (Hsü 469–71). This era marks the beginning of social, political, and economic revolutions informed by intellectuals well versed in Western ideals, including Marxism and democracy (Hsü 493–519).

The traditional awakening of China from multiple dimensions coalesces with the May Fourth movement related to the diplomatic ending of the Great War in Europe. The Versailles Settlement articles relating to China (1919–1920), despite China's considerable contribution to the war effort, created an overwhelming sense of political humiliation and inspired outrage among university students, who began protesting at Tiananmen Square Gate on 4 May 1919. The uprising had three causes. First, article 156, the Shantung section, ceded territories formerly under imperial Germany's control to Japan; the regions included Tsingtao, Jiaozhou Bay, and Shantung (Shandong), the hallowed birthplace of Confucius and Mencius (Martin 93). Technically, the negotiator's hands were tied because China had agreed to a secret treaty in 1918 that ceded Shantung to Japan, but the Chinese Republican government had not ratified the treaty. Second, the Versailles Treaty diplomats failed to distinguish between Chinese and Japanese geopolitical interests. Finally, the diplomats overlooked compensation for over 140,000 Chinese workers who dug trenches, built defensive walls, and risked their lives on the Western Front. The Chinese students, who included women in their ranks, rightly concluded that China had been sidelined by the West (Hsü 502–5; Guoqi 240–43).

In part, supreme myopia and imperial arrogance on the part of the Big Four (Georges Clemenceau, Vittorio Orlando, David Lloyd George, and Woodrow Wilson) incited the discontent. Social unrest spread to other cities, including Shanghai and Tianjin (Hsü 502–4). The

Sino-Japanese Treaty, signed on 4 February 1922, rectified the problem of the Shantung section, article 156. Although designed to reverse the misallocation, it could not undo the damage done or turn back the clock (Martin xxv, 93). Continued student unrest resulted in demands for the social reconstruction of society, including dismantling the feudal system and redressing women's rights. While these changes occurred in urban centers, the peasantry, China's largest demographic constituency, remained part of the backbone of traditional society until the communist social reconstruction began in 1949.

History from the Bottom Up: The Peasantry

Historians and literary scholars often focus on the literate gentry and palace culture because of the richness and expanse of written records. However, the "people of the soil," as peasants are called, are an equally important part of analyzing women's history, and for this group, there are few unfiltered texts. The reason for this lack of historical record is that peasants were working, not writing. Even so, peasants informed Mao's vision of society and the communist revolution because he saw their society as egalitarian. In terms of women in the family, he wrote: "As to the authority of the husband, this has always been weaker among the poor peasants because, out of economic necessity, their womenfolk have to do more manual labour than the women of the richer classes and therefore have more say and greater power of decision in family matters" (Mao 44). Throughout China's long history, the peasantry farmed the land, living day by day in concert with the seasons, the earth, sun, clouds, and wind. How, then, in the twentieth century, do peasants appear in the historical, sociological, and literary imagination? What elements of daily life appear as central to the Chinese character? These questions can be answered with a sociological history from the bottom up that examines peasants' life and work. Scholar-sociologist and anthropologist Fei Xiaotong's inimitable study of Chinese peasantry, *From the Soil: The Foundations of Chinese Society*, published in 1947, guides our understanding. Fei's brilliant lectures supported insights into the complexities of their lives. Replete with a glossary of terms in Pinyin, Fei highlights the distinctive characteristics of rural life up to the dawn of the revolution. He explains that peasants lived in a circular pattern of associations, like "the ripples flowing out from the splash of a rock thrown into water"

(Fei 20). By contrast, "Western society is represented by straws collected to form a haystack" (20). "The hayseeds," or those tied to the earth, "are truly the foundation of Chinese society." During Mao's early stages of the revolution, peasants could not live away from the soil. Their very livelihoods depended on the land (37). However, this reality changed over the next fifty years and up to the end of the millennium.

Life's uncertainties caused by the weather forced peasants, eternally familiar with arduous work, to engage with the world around them. They were not passive subjects or unwilling to take chances, as was reported during the Taiping Rebellion in western newspapers. The remarkable Hong Xiuquan (1813–1864) came from Hakka stock, or "guest peoples," who had migrated to the south from central China. After reading a translated set of pamphlets handed to him by Christian missionaries, Hong began to believe that he was the younger brother of Jesus Christ. The charismatic leader formed a troop of "God worshippers" (Spence 171–78). Hakka women with unbound feet joined their husbands and took on the mantle of warriors. Their families joined the Taiping to become what Kazuko calls his "feminist" followers. The women wore battle dress, readily accepting the dissolution of nuclear families and the separation of the sexes. These women, cast as barbarians with big feet, protested the influential British factory owners in Guangdong Province. An all-female army of over two thousand, led by "Sanmei" or Su Sanniang, grew to a battalion of over ten thousand women and became famous for their attack at the siege of Yongan in Hunan Province (Kazuko 9–10).

Unbound feet marked these women as barbarians, but Cixi, a Manchu woman, did not have bound feet. Neither did millions of other peasant women, although depending on the wealth of the peasant family, this was still possible. Traditional peasants worked in the fields and had little time to write, even if they were literate. Hence, we must rely on "faithful observers" such as Pearl Buck (1892–1973) to explain their lives. Although biased like all literary or historical accounts, Buck's *The Good Earth* allows us to read between the lines of life. Her novel offers a definitive account of the timeless peasant woman with unbound feet. So why should we count her work as authoritative? Buck, the daughter of missionary parents from West Virginia, grew up in China and later returned to live a part of her life there. She won a Pulitzer Prize in 1932 and the Nobel Prize for Literature in 1938 for her "rich and truly epic descriptions of peasant life in China and her biographical masterpieces" (The Nobel Prize in Literature 1938). Although Buck's work is

sometimes problematic because it combines populism with a reactionary view of Chinese modernity, it is accessible (Christie 49). Scholars such as Li Xingbo argue that Buck was "the most remarkable formulator of the image of China during the years 1930–60" (Christie 50). Today, she is honored at the Pearl S. Buck Memorial House and Museum on the campus of Nanjing University, where she authored her novel ("Pearl S. Buck Memorial House").

Buck describes family relationships and their ties to the soil, supplying a fine literary example of Fei Xiaotong's sociological study. She begins the first chapter with, "It was Wang Lung's wedding day," opening onto a straightforward biography of his wife, O'Lan, a formerly enslaved person (Buck 1). Undoubtedly, the new bride's upbringing gave her the wherewithal to be resourceful and brutally realistic; her first mission as a woman was to produce sons. She gave birth in their fields only to return to the soil alongside Wang Lung. As a malnourished mother, she birthed a brain-damaged daughter whom the family called the "little fool." The novel placed new life and O'Lan at a crossroads on a second occasion during a harsh famine when everyone was near starvation. Recounting her terrible and lonely choices as a peasant woman, Buck writes,

> She would give birth alone, squatting over the old tub she kept for the purpose. He [Wang Lung] listened intently for the small sharp cry he knew so well, and he listened with despair. Male or female, it mattered nothing to him now—there was only another mouth coming to feed. "It would be merciful if there were no breath he muttered and then he heard a feeble cry—how feeble a cry!"—hang for an instant upon the stillness. "But there is no mercy of any kind these days he finished bitterly, and he sat listening." There was no second cry, and over the house, the stillness became impenetrable. (81)

How O'Lan delivered a baby on her own, without the help of a midwife, remains a mystery. Wang Lung's description of his wife's desperation upon the birth of another child presents us with stark reality. He tells us that O'Lan pressed her thumbs into the newborn's neck to end the suffering. He describes this trial sympathetically:

> Her [O'Lan's] eyes were closed, and the color of her flesh was the color of ashes and her bones stuck up under the skin—a

poor silent face that laid there having endured to the utmost, there was nothing he could say. During these months, he had only his own body to drag around. What agony of starvation this woman had endured, with the starved creature gnawing at her from within, desperate for its own life! (82).

Buck's compassionate recounting of O'Lan's predicament helps us realize the depths of human suffering, especially for women as child-bearers. After birthing several sons, rescuing her family in a crisis, and seeing her husband's infidelity, O'Lan succumbed to cancer. This compelling account of herstory, O'Lan's story, is an excellent introduction to the historical past of China's peasant women, filtered but accessible.

A more recent novella about peasant life, *Red Sorghum* by Mo Yan (Moye Guan), was translated by Howard Goldblatt in 1993. *Red Sorghum* recounts a Chinese peasant family's struggle to survive warlords and the Japanese (c. 1923–1939). In 1987, Zhang Yimou produced a film version that offers a linear account; by contrast, the novel unfolds through disorienting and disturbing flashbacks, replicating the function of our memories. Anna Sun describes the work as "hallucinatory realism" (qtd. in Laughlin). Even though Mo Yan received the 2012 Nobel Prize in Literature, a mark of Western approval, the literary and arts community castigated him for his failure to support dissident Liu Xiaobo, accusing the writer of complicity with the Chinese Communist Party (CCP) (Laughlin). Nina Wang defends his work for its global and cross-cultural perspective (N. Wang 167). In terms of herstory, this novella illustrates a rare instance of feminine resistance, the rising leadership of a family matriarch, and her courageous abandonment of a dowered husband in favor of a sedan chair carrier (Tan and Zhang).

Like Buck, Mo Yan's novella and Zhang Yimou's film address the pivotal moment in a peasant woman's life: her wedding day. The artists show how a "privileged" woman could flirt with an attractive sedan carrier using her "three-inch, golden lilies" (Moye 38). *Red Sorghum* offers sufficient contextual details for the wedding ritual, such as three layers of new clothing she wore while riding to her destiny in a bridal sedan or "coffin" (38). Rocking back and forth in the chair as her carriers take her to the home of her betrothed, the bride prays, "Old Man in Heaven, protect me!" (41). The wedding party leads the bride to the betrothed—a leprous man. Unrepentantly repulsed, the young woman returns to her father only to discover he had traded her for a donkey! Returning to the

sorghum winery, she realizes that her most handsome sedan chair carrier had killed the leper, and she had fallen in love with him. In a twist of fate, a common trope in China's literary world, the young widow becomes the "red sorghum" wine distillery owner. She rises to power, only to be killed by the Japanese. Throughout the story, the women rise to the top as strong actors—bearing the strains of infidelities, attacks on their families, challenging marital relations, and sexual violence (Moye 54).

While Buck offers a very linear account of a woman's life, Mo Yan offers a series of circular flashbacks that asks readers to examine his approximation of the feminine experience. The text does not assign personal names, using only the titles "grandmother" and "grandfather" for the actors, elevating the familial over the personal or individual identity. *Red Sorghum* expands domestic life into the barnyard and fields, indispensable spaces for survival. In effect, the fields became a sanctuary for making love, birthing children, burying the dead, and battling the Chinese warlords and the Japanese. Buck and Mo Yan supply provocative analyses of peasant women making their living from the soil.

From Footbinding and Concubinage to the Anti-Footbinding Movement

Red Sorghum offers an example of a peasant family's desire to ensure a prosperous marriage partner for their daughter by binding her feet. In *Aching for Beauty*, Wang Ping explains the gendered rules of footbinding that created this moral landscape, which had already been known from about 2100 BCE (29). Footbinding among the gentry and imperial families started in earnest during the twelfth century (31). The practice was embedded in the feudal-patriarchal code and ensured the control of women. Even peasant families bound their daughters' feet, so they would not be expected to tread through the fields like a plow animal. The decision originated with her mother, who told her daughter that it was necessary to save face. When their little girls were around four years old, mothers took them to a foot binder. Bound feet promised marriage for the bride, sexual arousal for the groom, and offspring, hopefully, sons, for the family's longevity (225).

Records of Gathering Fragrance (*Cai Fei Lu*) by Yao Linxi offers firsthand accounts of the footbinding practice collected in the 1930s (Ping 5). The binder intentionally broke the bones by pushing the front of the foot back

so that eventually the toes and toenails grew into the bottom of the foot. The broken feet seldom healed well, had a horrific smell, inflicted lifelong pain, and raised little concern among men who were not afflicted with this curse. A footbound woman never removed her shoes in bed. She could not walk without support from ladies in waiting. She was dependent on her husband and his family. She could not run away from home. Most of all, footbinding taught humility, making her subservient to the world (4). Society simply accepted the practice until the end of the nineteenth century.

Lin Qinnan started the anti-footbinding movement and composed a popular protest song, "Stop Footbinding!" to inspire followers (Kazuko 30–32). The verses declared that an educated woman would not have her feet bound, she would not bind her daughter's feet, and she would not allow her son to marry a woman with bound feet. The ballad represents the values of the Anti-Footbinding Society, formed in 1883; over a decade later, the Natural Foot society (led by European missionary wives) also stood in solidarity with the movement (29). This like-minded group of sisters and fellows was formally organized in Shanghai, a city with a strong European influence, in 1897 (29–33). Even though the initiative failed, Lin Qinnan had planted the seeds for change. As mentioned above, people witnessed the Hakka women who fought in the Taiping Rebellion and Dowager Empress Cixi issued the Qing reforms that included the prohibition of footbinding despite its threat to patriarchy (27). Slowly the practice receded into the past as "new women" emerged.

Social changes in the *hutongs*, or narrow alleys that walled off the main streets, villages, and the countryside, marked the slow dismantling of Confucian traditions at the end of Cixi's reign. Shaken to the core were Confucian concepts of family loyalty, filial piety, chastity, the "Three Bonds, and Five Relationships."[3] These bonds and relationships gave way to fragile threads of Western individualism, freedom, and equality between the sexes (Hsü 426). The devolution of bonds and relationships based on superiority and subordination soon shook Chinese society to the core (Kazuko 93–94). In 1897, journalist Liang Qichao (1873–1929) published a set of principles, including a new curriculum for female education. In Qichao's view, the country's fate rested on China's 200 million women. Frankly, he argued that those with bound feet were and would continue to be dependents, consumers (not producers), even parasites. On the other hand, the better path forward supported independent, educated, professional women who would become excellent first teachers in their families, cultivating decent male citizens (27).

Changing social attitudes and cultural traditions overturned centuries of women's oppression in elite households. We can better understand this transitional cultural moment by following the representations of the educated university woman and concubinage as they appear in classical Chinese romance stories and contemporary literature. Although popular attitudes in the family continued to be shaped by Confucianism, education for women created an incubator for changes that supported the end of footbinding, concubinage, child brides, and increased awareness of the potential for self-fulfillment and self-determination (Cong 67).

Nonetheless, bound feet and a university education did not guarantee an immediately smooth road to success because the parent of an educated woman could still barter her life away. *Raise the Red Lantern* or *Wives and Concubines* by Su Tong clearly illustrates this reality. Zhang Yimou adapted the novella for the film. The story, set in the early twentieth century, begins with Lotus, whose father committed suicide after his tea production factory failed, which meant he no longer had the funds to pay for her college tuition (Tong 19). Her stepmother offered her a choice: choose to work or get married. Filial piety and respect for the stepmother convinced her that it was better to marry a wealthy man, Chen Zhuoqian, owner of a large household that included multiple wives, male and female housekeepers, and cooks (25). After her introduction to the panoply of characters, the marriage rites began with the celebratory raising of red lanterns by the household staff of men (in the film). This event signals Lotus's selection as the marriage partner for the night, and Chen, the fifty-year-old man, explains that he was thin because his wives exhausted him. Her competition among the other women was self-evident. They all jockeyed for the master's affections. Among them was Coral. To Lotus, Coral was adventuresome; she sang Chinese opera, played mahjong, fell in love with a doctor, and enjoyed leaving the family compound for a jaunt around town; she was a new woman.

Lotus observes witchcraft, homosexuality, marital infidelities, the execution of one of her sister wives, unfaithfulness to the family, and ghosts created by infidelities. She also witnessed the murder of Coral, the third wife, which was portrayed by the family as suicide by drowning. The family narrative claimed that Coral had thrown herself into a deep well; the other concubines thought this a just death. As everyone knew, "adulterous wives never come to a good end." Coral had witnessed not only the forcible murder of Lotus and but also the complicity of every woman in the household. Like Coral, she too lost her life by losing her

mind. This conclusion of both lives was neither a fair nor just end (Tong 97–99). *Raise the Red Lantern* closes with the arrival of the fifth mistress, Bamboo, proving that Coral, Lotus, and the other women in the compound were not only interchangeable but also replaceable.

As *Raise the Red Lantern* and other accounts will show, the progressive movement toward universal education and the rejection of footbinding and concubinage could not immediately reverse continuities from the past. Further investigation of these social complexities, when explored in fiction and nonfiction, heightens our awareness of feminine oppression. A dual memoir, *Bound Feet and Western Dress* by Pang-Mei Natasha Chang reveals the resilience of these far-reaching cultural practices. In this account, Chang, an American-born Chinese woman, provides a compelling study of her great-aunt's life, her grandfather's sister Yu-i, who left Shanghai for Cambridge with an unreformed husband in the 1920s (P. Chang 5). The tensions between the couple, the interior dialogues, and the cultural details of a traditional marriage reveal the discomforting conditions of her life. Leaving Shanghai for Britain, deemed a great adventure, turned into a humiliating defeat for Yu-i, who explains, "In China, husband and wife were supposed to act distant toward each other, especially in front of in-laws, to show respect" (113). Leaving China, however, placed Yu-i in a vulnerable position, especially because she was taken away from the supporting sphere of family protection, particularly from her husband's troublesome behavior.

Bound Feet illustrates how cultural practices moved across geographical boundaries and beyond the cultural confines of Chinese society. Control and submission appear as an overarching pattern in Yu-i's life with her husband at Cambridge. Although she felt privileged to live in England, being apart from family made her defenseless. When she revealed that she was pregnant, her husband ordered her to "get an abortion" (P. Chang 115). Then a challenger, a woman with bound feet appeared at the front door of their house, claiming that she wished to join them for "Shanghai" food. The guest was not starving, and Yu-i's husband had invited her for dinner. That her husband had asked Yu-i to accept a concubine was a bridge too far. Yu-i retorts, "bound feet and Western dress do not go together" (122). Yu-i left her husband proclaiming, "I am not an old-fashioned woman" (122). She petitioned for a divorce and joined her brother in Paris (127). She returned to Shanghai and later emigrated to the United States in 1949, just before the city fell to the communists, who had made it their mission to reconstruct Chinese society more radically than the progressive reforms of the 1920s and 1930s (204).

From the Anti-Footbinding Movement
to Women in the State

The influx of "diverse foreign ideas" that created competing views on reconstructing China figured prominently in publications by progressive Chinese women writers. They helped frame the debate between the Nationalist community, led by Chiang Kai-shek, and the CCP, which formed in 1923 under the Soviet Comintern guidance (Hsü 12). The formative texts for women intellectuals included the works of Karl Marx, Gustave Flaubert's *Madame Bovary*, and Henrik Ibsen's *The Doll's House* and *The Lady from the Sea*. In addition, ideas embedded in Western literature often seeped into personal narratives composed by China's new women. This canon reshaped what it meant to be an educated woman, especially for He-Yin Zhen (Hershatter, *Women* 95) and a little later, Ding Ling.

One of China's most notable and early feminist writers, He-Yin Zhen (1884–1920), started publishing before the establishment of the new Chinese republic (1908) and the outbreak of World War I in Europe (1914). Representative essays translated and published by Lydia Liu, Rebecca Karl, and Dorothy Ko in *The Birth of Chinese Feminism* illustrate the political concerns of the feminist literati. Zhen marks her target as the tyranny of men's rule over two millennia of Chinese scholastic traditions and ritual culture, from the *Yijing* to Xunzi (Zhen 122–46). She argues that Chinese script, distantly based on the oracle bones, and traditional family naming practices, oppressed women (Zhen 114). Zhen proclaims that the time had come to unseat the past, including classical learning, funerary rites, and marriage laws that relied on the Three Bonds and Five Relationships.

Her published essay, "On the Question of Women's Liberation," espouses feminist concerns (1907). Marxism strongly influenced her ideas, which transformed social ideals for Chinese feminists (Zhen 53–70). Her discourses address "freedom of (in) marriage." Framing her argument as complaints, Zhen challenges the past, especially in the manifesto, "On the Revenge of Women." She bluntly states that there was no distinction between slaves, women, and property under the feudal state, and until this situation changed, women would continue to be slaves (Zhen 103). She writes, "One cannot deny that an empress occupies a highly esteemed position, but she never questions her subjugation to a man. At the other end of the hierarchy, one finds beggars whose social position

cannot be more degraded. Nevertheless, even a female beggar would not question her subjugation to a man" (Zhen 103). Pointedly, Zhen argues that women were party to yet unaware of their subjugation and thus no different from beggars and enslaved peoples.

After 1919, during the May Fourth, New Culture movements and the emergence of the Chinese Communist Party (CCP), the most representative feminist writer of this era, Ding Ling, published her work, *I Am Myself a Woman*, which Barlow and Bjorge have translated. Witnessing the outpouring of nationalist sentiment stirred up by the May Fourth movement, Ding Ling joined the CCP because the party platform advocated for political reforms. In "Miss Sophia's Diary" (Ding Ling 49–81), inspired by French writers de Maupassant and Rousseau, asks, "What is love?" In unfolding the answer, she concludes that the feminine liberates the heart but not the body (50). Ding Ling's comments show that she was not a blind idealist, particularly when she compares women's engagement with the CCP movement as "a miscarriage of justice" or the "miscarriage of a fetus" (50). Despite the widely touted egalitarian ideals of the CCP, her male comrades muffled Ding Ling's voice.

By 1932, Ding Ling increasingly wrestled with the flaws of Marxism. In the "Net of Law," she highlights the strains of life in urban *hutongs* (housing units connected wall to wall and surrounded by walls). She asks why women suffer more than men and asserts, "women die so that men can unite in proletarian brotherhood" (Ding Ling 172). Ding Ling demonstrates how seemingly insurmountable problems tried everyone's patience. She recounts the pressures urban poverty placed on women living in the *hutong*, writing, "The news of Acui's miscarriage was passed along the entire alley. . . . He [her husband] thought it is all her fault. She brought on the miscarriage by all that unreasonable crying" (184). Acui responded: "How can he help but beat me? We've no way out. Our food is gone. We've pawned everything. We've begged. We've waited for temporary work. It's no use. Starvation is all that is ahead of us" (190). The sheer desperation of Acui's account explains why, in 1940, Ding Ling left home to join the CCP in its capital, Yan'an. She hoped to find favor among her comrades because, on paper, the CCP challenged not only feudalism but also traditional male-female relations, the patriarchal family structure, and the limited legal status of women. It promised "women's emancipation," or *fùnu jiefang yundong* (Gilmartin 8). Inspired, Ding Ling joined the women's "rights" or the "power" movement,

nüquan yundong (Gilmartin 7), which hoped to strengthen the state by improving their own lives. When the party assurances failed, Ding Ling published a sarcastic essay, "Thoughts on March 8, Women's Day, 1942" (Ding Ling 316–21). She attacked the persistence of traditional views of womanhood, presenting an unanticipated affront or challenge to party authority that prompted harsh criticism from censors (Kazuko 170). Despite its idealistic hopes, the party "reproduced and reinscribed central aspects of the gender system from the larger society" (Gilmartin 8). Mao and his followers also contradicted feminist ideals in their personal lives, replicating the traditional patriarchal gender system in the CCP. For the men who led the political revolution, women's liberation—a social revolution akin to the struggle for racial equality—paled in comparison to the overarching goal and challenges of the social reconstruction of China as a Marxist-Leninist state (Gilmartin 8).

Between 1945 and 1949, the Nationalist Army, led by Chiang Kai-shek, and the Red Army, led by Mao, battled for supremacy. The Chinese civil war ended with a successful revolution supported by the People's Army. All foreign-occupying troops, including US Marines, abandoned mainland China, leaving behind military supplies—enough to bring the protracted conflict to a close when aided and abetted by the Soviets. In September 1949, Mao called the first party plenum in Beijing, symbolized by raising a flag with yellow stars on a red background above the Forbidden City. Mao achieved a political, not a social revolution (Hsü 645–46).

After achieving a politico-military victory, Mao based his social revolution on promises of a reconstructed society; these ideas emerged during the Republic and started to evolve when Mao removed centuries-old civil codes relating to marriage rights that intersected with "self-determination in the 1930s. This action strained idealistic visions of women with the freedom to determine whom they would become and their prescribed duties (Cong 150). The social revolution (or social reconstruction of society) commenced in full in 1950 when the People's Republic of China passed revised legislation addressing marriage and land reform (Kazuko 176–88; Kristeva 58). The newly constructed society dismantled the feudal system and required women to take responsibility for their economic well-being. Revised marriage laws permitted remarriage for widows, as had been called for at the turn of the twentieth century by fiction writers and translators of foreign fiction, including Liang Qichao and Lin Qinnan. Interestingly, the revised code enumerated activities associated

with "bourgeois morality," including prostitution, adultery, concubinage, bigamy, child marriages, and excessive dowries (Hershatter, *Women and China's Revolutions* 221; Kristeva 58).

Social reconstruction targeted land reform, family stabilization, scientific midwifery in rural areas, mobilization of women in the workforce, and urban and rural economic development (Kazuko 140–75). Maoists enlisted the All-China Women's Federation (ACWF) to aid in transforming the Chinese peasantry into an educated and productive workforce (Hershatter, *Women and China's Revolutions* 220). For firsthand accounts of this process, turn to Wang Zheng's scholarship, which explains the significant role urban and peasant women played in revolutionary state-building. A subsidiary of the larger ACWF, the Shanghai Women's Federation (SWF), joined together six "housewives associations" that mobilized a group of one million women in a city of five million. Unlike factory unions, these women worked to recover the city from the devastation of war. SWF community projects, such as street sweeping, building food pantries, teaching, and managing schools, empowered women in new ways. The activists convened congresses, developed regional administrative districts, participated in parades, and made their opinions known to the CCP. They realized new powers unknown to their mothers and grandmothers (Zheng, *Finding Women* 300–337).

Two decades later after the turmoil of the Cultural Revolution (1966–1976), the demise of Mao, the Gang of Four, and the rise of Deng Xiaoping in 1978, Ding Ling's published novellas revisited the status of women in relationship to the CCP. In "Du Wanxiang," she boldly compares the old associations and the endless layers of party directives with the imperial system, suggesting that not much had changed (Ding Ling 329–54). She communicated these criticisms through the account of Wanxiang, a party apparatchik who lacked a "lofty, bigger than life spirit" and participated as a faithful party servant. This woman stayed in her lane. She did not stray. She represented the women married to the party. For her exemplary behavior, Du Wanxiang received national recognition for an hour in the spotlight before an audience of well-wishers. Officials solicitously shouted through a loudspeaker, "you've taught us a wonderful lesson. . . . Du Wanxiang is our frontline soldier. We must learn from her. We must go forward with her" (354). The subtext is that the honor she received was incommensurate with her diligence. This novella on the feminist builders of the new state offers a final and personal reflection on Ding Ling's own life.

Love and Marriage

Outside of the party, the unsettled cultural environment between 1930 and 1976 included the breakdown of the patriarchal family, honor codes, social displacement, and a reassessment of marriage. In concert with these themes, Eileen Chang's sophisticated collection of novellas published as *Love in a Fallen City* aids understanding of the meaning of love and duty in Shanghai and Hong Kong during the 1930s and 1940s. In addition to translations of French, German, and English literature, the cultural practices, and tastes of European communities living in China informed the lives of elite women. These cities of designer perfume, books, and book talks, smoking cigarettes, drinking wine and cocktails, and thinking about life issues become vividly alive through the essays of Eileen Chang, also known as Zhang Ailing or Chang Ai-ling. Her accounts illuminate a liminal space between China and Europe. Educated at an Episcopal girls' school in Shanghai, Chang's influential reading preferences included Chinese classics such as *Dream of the Red Chamber* and works by O. Henry and W. Somerset Maugham (Zi, Zhendong, and Hong 213–14). At age fifteen, she titled her first publication, "What a Life! What a Girl's Life!" and released it to the *Shanghai Evening News* in 1938 (Der-Wei Wang 215).

Despite the swirl of high politics and the strains of the Japanese invasions, her literature turns to everyday life and a world that ignores the turmoil (Link, "Chinese Shadows"). Eileen Chang transcended this era by blotting out the sacking of Nanjing, the fighting between the Nationalists and communists, and by rising above human suffering. Her themes, as Perry Link writes in the *New York Review of Books*, include "love, money, status, saving face, jealousy, longing, calculation, manipulation, psychological compulsion, and almost always frustration and ruin" (Link, "Chinese Shadows"). Scholars have compared her to Jane Austen, but Link argues that her female characters do not fully control their destinies. For Austen and Chang, freedom rests in finding ways of circumventing entrenched patriarchy. Like the insights provided by He-Yin Zhen and Ding Ling, Chang's perceptions lay claim to an elite literary space. Her literature shows the women who had few choices other than to navigate the treacherous passage from the world of traditional China to the freedom and danger of life in the West (Lee and Stefanowska 41–46). After the Maoist revolution, she challenged her fate by finding an escape route from Shanghai to Hong Kong and then to the United States in 1952.[4]

In one of Chang's most famous stories, "The Golden Cangue," she peers into the world of Chinese maids, enabling the reader to cross the threshold into the hidden rooms of a household. Reminiscent of *The Analects for Women*, she writes about two servants discussing the "Second Master's" concubine's behavior: "Dragons breed dragons; phoenixes breed phoenixes, as the saying goes. You haven't heard her conversation! Even in front of the unmarried young ladies, she says anything she likes. Lucky that in our house, not a word goes out from inside, nor comes in from outside, so the young ladies don't understand a thing. Even then, they get so embarrassed they don't know where to hide" (E. Chang 175). From Chang, we learn how the old rules of deportment shaped the young maids' lives as articulated in *The Analects for Women*: do not talk to strangers and do not smile. Curiously, Chang's literature prefigures *Upstairs Downstairs* and *Downton Abbey*, both well-known accounts of the British elite in the West.

Literary critics rank Chang as the most notable Chinese woman writer of the twentieth century, while British and American readers may find her novellas off-putting. Her most recent translator suggests this is because of the "melancholy incisiveness," well surpassing Buck's *The Good Earth* (Kingsbury xiv). Honored in 2006 by the *New York Review of Books*, her works have been newly translated and published. Journalist Ian Johnson compares Chang's literature and life to contemporary writer Wang Xiaobo (1952–1997), who challenged CCP Chairman Deng Xiaoping's (1904–1997) efforts to control the nation's personal, private, and intimate life with the ruse of the one-child policy. Wang, also known as the dark horse of Chinese literature, understood that the all-watchful state followed him, and to escape surveillance, he wrote about sex and love in *Wang in Love and Bondage*. In this way, Chang's life and that of Wang Xiaobo were forms of quiet protest (Johnson, "Sexual").

From Marriage to Family Reverence

Family biographies and novels, like *Bound Feet and Western Dress*, may also include *To Live* by Yu Hua, *Falling Leaves* by Adeline Yen Mah, and *Wild Swans* by Jung Chang. These stories echo each other with accounts of weddings where the bride relinquishes her identity as she marries, encounters trials and tribulations, leaves China, settles in the West, or remains in China for a brighter future. The family histories that place women at the epicenter open a lens into lives that would not otherwise

be available to us. Significantly, the novella by Yu Hua, *To Live*, like *Red Sorghum* and *Raise the Red Lantern* opens a third accessible lens through print and film for Western consumers of Chinese culture.

Adeline Yen Mah's reflection on growing up in 1940s China recounts the arrival of Mao's troops in Shanghai and the forced displacement of family life and businesses. She chooses Chinese aphorisms as titles for each chapter, yielding cultural insights. Titles, for example, "Family Ugliness Should Never Be Aired in Public," "Extend the Same Treatment to All," and "Falling Leaves Return to Their Roots" capture deeply held beliefs. Filial piety appears as a dominant theme in the intertwined stories. Yen Mah begins with her grandmother's description of her wedding day when she was told that she was going to step over the threshold into a new household: "Tomorrow, you will belong to the Yen family. . . . From now on, this is no longer your home" (Yen Mah 10–11). Having set up personal loss in marriage as a motif, Yen Mah progresses to an account of her own life with her mother's death in childbirth and the arrival of a stepmother. Her accounts of cultural and social relationships in Shanghai, the Paris of the East, and then Hong Kong, London's counterpart, emphasize her attempts to create an identity in the family, school, and city. Education promised success for Yen Mah, who pursued a medical degree in London and, after a second marriage, emigrated to the United States.

The traditional concept of family reverence becomes clearer in Jung Chang's first book, *Wild Swans: Three Daughters of China*. Highly readable and engaging, Chang's hybrid autobiography of her family, which began in the age of footbinding and ended with the protests in Tiananmen Square, portrays agency over submission in the lives of her grandmother, mother, and her own young life. Her grandmother's marriage, first to a warlord and then to a Manchu doctor, shows the young woman as a tradeable item (J. Chang 13). Chang's mother, a role model for CCP women, joined Mao's army and met her guerrilla fighter father in 1948. Ironically, her parents' prenuptial lives reveal their shared affinity for Western literary figures such as Gustave Flaubert and Guy de Maupassant (114). The family quickly recognized that promotion in the CCP depended on faithful adherence to party initiatives and quickly advanced themselves as "educated" party comrades. Chang's mother worked as a leader in the Youth League. She rose to the level of the governor of Yibin and then head of Sichuan Public Affairs. From 1949, Chang outlined purges and executions, foreshadowing her parents' harrowing experiences under Mao's regime during the Great Leap Forward and the Cultural Revolution.

Excruciating details of her tortured father's life address the political consequences of his loyalty. However, during the Cultural Revolution, the CCP cast them as "capitalist roaders," a rank equal to the kiss of death.

Chang's education began in 1958, continuing sporadically until after Mao died in 1976. During the Cultural Revolution, Chang joined the Red Guard and became part of the "sent-down" youth, meaning she went to the countryside to work in rice paddies. Next, she worked as a "barefoot doctor," a youth with basic medical skills sent to the countryside (J. Chang 276). Finally, she returned to the city to work in a steel mill. Just as she was looking for a way out of her dismal world, she learned about the 1972 state visits of President Richard M. Nixon and Secretary of State Henry Kissinger, which changed not only her circumstances but also China's future (603). Upon returning to school, she studied English, won a national competition, and went to Oxford University (353, 688). *Wild Swans* not only captures a human-interest story embedded in China's tumultuous history of the twentieth century, but it also opens a lens into the lives of women, their families, and their overarching respect for higher education.

The novella *To Live*, written by Yu Hua, translated by Michael Berry, and produced as a film by Zhang Yimou, parallels *Wild Swans*. The cinematically beautiful production won awards at the Cannes Film Festival and the British Academy of Film and Television Arts competition. The film mirrors the forty years covered by the novel, offering an engaging historical perspective of family life, the role of women, and the place of children (Tan and Zhang). The book and film begin where *The Good Earth* leaves off: from prerevolutionary town life in the 1940s to the Communist Revolution (1945–1949), the Great Leap Forward (1958–1963), and the Cultural Revolution. Subtle clues in the film make the unfolding of history comprehensible only by sound. In the beginning, there is silence in the town; as time passes, we hear the whistle of a train in the distance. Throughout the film, women's apparel changes, from the traditional silk *qipao* or chemises to colorful plaid and cotton dresses in the 1950s. During the Cultural Revolution, alterations in clothing occur again. Colors are toned down to drab blues and grays, while Mao jackets, collars, and caps for men and women appear. Although silent, the clothing signals adaptations to changing cultural expectations and aid in understanding China's cultural history.

Reminiscent of the feudal landlord class, the film opens with the ne'er do well son, a gambler, Fugui. He lost his family estate to gambling,

while his wife Jiazhen proved her resilience by leaving him in desperate circumstances. Fugui's gambling creditor gifted him with a case of stick puppets. To survive, he drew on his gentrified abilities to sing opera and created a Chinese opera troupe of puppeteers. The troupe followed the Nationalist soldiers and eventually "joined" the Red Army. In 1949 at the end of hostilities, he rejoined his family, regenerating and restoring his life with Jiazhen and two children. During the Great Leap Forward, the couple lost their son to an accident while villagers were busy turning their iron pots and pans into steel to defeat the Americans; it was a loss representative of the futility of the CCP's efforts to create an industrialized state. As Hsü argues, the Party administered continuous organization and mass reorganizations to reach specific objectives (658). Supporting Mao's revolutionary ambitions caused overwhelming hardships too sad to understand; the family, who lost two children during this era, had to rely on itself, as it had in the past. The film's closing is life-affirming in the form of Little Bun, the young grandchild. While visiting ancestral graves during the Qingming Festival, Little Bun received a box full of chicks. Fugui asks Little Bun if it is okay to put his chicks in the old puppeteer box that barely survived the Cultural Revolution.

> Fugui: How about in here? The chicks will have more room to run around. Then they'll eat more. Little Bun: What happens then? Fugui: And then, the chickens will turn into geese. And the geese will turn into sheep. And the sheep will turn into oxen. Little Bun: And, after the oxen? Fugui: After oxen? Jiazhen: After oxen, Little Bun will grow up. Little Bun: I want to ride on an oxen's back. Jiazhen: You will ride on an ox's back. Fugui: Little Bun won't ride on an ox; he'll ride trains and planes. And life will get better and better. (*To Live*)

The movie ends on a very hopeful note. Ironically the censors banned this film about family reverence and resilience, asserting that *To Live* was too critical of government policies that caused famine, human suffering, and death (Ye and Zhang 3).

Large-Scale Tragedies

Throughout twentieth-century China's history, her people were no strangers to the horrors of war and famine caused by external and internal

historical actors. The Japanese and Mao's followers persecuted, raped, pillaged, starved, exploited, and forced social dislocation. Writers contrast themes of pain against love and marriage. It is imprudent to overlook the tremendous agony of these events, including the Nanjing massacre, recurring famines, failed government policies (especially the one-child-only laws), and war. Iris Chang's *Rape of Nanking* offers insights into women's lives that Gail Hershatter's *Gender of Memory* confirms. When coupled with Frank Dikötter's *The Cultural Revolution: A People's History, 1962–1975*, a foundational and essential record can be established for building awareness of the recent past that still haunts the memories of those who lived through such trials.

Gale Hershatter compiles similar losses from a woman's perspective in a collection of memoirs, *The Gender of Memory*. Her scholarship analyzes the lives of rural women living in four counties of the Shaanxi Province. In the era of Buck's O'Lan, she notes that profound loss was part of everyday life; those who remembered the losses anchored the events in history. Hunger, serious illness, forced separation, and death punctuate women's stories of life before 1949. Women talk of these events as individual catastrophes. However, they often link them to recognizable historical occasions: the drought of 1928, the cholera epidemic of 1932, the Henan famine of 1942 (48). Hershatter shows us the suffering of desperate parents who tried to ensure their sons' survival while abandoning or "selling" a daughter was not uncommon (1).

Iris Chang documents the failure of humanity in the historical onslaught of the Japanese in *The Rape of Nanking*, an event with deaths that rival the joint civilian casualties across Europe during this era. After years of research, Chang asks her readers to follow her to the precipice of evil and human misery. She believes the long-unacknowledged and hidden catastrophe evaded investigation because victims remained silent (I. Chang 11). Since rape was the primary means of control by Japanese soldiers, she asks how many ways could a person be raped and executed? Why were noncombatants, women, and children targeted? Chang's account of the Japanese attacks on the capital of Nationalist China is best characterized by the order to Matsui's lieutenants, "KILL ALL CAPTIVES" (40). Her description of brutal rapes that ended with executions shows only part of the tale (49–50). She accuses us of forgetting this "second Holocaust" because destroying the historic city and its women, children, and men was not an act of war. It was a crime against humanity (199). Chang's book insists on commemorating its victims because even though they are gone, the memories of survivors cannot be assuaged, even by

apologies from General Matsui, who expressed regrets for his troops' orgiastic behavior of raping, killing, and pillaging. Matsui characterized the crime as a struggle between Japan and China, which "was always a fight between brothers within the 'Asian family'" (219). The use of the family as a trope in Matsui's apology rings hollow because, in China, women, the primary victims of the rape of Nanjing were the anchors of their families. Similar to the agonizing experiences of American slavery and the Holocaust, Nanjing's horrors left its casualties to comfort themselves.

During the Maoist years, an estimated thirty million died from starvation, overwork, and beatings during the Great Leap Forward (Dikötter 223). It is difficult to estimate the number of girls and infants lost to devastating social "reconstruction" policies. The CCP called the Great Leap famine a natural disaster; while food shortages caused 70 percent of the losses, the other 30 percent were caused by human error. Agricultural observers were aware of what was happening in various parts of the country. For example, people in Sichuan asked how people could be dying from starvation even though fields were filled with a plentiful harvest (310). According to Jung Chang, the famine occurred because of collectivization, not weather-related drought, floods, or swarms of locusts as was the case in the era of *The Good Earth*. Instead, the disastrous loss of lives resulted from failed government policies. Approximately seven million died in Sichuan alone during the Great Leap Forward (J. Chang, *Wild Swans* 309–10). Accounts circulating in the countryside claim that the starving resorted to cannibalism. Chang relates one example of a landlord who purportedly sold his dead infant on the streets as "wind-dried meat" (310). Individual accounts of these stories, whether apocryphal or underpinned by statistics, persist in these gendered memories (J. Chang, *Wild Swans* 309–10).

Famine continued to crush the spirit of the powerful mother-infant duo, and its results appear in longitudinal medical studies that show persistently high infant and maternal mortality rates as late as 1982. Famine mothers suffered from the horrible affliction of puerperal or milk fever caused by a breast infection after the birth of an infant. Despite the loss of medical personnel, midwives accompanied by barefoot doctors slowly returned to the countryside, but they had no access to medications to stop infections. In addition, women experienced prolapsed uteruses, deteriorated cervixes, and pelvic inflammatory disease from poor health services and harsh working conditions (Dikötter 269). The magnitude of suffering among women during this era presents a difficult-to-understand

historical challenge that deserves our attention. How do we wrestle with their accounts and what it means to live?

"The World Is Yours": Mao's Promises and Deng's Fulfillment of Promises

Mao's promises to China's youth, numbering approximately 40 percent of the total population of 723 million in 1964, were a clarion call to those coming of age ("Major Statistics" 66–68). He proclaimed, "The world is yours, as well as ours, but in the last analysis, it is yours. You, young people, full of vigour and vitality, are in the bloom of life, like the sun at eight or nine in the morning. Our hope is placed on you" (Mao 543). His inspirational tone resonated through the ears of China's youth, as shown in the feminist accounts of the Great Leap Forward and the Cultural Revolution.

The memoir *Spider Eaters* by Rae Yang recounts the tragic experiences of the Cultural Revolution. She wrote about her life in the 1980s while a graduate student at the University of Massachusetts, Amherst. She helps us see the complications of growing up in Mao's China. She was the daughter of a well-educated revolutionary and an English teacher. Her privileges included reading fiction and nonfiction books from the West in translation, including *Wuthering Heights*, *Jane Eyre*, *War and Peace*, and *A Tale of Two Cities* (Yang 102–3). Mao's disruption to her life destroyed her childhood ideals. Her account explains how Mao recruited teens to get rid of the "olds." He set the youth free to rebel against authorities, including teachers and parents, thus breaking the bonds of family reverence. According to Yang, "The sacred halo around the teachers' heads that dated back 2500 years to the time of Confucius disappeared . . . Heaven and earth were turned upside down" (118). The party sent the sophisticated Yang to the Great Northern Wilderness, where life was so hard that she contemplated suicide (237). Although the Cultural Revolution, as Rae Yang and millions of others knew it ended in 1976 with Mao's death, the concept of challenging revolutionary and traditional society persists, whatever the costs.

As early as 1927, Mao responded to comrades in the peasant movement in Hunan: "A revolution is not a dinner party, or writing an essay, or painting a picture, or doing embroidery; it cannot be so refined, so leisurely and gentle, so temperate, kind, courteous, restrained,

and magnanimous. A revolution is an insurrection, an act of violence by which one class overthrows another" (Mao 23). Mao ensured that all ages of society would be shaped and reframed by his ambitions to reconstruct society. Building on the idea of continuous revolution, a coming-of-age account, *Revolution Is Not a Dinner Party* by Ying Chang Compestine, offers an account by the daughter of a Wuhan doctor and nurse during the Cultural Revolution. The book is replete with aphorisms from Mao (Compestine 55). Juxtaposed against these short party lines, "Long live Chairman Mao" competed with influences from her parents, who could read, write, and speak English. They hung a photo of the San Francisco Golden Gate Bridge in their home and enjoyed listening to the BBC, which warranted their arrest by the Red Guards. Despite her parents' avowed sympathies for the West, nine-year-old Compestine in 1972 sang the CCP propaganda songs that undercut her parents' influence. "Dear Chairman Mao / Great leader of our country, / The sun in our heart, / you are more dear than our mother and father" (10).

Eventually, the CCP jailed her father and only retrieved him from his cell to perform surgeries while her mother mopped the hospital floors. Ying was bullied at school by Red Guard Boys. In order to alleviate the emotional pain, she adopted the persona of a dragon fighting Pimple Face, Chopstick, Mouse Eye, and Belly, antagonistic Red Guard boys. Her outbursts saw her sentenced to jail, where she suffered from a lice infestation. Upon release, she faced the humiliation of having her head shaved. Through this experience, she learned to stifle her anger and replaced the negative emotions with dreams of going to San Francisco. Finally, in 1976, when loudspeakers mourned Mao's death, the thugs were forced to pay restitution, her father returned home, and she left China to attend university in the United States (230).

For another coming-of-age perspective incorporating Chinese minorities, the Uighurs, or Muslim Chinese, and a young girl during the Cultural Revolution, we can turn to *Red Scarf Girl*. Ji Li Jiang offers a fine example of intersectionality, combining gender, religion, and ethnicity into a simplified narrative. Jiang encourages readers to reflect on the power that ethnic differences can have in the lives of young women in western China. Ji-Li was a successful student until Mao targeted her village for reeducation. At this point, her friends recognized Ji Li as a Muslim and turned against her. Shortly afterward, the CCP imprisoned her father for listening to the BBC. Being a young girl under duress, she denounced her

father. This text, published in 1997, portended a dark future for ethnic minorities, especially the Uighurs (Grose 18–19).

After Mao died, the "old guard" who supported him and the Gang of Four met their demise. At the same time, the world celebrated the end of the era; many watched with hope when Deng Xiaoping took office. In the 1960s, Deng developed China's hinterlands and later emerged as the chief architect of reform, encouraging openness to the outside world and reframing the party plan with Four Modernizations (MacFarquhar). Deng's strategy allowed the party to define economics and implement the policies. His pragmatism shines through in this often-quoted phrase that he borrowed from the peasants, "It doesn't matter if the cat is black or white, so long as it catches mice" (MacFarquhar). The Four Modernizations called for internal self-criticism, the removal of Maoist sympathizers, and the "geriatric old guard." His policies dismantled large agricultural enterprises, promoted industrial reform, and instituted the decentralization of decision-making while increasing reliance on the markets for guidance (Wilson 298). In addition, Deng included investment opportunities for factory entrepreneurs and the transformation of state-owned enterprises into competitive economic zones in his policies (Wilson 298–328). The economic reconstruction of society had phenomenal social results for Chinese women, whose lives mirrored the changes.

A collection of personal essays edited by Xueping Zhong, Wang Zheng, and Bai Dai, *Some of Us: Chinese Women Growing Up in the Mao Era*, offers rich insight into their experiences during the transition from the Maoist era to that of Deng Xiaoping. In a fascinating chapter, "Call Me *Qingnian*, But Not *Funü*," Zheng points to her illiterate mother, who had bound feet and whom she regarded as an oppressed victim of the old patriarchal system, and explains how the "social reconstruction" of the new China emerged. Zheng even questions whether she may have been "brainwashed," an English term she uses for lack of a better word. She jokingly recalls Women's Day, 8 March 1978, when she and her friends discussed the possibility of becoming future homemakers or *funü* (27–30). She and her friends, however, dismissed this "Betty Crocker" world as old-fashioned and chose to become Maoist comrades or *qingnian* (Zheng, "Call Me" 47–51). Unfortunately, Zheng's American readers, who will recognize the growing pains and social behaviors they share with young women in China, will not easily understand Zheng's explanation of conflicting generational, state, and personal expectations.

For Zheng, "becoming a part of the State's social construction" meant "fitting in," not following personal dreams.

Zheng reflects angst in her accounts of those harrowing years because of the fearful pressure on individuals and families to maintain political correctness, that is, conforming to the communitarian vision of the CCP. Although her peers did not accept the traditional belief system that positioned women as inferiors or only good enough for marriage and family, they believed that to be a good woman; one had to "devote her heart and soul to the revolution" (Zheng, "Call Me" 50). The state was so influential in her life that Zheng soon realized she had married the state. Twenty years after, women challenged this choice because of its strictures on their lives. They divorced themselves from the state and coined a new term that defines rules of social engagement. The new term, *nüxing* (female sex, or femininity), meant that young women began to distinguish themselves by standing out from the group (47–51). These choices spelled uncertainty for the future of patriarchy in China.

Deng's modernization plans increased industrial output and precipitated China's meteoric wealth rise. Escalating personal wealth marked the emergence of a more stratified society based on class and rank. While wealthy families had the wherewithal to send their children abroad for an education, rural families sent their children to factory campuses to provide for their livelihood. This process led to a slow, silent fracturing of family ties and the creeping rise of individualism. The consequences appear in a disconnected comradeship that shaped the lives of young women who worked for large industrial complexes. *Factory Girls: From Village to City in a Changing China* by Lesley T. Chang informs American readers about the differences between their lives and Chinese peers. While we acknowledge that front-of-the-house jobs often come with some expectations of personal appearance, we seldom consider how essential credentials play a decisive role in employers' selections for industrial jobs. For example, one cannot be over thirty-five years of age for certain employment types because of "inferior thinking" (L. Chang 91). A girl's physical height counts as another measure; one must be no less than five feet, three inches tall. The *hukou*, or registration papers revealing the village of origin, may also limit employment, mainly if the young woman originates from rural Hebei or Anhui Province (101). Chang tracks the terms of employment and the experiences of young people moving from a village to a factory campus, where tens of thousands of other people work their shifts, live in dormitories, save their money, and send the cash home to their families who depend on this income for survival.

As many as 70,000 workers live in confined spaces in each compound, creating a sense of anomie caused by separation from family and community. Separated from village life, younger women become untethered and alienated from the web of traditional circular associations. Without the protection provided by their families, they were exposed to questionable romantic liaisons, extramarital affairs, gangs, and heavy labor. Out-of-wedlock births, especially under the one-child-only policy instituted in 1980, led young women to desperation. If she found she was pregnant, her choice was to keep the job or the baby; she could not have both. Flushing a baby down the toilet, a phrase we might reflect on as "drowning a daughter," was a shared experience among young workers (104).

One Child Only or Fertility Control

In the historical past, this choice, infanticide, was known only by hearsay. As accounts of a mother's hardships bring together the elements of women's history, fertility, maternity, and family duties, contemporarily, statistics inform this consideration causing politicians, journalists, and demographers (Tucker 17). From the end of the Qing dynasty and the establishment of the People's Republic of China, women continued to practice traditional family planning. As part of the "social reconstruction" of society, the CCP implemented family planning policies after 1949. Initially, this was a pronatalist plan as supported by Mao. Great posters reinforced Mao's principle that more people meant "a greater ferment of ideas, more enthusiasm, and more energy" (Mao 69). Such a policy proved necessary to replenish the estimated millions lost during the Great Leap Forward.

Consequently, fertility rates rose to six children per mother. In 1972, the CCP associated the problem of a burgeoning population with the pressure to feed the millions. These concerns precipitated a shift to "Chinese Marxist Malthusianism, marked by the CCP's liberal distribution of birth control pills (Aird 236–39). However, the most dramatic shift in family planning occurred with the single-child policy ruling initiated by Deng Xiaoping in 1980. Acknowledging the challenges of this ruling, mainly because of the desire for male offspring, in 1984–85, the government drew up a list of fourteen cases or scenarios that defined eligibility for a second child (Zhang 141–43).

The local party officials gave rural couples more latitude in family size. Parents could petition for a second child if their first infant were a

girl. On the other hand, the law barred urban couples from such privileges (Zhang 145). The rationale was that rural families depended on sons to work on farms, coal mines, and fishing. The legislation also made exceptions for ethnicity. Those who claimed Tibetan heritage, or were willing to pay to have another child, should the first one be a girl, received approval for a second child. In *One Child*, Mei Fong argues that prospective parents regarded their first baby as a trial because every pregnancy aimed to issue a son. With the arrival of the modern ultrasound machine, about eight million families applied for scanning certificates (Fong 41). The introduction of the machinery revealed strong preferences for boys and unhinged the natural ratio of about 101 girls to 100 boys. By 1995, about fifteen years after implementing the policy, scholars began to recognize a significant gender imbalance (Zhang 153). Despite the alarm of demographers, their clinical accounting does not reveal the most profound costs to families, whose very existence stands at the center of Chinese culture, as affirmed by Gail Hershatter in *The Gender of Memory*.

Generational and gender differences remind us that the successes and failures and human cost of the birth planning campaign, like other state initiatives, only make sense if we consider the diverse understandings of the various people involved. It is not enough to posit an abstract state on the one hand and a reified family on the other, with hapless family planning workers shuttling back and forth between the two (Hershatter, *Gender* 209). Hershatter has a point. The government was responsible for ensuring a food supply and limiting the environmental degradation caused by the rapidly rising national population. Nevertheless, the executors of the one-child-only policy originated from the same individuals married to the state, particularly the ACWF, as this group of women took on the role of family planning workers. Moreover, the policy yielded unanticipated consequences when horrific natural disasters struck and caused even more suffering. According to Fong, the government had touted Sichuan as the model for family planning, the phrase that served as a euphemism for voluntary and involuntary sterilizations (Fong 22–25). The "social con-struction" of society, as explained by Wang Zheng, affected the lives of every family who tried to be exemplary couples but lost their future if they had one son, only female children, or no children at all.

When disaster struck Sichuan Province on 12 May 2008, the incon-ceivable occurred; 8000 parents lost their children attending school on that day (Fong 16). The Earth's tectonic plates fractured and unleashed as much power as the atomic bomb that exploded over Nagasaki (9 August

1945). The unanticipated crisis forced the government to respond as quickly as possible. However, the damage to model families who diligently practiced fertility control had been done. In addition to the children who died in the schools, 17,000 people were missing, 69,226 were killed, and over 375,000 were injured. Parents believed their children's deaths could have been prevented if the government had invested in earthquake-proof buildings (Fong 38–39). Not heeding the anguish of the parents, the state responded with a heartless slogan, "I pledge to come back to normal life and normal production as soon as possible" (21). No matter how much propaganda the government published, the parents could not be consoled. They could not recover from the loss of their children. Paradoxically, the natural disaster coincided with the 2008 Olympics in Beijing, which placed all eyes on the capital city and the international sports competitions. Hence, the disaster faded into the background of national and international news (Johnson, "After-Shocks").

Most families who sent their children to school on that day had only one child. Parents who lost their only child and mothers who had been sterilized or aged out of the fertility window were inconsolable. They had followed the government indoctrination that advised late marriages and one child only. Naturally, they felt let down and abandoned. Moreover, the planned birth program heightened the traditional preference for sons. If one had to choose between a son and a daughter, parents abandoned their daughters or gave them away. Yet girls become young women, mothers, and traditional caregivers for families. The loss of girls to society aggravated social concerns about the breakdown of the ancient traditional practice of children caring for parents in their old age. Aging and childless parents, a burgeoning sector of the population, faced even more challenges because of the scarcity of assisted living homes. Not yet completely known, the long-term consequences of social engineering foretell dire consequences (Hong Fincher, *Leftover Women* 15).

The human agony created by the one-child-only policy is relevant to learning about the plight of women in China because of the complex journalistic and creative products that have emanated from it. Artists who expressed their concerns through public protests relating to the one-child-only legislation received quick retribution. "Censors" targeted artist Ai Weiwei, known as the Andy Warhol of China and designer of the Olympic Bird Nest Stadium, for standing up with the democracy activist Tan Zuoren and the independent filmmaker Ai Xiaoming. The authorities beat Ai so severely that he left China for medical help in

Germany (Johnson, "After-Shocks"). The CCP completely disparaged the films of Zhang Yimou (*To Live* and *Red Sorghum*) for his disregard of social rules defined by the CCP. Ai Weiwei has chosen to live abroad in Europe, and Zhang Yimou remains in China despite his prosecution for having more than three children (Fong 35–36). Still, artists, writers, photographers, and sculptors continue to find ways to remonstrate the tragic losses of human lives.[5]

A finely nuanced characterization of the one-child-only policy appears in *The Dark Road*, a novel by Ma Jian. The novelist terrorizes the reader into learning about the policy by presenting realities too challenging for us to appreciate fully. The protagonists were destitute wanderers, paperless itinerants, and part of China's floating population (Xiong and Wei 1–12). Ma Jian uses keywords as shorthand for chapter titles, cluing the reader into concepts and themes. For example, the first title, "sterilised, dugout, breast milk, family planning squad, date tree, longevity locket, *Nuwa* Cave," opens with a provocation, the arrival of the "Fertility Squad" from the Family Planning Office at Meili's neighbor's place (Ma 1). In a few short lines of the first chapter, the squad arrests Fang, the mother, and they take her away to be sterilized. The squad left her three-week-old baby with other mothers, whether they were lactating or not (Ma 2). Meili cries in despair, knowing what would happen to her friend. She pleads with the squad, "Every one of you were nursed as a child by your mother" (2).

As a warning to the women, the authority barks back, "Keep out of this . . . Haven't you read the notice? If a woman is found pregnant without authorization, every household within a hundred metres will be punished" (Ma 2). Meili rescues Fang's infant as the fertility squad takes her friend away. Both mothers understand that such sterilization causes breast milk to dry up and infant death by starvation. The narrative offers insight into why couples promptly dismissed common forms of birth control, such as IUDs and condoms. They thought they were ludicrous. Other options were much the same as in the past: abstain from sex, leave the husband, have the husband take a concubine, or commit infanticide. Poverty prohibited alternatives, and therefore escaping the dragnet of opportunists hunting for women was essential. How could one defend herself as a woman with an infant against a state-paid bounty hunter searching for non-compliant families? The text of this brilliant novel conveys the stark and dark road for women living in poverty. When asked, the now-exiled Ma Jian's solution for China is to return to the *Analects*, which encourage "respect for learning, honoring parents, caring for children, and leading a virtuous life" (Fifer 34).

Desperation and censorship relating to the harsh realities of the one-child-only policy inspired a set of evocative images by photographer Wang Peng. The photos documented the ruins of a policy gone wrong. His published work *Wild Field*, *Ruins*, and *Grove Monument* shows fetuses lying in trash dumps; the images have been discussed as a counter-memorialization of 400 million aborted female fetuses. Unfortunately, like Zhang Yimou and Ai Weiwei, Peng's creative work attracted the notice of censors. The state arrested him, seized his artwork, and made him a prisoner of conscience. Some have argued that the policy should be regarded as a crime against humanity, but at this time, there is not enough political will to pursue that argument.

Touchingly, French artist Prune Nourry created an art installation, *The Terracotta Daughters* that shines a light on the girls lost to gender selection (Cheung; Nourry). Her creative project interprets the consequences of the state-sponsored fertility control campaign in a very unique way. This creation comprises 108 clay statues of girls, serving as an analog to the Terracotta Army, created by the Qin dynasty (221–206 BCE) in Xi'an, Shaanxi Province. Nourry traveled to Xi'an and received support from local artisans and the Jiaotong University Sociology Department to gain insight and complete her creative vision. The nonprofit organization Children of Madaifu, which cares for and educates orphaned Chinese girls, provided the eight models for her project. Upon completion, *Terracotta Daughters* was first exhibited in Shanghai and then traveled to Paris, Zurich, Mexico City, and New York, receiving international acclaim. In 2015, the entire lot of clay daughters returned to China, and Nourry oversaw the burial of this marvelous collection at an undisclosed location (Cheung). Her exhibition simply drives home the point that according to the latest CIA World Factbook for 2020, the gender ratio is 111 boys to 100 girls in the zero to fourteen age cohort. In the fifteen to twenty-four cohort, the ratio is 117 boys to 100 girls. As China's population ages, there are 97.6 males to 100 females, indicating the toll that age takes on men. Nonetheless, the gender ratio tables will turn, as demographers demonstrate in the CIA World Factbook data tables.

The Revenge: China's Leftover Women

As outlined in the discussion of *The Birth of Chinese Feminism*, He-Yin Zhen contested the gendered stratifications embedded in the fabric of society. She analyzed patriarchy by turning to the ancient stanzas from

The Book of Songs: "Sons shall be born to him / They will be put to sleep on couches; / They will be clothed in robes; / They will have scepters to play with. / Daughters shall be born to him; / They will be put to sleep on the ground; / They will be clothed with wrappers; / They will have tiles to play with" (Zhen 113). She argued that Chinese script, marriage rituals, funerary rites, and classical learning shaped the rules of gendered behavior. She recognized that social power devolves through the family as a negotiated activity, particularly at a daughter's birth. Her birth, her sex, her life met with jeopardy because of misogyny. Zhen argued that "the goal of equality cannot be achieved except through women's liberation" (Zhen 53–71). Moreover, in her masterpiece "Revenge of the Women," written in 1907, she calls on women to confront their subjugation (105–68).

The social reconstruction of society in China links the past and present. Yet it has taken until the first decades of the twenty-first century for Chinese women to find their voices, a situation made possible through access to higher education, professional and technical occupations, and money acquisition, to assert their revenge. *Leftover Women: The Resurgence of Gender Inequality in China* and *Betraying Big Brother: The Feminist Awakening of China* by Leta Hong Fincher highlights the long hard slog toward social and personal equality for feminists through controlling their fertility and delaying childbearing.

Active gender selection before birth and delayed childbearing have costs to society. As Hong Fincher reiterates what Zhen knew and states in her most recent work, "Misogyny has no political boundaries, and there can be no higher expression of misogyny than female infanticide" (Hong Fincher, *Betraying* 77). If female infants survive early childhood and pass through puberty unscathed, they may reach marriageable ages. Significantly, the state expected women to marry by twenty-two or twenty-three years of age. If they did not marry, the powerful All-China Women's Federation, or the social reconstruction of society team, reproached women with jeers, snidely categorizing them as "leftover," meaning the woman remained unmarried at age twenty-seven. Unmarried women in the next group, aged twenty-eight to thirty-five, were building careers; they claimed they had no time to select a suitable partner. In truth, they had little desire to jeopardize their education, self-made money, and opportunities to purchase a home and retain their options to be scrupulous in choosing their mates. By age thirty-five and still "leftover," the women now owned companies, cars, and homes. She lived independently and without family responsibilities (Hong Fincher, *Leftover Women* 42–43). However,

women who decline marriage in favor of an independent lifestyle find society blaming them for placing China's aging population at risk. The state expressed its fears in the slogan "Women Marrying Late Shouldn't Blindly Let 'Late' Become 'Never'" (Hong Fincher, *Leftover* 15).

Contemporarily, power for a young woman means controlling her fertility, education, money, and electronic social identity. In this way, Hong Fincher moves beyond social constraints but not the present, as she demonstrates in *Betraying Big Brother*. In her provocative study, she explains how activists challenged patriarchy and the bulkhead of authoritarian misogyny. By tracing the imprisonment of the "Feminist Five," she reveals how women jailed for challenging the state could be so brave yet be so controlled by others. Significantly, the surveillance state in China makes feminist activism very problematic. The government no longer needs to rely on the All-China Women's Federation to enforce social controls; it merely needs to control a person's engagement with social media, the Internet, phones, and facial recognition cameras (Chin and Lin).

Conclusion

This chapter aims to serve as an umbrella to the general studies of Chinese women's history, or herstory. It is vital to honor the timeless choices and challenges Chinese women have made and continue to make concerning their education, fertility, marriage, and family. This accounting of herstory is a complicated political and social narrative that begins with the oracle bones to start the conversation, moves to Dowager Empress Cixi, and then to the timeless account of peasant women in *The Good Earth*. At the dawn of the twentieth century, the challenges to Chinese patriarchy began with scholarly thinkers like He-Yin Zhen and Ding Ling. These writers sparked social change with their ideas, challenging and reconceptualizing Chinese patriarchy. Interwar accounts of women's lives show their generation struggling with newfound freedoms, the end of concubinage, and the end of footbinding, which are well explained in *Bound Feet and Western Dress*, *Falling Leaves*, and the brilliant work of Eileen Chang. This generation helped women imagine liberated lives that rose into a realm of unforeseen possibilities as they joined the Maoist revolution, participated in the "social reconstruction of the state," and lived in hopes of a better future. Their challenges during the Great Leap Forward and Cultural Revolution were not unlike those of their brothers

and are clearly articulated by the shared memoirs in *Some of Us*. Their stories certainly warranted our empathy as documented in *Wild Swans* and *Red Scarf Girl*. Mao's death and the rise of the new China in 1978 coincided with the dramatic one-child-only policy that had unintended consequences and led to the loss of countless lives, primarily female fetuses, and babies. Artists responded to these harsh measures and brought us a richer understanding of the plight of mothers. Today, as women achieve independence from the hierarchy of male privilege and gain more access to power, Hong Fincher explains how these women are being asked to "stay at home and become mothers." This call to action by the state is once again asking women to serve the "higher order" and become "selfless." Whether women will concede or resist is yet to be seen.

Notes

1. During this long nineteenth century, British aficionados for Chinese artifacts removed Ming vases, Tang bronzes, and Qing porcelains to satisfy their obsession with Chinoiserie. The history behind the transportation of the silk scroll from China to the British Museum represents the transfer of Chinese cultural wealth during times of national duress and as such raises many questions. According to the British Museum account, an unidentified person removed the *Admonitions* hand scroll from the Forbidden City during the Boxer Rebellion (1899–1901); suggesting that the scroll was saved from potential damages. Like other artifacts collected by the British at the height of the empire, it landed in the hands of the man on the spot, Captain Clarence Johnson. He sold the scroll to the British Museum in 1903 (Kosek et al. 25–43). The curators determined the provenance of the work, appreciated the artistry of the embroidery on silk, and the insights it lent to understanding the rules of feminine deportment in imperial China. In 2001, a colloquy funded by the Percival David Foundation in London convened to explain the social and historical value of this artifact (Hironobu; McCausland 2000). Recently, conservators at the British Museum restored the silk panels to their original beauty (Kosek et al., Stuart).

2. See Wintergreen Kunqu Society, "What Is Kunqu Theatre?" 冬青昆曲社 | 冬青昆曲社, https://wtrgreenkunqu.org. Accessed 15 January 2022.

3. The Three Bonds were family loyalty, filial piety, chastity; the Five Relationships tied subject to ruler, son to father, wife to husband, younger to elder brother, and friend to friend.

4. In 1952, the CCP black-listed Chang for a failed three-year marriage to a Japanese sympathizer. She fled Shanghai for Hong Kong, where she obtained

employment with the US Information Service. The United States awarded her an emigration visa in 1955. She remarried a screenwriter in 1956 and died in Los Angeles in 1995 in humble circumstances (Kingsbury xiii–ix).

5. For a provocative and full assessment of the one-child-only policy, see *One Child Nation*, a twenty-one-part series produced by filmmaker Nanfu Wang.

Works Cited

Aird, John S. "Population Policy and Demographic Prospects in the People's Republic of China." *People's Republic of China: An Economic Assessment: A Compendium of Papers Submitted to the Joint Economic Committee, Congress of the United States*. US Government Printing Office, 1972, pp. 220–331.

Ames, Roger, and Henry Rosemont Jr. *The Analects of Confucius: A Philosophical Translation*. Ballantine Books, 1998.

Buck, Pearl S. *The Good Earth*. 1931; Simon & Schuster, 1994.

Cao, Qin. "Oracle Bones." Chinese Collection of the National Museum of Scotland, https://www.nms.ac.uk/explore-our-collections/stories/world-cultures/oracle-bones/. Accessed 8 September 2021.

Chang, Eileen. *Love in a Fallen City*. Translated by Karen S. Kingsbury, Penguin, 2007.

Chang, Iris. *The Rape of Nanking: The Forgotten Holocaust of World War II*. Penguin Books, 1998.

Chang, Jung. *Empress Dowager Cixi: The Concubine Who Launched Modern China*. Anchor Books, 2014.

———. *Wild Swans: Three Daughters of China*. Simon & Schuster, 1991.

Chang, Leslie T. *Factory Girls: From Village to City in a Changing China*. Spiegel & Grass, 2009.

Chang, Pang-Mei Natasha. *Bound Feet and Western Dress: A Memoir*. Anchor Books, 1996.

Cheung, Ysabelle. "After Touring the World, Terracotta Daughters to Be Buried for 15 Years." Hyperallergic, 30 Oct. 2015, https://hyperallergic.com/249888/after-touring-the-world-terracotta-daughters-to-be-buried-for-15-years/. Accessed 8 October 2021.

Chin, Josh, and Lia Lin. "China's All-Seeing Surveillance State Is Reading Its Citizens' Faces." *Wall Street Journal*, 26 June 2017, https://www.wsj.com/articles/the-all-seeing-surveillance-state-feared-in-the-west-is-a-reality-in-china-1498493020. Accessed 2 February 2022.

Christie, Stuart. "Reading the Gap in the Chinese Gorge: Modernist Untranslatability in John Hersey's *A Single Pebble*." *Comparative Literature: East and West*, vol. 15, 2011, pp. 49–56.

CIA World Factbook. "China: People and Society, Age Structure, Sex Ratio." https://www.cia.gov/library/publications/the-world-factbook/geos/ch.html. Accessed 4 August 2022.

Compestine, Ying Chang. *Revolution Is Not a Dinner Party*. Henry Holt, 2007.

Cong, Xiaoping. *Marriage, Law, and Gender in Revolutionary China, 1940–1960*. Cambridge UP, 2016.

Crispin, Denis Twitchett, John K. Fairbank, Albert D. Dien, Keith N. Knapp, and Willard J. Peterson, eds. *The Cambridge Histories of China*. Cambridge UP, 1978–.

Der-Wei Wang, David. "Madame White, *The Book of Change* and Eileen Chang." *Eileen Chang: Romancing Languages, Cultures and Genre*, edited by Kam Louie. Hong Kong UP, 2012, pp. 215–242.

Dikötter, Frank. *The Cultural Revolution: A People's History, 1962–1975*. Bloomsbury, 2016.

Ding Ling. "Miss Sophia's Diary" in *I Myself Am a Woman: Selected Writings of Ding Ling* edited by Tani E. Barlow with Gary J. Bjorge Beacon P, 2001, pp. 49–81.

———. "Net of Law" in *I Myself Am a Woman: Selected Writings of Ding Ling* edited by Tani E. Barlow with Gary J. Bjorge. Beacon P, 2001, pp. 172–200.

———. "Thoughts on March 8" in *I Myself Am a Woman: Selected Writings of Ding Ling* edited by Tani E. Barlow with Gary J. Bjorge. Beacon P, 2001, pp. 316–21.

Fei Xiaotong. *Xiangtu Zhongguo. From the Soil: The Foundations of Chinese Society*. Translated by Gary G. Hamilton and Wang Zheng, U California P, 2013.

Fifer, Elizabeth. "Love and Sexuality in the Fallen World of Ma Jian." *World Literature Today*, vol. 93, no. 2, 2019, pp. 32–35.

Fong, Mei. *One Child: The Story of China's Most Radical Experiment*. Houghton Mifflin Harcourt, 2016.

Gaunt, Mary Elizabeth Bakewell. *A Woman in China*. Lippincott, 1914.

Gilmartin, Christina Kelley. *Engendering the Chinese Revolution: Radical Women, Communist Politics, and Mass Movements in the 1920s*. U California P, 1995.

Gray, Jack. *Rebellions and Revolutions: China from the 1800s to 2000*. 2nd ed. Oxford UP, 2002.

———. "Remembering Jack Gray: Mao in Perspective." *China Quarterly*, vol. 187, 2006, pp. 659–79.

Grose, Timothy. "Incubating Loyalty (or Resistance) in Chinese Boarding Schools," in *Negotiating Inseparability in China: The Xinjiang Class and the Dynamics of Uyghur Identity*. Hong Kong UP, 2019, pp. 18–49.

Guoqi, Xu. *Strangers on the Western Front: Chinese Workers in the Great War*. Harvard UP, 2011.

Headland, Isaac Taylor. *Court Life in China: The Capital, Its Officials, and People*. Fleming H. Revell, 1909.

Hershatter, Gail. *The Gender of Memory: Rural Women and China's Collective Past.* U California P, 2013.

———. *Women and China's Revolutions.* Rowman & Littlefield, 2019.

Hershatter, Gail, and Wang Zheng. "Chinese History: A Useful Category of Gender Analysis." *The American Historical Review*, vol. 113, 2008, pp. 1404–21.

Hironobu, Kohara. *The Admonitions from the Instructress to the Court Ladies Scroll.* Translated and edited by Sean McCausland. University of London, 2000.

Hong Fincher, Leta. *Betraying Big Brother: The Feminist Awakening.* Verso Books, 2018.

———. *Leftover Women: The Resurgence of Gender Inequality in China.* Zed Books, 2016.

Hsü, C. Y. Immanuel. *The Rise of Modern China.* 6th ed. Oxford UP, 2000.

Hua, Yu. *To Live.* Translated by Michael Berry. Anchor Books, 2003.

Jen-der Lee. "Women, Families, and Gendered Society." *The Cambridge History of China, Volume 2. The Six Dynasties, 220–589*, edited by Albert D. Dien and Keith N. Knapp, Cambridge UP, 2019, pp. 443–459.

Jiang, Ji-Li. *Red Scarf Girl: A Memoir of the Cultural Revolution.* Harper, 1997.

Johnson, Ian. "After-Shocks of the 2008 Sichuan Earthquake." *New York Review of Books*, 9 May 2018.

———. "Sexual Life in Modern China: Wang Xiaobo." *New York Review of Books*, 26 Oct. 2017.

Kazuko, Ono. *Chinese Women in a Century of Revolution, 1850–1950.* Edited by Joshua A. Fogel. Stanford UP, 1989.

King, Michelle T. *Between Birth and Death: Female Infanticide in Nineteenth Century China.* Stanford UP, 2014.

Kingsbury, Karen S. "Introduction" to *Love in a Fallen City and Other Stories* by Eileen Chang. Penguin, 2007, pp. ix–xvii.

Kosek, Joanna, Jin Xian Qiu, Keisuke Sugiyama, Carol Weiss, David Saunders, Catherine Higgitt, Janet Ambers, and Caroline Cartwright. *The Admonitions Scroll Condition, Treatment, and Housing 1903–2014.* British Museum, 2014.

Kristeva, Julia. "On the Women of China." Translated by Ellen Conroy Kennedy. *Signs*, vol. 1, 1975, pp. 57–81.

Laughlin, Charles A. "Why Critics of Nobel Prize-Winner Mo Yan Are Just Plain Wrong." *Asia Society*, 12 Dec. 2012, https://asiasociety.org/blog/asia/why-critics-chinese-nobel-prize-winner-mo-yan-are-just-plain-wrong. Accessed 15 December 2021.

Lee, Lily XiaoHong and A.D. Stefanowska. "Chang, Eileen" in *Biographical Dictionary of Chinese Women: The Twentieth-Century, 1912–2000.* M.E. Sharpe, 2003.

Li, Yingtao, and Di Wang. "China's 'State Feminism' in Context: The All-China Women's Federation from Inception to Current Challenges." *Women of*

Asia: Globalization, Development, and Gender Equity, edited by Mehrangiz Najafizadeh and Linda Lindsey, Routledge, 2019, pp. 66–82.

Link, Perry. "Chinese Shadows: Love in a Fallen City; Loud Sparrows, Contemporary Chinese Short-Shorts; The Banquet Bug; and Love and Revolution, A Novel about Song Chingling and Sun Yat-Sen." *New York Review of Books*, 16 Nov. 2006.

Liu, Lydia H., Rebecca E. Karl, and Dorothy Ko, eds. *The Birth of Chinese Feminism: Essential Texts in Transnational Theory*. Columbia UP, 2013.

Ma, Jian. *The Dark Road*. Translated by Flora Drew. Penguin Books, 2014.

MacFarquhar, Roderick. "Demolition Man." *New York Review of Books*, 27 March 1997.

"Major Statistics from the Second National Population Census (1964)." *Chinese Sociology & Anthropology*, vol. 16, 1984, pp. 66–68.

Mann, Susan. *Precious Records: Women in China's Long Eighteenth Century*. Stanford UP, 1997.

———. "Women, Families, and Gender Relations." *The Cambridge History of China: Volume 9: Part One: The Ch'ing Empire to 1800*, edited by Willard J. Peterson, Cambridge UP, 2002, pp. 428–72.

Mao Zedong. *Quotations from Chairman Mao Tse-Tung*. Foreign Language P, 1967.

Martin, Lt. Col. Lawrence. *The Treaties of Peace, 1919–1923*, vol. 1. Carnegie Endowment for International Peace, 1924.

McCausland, Shane. *Gu Kaizhi and the Admonitions Scroll*. British Museum P, 2000.

Moye Guan (Mo Yan). *Red Sorghum*. Translated by Howard Goldblatt. Penguin Books, 1993.

Nourry, Prune. "Terracotta Daughters." *Prune Nourry*, https://sfi.usc.edu/collections/nanjing-massacre. Accessed 15 December 2021.

"Pearl Buck." Nobel Prize in Literature 1938. *Nobel Prizes and Laureates*, https://www.nobelprize.org/prizes/literature/1938/summary/. Accessed 8 March 2022.

"Pearl S. Buck Memorial House." Nanjing University, https://sfi.usc.edu/collections/nanjing-massacre. Accessed 8 March 2022.

Ping, Wang. *Aching for Beauty: Footbinding in China*. Anchor Books, 2002.

Raise the Red Lantern. Directed by Zhang Yimou, Orion Classics, 1991.

Red Sorghum. Directed by Zhang Yimou, Xi'an Film Studio, 1987.

Rosemont, Henry Jr., and Roger T. Ames. *The Chinese Classic of Family Reverence: A Philosophical Translation of the Xiaojing*. U Hawai'i P, 2009.

Scott, Joan Wallach. "Gender: A Useful Category of Analysis." *American Historical Review*, vol. 91, 1986, pp. 1053–75.

———. "Women in History: The Modern Period." *Past & Present*, vol. 101, 1983, pp. 141–57.

Spence, Jonathan. *The Search for Modern China*. 3rd ed. Norton, 2013.

Stuart, Jan. *The Admonitions Scroll: Objects in Focus*. British Museum, 2014.

Tan, Ye, and Yimou Zhang. "From the Fifth to the Sixth Generation: An Interview with Zhang Yimou." *Film Quarterly*, vol. 53, 1999–2000, pp. 2–13. https://www.onacademic.com/detail/journal_1000036425550610_d093.html. Accessed 15 December 2021.

"The Nobel Prize in Literature 1938." *NobelPrize.org*, https://www.nobelprize.org/prizes/literature/1938/buck/facts/. Accessed 8 March 2022.

To Live. Directed by Zhang Yimou, Samuel Goldwyn Mayer, 1994.

Tong, Su. *Raise the Red Lantern*. Translated by Michael S. Duke. Harper Perennial, 2004.

Tucker, Frank H. "The Study of Women in History." *Improving College and University Teaching*, vol. 20, 1972, pp. 16–17.

Wang, Nanfu. *One Child Nation*. Independent Lens. PBS, 2020.

Wang, Nina. "Cosmopolitanism and the Internationalization of Chinese Literature." *Mo Yan in Context: Nobel Laureate and Global Storyteller*, edited by Angelica Duran and Yuhan Huang. Purdue UP, 2014, pp. 167–82.

Wang, Robin R. *Images of Women in Chinese Thought and Culture: Writings from the Pre-Qin Period through the Song Dynasty*. Hackett, 2003.

Wilson, Jeanne L. "The Institution of Democratic Reforms in the Chinese Enterprise since 1978." *Worker Participation and the Politics of Reform*, edited by Carmen Sirianni. Temple UP, 1987, pp. 298–328.

Xiong, Ran, and Ping Wei. "Influence of Confucian Culture on Entrepreneurial Decision-Making Using Data from China's Floating Population." *Social Behavior and Personality: An International Journal*, vol. 48, 2020, pp. 1–12.

Yang, Rae. *Spider Eaters: A Memoir*. U California P, 2013.

Ye, Tan, and Zhang Yimou. "From the Fifth to the Sixth Generation: An Interview with Zhang Yimou." *Film Quarterly*, vol. 53, 1999–2000, pp. 2–13.

Yen Mah, Adeline. *Falling Leaves: The Memoir of an Unwanted Chinese Daughter*. Broadway Books, 1997.

Zhang, Junsen. "The Evolution of China's One-Child Policy and Its Effects on Family Outcomes." *Journal of Economic Perspectives*, vol. 31, 2017, pp. 141–60.

Zhen, He-Yin. "On the Question of Women's Liberation" in *The Birth of Chinese Feminism: Essential Texts in Transnational Theory* edited by Lydia H. Liu, Rebecca E. Karl, and Dorothy Ko. Columbia UP, 2013, pp. 53–71.

———. "On the Revenge of Women" in *The Birth of Chinese Feminism: Essential Texts in Transnational Theory* edited by Lydia H. Liu, Rebecca E. Karl, and Dorothy Ko. Columbia UP, 2013, pp. 105–68.

Zheng, Wang. "Call Me *Qingnian*, But Not *Funü*" in *Some of Us: Chinese Women Growing Up in the Mao Era*. Rutgers UP, 2001, pp. 27–52.

———. *Finding Women in the State: A Socialist Feminist Revolution in the People's Republic of China, 1949–1964*. U California P, 2017.

———. *Women in the Chinese Enlightenment: Oral and Textual Histories*. U California P, 1999.

Zhong, Xueping, Wang Zheng, and Bai Di, eds. *Some of Us: Chinese Women Growing Up in the Mao Era*. Rutgers UP, 2001.

Zi, Chun, Wang Zhendong, Feng Hong, and Highlight Studio. *Eileen Chang's Literature*. Tongji UP, 2019.

Index

www.ingramcontent.com/pod-product-compliance
Lightning Source LLC
Chambersburg PA
CBHW030349270326
41926CB00009B/1021